AMERICAN FURNITURE IN THE BYBEE COLLECTION

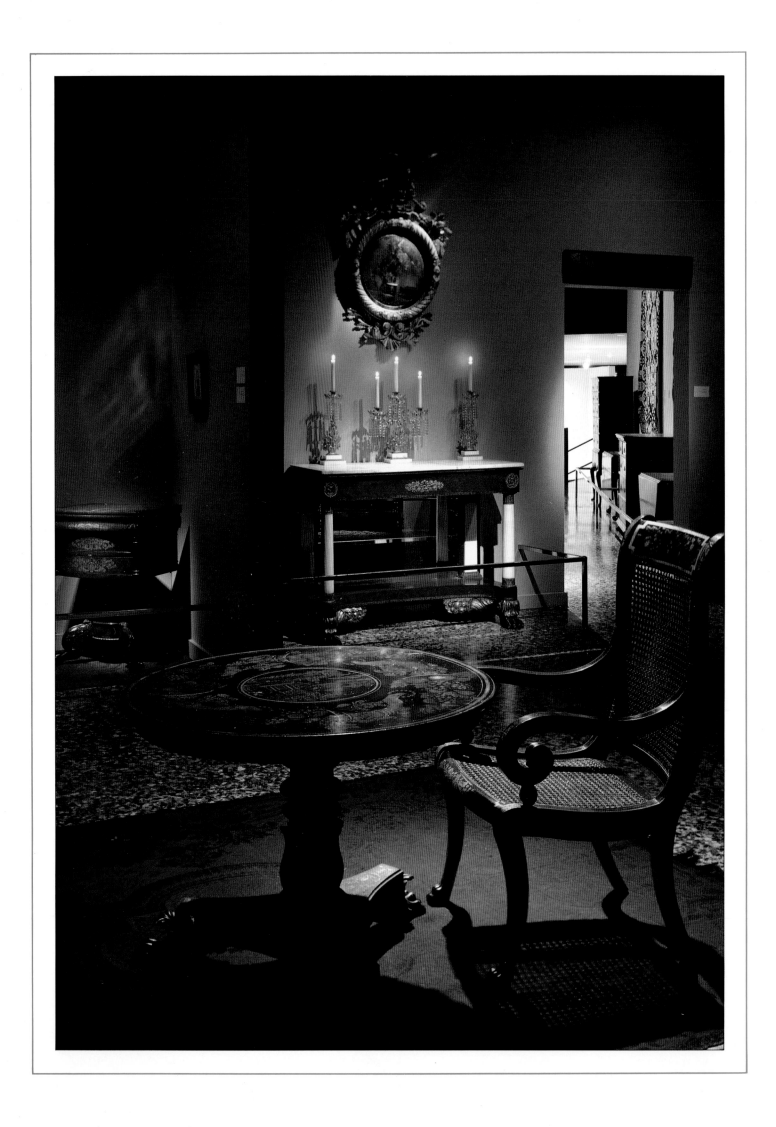

AMERICAN FURNITURE IN THE BYBEE COLLECTION

INTRODUCTION BY JONATHAN L. FAIRBANKS

TEXT BY CHARLES L. VENABLE

PHOTOGRAPHY BY LEE CLOCKMAN

UNIVERSITY OF TEXAS PRESS, AUSTIN

PUBLISHED IN ASSOCIATION WITH THE DALLAS MUSEUM OF ART

Gerald W. R. Ward, Guest Editor
Robert V. Rozelle, Associate Editor

THIS PUBLICATION is made possible by a generous grant from the Luce
Fund for Scholarship in American Art, a program of The Henry Luce
Foundation, Inc. Additional research funds were made available by The
Andrew W. Mellon Foundation, and a generous grant from the National
Endowment for the Arts, a Federal agency, was provided to support the
exhibition which this publication documents.

Library of Congress Cataloging-in-Publication Data

Dallas Museum of Art.
 American furniture in the Bybee collection / introduction by
Jonathan L. Fairbanks ; text by Charles L. Venable ; photography by
Lee Clockman.—1st ed.
 p. cm.
 "Published in association with the Dallas Museum of Art."
 Bibliography: p.
 Includes index.
 ISBN 0-292-70774-6
 1. Furniture—United States—Exhibitions. 2. Bybee, Faith
Poorman—Art collections—Exhibitions. 3. Bybee, Charles Lewis—
Art collections—Exhibitions. 4. Furniture—Private collections—
Texas—Dallas—Exhibitions. 5. Dallas Museum of Art—Exhibitions.
I. Venable, Charles L. (Charles Lane), 1960– . II. Title.
NK2405.D35 1989
749.213′074′01642812—dc19 89-30888
 CIP

Frontispiece:
"An American Sampler, 1700–1875," featuring the Bybee Collection at
the Museum of Fine Arts, Houston. The exhibition ran from 23 October
1981 to 7 February 1982. (Courtesy, Hickey-Robertson.)

THIS BOOK IS DEDICATED
TO THE MEMORY OF CHARLES L. BYBEE,
THE DETERMINATION OF FAITH P. BYBEE,
AND THE VISION OF THE PEOPLE OF DALLAS

CONTENTS

CONTRIBUTORS TO THE BYBEE PURCHASE FUND

Tri Delta Charity Antiques Show
Cecil and Ida Green
Anonymous
Mr. and Mrs. Vincent A. Carrozza
Mr. and Mrs. James R. McNab, Jr.
Mr. and Mrs. H. Ross Perot
Mrs. Nancy Hamon
Donaldson, Lufkin & Jenrette
The Rosewood Corporation
Mr. and Mrs. George A. Shutt
Anonymous
Mrs. Ruth Sharp
Cain Foundation
Mrs. J. William Griffith
Mrs. Elloine Calder
Mrs. Eugene McDermott
Mr. and Mrs. Charles Paschall
The Southland Corporation
Dr. and Mrs. Mark L. Lemmon, Jr.

Mr. and Mrs. Duncan E. Boeckman
Mrs. Jane S. Beasley
Mr. Henry C. Beck
Mrs. Alta Ewalt Evans
Mr. and Mrs. Edward B. Linthicum
Mr. and Mrs. Tom F. Marsh
Southwestern Bell Foundation
Mrs. Barbara B. Thomas
Mr. and Mrs. Richard W. Cree, Sr.
Mr. and Mrs. S. Roger Horchow
Mr. and Mrs. C. Thomas May
Ms. Susan Mead
Mrs. James H. Clark
Mr. and Mrs. Irwin Grossman
Mrs. Ashley Priddy
Mr. and Mrs. Lawrence S. Pollock, Jr.
Ms. Carol Casson
Governor and Mrs. William P. Clements
Mr. and Mrs. Gerald C. Johansen

Mr. and Mrs. Barron U. Kidd
Mr. and Mrs. Irvin L. Levy
Mr. and Mrs. Ronald McCutchin
Mr. and Mrs. P. O'B. Montgomery
Mr. and Mrs. Addison P. Moore
Mrs. Jeanne Gray Wilson
Mr. and Mrs. John R. Watson
Mr. and Mrs. George T. Lee, Jr.
Mr. and Mrs. Lawrence R. Herkimer
The Priddy Foundation
Apple Interiors
Mr. and Mrs. James B. Francis
Mr. and Mrs. Keith Stone
Mr. and Mrs. Harry S. Parker III
Mrs. James F. Williams
Mr. and Mrs. Raymond A. Hay
Ms. Dorothy Savage
Museum Guards

FOREWORD
ESSENTIAL OBJECTS: AMERICAN FURNITURE AS ART

THIS PUBLICATION and the collection it documents celebrate the applied arts in America. The Faith P. and Charles L. Bybee Collection is among a small group of private collections of American furniture formed in this century which treated furniture as an art form rather than as domestic decoration. The individual works of art in the collection were chosen both for their authority as individual objects and for their participation in the larger history of American furniture. They were *not* chosen simply to look good in a particular room in the Bybees' home, nor were they sought as mere examples of any individual period or region. Rather, they were chosen as singularly important works of art.

The Bybee Collection is not encyclopedic. It is, instead, a carefully balanced group of works that is now the core of what will become a great institutional collection of American furniture. Because the quality of the collection is so high, we have chosen to exhibit and publish it before it is supplemented with judiciously chosen purchases and gifts. Thus, the pieces of American furniture selected over the years by Faith and Charles Bybee will be the touchstone against which we will measure every object in the future.

The acquisition of the Bybee Collection was the catalyst for the museum to enter a new area of collecting and, thus, to create a new curatorial department, decorative arts. It came to the museum soon after the acquisition of the Wendy and Emery Reves Collection, which has many masterpieces of European furniture, glass, ceramics, silver, and textiles, as well as Chinese export porcelain and eastern carpets. The Reves holdings, together with the Hoblitzelle Collection of English and Irish Silver, gave the museum a real strength in European decorative arts. The acquisition of the Bybee Collection has catapulted the Dallas Museum of Art into the first rank of museums in the area of American furniture.

The Bybee Collection is not as large as the major institutional collections on the East Coast or in Chicago, but the high quality and broad geographic range of individual objects are exceptional. For Faith and Charles Bybee, American furniture was more than "high style" work from this country's eighteenth- and nineteenth-century cabinetmaking centers. The Bybees also recognized the importance of regional and rural objects. As many of the works in this catalogue eloquently attest, some of the most beautifully proportioned and carefully crafted pieces of American furniture were made outside the urban centers along the eastern seaboard. Indeed, their appreciation of what might be considered "provincial" furniture is legendary and, as many of their admirers have pointed out, the Bybees' aesthetic was at once rigorous and free of conventional assumptions,

making them among the most original and, in a sense, "modern" collectors of American furniture in this century.

Like a few other richly prized acquisitions in the museum's history, the story of how the Bybee Collection came to Dallas, rather than to Houston, Boston, or elsewhere, is a complicated one featuring a cast of influential, farsighted, and generous individuals—museum officers and patrons, directors and curators, benefactors and DMA family members. In 1985 the availability of the Bybee Collection was learned by then President Vincent A. Carrozza, Director Harry S. Parker III, and Dr. Rick Stewart, Curator of American Art. Because of the stipulation of Charles L. Bybee's last will and testament, his personal properties could not be given away, but rather could be sold with the proceeds going into a trust for the benefit of Faith P. Bybee. After seeing the collection in Faith Bybee's Houston apartment, the museum formed a Decorative Arts Study Committee. Chaired by trustee James McNab, the enthusiastic committee recommended that the museum expand its collecting interest to include decorative arts and that it enter into serious negotiations with Faith Bybee concerning the future of her great collection. Since other public institutions, private collectors, dealers, and auction houses were also eager to speak with her regarding single masterworks or groups of objects in the collection, another committee co-chaired by Ruth Ann Montgomery and the determined James McNab launched an aggressive fund-raising campaign to secure the collection for Dallas.

Three factors were crucial to the DMA's initial decision to acquire the collection. The first was Faith Bybee's ardent desire that her collection remain in Texas. Second, it was understood that the institution which purchased the core furniture collection would receive extensive holding in textiles, ceramics, glass, and metalwork, as well as more furniture, as a promised gift from Faith Bybee. Finally, the Tri Delta Antiques Show committed itself to underwrite a substantial percentage of the cost of the collection's long-term purchase. This farsighted pledge proved pivotal in the museum's decision to purchase the collection since the remaining funds would be difficult to raise given the sluggish Dallas economy.

Not long after the DMA agreed to acquire the collection, encouraging news was received that the Henry Luce Foundation had reviewed Rick Stewart's grant application and had generously awarded the museum funds to publish a major scholarly catalogue on the Bybee Collection. Concurrent with this vital development was the equally important staff addition in the person of Charles L. Venable as Curator of Decorative Arts. Already an acquaintance of Faith Bybee and professionally aware of the importance of her collection, Venable was a logical, quali-

fied, and enthusiastic candidate to research the collection and to write the scholarly component of this catalogue.

In the ensuing year, the Decorative Arts Committee, with the help of former Director Parker and then Director of Development Charles A. Taggart, succeeded in raising the balance of funds needed for the collection's purchase. The triumphant conclusion of this capital campaign would have been virtually impossible were it not for extremely generous contributions by Cecil and Ida Green, James and Mary McNab, Ross and Margot Perot, and Vincent and Anne Carrozza. These key contributors and the collective gifts of another fifty civic-minded individuals, foundations, and organizations enabled the Dallas Museum of Art to acquire an American furniture collection that rivals any other museum or private collection of comparable size throughout the United States. Generous grants from the Henry Luce Foundation and the National Endowment for the Arts, as well as the availability of Andrew W. Mellon research funds, have since enabled us to present this outstanding collection to the world.

Now that the Bybee Collection is part of the Dallas Museum of Art, the people of central and north Texas will have the opportunity to measure the achievements of early Americans as they moved triumphantly across the frontier. It was Charles Bybee's hope, and it remains a major commitment of his wife, Faith, that today's Texans, many of whom are new to the state, learn about the participation of this state in the larger history of the United States. For that reason, the couple devoted much of their last years together collecting early Texas architecture, furniture, textiles, and ceramics. These collections, which are centered at historic Round Top, Texas, just north of LaGrange, form a link between the "American" furniture at the Dallas Museum of Art and the history of this state. We at the museum are proud to present this artistic heritage to our expanding public and to pass on the vision of Charles and Faith Bybee to future generations.

Works of art, whether "decorative" or "fine," are among the most potent embodiments of history and, living in a new city, we must remember that the short history of Dallas as a great city is part of the longer history of Texas and the even more extensive history of the United States and the Old World beyond. Faith and Charles Bybee worked to preserve that history by collecting works of art which speak more eloquently about our past ambitions than do our present words. This catalogue is therefore dedicated to the memory of Charles Bybee and the courage, wit, determination, and knowledge of his widow, Faith P. Bybee, as well as the numerous individuals who worked to secure this collection for the people of Texas.

RICHARD R. BRETTELL
Director
Dallas Museum of Art

PREFACE
AND ACKNOWLEDGMENTS

DURING THE LAST TWO DECADES, numerous books on American furniture have been published. Studies of furniture from diverse regions, including Texas, New Mexico, Hawaii, and Georgia, have appeared, as have works treating specific forms, like easy and rocking chairs. Along with these more specialized studies, numerous permanent collection catalogues have also appeared.

Unlike studies which are often done to accompany temporary museum exhibitions and thus contain objects from many public and private sources, permanent collection catalogues by definition represent the holdings of a single institution. As a result they generally prove extremely useful simply because the location of the pieces they document is static. Even if the interpretive information associated with an object in a catalogue proves faulty or becomes outdated, the volume still provides a visual index to an institutional collection at a specific point in time. With the proper arrangements, one can examine a piece in person, because the catalogue has told you where to go.

Besides providing a visual index to a permanent collection, this type of catalogue also incorporates large quantities of objective rather than subjective information. Having photographs and details, such as measurements, accession numbers, and wood and constructional analyses available for large numbers of objects proves invaluable when done properly, since it allows one to reliably compare fundamental design and construction elements of pieces which may now be separated geographically by thousands of miles.

The basic cataloguing format used in furniture catalogues published in this country was codified by Richard Randall and Charles F. Montgomery over twenty years ago. With the publication of Randall's *American Furniture in the Museum of Fine Arts, Boston* (1965) and Montgomery's *American Furniture: The Federal Period, in the Henry Francis du Pont Winterthur Museum* (1966), the two introduced formulas for furniture catalogues upon which almost all subsequent works in this genre have been based. In each of their entries Randall and Montgomery include an illustration of the object along with its name, place of origin, date, size, accession number, and type of woods used. The body of each entry consists of a short essay which describes the object under consideration, and places it within its original socio-historic context when possible.

In many ways this catalogue closely follows these early prototypes. The name of each object is listed at the beginning of an entry. Period terms have been used when known. This information is followed by the piece's place of origin and date. In a few instances both of these elements are precisely known;

more typically they represent informed guesses based upon current scholarship. As in Montgomery, the woods used in all objects, unless otherwise noted, were microanalysed to provide accurate information on the various woods employed in the construction of each piece. Like Randall, each entry includes information on construction and condition, as well as publication history and provenance. Entries conclude with the Dallas Museum of Art's accession or promised gift numbers.

Since Randall and Montgomery completed their famous works, numerous other permanent collection catalogues have been published. While virtually all of these have been based on these pioneering models, some have gone beyond them in significant ways. Brock Jobe and Myrna Kaye's excellent catalogue *New England Furniture, The Colonial Era: Selections from the Society for the Preservation of New England Antiquities* (1984), for example, provides the reader with much more extensive constructional analyses than did Randall (Montgomery contains virtually none). Also, their use of lengthy endnotes serves to direct the reader to a wide variety of related information, including similar examples, period documents, and secondary material. *American Furniture in the Bybee Collection* follows the terminology for the different parts of furniture that are used in *New England Furniture*. For a schematic discussion of this terminology, the reader is referred to *New England Furniture*, pp. xiii–xviii.

Another recent publication that improves upon both Randall and Montgomery in the area of photography is Morrison H. Heckscher's *American Furniture in the Metropolitan Museum of Art, Vol. 2, Late Colonial Period: The Queen Anne and Chippendale Styles* (1985). Although its overall layout follows Montgomery in general and Jobe and Kaye in particular, Heckscher incorporates many more illustrations of design details which are extremely helpful for comparative purposes. Jack Flanigan's *American Furniture in the Kaufman Collection* (1986) goes one step further by including color plates of each object, as well as numerous details.

In the Bybee Collection catalogue we have tried to combine the best aspects of these recent publications. Montgomery's basic format has been expanded to include constructional analyses and extensive information in the form of endnotes. Thanks to substantial funding by the Henry Luce Foundation and the National Endowment for the Arts, it has also been possible to include a color overall illustration of every object, as well as numerous high quality (duotone) black-and-white photographs. However, unlike other heavily illustrated catalogues, the focus of the illustrations included here is not decorative details such as carving and painting. Rather, I have chosen to extensively document the construction of each piece. Con-

sequently, this volume contains dozens of illustrations of seat frames, case interiors, bottoms, and backs. It is my belief that clear photographs of these details, in conjunction with overall views, will prove invaluable to future students of American furniture because they contain more information than the most eloquent author can pack into a few paragraphs on condition and structure. Furthermore, they document aspects of these pieces which would otherwise be available only to those few who have the pleasure of closely examining the collection in person at the Dallas Museum of Art. I only wish that we had had sufficient space to include other construction photographs, such as those of dovetails and drawer construction.

Besides my firm belief in the importance of extensive constructional photography, the reason why we were able to illustrate the Bybee collection so thoroughly is the simple fact that, while extremely diverse, the collection is relatively small in comparison to the holdings of institutions like Winterthur Museum, the Society for the Preservation of New England Antiquities, and the Metropolitan Museum of Art.

This group's compact size has also made it possible for us to include every piece in both the Bybee Collection proper, as well as study objects. The only exceptions to this rule are a very few examples which will eventually be sold or traded from the collection because of unnecessary duplication or their inappropriateness to an art museum's holdings. It is unfortunate that institutions with larger holdings can or will not publish all of their objects, including those in their study collections, due to financial limitations or aesthetic considerations. To date, only Gerald W. R. Ward's *American Case Furniture in the Mabel Brady Garvan and Other Collections at Yale University* (1988) has included problem pieces in a catalogue of a large institutional collection.

It is also unfortunate that the condition of many of the objects which are published is not accurately noted because institutions and especially private collectors and dealers are afraid of embarrassment. All who study old furniture must simply come to the realization that virtually no early American furniture exists in untouched condition. I have tried diligently to accurately record the condition of all objects in the Bybee Collection. The reader should assume that every piece has been refinished and reupholstered unless otherwise noted. Dimensions for each object are given in inches, followed by the equivalent in centimeters enclosed in parentheses. In describing pieces, the terms *right* and *left* are used as if the viewer were facing the object, *not* sitting in it. If headings such as *Inscriptions* or *Exhibitions and Publications* do not appear in an entry, the reader should assume there is no such information for that particular example.

Although the size of the Bybee Collection has made it possible to provide more information on individual objects, the collection's character has set interpretive limitations on this project. The Bybee Collection was formed for the sole purpose of furnishing the private home of two energetic and gifted collectors, rather than as an encyclopedic museum collection. Consequently, the collection reflects the Bybees' aesthetic preferences, as well as their economic and intellectual parameters.

As the reader will quickly note, the Bybee Collection is an exceptionally broad one, including furniture from New England and California, from the early 1700s and the 1980s. It also contains examples made of such diverse materials as bent willow, laminated walnut, and cast iron. But regardless of the unusually wide scope of the collection, there are certain types of furniture which are not represented due to losses and aesthetic preferences. Virtually all of the Bybees' superb early eighteenth-century furniture was destroyed by fire in 1972. Furthermore, the collection does not include examples of ornately carved furniture, such as rococo pieces from eighteenth-century Philadelphia or examples in the rococo revival style of mid-nineteenth-century New York. Although the Bybees appreciated the importance of such ornate pieces, they were not aesthetically attracted to them and therefore did not purchase examples for their Houston home. Attesting to both her farsightedness and generosity, Faith Bybee has recently begun to acquire exceptional examples of ornately carved furniture (see cats. 70, 73) for the Dallas Museum of Art. As she says, "Now that the Bybee Collection belongs to the public, it should be filled out by pieces which are important to the history of furniture, but which Charles and I would never have selected for our home."

Given the wide geographic and temporal scope of the Bybee Collection, and its formation as furnishings for a single home, this catalogue has been arranged in chronological order, rather than by furniture form. This arrangement has the advantage of providing the reader with a relatively complete visual progression of furniture styles from approximately 1700 to 1850. The inclusion of major examples of late nineteenth- and twentieth-century furniture provides interesting comparisons to the earlier material. But regardless of its advantages, this catalogue's chronological arrangement makes it difficult to compare temporally separated examples of the same furniture form.

The geographic and temporal diversity of the Bybee Collection has also made it difficult to open this catalogue with a series of interpretive essays as other permanent collection catalogues have successfully done. Where the collecting practices of an institution or the enormous size of its permanent holdings enabled the cataloguer to concentrate on some limited aspect of American furniture history, such as New England or eighteenth-century furniture, it is far easier to provide coherent interpretive essays which are both general enough to accommodate the casual reader, but specific enough to be of use to the furniture scholar. In the case of collections such as this which contain a wide variety of objects, the essays written for their catalogues have too often taken the form of commentary on stylistic change in American furniture. Typically these essays are general and appeal primarily to beginning readers.

Rather than publish yet another version on the theme of stylistic development, I have chosen not to include any lengthy interpretive essays whatsoever. All efforts were directed toward providing an introduction which gives insight into the couple who assembled this marvelous group of objects, and to individual entries which provide as much information as realistically possible on each piece.

When I arrived at the Dallas Museum of Art in August 1986, fresh from the Winterthur Program in Early American Culture, there was already a deadline for completion of a Bybee Collec-

tion catalogue—exactly two years. Compared to other cataloguing projects, two years is a short time to complete work on such an important and diverse collection. Consequently, I made the decision to target those objects in the collection which had the greatest potential for providing furniture historians with new and useful information on a variety of subjects. Of the eighty-two entries included here, approximately one-third represent concentrated primary research on my part. For the rest I have tried to include the most current information available in the work of other furniture historians. However, in every case the provenance of an object has been investigated as extensively as possible.

The final way in which this catalogue differs from the vast majority of its predecessors, is that I have consistently avoided using twentieth-century stylistic terms, such as *William and Mary, Queen Anne, Chippendale,* and *Federal.* It is my opinion that, while such terms may ease communication between furniture historians who realize such a term's limitations, their disadvantages far outweigh their advantages. To the average reader it is virtually impossible to separate these long-used labels from logical temporal associations with the lives of English monarchs, cabinetmakers, and political movements. Rather than add to this confusion, I have chosen to use terminology which helps to move furniture into the mainstream of art history and out of the shadow of antiquarianism. Consequently, the reader will encounter terms such as *mannerist, baroque, rococo,* and *neoclassical.* Since art historians have long observed that these stylistic developments overlapped through time and flowed uninterrupted across national borders, it is hoped that their use here will help to counteract the vagaries of "traditional" American furniture terminology.

The two years which I have worked on this project have been some of the most rewarding (and occasionally frustrating) of my life. I have had the opportunity to meet many colleagues and dealers for the first time, and strengthen existing relationships with others. Most have been extremely generous in making accessible their research and opinions; rarely have individuals refused to cooperate. I am pleased to say that the vast majority of decorative arts curators, dealers, and collectors were more than willing to share their knowledge freely. Without the free exchange of information, all historical and scientific enquiries are severely limited at best, and doomed to failure at worst.

Although this volume lists but a few names on its cover, it is actually the work of many hands and minds. Those who deserve a special thanks include Edward S. Cooke, Jr., of the Museum of Fine Arts, Boston; Philip Zea of Historic Deerfield; and Brock Jobe of SPNEA. These three were kind enough to come to Dallas and examine the entire collection. While their comments were not always in agreement, they were all intelligently reasoned and constructive. Similarly, the analysis of wood samples by Bruce Hoadley of the University of Massachusetts has proven invaluable in the evaluation thereof. Hoadley, with his traveling caravan of scientific equipment, has truly elevated the testing of woods used in furniture to a fine art. A special thanks is also due to Robert Walker of the Museum of Fine Arts, Boston, who shared important information on the

conservation of pieces following the 1972 fire. While Barry Greenlaw's and my conclusions were not always identical, the preliminary research on the collection which he did before it came to the Dallas Museum of Art proved a useful starting place for this project. Similarly, I am indebted to Albert and Harold Sack and their staff for assisting in researching the provenance of many objects in the collection and for putting me in touch with numerous private collectors.

Another group of professionals who deserve special recognition is the faculty of the American and New England Studies Program at Boston University. Not only were they willing to grant me a year's deferral so that I could come to Dallas and begin the research for this catalogue, but they never once objected to my occasional returns to Texas while I completed all of my Ph.D. coursework during the 1987–1988 academic year. David Hall, Robert Blair St. George, Keith Morgan, John T. Kirk, and Alan Taylor, thanks for understanding.

Finally, numerous people on the staff of the Dallas Museum of Art merit special thanks. These include Lee Clockman for his exceptional photographs; Regina Monfort Arrendondo and Tom Jenkins for printing dozens of negatives; Manuel Mauricio, Russell Sublette, Ron Moody, Connie Cullum, Mark Snedegar, Casey Chetham, Cathy Burke, and Phil Angell for moving the pieces countless times for photography; Gerturd Rath Montgomery and Sharon Boese for their help in organizing collection records and the bibliography; Eileen Coffman and Beth Dinoff for keeping track of Bybee photographic material; Amy Schaffner and Susanne Milton for not laughing (or crying) too much at my repeated obscure inter-library loan requests; the staff of the Registrar's office, especially Steve Mann, for keeping track of so many things; Maureen McKenna for overseeing grant applications and expenditures; Bob Rozelle for his negotiations with various publishers and his sharp proofreading; Rick Stewart (now Amon Carter Museum) for his encouragement and work on grant applications; Harry Parker III and Steven Nash (both now with the Fine Arts Museums of San Francisco) for their taking a chance on an unknown quantity in allowing me to do this project; and finally Rick Brettell and Jack Rutland for their unfailing enthusiasm for both the Bybee cataloguing project and the Dallas Museum of Art's decorative arts program.

Although it is not possible to list all those who have aided this project in some way, the following is a roster of persons who have responded to my many inquiries and made available objects in their collections: Kenneth Ames, Winterthur Museum; John S. Barker, Chesterland, Ohio; David Barquist, Yale University Art Gallery; Judith A. Barter, Mead Art Museum; Barbara C. Batson, Valentine Museum; Janette G. Boothby, Middlesex County Historical Society; Ronald Bourgeault, Hampton, N. H.; Michael Brown, Bayou Bend; Alma K. Carpenter, Natchez, Miss.; Edwin A. Churchill, Maine State Museum; Mr. and Mrs. Chalmers E. Cornelius III, Haverford, Pa.; Bert Denker, Winterthur Museum; John P. Elliott, Charlottesville, Va.; Nancy G. Evans, Winterthur Museum; Donald Fennimore, Winterthur Museum; J. Michael Flanigan, Baltimore, Md.; Edward La Fond, Mechanicsburg, Pa.; H. A. Crosby Forbes, Peabody Museum; Eugenia Fountain, Essex Institute; Craig A. Gilborn, Adi-

rondack Museum; Vesta Lee Gordon, Charlottesville, Va.; Lee Griffith-Chalfant, West Chester, Pa.; Granville Haines, Mt. Holly, N. J.; David Hanks, New York City; Morrison Heckscher, Metropolitan Museum of Art; Peter Hill, East Lempster, N. H.; Georg Himmelheber, Bavarian National Museum, Munich, West Germany; Frank L. Horton, MESDA; Ronald Hurst, Colonial Williamsburg; Mr. and Mrs. Joseph F. Johnston, Bremo Plantation, Va.; Barry Kessler, Baltimore City Life Museums; Joyce King, Salem, Mass.; Gary Kingsley, Greenville, Del.; Betsy Lahikainen, SPNEA; Ann S. Lainhart, Boston, Mass.; Christine Lamar, Providence, R. I.; Carol Lehman, Frazer, Pa.; S. Dean Levy, New York City; Joseph Lionetti, Jewett City, Conn.; Nina F. Little, Brookline, Mass.; Robert B. MacKay, Society for the Preservation of Long Island Antiquities; Sam Maloof, Alta Loma, Cal.; Jack McGregor, Houston; Laura McKinney, Winterthur Museum; Ronald L. Mitchell, Atlanta, Ga.; Christopher Monkhouse, RISD; Roger Moss, Philadelphia Athenaeum; Robert Mussey, SPNEA; Dr. Helmut Ottenjann, Museumsdorf Cloppenburg, West Germany; Mrs. Olly Parma and Tom Parma, Dallas; David Penney, Wadhurst, England; Elizabeth M. Perinchief, Mt. Holly, N. J.; Charles E. Peterson, Philadelphia; Sumpter Priddy, Alexandria, Va.; Richard Reed, Fruitlands Museum; Ellie Reichlin, SPNEA; Nancy Richards, Winterthur Museum; Marguerite Riordan, Stonington, Conn.; Mr. and Mrs. Edward J. Scheider, New York City; Mary S. Smith, Essex Institute; Ellen M. Snyder, Brooklyn Historical Society; David H. Stockwell, Wilmington, Del.; John A. H. Sweeney, Winterthur Museum; Kevin Sweeney, Historic Deerfield; Elizabeth L. Tait, Redington Shore, Fla.; Nancy Terry, Boston, Mass.; Neville Thompson, Winterthur Museum; Robert Trent, Winterthur Museum; Gregory R. Weidman, Maryland Historical Society; Sir George White, London, England; James A. Williams, Savannah, Ga.; Aline Zeno, Yale University Art Gallery.

Finally, I would like to give a special thanks to Jonathan L. Fairbanks, Museum of Fine Arts, Boston, for undertaking to capture personalities and careers of two multifaceted collectors in a brief introduction, and to Gerald W. R. Ward, Strawbery Banke, for giving my text an added sense of clarity while allowing it to remain *mine*. Also, this volume's completion would not have been possible without the enthusiastic cooperation of Faith P. Bybee. While she tragically lost many important documents pertaining to the collection, as well as superb objects, in the 1972 fire, her memory is an invaluable source of information.

And perhaps most importantly of all, I owe a sincere thanks to my wife Sylvia, who was always willing to critique freshly written entries for her impatient husband regardless of how late at night it was; who unselfishly pitched in when I needed someone to read a few hundred patent records or skim a book looking for a citation I had lost; and who corrected millions of misspelled words written by the world's worst speller! Completing this project would have been very difficult without her.

CHARLES L. VENABLE
Associate Curator of Decorative Arts
Dallas Museum of Art

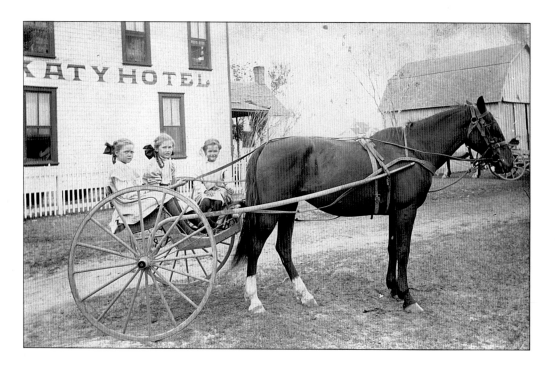

Faith Poorman Bybee (center) and her sisters Mary (left) and Eunice (right)
on their way to school in Katy, Texas, around 1912. (Courtesy, Faith P. Bybee.)

INTRODUCTION
FAITH POORMAN BYBEE AND CHARLES LEWIS BYBEE
COLLECTORS OF PERSONAL VISION

AN ABIDING FRIENDSHIP began in 1961 when I met Charles and Faith Bybee. This meeting took place at a symphony party in their home on Larchmont Street in the River Oaks section of Houston. Charles was the vice president and treasurer of the Symphony; Faith was a benefactor/fund raiser and volunteer. I came to the party with their friend and fellow Houston collector, Miss Ima Hogg. When I arrived, the Bybees were busy with guests, which gave me a chance to look around. To my astonishment I discovered that their home contained an unexpected treasury of American art. For example, in a chamber Faith called her Keeping Room, there stood a marvelous gate-leg table (cat. 3) from early eighteenth-century New England. On its top were handsome early delft plates and bell metal candlesticks from seventeenth-century England and Holland. Beside the fireplace was a rare chest of drawers from Chester County, Pennsylvania (cat. 1). The front of its drawers were superbly ornamented with vine-and-ball inlay. Beside a William and Mary–style chest-on-frame there stood an early eighteenth-century great chair made in New York. It was one of the best examples of only a few survivors with richly carved front stretchers. Near the chair hung a colored engraving of *The Boston Massacre* by patriot Paul Revere, in its original pre-Revolutionary frame. No matter where I looked, the Bybee home contained superb antiques (as this catalogue amply attests). Surrounding the home was a handsome brick-walled garden of flowering azalea, magnolia, and monumental live oak trees. Clearly, the Bybees were persons of developed tastes. Their appreciation of fine music, horticulture, and American antiques was beautifully balanced.

When introduced to Charles and Faith, I experienced a strange feeling that I had already known them for years. Perhaps this was because of their warm welcome, vitality, and ready humor. Charles was robust and hearty, Faith was serene and seemed deservedly content in her opulent surroundings. They had just acquired a Massachusetts blockfront chest of drawers which they were eager to show me (cat. 27). As soon as guests had gone we turned that pre-Revolutionary cabinet upside down in the front hall and took out all of its drawers for detailed inspection. The Bybees' inquiring nature and interest in learning was a refreshing experience. In their quest for antiques the Bybees were completely open to sharing. Through genuine curiosity they had developed remarkable connoisseurship and a personal style expressive of their own heritage.

Within the year I was back in Houston, this time as a guest of the Bybees for a month in their home. I had just been employed as a curatorial assistant at Winterthur Museum, but was on leave from Winterthur for a month to instruct the first class of docents at Miss Ima's house, Bayou Bend, every morning. In the afternoon I met with members of the Harris County Heritage Society. Faith was president of that society. My invitation to Houston was thus a joint venture between Faith and Miss Ima.

That experience gave me a deeper understanding of the Bybees and their collection. They had been collecting Americana ever since they were married in 1924. Such an early beginning placed them within the generation of pioneer collectors, most of whom are now gone. This introduction attempts to place their collection in context through a brief sketch of their lives. It is my belief that whatever one collects is a reflection of the person's spirit within. What sets the Bybee collection apart from many others is the Bybees' view of American taste and history as sensed through their own family experiences and ancestries.

Collecting is an art form as complex and sometimes as perplexing as any human activity. Some have said that "art is selection." If this is true, then all humans are artists, more or less, according to the quality of their choices. The impulse which prompts people to live with one sort of furnishings or another can be only partially understood through biography. But much of the character of the Bybee collection springs naturally from their family backgrounds. Both Charles and Faith have had a strong sense of their place in American history and a concern for memory. Faith explains that her first ancestor in this country on her mother's side was of Dutch descent. Captain Gerritsten DeVries Van Dalfsen arrived in New Amsterdam (later New York) in 1640 and his wife bore him a son, Teunis, reputedly the first white male born on the island of Manhattan. The Van Dalfsens moved to Ulster County, New York, and after the Revolution migrated to western Pennsylvania. From there, some generations later, they moved to Fort Vincennes, Indiana. On Faith's paternal side, her Poorman family ancestors came from Germany to New York and also moved to Pennsylvania and thence to Fort Vincennes. They were Quakers and helped form the settlement of West Union, Clarke County, Illinois. It was at this juncture, some six or seven generations after the Van Dalfsens arrived in this country, that Faith traces her ancestry through the Poorman family line. They were involved with grain for making flour on the Wabash River in the territory that later became the state of Illinois.

Perry Alfred Poorman, Faith's father, was a Texas pioneer in the development of rice farming and registering cattle and swine on the Gulf Coast in cooperation with Texas A & M University. He was also exceptionally civic–minded, leading in the development of Texas public schools and highways. Faith's

mother was Angie Shawler, who had given Perry four children (Faith, Mary Jane, Eunice, and Samuel) prior to the Texas move. The fifth child, Elizabeth, was born after their move to Texas and remains Faith's only sibling alive today.

The Poormans, as Quakers, were abolitionists and favored the Union. Faith's kinfolk were pioneers from the center of American geography, from the heartland of grain and prairie, and thus their backgrounds straddled both North and South. Her sympathies and collecting instincts reflect this heritage. She speaks often of her Quaker birthright and favors furniture which people of that persuasion referred to as "of the best sort but plain." In this context, the term plain did not mean simple or even spare in the Shaker sense. "Plain" allowed a wide latitude of visual richness, even opulence, without superficial ornamentation. One of Faith's most important early acquisitions illustrated Quaker taste. It is a desk (cat. 2) owned by Asher Woolman, brother of famous Quaker diarist, preacher, and philanthropist, John Woolman (1720–1772), who was renowned for his efforts to abolish slavery. Also, the Philadelphia claw-and-ball tilt-top tea table (cat. 23) probably carries overtones of Quaker preference for plainness or sculptural simplicity. An identical table was owned by the Gill family of New Jersey, who were well-known Quakers. Faith's affection for her ancestry is also reflected in her New York and Pennsylvania country furniture, and in her outstanding collection of frontier-made furniture from Texas and from cabinet shops of small village craftsmen in southern states.

This portrait of Faith P. Bybee was taken on her birthday in Houston in 1918. (Courtesy, Faith P. Bybee.)

At a Christmas social gathering in 1923, Faith met a young man, Charles Lewis Bybee. They were married the following June by Bishop A. Frank Smith in Houston's First Methodist Church.

Even before Charles graduated in finance from the University of Texas in the class of 1922, he had begun work in the summers with the Houston Bank and Trust Company. His winning personality and keen business sense gained him rapid advancements. Within a year he became an assistant cashier. In characteristic understatement Faith observes that, "Charles was always good with numbers." After several additional promotions, Charles became president of the Houston Bank and Trust in 1958, a position he held until retirement in 1971. By the time I met him, he had already begun to help change the skyline during the Houston building boom. His financing helped build the Houston Astrodome and a new central banking office at Main Street and Jefferson Avenue. But that era gets ahead of the story of the Bybees' collecting.

Charles descended from a family which had moved to Texas in the 1830s or early 1840s, from what Faith describes as "one of the larger plantations in Virginia." The Bybees came to Texas as early pioneers, bringing with them fifty-seven slave families. It is undoubtedly this early heritage, with its roots in the South, that inspired Charles and Faith to assemble their incomparable collection of Texas pioneer buildings, furniture, and furnishings, the nucleus of which is at Historic Round Top, Texas.

In the 1930s Charles began to conduct bank business in New York City. This took the couple East several times a year. Faith spent her time at the Metropolitan Museum admiring the newly opened American period rooms, a display which thrilled her. She became acquainted with Joseph Downs (later of Winterthur Museum) and Marshall Davidson and found their staff most helpful in guiding her study. Mr. Bybee often joined Faith for lunch at the museum's restaurant, and afterward they would call on their favorite firm of Israel Sack, Inc. One of the many pieces purchased from that firm, of which Faith is particularly proud, is the New York great chair which I first saw on entering their home. This particular piece was badly scorched by a 1972 fire in the Keeping Room of the Bybees' house. When Faith realized that it could not be restored without completely altering its entire surface, she donated it to the Museum of Fine Arts, Boston, as a study specimen.

During the early 1940s the field of those who collected, dealt, published, or otherwise worked with American antiques was relatively small. Most of those involved knew each other well. Faith and Charles were encouraged in their quest through contacts with Curator John Graham at Colonial Williamsburg; Frank Horton, a scholar who founded and developed the Museum of Early Southern Decorative Arts, Winston-Salem, North Carolina; Mr. and Mrs. Henry N. Flynt, who were restoring and furnishing Old Deerfield, Massachusetts; Charles F. Montgomery; Henry Francis du Pont, the incomparable collector of Americana at Winterthur; and Mr. Donald Shelley, director of the Henry Ford Museum and Greenfield Village in Dearborn, Michigan. These and many other individuals shared their experiences with the Bybees and broadened their horizons.

In 1947, when they attended the first annual Antiques Forum at Colonial Williamsburg, they came to know Katharine Prentis Murphy, Electra Webb of Shelburne, Frances Wister, an early civic leader in the field of preservation and collecting, and also one of the organizers of the Landmark Commission in Philadelphia, Nina Fletcher and Bertram K. Little, Edgar and Charlotte Sittig, Maxim Karolik, and the senior Joe Kindig. Their collections also began to grow but, despite their friendships with collectors, the character of their collection remained individualistic. Faith explains: "I never copied anybody. I admired Bayou Bend and what Miss Ima did, but it didn't appeal to me.

Mr. du Pont had taste for sophisticated Chippendale-style furniture which was beautiful in his house. I loved it there, but I didn't aspire to have it myself." What Faith and Charles seemed to prefer was furniture with splendid contour or outline but not that which was ornamented with deep carving.

As the Bybee collection grew it was necessary to obtain more space. Their first house was built in 1939 at 1909 Olympia Street by an organ builder from Russia after architectural designs made by Harvin C. Moore, Faith's brother-in-law and husband of Elizabeth. In 1960 they moved once again into a house at 1912 Larchmont Street, which they enlarged from designs also provided by Harvin. It is the furniture and furnishings of this house, which they filled over the years, that graces the pages of this catalogue.

Collecting was for Charles and remains for Faith a necessary and an instinctive outgrowth of personal needs to express awareness of American craftsmanship, to create a beautiful environment, and to make a statement in community life. Early in Faith's married life it was not at all extraordinary to volunteer for social services. This was an expected contribution to society customary for individuals who understood their station and social responsibilities. Even in the depression years of the 1930s, Faith was successful in raising funds to provide a floor of a clinic for neurologically disturbed children at the Methodist Hospital in Houston. Encouraged with the discovery of such persuasive talents, Faith assisted with volunteer work for the Symphony and the Houston Museum of Fine Arts. Her abilities continued to mature and they eventually dovetailed with her preservation instincts as she worked to save endangered historic buildings.

When I met Faith she was the president of the Harris County Heritage Society. This organization was saving the city's Sam Houston Park while at the same time restoring and furnishing two early nineteenth-century structures in that park: the Kellum-Noble House and the Rice-Cherry House. Those two houses were the beginnings of a more fully developed gathering of historic buildings that gives the visitor a sense of time in a space. The park otherwise would have had a horizon of cars on freeways.

While Faith was working on historic preservation and furnishing for the town of Houston she was also privately developing a rural village in the Texas countryside at Round Top. Here she had moved and was furnishing more than a dozen nineteenth-century pioneer structures at Henkel Square. She and Charles had formed a foundation for the preservation of Anglo- and German-American pioneer culture. This they did on a large scale with a magnificent assemblage of furniture, tools, coverlets, stoneware, and implements of everyday life artfully arranged in log and stone houses. Some houses had ornately stenciled rooms, others were spare and plain. At one end of the square Faith preserved a store; at the other end she moved in a schoolhouse/church building from Haw Creek. In addition to the structures at Round Top, Faith and Charles restored or preserved at least another dozen buildings scattered throughout the rolling Texas countryside between the Brazos and Colorado rivers. Drawing from these resources in 1975, Faith generously loaned for two years forty-five objects from the pioneer Texas collection to the exhibition "Frontier America: The Far West," which was organized and displayed by the Museum of Fine Arts, Boston. This exhibition was shown in three other American museums (in Denver, San Diego, and Milwaukee) and toured four European museums (in Holland, Germany, Austria, and Switzerland) to celebrate the American bicentennial. It is clear that the Bybees led the way in helping Texans discover the importance of their local history, in relation to America's arts and crafts, and the urgency of her preservation needs.

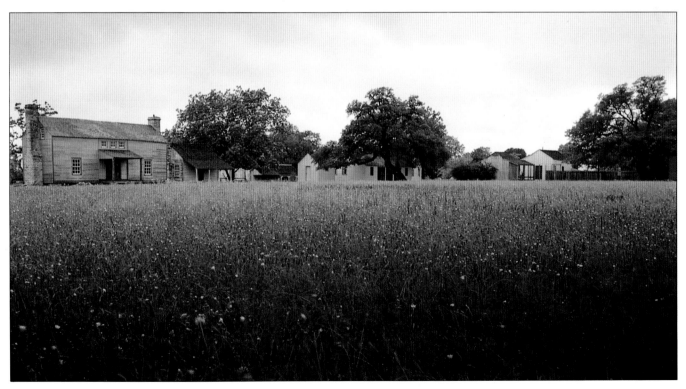

View across Henkel Square at Historic Round Top, Texas, in 1986. (Photo, Charles Thatcher.)

Faith and Charles Bybee at a National Trust Meeting, San Antonio, Texas, 1964. (Courtesy, Jonathan L. Fairbanks.)

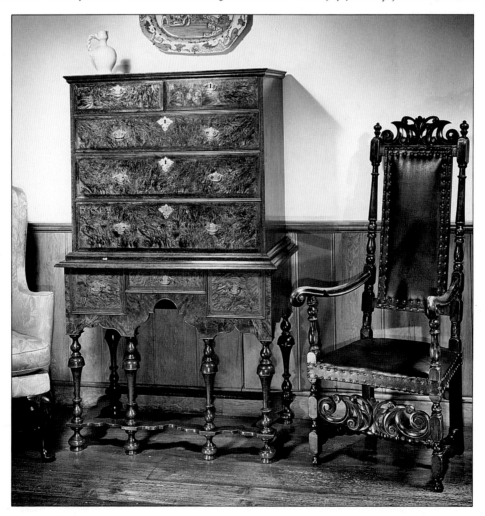

Boston chest-on-frame (ca. 1710–1730) and New York armchair (ca. 1700–1720) in the "Keeping Room" of the Bybees' Houston home in 1968. Neither of these objects are now in the Bybee Collection. (Dallas Museum of Art Archives, courtesy, *Antiques*: Photo, Edward A. Bourdon.)

The Bybees' home at 1912 Larchmont Street, Houston, Texas, in 1968. (Dallas Museum of Art Archives: Photo, Edward A. Bourdon.)

The living room in the Bybees' Houston home on Larchmont Street in 1968.
(Dallas Museum of Art Archives, courtesy, *Antiques:* Photo, Edward A. Bourdon.)

Faith and Charles sponsored three preservation symposia which brought international figures to Texas. One participant who keynoted many outstanding speakers was Dr. Harold J. Plenderleith, then the director of the International Centre for the Study of Preservation and Restoration of Cultural Property, Rome. He spoke eloquently at the Houston Baptist College Symposium in 1966 and helped inspire Texans with fresh new vision concerning worldwide preservation concerns.

Although Faith simply states that "I just went from one thing to another," her achievements in collecting and preservation set such high standards that she received the third Texas State Historic Preservation Award. This award and its gold medal were presented to Faith in the East Room of the White House by Lady Bird Johnson, who was then the First Lady of the country. It was my privilege to attend this ceremony together with Charles E. Peterson, an eminent preservationist, teacher, and architect from Philadelphia. Ever since receiving this award, Faith has continued to pour her energy and resources into the development and enhancement of Round Top and into the refinement of the collection she formed with Charles. What Faith instinctively sensed about antiques, Charles confirmed and supported with characteristic enthusiasm and decisive action. Tragically, Charles suddenly passed away from a heart attack in 1972.

Within the year, a gas leak in the basement of the Larchmont Street home caused a fire that destroyed several important works of art. The Keeping Room was closest to the fire. In it was lost the Revere engraving of *The Boston Massacre*. Most of the delft and pewter in that room was shattered or melted. Smoke covered much of the rest of the collection. For conservation and cleaning, Faith sent the entire collection to the Museum of Fine Arts, Boston, where for several years Vincent Cerbone, Robert Walker, and Andrew Passeri worked on its reclamation. As works were completed, Faith generously allowed the museum to put the collection on public view. In 1981 the collection was called back to Texas for a special loan exhibition organized by David B. Warren at the Museum of Fine Arts, Houston, entitled "An American Sampler, 1700–1875: The Charles Lewis Bybee Memorial Collections." Faith's desire to see the collection together once again is now fulfilled at the Dallas Museum of Art.

Being in the right place at the right time is an important element in forming a great collection. Charles and Faith made it a point to be where great objects became available. They distinguished themselves with superb choices. Many other individuals, given the same circumstances, have failed to recognize collecting opportunities because they did not have the vision, taste, or passion for craftsmanship which the Bybees so consistently shared. It is this innate good sense and the Bybees' special vision of America's arts and skills, as felt through their own heritage, that makes their collection unique and a pleasure to experience.

JONATHAN L. FAIRBANKS
Katharine Lane Weems Curator of
American Decorative Arts and Sculpture
Museum of Fine Arts, Boston

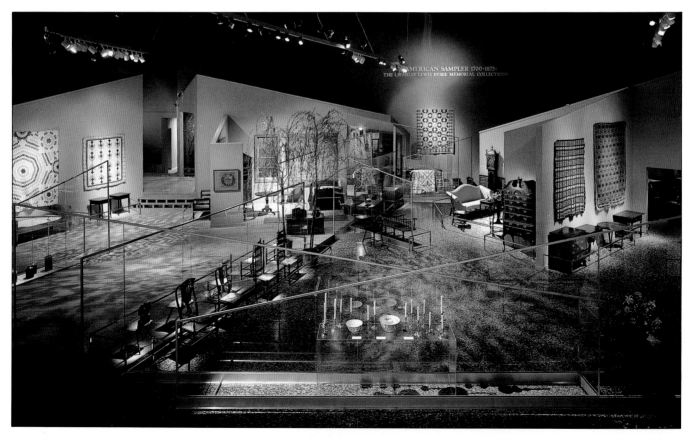

"An American Sampler, 1700–1875," Museum of Fine Arts, Houston. (Courtesy, Hickey-Robertson.)

AMERICAN FURNITURE IN THE BYBEE COLLECTION

1
CHEST OF DRAWERS

1710–1730
Chester County, Pennsylvania

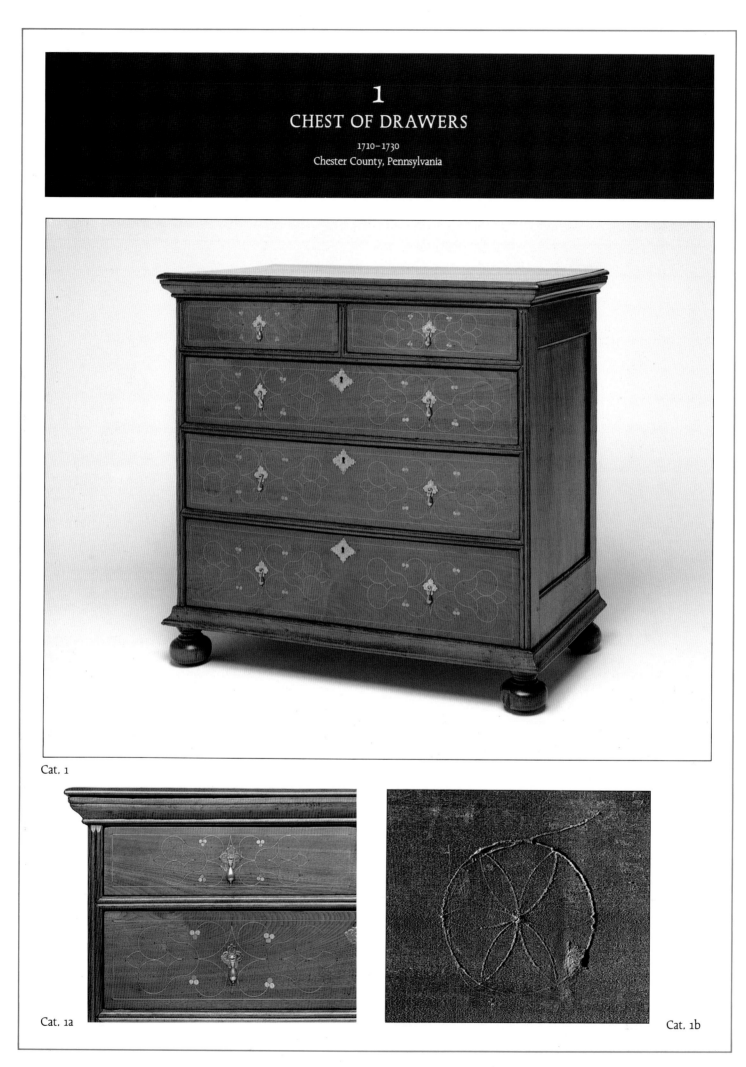

Cat. 1

Cat. 1a

Cat. 1b

FURNITURE ORNAMENTED with distinctive inlaid patterns of lines and berries has long been associated with Chester County, Pennsylvania. Recent scholarship has confirmed the localized nature of this tradition in southeastern Pennsylvania. However, some examples were probably also made outside of Chester County in Philadelphia. The presence of oak as a secondary wood argues strongly in favor of a rural origin for the chest illustrated here.[1]

Although southeastern Pennsylvania is known more for its strong German traditions, numerous immigrants from Wales also settled in the area. It was Welsh craftsmen who first produced this type of decorated case furniture in Chester County.[2]

The ornamental pattern on the drawer fronts was first laid out with a compass. Next the design was channeled out and finally filled with strips of light-color wood, usually holly and red cedar. Specific types of inlaid designs were reserved for particular furniture forms. For example, the elongated tulip-and-berry motif present here (as well as its variants) was restricted to chests of drawers. The pinwheel design inscribed on the backboard of this chest is found in its inlaid form on the doors of spice boxes (see cat. 1b).[3]

In contrast to the delicate decoration on the facade, this chest is massively constructed. The piece is basically conceived of as a joined chest with flat-paneled sides and mortise-and-tenon construction throughout. The massive framing supports an early date for this chest. The line-and-berry tradition reached a peak of popularity in the 1740s.[4]

STRUCTURE AND CONDITION: The sides are framed with stiles into which the rails are tenoned and pinned. Flat, floating panels are set into this framework. Three horizontal interior braces are rabbeted and nailed onto the inside of the stiles. The drawer dividers are tenoned into the stiles. There is a vertical drawer divider between the top two drawers. The upper and lower framing members are tenoned into the side stiles. The backboards are nailed into rabbets.

The drawers are dovetailed together with exceptionally wide dovetails. Their bottoms fit into grooves on the drawer fronts and are nailed in place along their sides and backs. The upper two drawers are fitted with wooden spring locks.

At some time in its history, this chest was disassembled and refinished. The bottom boards are replacements, as are the glue blocks above each foot. The right rear bun foot is probably a replacement. The brasses are period replacements.

INSCRIPTIONS: There is a compass-work pinwheel design on the upper left corner of the rear of the case. There is an old shipping label from Philadelphia on the bottom boards.

WOODS: Feet and most exterior surfaces, American black walnut; drawer bottoms, sides, and backs, case back, bottom boards, yellow poplar; side braces, drawer runners, red oak; framing member behind front, base molding, chestnut.

DIMENSIONS: H. 40 (102.0); W. 43½ (111.0); D. 22 (55.9).

PROVENANCE: Joe Kindig, Sr., York, Pa.; Bybee Collection, probably 1950s.

EXHIBITIONS AND PUBLICATIONS: Fairbanks 1967, 838; MFA, H 1981; *Antiques* 120:6 (Dec. 1981): 1326; Fairbanks and Bates 1981, 49.

1985.B1

1. Lee Griffith-Chalfant, letter to the author, 13 May 1987, DMA files. Her research indicates that the use of oak is much more prevalent in rural work.

2. See Griffith 1986 for a discussion of Welsh furniture traditions in southeastern Pennsylvania.

3. Two virtually identical chests of drawers are known: DAPC 76.592; SPB 798 (24–26 Oct. 1946): lot 404. Related examples which also have flat side panels are illustrated in M. Schiffer 1980, 72–73; DAPC 78.1533. Other related examples are found in M. Schiffer 1966, nos. 127, 168; DAPC 78.1595.

4. See Griffith-Chalfant, letter to the author.

Cat. 1c

Cat. 1d

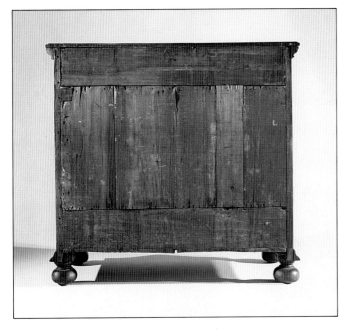

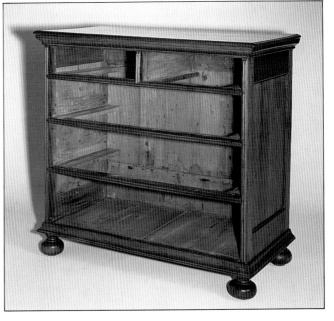

2
TABLE

1710–1750
Delaware Valley, possibly Philadelphia, Pennsylvania

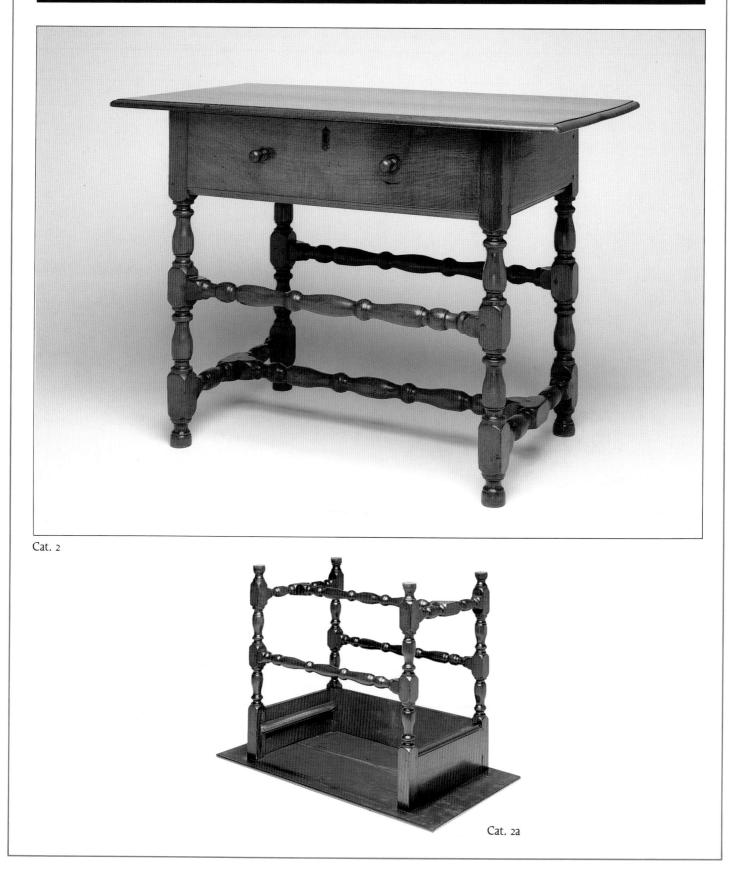

Cat. 2

Cat. 2a

AROUND 1900 Granville W. Leeds inscribed the family history of this table on the inside of its drawer. According to Leeds, as well as to oral tradition, the table once was used as a desk and belonged to Rachel and Asher Woolman (1722–1796). The Woolman family had originally emigrated from Gloucestershire, England, and settled near Rancocas, New Jersey, in 1677. By the time Asher Woolman inherited the family farm from his father Samuel in 1750, the Woolmans were an important and prosperous family in the Delaware Valley. Asher's brother, John, was a well-known Quaker preacher and diarist.[1]

Although the inscription most prominently lists Asher Woolman as an early owner of this table, it also states that his father, Samuel, had it at his home at some point. Based on several early features, it is likely that Samuel Woolman (1690–1750) and his wife, Elizabeth Burr (1696–1773), were the original owners of this table.[2]

Features on this table which suggest a date earlier than the mid eighteenth century include the massively constructed stretcher system. Also arguing for a pre-1750 date is the manner in which the stretchers are joined together with tenons cut the entire width of the stretchers; the molded edges along the bottoms of the drawer front and rails; and the use of a widely overhanging top. However, the feature which is most indicative of early case furniture is a side-hung drawer joined with large dovetails. If this table was actually made during the mid eighteenth century, it represents the survival of construction practices which were first employed almost a century earlier.

Exactly where in the Delaware Valley this table was made is unknown. Conceivably, it is the product of a skilled craftsman who worked in Mt. Holly or Burlington, New Jersey, near the Woolman farm. However, it is also possible that the Woolmans ordered their table from one of the many skilled furniture makers in Philadelphia. Not only did the family farm have direct access to the Delaware River and Philadelphia via Rancocas Creek, but the Woolmans were prominent enough to warrant having their furniture made in the region's stylistic capital, Philadelphia. But wherever this table was made, it appears to be the work of an English-trained artisan, rather than a Germanic one. The placement of the stretchers and their division into numerous turned elements is known on late seventeenth-century English examples.[3] These same details are uncharacteristic of German work.[4]

STRUCTURE AND CONDITION: The table's frame is constructed with pinned mortise-and-tenon joints. The stretchers have tenons their entire width. The rails of the top section have molded lower edges. The drawer is constructed with large dovetails and is side hung; its chamfered bottom board fits into grooves run along the front and sides. One large rose-head nail secures the bottom to each side and two nails fasten its rear edge.

The drawer runners have been turned over. The dovetails on the drawer have had T-head nails run through them. The table's top has been off and reset, and a crack in it has been repaired; the drawer's lock is missing and the wooden knobs are later additions. There is no evidence that the drawer ever had drop-shaped pulls. The iron escutcheon is original. The drawer linings have suffered extensive insect damage. Casters have been added and removed from the feet.

INSCRIPTIONS: On the inside of the drawer is written in pencil: "This desk belonged to / Asher Woolman in about / the year of 1750 and has always been in this house / (except a / few years that his father had it at his home in / the village) was purchased again by her Mother in the / yr of 1879 . . . Mary . . . (if no heirs) . . . go to Gertrude to have it . . . to the Woolman / who would prize it . . . G. W. Leeds / At Gertrude's death to go to Mary if no heirs / then to someone of the Woolmans / [signed] G. W. Leeds."

WOODS: Most parts, American black walnut; drawer sides, backs, bottoms, and runners, southern yellow pine.

DIMENSIONS: H. 29¼ (74.3); W. 42⅛ (107.0); D. 23¼ (59.1).

PROVENANCE: Samuel (1690–1750) and Elizabeth Burr Woolman (1696–1773), Rancocas, N.J.; Asher (1722–1796) and Rachel N. Woolman, Rancocas, N. J.; Granville (1774–1854) and Hannah Stokes Woolman (1775–1868), Rancocas, N.J.; Dr. Granville S. (1807–1870) and Phoebe Lippencott Woolman, Rancocas, N.J.; Jacob H. (1826–1910) and Margaret Woolman Leeds (1833–1901), Rancocas, N.J.; Granville W. (d. 1917) and Nancy Haines Leeds, Rancocas, N.J.; Hudson B. and Gertrude Leeds Haines (1879–1946), Rancocas, N.J.; probably Rozella Becker, Hyde Park, N.Y., ca. 1933; Bybee Collection, 1930s.

EXHIBITIONS AND PUBLICATIONS: Fairbanks 1967, 837; Fairbanks and Bates 1981, 313; MFA, H 1981.

1985.B7

1. Information on the Woolman family and the history of this table was provided by Asher Woolman descendants. See Elizabeth Leeds Tait, letter to the author, 22 Apr. 1987, and Granville E. Haines, letter to the author, 25 Apr. 1987, DMA files. According to Haines, his parents, Gertrude A. Leeds and Hudson Haines, sold the table in the early 1930s to save the family farm. They were paid approximately $1,000 for it.

2. All surviving wills and inventories of former owners of this table have been examined but none are specific enough to definitely identify this piece.

3. For related English examples, see Kirk 1982, nos. 1226–1227.

4. For a Germanic example made by Moravians in North Carolina, see Quimby 1984, 281. The non-Germanic character of the Bybee table was outlined by the director of the Museumsdorf Cloppenburg, West Germany; see Helmut Ottenjann, letter to the author, 23 Feb. 1988, DMA files.

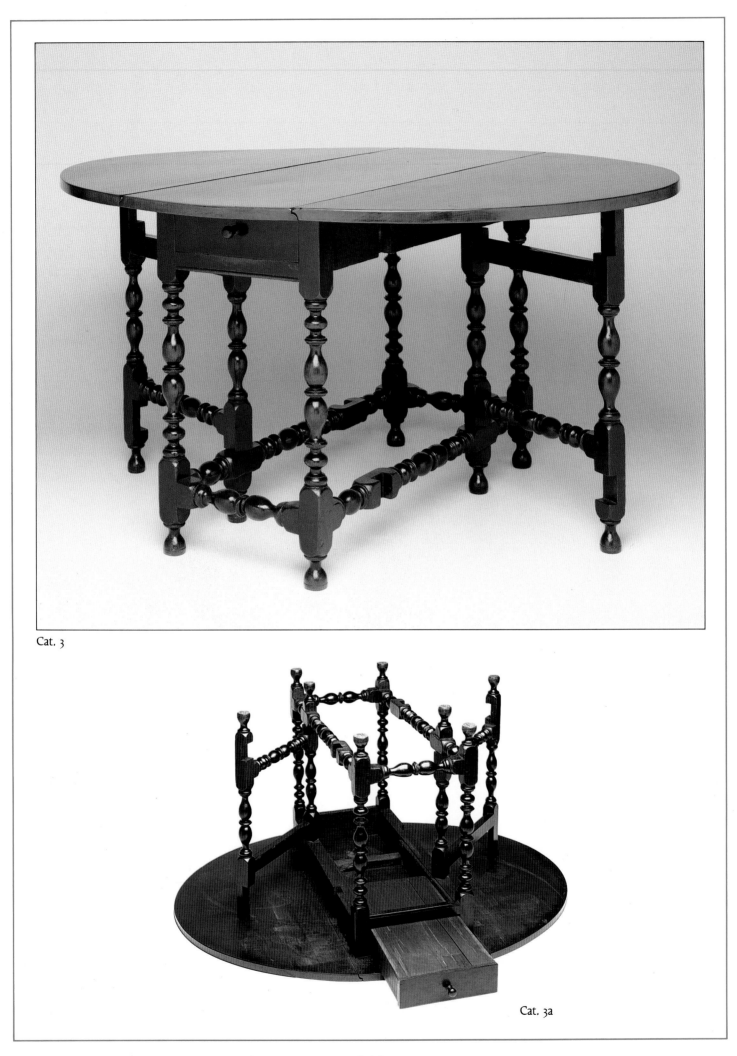

Cat. 3

Cat. 3a

3
DROP-LEAF TABLE

1710–1770
Boston, Massachusetts

OVAL, DROP-LEAF TABLES with turned legs such as this were based on late seventeenth-century English examples.[1] From the beginning of the seventeenth century until the 1740s, this table form was fashionable and widely used in colonial America. In Boston such tables appear to have been especially popular among the wealthy merchant class during this period. Numerous examples from the Boston area survive.[2]

Besides the pleasing juxtaposition of broad flat surfaces and ornately turned legs found in this type of table, they were popular because of their usefulness. When extended this table is 56⅝" (143.8 cm.) long. Consequently it could serve admirably as a dining table for several persons. When the leaves were down, it could be conveniently stored against the wall (see cat. 3a). Other types of work such as reading or writing could also be performed on such a table.

Although the popularity of tables with elaborately turned legs waned after the 1740s, when cabriole legs became fashionable, this particular table suggests that the form continued to be made and used well into the third quarter of the eighteenth century. First, both the top and frame of this table are made of dense mahogany. Before the 1740s imported mahogany was rarely used in American furniture, unlike oak, walnut, and maple, which were frequently used.

Even more puzzling is the use of a rule-joint between the top and the two leaves. Typically, early eighteenth-century drop-leaf tables have tongue-and-groove joints on their tops. Rule-joints like the one used here are considered later in date and suggest that the top was made during the third quarter of the century.[3] Although many drop-leaf tables have had their tops replaced due to the heavy wear they received, this particular top appears to have been on this frame for an extremely long time. It is made of the same dense mahogany as are the legs and shows no signs of ever having been on another table. If this top is a replacement, it was probably put on in the eighteenth century.

STRUCTURE AND CONDITION: The turned legs and stretchers are mortise-and-tenoned together and double-pegged in place. The pivot-posts of the swing legs pivot between the skirt rails and the lower stretchers. The skirt rails tenon into the corner legs. The drawer runners are secured to the sides of the rails with rosehead nails. Bruise marks from the swing legs and leaves, apparently undisturbed hinges, and proper oxidation indicate that this top has been on this frame for many years.

Although there is general wear on the stretchers and legs, they survive in excellent condition. The top has been off and repinned through the same holes. It has been refinished, while the legs retain traces of an old finish. The hinges appear to be original. The drawer and the cross brace which acts as a drawer stop are not original. The drawer bottom is not secured with rosehead nails as one would expect, the interior is lined with late nineteenth-century woven paper, and the linings are of Sylvester's pine. The brace is also of this foreign wood.

WOODS: Top, legs, skirt ends, and drawer front (replaced), mahogany; drawer runners, skirt sides, and cross brace, eastern white pine; drawer stop and linings (replaced), Sylvester's pine.

DIMENSIONS: H. 28¼ (71.7); W. open 56⅝ (143.8); W. closed 18 (45.1); D. 47⅞ (121.6).

PROVENANCE: Probably John Walton, Inc., Riverside, Conn.; Bybee Collection, 1950s.

EXHIBITIONS AND PUBLICATIONS: Fairbanks 1967, 836; Fairbanks and Bates 1981, 67; MFA, H 1981.

1985.B3

1. For English examples, see Kirk 1982, 1231–1234.

2. For an excellent discussion of this form of table, see Jobe and Kaye 1984, nos. 58–59. For other closely related tables, see A. Sack 1950, 240; *Antiques* 117:2 (Feb. 1980): inside cover. For a walnut example with virtually identical turnings, see Monkhouse and Michie 1986, no. 62.

3. For a discussion of tongue-and-groove and rule-joints, see Jobe and Kaye 1984, 79–80. The tongue-and-groove joint was favored through the 1740s, but was superseded by the rule-joint which minimized the gap between the leaf and the table top. For a similar table with a rule-jointed top, see *Sack Collection* 1931, lot 343. It is not known whether this top is original.

Cat. 3b

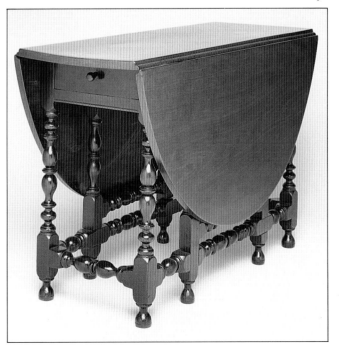

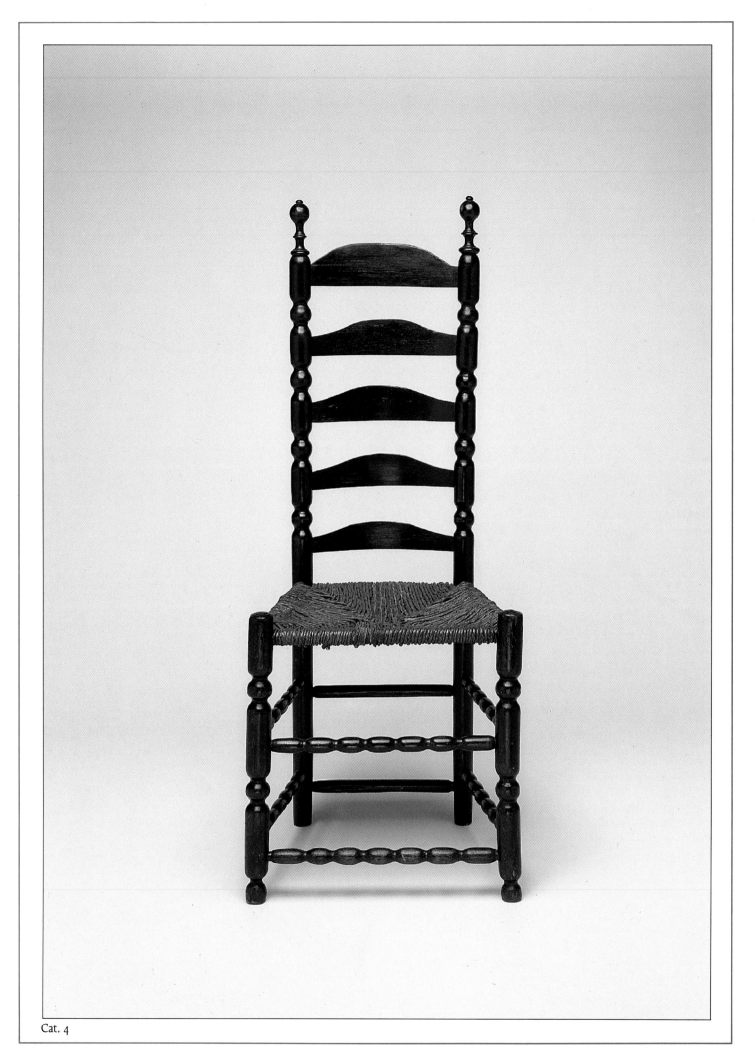

Cat. 4

4
SIDE CHAIR
1710–1750
Eastern Massachusetts, probably Boston area

THE TRADITION of making turned chairs was brought to this country by the earliest European colonists. Although the character of such chairs changed over time—seventeenth-century chairs have heavier turnings, while nineteenth-century ones have lighter turnings—the turned chair has been in continual use in this country for three hundred years.

Chairs such as this example were the products of turners. The various elements of these chairs were produced in great quantity and allowed to season for specific lengths of time before assembly. The slightly warped profile of this chair's posts indicates that they were turned while the wood was still green. This technique insured tight joints since the posts shrank around the slats and stretchers as they dried.

By streamlining production and stockpiling parts until they were needed, turners were able to produce slat-back chairs cheaply in large numbers. Slat-back chairs were priced according to the number of slats in the back. More expensive chairs had more slats.[1]

As indicated by numerous surviving examples, turned slat-back chairs found wide acceptance among New England's middle class. Similar examples are distributed throughout eastern New England.[2] The affinity of these chairs' turnings and their wide distribution suggest that slat-back chairs, like the more sophisticated "Boston" leather chairs, may represent the work of several Boston-area shops which exported large numbers of chairs.[3]

STRUCTURE AND CONDITION: This chair is in excellent condition. There are nail holes along the seat lists indicating the presence of upholstery on this chair at some time. The black paint is not original, but appropriate. The seat is old, but probably not original. The crude variations in some of the slats suggest one or more replacements. However, similar irregularities occur in other examples.

WOODS: Aspen.

DIMENSIONS: H. 47⅜ (120.3); S.H. 18⅛ (46.1); W. 19⅜ (49.2); D. 18 (45.7).

PROVENANCE: Although no record of the sale of this chair is retained in the Sack archives, both Albert Sack and Faith Bybee agree that it was purchased from Israel Sack, Inc., New York, N.Y.

EXHIBITIONS AND PUBLICATIONS: Fairbanks 1967, 836; MFA, H 1981.

1985.B6

1. Jobe and Kaye 1984, 312.
2. For chairs from the same shop tradition as this example, see Jobe and Kaye 1984, no. 79; Nutting 1928, 2:no. 1875 (same as A. Sack 1950, 11); Elder and Stokes 1987, no. 2. For related examples, see Ormsbee 1934, 159; Randall 1965, no. 123; Lyon 1924, 74; Kane 1976, no. 9; Kirk 1967, nos. 192–195; Norwalk 1979, n.p.; Page 1969, 14–15.
3. Whitehill 1974, 40–47.

LATE SEVENTEENTH- and early eighteenth-century Boston was not a profitable place for clockmakers. Before 1700, the town does not seem to have had a professional clockmaker. Black- and gunsmiths kept the town's timepieces in order.[1] Of the eleven clock- and watchmakers known to have worked in Boston between 1700 and 1750, most appear to have had difficulty supporting themselves.[2] The estates of six of these artisans were never probated, suggesting that they died with small estates or left Boston. The option of leaving town was one regularly taken. John Brand returned to England, William Clagget went to Newport, and Robert Peaseley left for parts unknown.[3] Even James Atkinson, who worked for many years in Boston, was apparently trying his luck in Halifax, Nova Scotia, at his death in 1756. His estate, which included "28 Books and Pamphlets" and "sundry watchmaking tools," was ruled insolvent.[4] When Joseph Essex died in 1719, his estate worth £37 was also too small to cover his debts. Especially interesting is the reference to Essex in his estate papers as a "Jackmaker." Evidently he had turned from clockmaking to producing mechanical rotisseries called "jacks" by the time of his death.[5] A year later in 1720, the clockmaker Thomas Badley's estate was also ruled insolvent.[6]

The one clockmaker who appears to have been successful at his profession was Benjamin Bagnall, Sr. Bagnall's exact place of birth in England is unknown. However, it is likely that he came from the vicinity of Stoke-on-Trent, Staffordshire, between Manchester and Birmingham.[7] Since no records of a Benjamin Bagnall apprenticing in London survive at the Worshipful Company of Clockmakers, it is probable that Bagnall served his apprenticeship with a provincial master and subsequently left for the colonies.[8] He was in Boston by 1712, when he brought charges against the Boston joiner Caleb Ray (d. 1721) for not paying the £9.10.0 Ray owed him.[9] On 18 June 1713, Bagnall married Elizabeth Shove of Charlestown.[10]

It appears that Bagnall's shop was relatively successful from the start, even though there were competing makers in Boston at the time, as well as many imported timepieces. Besides producing timepieces himself, Bagnall profited as a retailer and repairer of English timepieces, especially watches. On 5 March 1712, for example, Bagnall's shop was robbed and numerous expensive watches were taken. Judging from the detailed descriptions of these watches, they were probably all of English origin.[11] This supposition is supported by depositions taken concerning the theft of a watch in 1737. In that year a Capt. L'Hommeliey of Long Island bought a watch and chain from Bagnall made by Joseph Thornton of London. Shortly thereafter it was stolen, but six months later it was brought back to Bagnall by William Pincheon, Jr., of Springfield, Massachusetts, for repairs.[12] Besides watches, Bagnall may also have sold English clocks. Contemporary newspaper advertisements list numerous types of English clocks for sale in Boston.[13]

Much of Bagnall's success in Boston was undoubtedly due to the extensive mercantile network in which he participated and his standing among Boston artisans. Judging from court cases brought by or against him during the second quarter of the eighteenth century, Bagnall maintained contacts in England, the West Indies, Philadelphia, and Long Island, as well as the North Shore and interior of Massachusetts.[14] This network was aided by Bagnall's part-ownership of the sloop *Ann and Abigail* in the mid 1730s.[15] To support his trading ventures, Bagnall owned a warehouse and several pieces of land. As investment capital was needed, Bagnall repeatedly mortgaged his home and landholdings.[16]

Along with his trading network, Bagnall also maintained a respected position within the Boston artisan community in spite of his being a Quaker.[17] For example, when the selectmen of Boston decided to have a public clock installed on the roof of the First Meetinghouse (Old Brick) in Cornhill Square in 1718, they chose Bagnall to build the clock.[18] The town fathers also looked favorably upon Bagnall in the 1720s. In 1723 they appointed him town constable (Bagnall was subsequently excused from service). He was selected as an assessor in 1724.[19] However, the most telling reflection of Bagnall's prominence within the community came at the marriage of his son Benjamin, Jr., in 1737. On 9 August of that year the *New England Weekly Journal* reported:

> Last Thursday in the Afternoon Mr. Benjamin Bagnall, Jun. eldest son of Mr. Benjamin Bagnall of this Town, Merchant, married to Mistress Anna Hawden, Daughter of Mr. James Hawden of this Town, Shopkeeper, in the manner of the Quakers. The marriage was solemnized in the Old Brick Church, the Quaker Meeting House not being large enough to contain the vast Concourse of People of all Perswations who came to see the Solemnity. The parents of the married Couple gratefully acknowledged the favor of having the marriage solemnized in said Meeting House. His Excellency, our Governor and several of the Council and of the Justices, etc. attended the said Marriage, which was carried on with becoming decency. It being a rainy time, His Excellency favored the Bridegroom and his Bride with his Chariot.

If Benjamin Bagnall had not been an important member of Boston's artisan class, the governor of Massachusetts would certainly not have honored the Bagnall family with his presence and chariot.

During his career, Bagnall trained two of his seven children as clockmakers: Benjamin, Jr. (b. ca. 1713), and Samuel (b. 1715).[20]

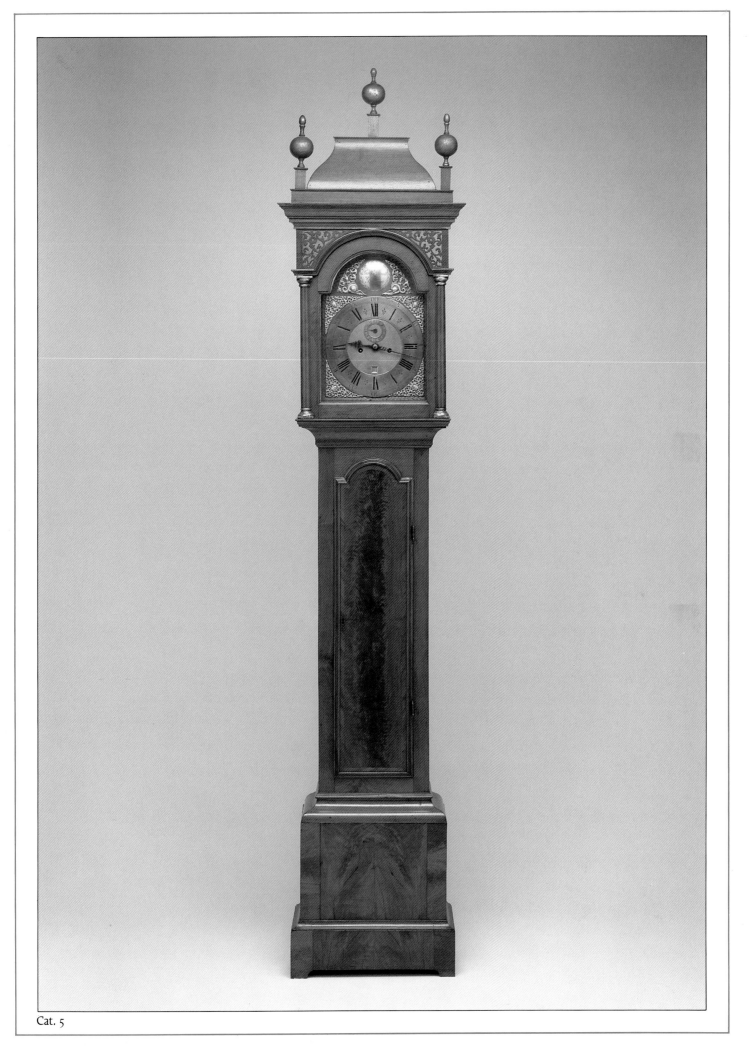

Cat. 5

Although Benjamin, Jr., went to Newport, Rhode Island, sometime in the 1750s (he returned in 1761), both sons appear to have worked with their father until he retired. In his old age, Benjamin, Sr., seems to have run a boardinghouse. In 1771 he petitioned the court for a license to sell liquor at his house. His petition stated:

> That he has for a number of Years past received into his House as Boarders a considerable number of Strangers from the other Governments as well as Gentlemen belonging to the Country; being for this purpose well provided with beds, and other conveniences at his House in Cornhill . . . That he has more especially of late found himself under great difficulties in not being able to supply them with the Liquors they require. . . . which will greatly accommodate him in his present business which is indeed the only business he can think of engaging in at his advanced age for the support of his Family.[21]

At his death in 1773, Bagnall left an insolvent estate worth £1074.0.8. By this time he had probably given most of his tools, and perhaps other possessions, to his children. The only mention of tools is a single entry at the bottom of his inventory which reads, "Scales & weights 12s.—a parcel Clock tools etc. 20s."[22] In his obituary of 15 July 1773, the *Boston News-Letter* noted that Bagnall

> came from England to America in life and has always resided in the Place; He was a good husband and a good Parent; honest and upright in his Dealings; sincere and steadfast in his friendship; liberal to the Poor, and a good citizen; he acquired the Regard and Esteem of all who had the Pleasure of his Acquaintance.

Due to their extreme costliness, tall case pendulum clocks were uncommon in the first half of the eighteenth century. At present only four are known by Benjamin Bagnall, Sr.[23] Of these, this eight-day striking clock is perhaps the best preserved. When Bagnall made these works and ordered the case from a local cabinetmaker, he was greatly influenced by contemporary English clock design. Numerous English clocks made during the 1730s and 1740s, for example, have arched face plates which incorporate virtually identical cast corner elements and dolphins in the arched upper section. Similar herringbone engraving appears around English name bosses, as does the style of Roman letters and *fleur-de-lis* seen here on the main chapter ring. Bagnall's face plates are especially close to contemporary examples from the eastern counties of England, Norfolk, Suffolk, and Essex.[24] These similarities may reflect Bagnall's own origin or that of his English master.

Since cast ornaments for clocks appear in eighteenth-century English hardware catalogues, it is possible that some colonial clockmakers ordered their spandrels and perhaps engraved face plates from abroad. However, Benjamin Bagnall, Jr., and probably his father as well, obtained many of the parts they needed from the Boston founders Mercy Jackson and Robert Charles. Records of purchases from Jackson and Charles reveal that the Bagnall shop obtained wire, brass plates, hinges, locks, and escutcheons, as well as "Dolphins for Clock[s]," between 1739 and 1743.[25]

Like his brass- and hardware, Bagnall also had his clock cases made locally. Who made this case or any of the other surviving examples is unknown. However, court records reveal that Bag-

Cat. 5a

Cat. 5b

nall had dealings, albeit troubled ones, with the joiner Caleb Ray (d. 1721) and the cabinetmaker Samuel Collins (1706–1751).[26] Whoever made this particular case was strongly influenced by English examples and may well have been trained there. The way in which the sarcophagus top fits between the side finials and does not extend to the sides of the top moldings is highly unusual on American clock cases. The feature is much more common on English, especially provincial, examples.[27]

This clock was probably made during the 1730s. Arched dials first appeared on English clocks in the 1710s and were soon being used in the colonies. However, the arched dial was not in widespread use in America until the mid 1720s. Furthermore, the lack of rings around the winding holes indicates that this clock was probably not made before the 1730s and might have been produced as late as 1745. Winding holes surrounded by rings were in use almost without exception in both England and America between the 1680s and 1740s.[28]

STRUCTURE AND CONDITION: The case sides and front appear to be lap-joined and nailed together. Veneer covers these joints. The baseboard and solid walnut moldings are nailed to the case. The door and front of the base are veneered. To prevent the door from warping, the door has cleats along its top and bottom edges. The backboard has pronounced plane

marks on it and is nailed to the rabbeted edges of the sides and top. There is no bottom board. The fragile bonnet is constructed of three framed sides inset with glass. Three-quarter columns are attached to the front door and plain, quarter-round columns are at the rear of each side panel. The layered moldings and sarcophagus top are nailed and glued to the bonnet (see cat. 5a). A hole on the level with and centered between the two side finials suggests that the upper, central finial was moved to this lower position at some point or that the bonnet once had an additional ornament.

The movement is an eight-day striking clock with an anchor-recoil escapement. The frame is made of cast brass and has five posts. Most American clocks are not as well made, having only four posts. This clock is exceptional for having a repeating (rack-and-snail) striking mechanism. Most early American tall-case clocks have a "count-wheel locking plate" striking mechanism. The main plate of the dial is fairly heavy and was worked and scraped out from a single casting in the English tradition. To save brass, many American dial sheets were hammered out from smaller, thicker castings, resulting in thinner, flimsier dials.

This clock survives in good condition. The hour and minute hands and all six spandrels appear to be original. The second hand, pendulum, and one of the four feet on the works are replacements. A crack in the face plate has been repaired. The name boss, main chapter ring, second chapter ring, and calendar ring have recently been resilvered. The hands and numerals have been recolored.[29]

The case has probably been shortened by cutting down the feet. The hinges on the door are replacements. The glass in the upper door has been replaced. The pierced fretwork above the arched door may be original, but the fabric behind it has been renewed and is lined with nineteenth-century newspaper. The sarcophagus top may have been off at some point, but, along with the finials, appears to be original. The glue blocks inside the case and top are either missing or replaced. The plinths under the ball finials may not be original. There have been minor repairs made to the veneer.

INSCRIPTIONS: Engraved on the disk above dial is "Ben Bagnall / Boston." Scratched into the back of the face plate is "88137."

WOODS: Veneer, moldings, case sides, American black walnut; one finial, soft maple; other two finials, beech; two horizontal boards in bonnet, Spanish cedar; blocks inside bonnet (replacements), fir.

DIMENSIONS: H. to top of bonnet 90¾ (230.5); H. to top of center finial 98½ (250.2); W. 21⅞ (55.2); D. 10½ (26.7).

PROVENANCE: John Walton, Inc., Riverside, Conn.; Bybee Collection, 1954.

EXHIBITIONS AND PUBLICATIONS: Fairbanks 1968, 77; Whitehill 1974, fig. 11; Theta Charity Antique Show, Houston, Tex., 1979; Fairbanks and Bates 1981, 116; MFA, H 1981; *Antiquarian Horology* (Winter 1987): 194; *Discover Dallas* 1988, 21.

1985.B4

1. See Lyon 1924, 248; *Record Commissioners* 1881, 7:170.

2. These eleven makers are taken from Dow 1927. They are James Atkinson, Thomas Badley, Benjamin Bagnall, James Batterson, James Bichaut, John Brand, William Clagget, Elijah Collins, Joseph Essex, Robert Peaseley, and Isaac Webb.

3. See Dow 1927, 134, 143. Several Newport clocks by Clagget survive.

4. James Atkinson will and inventory (1756), docket 11326, 51:587, Suffolk County Probate Records (hereafter SCPR), Suffolk County Courthouse, Boston, Mass. Also see Dow 1927, 133.

5. Joseph Essex will and inventory (1719), docket 4218, 21:505–506, SCPR.

6. See Dow 1927, 133. No estate papers survive for Badley.

7. A Bagnall dynasty of clockmakers existed in this part of Staffordshire. A R. Bagnall was working in Talke, Staffordshire, as early as 1710. Other Bagnall clockmakers worked throughout the area until the mid nineteenth century. See Baillie 1969, 13; Loomes 1976, 10.

8. See Atkins 1931. It has been published that Bagnall apprenticed with Peter Stretch of Philadelphia. No evidence of this has been found.

9. Benjamin Bagnall vs. Caleb Ray (11 Feb. 1712), Suffolk Files (hereafter SF) no. 8988, Superior Court of Judicature Records, Massachusetts State Archives, Boston, Mass.

10. For information on the Shove family, see Shove 1941, 63–64, 129–130.

11. Giles Dyer, Jr., vs. Benjamin Bagnall (23 June 1713), SF 9090. The description of the stolen goods is as follows:

One plain Gold Watch, having no Chain, being hooked together by Two pendants. One Small Oval Gold Watch having a very dull Chrystal, a Shagreen Case and Red string; One large Silver Watch with a Sun and Moon dyalplate, the Steelplate not reaching to the Silver plate with a Graved Case, the Enamel worn out; One Small Tortoise Shell Watch with a Silver Chain a pierced Dial plate laid upon a Gilt frosted plate; One plain Shagreen Watch with a Single motion with a Blue string, A Box Case & Chain of a large Silver Watch; A Small Shagreen Case with a Broken Chrystal Showing the Minutes, A Small Silver Case Watch Showing the Minutes with a single Square Chain; A Shagreen String Watch plain faced with a red Leather String; A Large String Watch Single Case, Frosted Dialplate; One middle sized Tortoise Shell Watch Showing the Minutes blue Ribboned; One large Silver Watch Showing the Minutes with a Silver Chain; A Shagreen Watch Showing the Minutes.

12. Benjamin Bagnall, Jr., deposition (Apr. 1737), SF 43632.

13. See Dow 1927, 146.

14. Bagnall was involved in numerous court actions during this period. See SF 8988, 9090, 11149, 16335, 23089, 37137, 38511, 43632, 55114, 55140, 58042, 58141, 58804, 58906, 58920, 60106, 60363, and 89913.

15. *Record Commissioners* 1881, 16:16 (5 Jan. 1736).

16. Bagnall purchased a brick house, warehouse, and several pieces of land in the 1730s. He repeatedly mortgaged these properties between the 1740s and 1771. Mortgages occurred almost yearly in the 1740s. For a record of these land transactions, see the Thwing Index, Massachusetts Historical Society, Boston, Mass.

17. Bagnall was a devout Quaker. In 1739 he and six leading Quakers "issued a paper . . . publicly defending Friends from the charge of holding erroneous principles." See Selleck 1976, 48. Bagnall also had ties to the Quaker community in Newport, R. I. His son, Benjamin Bagnall, Jr., worked in Newport before 1761 and Bagnall, Sr., went to Newport to get his second wife, Sarah Redwood (1703–1791). Sarah was the daughter of Abraham Redwood of Newport; see Partridge 1935, 28–29.

18. See Lyon 1924, 252–253; Drake 1900, 84–85.

19. *Record Commissioners* 1881, 8:181 and 186 (10 Mar. 1723 and 8 Mar. 1724).

20. For a clock by Benjamin, Jr., see DAPC 70.684. For clocks by Samuel, see *Antiques* 3:1 (Jan. 1923): 28; Sack 1981, 3:641; Heckscher 1985, no. 188; DAPC 70.522.

21. Benjamin Bagnall petition (1771), SF 89913.

22. Benjamin Bagnall, Sr., will and inventory (1773), docket 15457, 73:111 and 203, SCPR.

23. For clocks by Bagnall, Sr., see Nutting 1928, 2: fig. 3240; Partridge 1935, 27–31; Heckscher 1985, no. 187.

24. For remarkably similar face plates from eastern England, see Mason 1969, 115, 120, 159.

25. Jackson and Charles vs. Benjamin Bagnall, Jr. (19 June 1744), SF 58804. While it is possible that Jackson and Charles imported decorative clock parts from England and retailed them to local makers, the ease with which most of these pieces could be cast from English examples suggests that such parts were made by Jackson and Charles themselves.

26. See note 9 above and Benjamin Bagnall vs. Samuel Collins (2 Feb. 1741), SF 55140.

27. For a discussion of this clock's top and its relationship to other American examples, see Edward F. LaFond, Jr., letter to the author, 1 Oct. 1987, DMA files. For related English examples, see Mason 1969, 120, 159.

28. These features are also discussed in LaFond, letter to the author, 1 Oct. 1987.

29. All information on the construction and condition was furnished by Edward F. LaFond who recently restored the works. See Edward F. Lafond, letter to the author, 1 Nov. 1988.

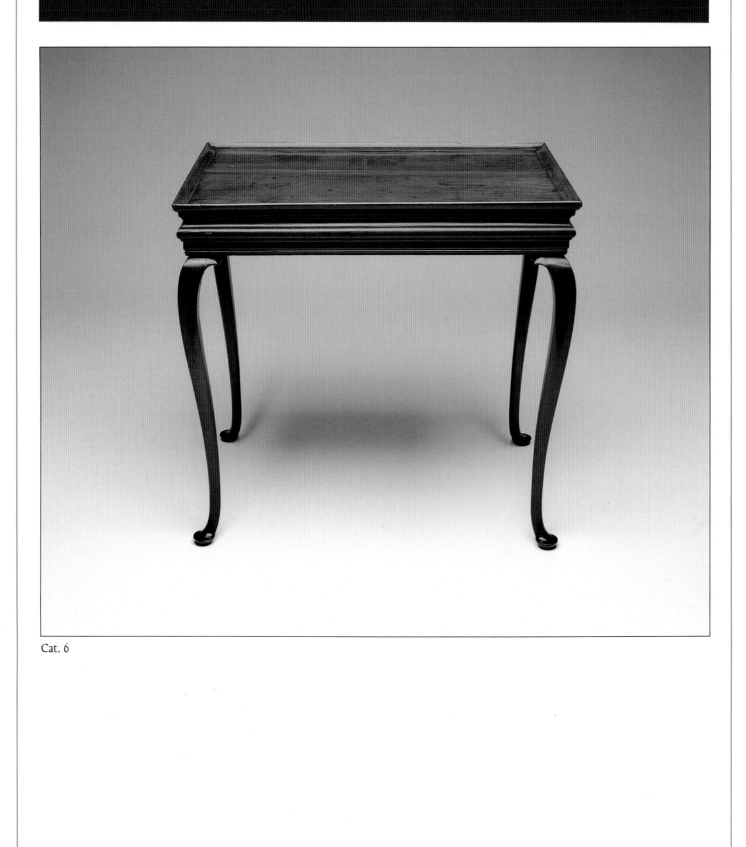

Cat. 6

DURING the late sixteenth century, the drinking of tea became fashionable in the British Empire. In response to this new practice utensils such as teapots, teaspoons, strainers, tea caddies, and teacups were invented or introduced from the Orient. Tea tables with pronounced upper rims were developed about 1700 to support these various devices and to prevent accidents. By the time this particular table was made, tea drinking had evolved into an elaborate ceremony in which manners, wit, and equipage were used to test one's gentility and wealth.[1]

This table may represent one of the earliest forms of tea table made in colonial America. The repetition of a concave-convex molding profile in the skirt divides the upper section in half. This visual division recalls earlier tea tables which consisted of a removable tray and a frame upon which to set it. The manner in which the skirt is built from a molded exterior section which is applied over an inner rail is reminiscent of early eighteenth-century furniture, which often featured surfaces covered with applied moldings and veneers.

Like the date of this table, its origin is also difficult to ascertain. Tea tables with molded upper sections and legs which curve only slightly are known from various places in New England.[2] However, several factors suggest that the table seen here was made in Connecticut. First, the only identical table known originally belonged to an early twentieth-century collector in Hartford.[3] Secondly, a group of rectangular tea tables from the Connecticut River Valley exists which have similar proportions, legs, pad feet, and top rims.[4] And finally, the use of cherry for expensive pieces of furniture was common in Connecticut.

STRUCTURE AND CONDITION: The molded exterior surfaces of the skirt are applied to inner rails which tenon into the legs. The rim which surrounds the top is integral with this molded exterior facing. The top rests on the rabbeted edge of the inner rails. Glue blocks secure the top in place. The knee brackets are applied onto the lower portion of the inner rails.

The table is in good condition. One leg has been broken above the foot and repaired. The top has a central shrinkage crack and has pulled away from one side; the crack has been filled and webbing glued to the bottom of the top to prevent further cracking. Screws have been inserted through several of the glue blocks to draw the slightly warped top down. Some of the glue blocks may be original. The molded rim has several minor cracks. The knee bracket missing in cat. 6a has been reattached.

WOODS: Top and legs, cherry; glue blocks, eastern white pine.

DIMENSIONS: H. 26⅜ (67.0); W. 28¾ (73.0); D. 19 (48.3).

PROVENANCE: John Walton, Inc., Riverside, Conn.; Bybee Collection, 1954.

EXHIBITIONS AND PUBLICATIONS: Fairbanks 1968, 79; MFA, H 1981.

1985.B13

1. For a discussion of tea drinking in eighteenth-century America, see Roth 1961.

2. For related examples from Massachusetts, see Clunie 1980, no. 14; Sack 1981, 5:1175; Jobe and Kaye 1984, no. 68. For Rhode Island examples, see Ott 1965, no. 31; Sack 1981, 4:1014. For one from New Hampshire, see Currier Gallery 1964, no. 15.

3. This table is illustrated in Little 1984, no. 283. Although this table is missing its knee brackets and has been grained, it is definitely from the same shop. The molding and leg profiles are identical, as are the proportions. This table was purchased in 1959 from Roger Bacon, who had acquired it from the Innes collection in Hartford; Nina Fletcher Little, letter to the author, 26 May 1987, DMA files.

4. For illustrations of such tables, see Antiques 41:1 (Jan. 1942): 1; CHS 1963, 24–25; Fales 1976, 148–149.

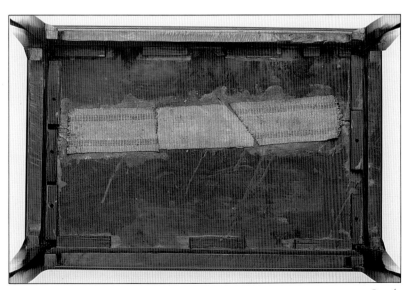

Cat. 6a

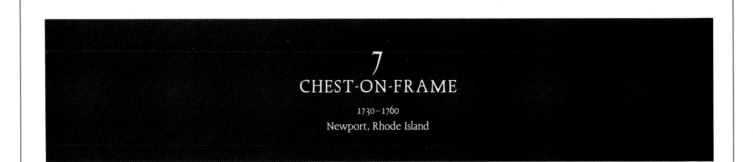

7
CHEST-ON-FRAME

1730–1760
Newport, Rhode Island

DURING THE EIGHTEENTH CENTURY, Newport, Rhode Island, supported dozens of cabinetmakers.[1] In their shops these craftsmen produced some of the most elaborate furniture made in colonial America.[2] However, the greatest demand was for less expensive furniture. Consequently, Newport shops made a wide range of furniture, from costly mahogany desks and bookcases to cheap pine tables.

This chest-on-frame represents the middle range of Newport products. Unlike more expensive versions which have

Cat. 7a

scrolled pediments with finials, this piece has a flat top. It is made of maple, not mahogany, and has no drawers in the lower section.[3] And finally, the legs have little finish, tool marks being visible on their surface. Nevertheless, this chest-on-frame is not without its pretensions. Its overall scale, use of harmonically proportioned drawers, pointed feet, and scalloped skirt all relate closely to more elaborate examples. Also, the depth of the skirt visually acts as a drawer and the brown color applied to the maple resembles mahogany.

Besides being made for the local middle-class market, chests such as this were produced both for export and for wealthy patrons. In 1759, for example, John Brown, the rich Newport distiller, had his main parlor or "Great Room" furnished with all mahogany furniture. However, in the kitchen, two upstairs bedrooms, and a second-floor room, Brown used only maple furniture.[4]

Although this chest-on-frame is part of a group of Newport chests, the identity of its maker is unknown. Within this group are two other maple, flat-top chest-on-frames. Externally, these examples appear to differ from this piece only in that they have two small upper drawers, rather than a single long one; their skirts are more deeply scalloped around the central drop; and they have pad, not slipper, feet.[5] Neither of these related examples is documented to a specific maker.

However, within the extended group of related mahogany examples which have flat-tops and drawers in their lower sections, there is a documented example. This chest of drawers was made by Christopher Townsend (1702–1773) in 1748. In its basic design the Bybee chest is closely related to the Townsend example. Both have similarly scalloped skirts, leg profiles, and proportions. Major construction differences do exist, however. For example, the midmolding on this chest is attached to the upper section, as opposed to the lower section on the Townsend example. Similarly, the legs on the Bybee chest are continuous, while they are detachable above the knee on the other. Overall, the Bybee chest-on-frame is less complicated in its construction.[6] Given these important differences, it is not possible to attribute this chest to Christopher Townsend's shop. Any number of the more than fifty joiners working in Newport during this period could have made this piece.

STRUCTURE AND CONDITION: The legs are continuous from top to bottom. They do not separate at the knee as do other Newport examples. The skirt rails of the lower section tenon into the legs. A medial cross-brace is dovetailed to the front and back skirts and nailed in place. This member helps to stabilize the lower section.

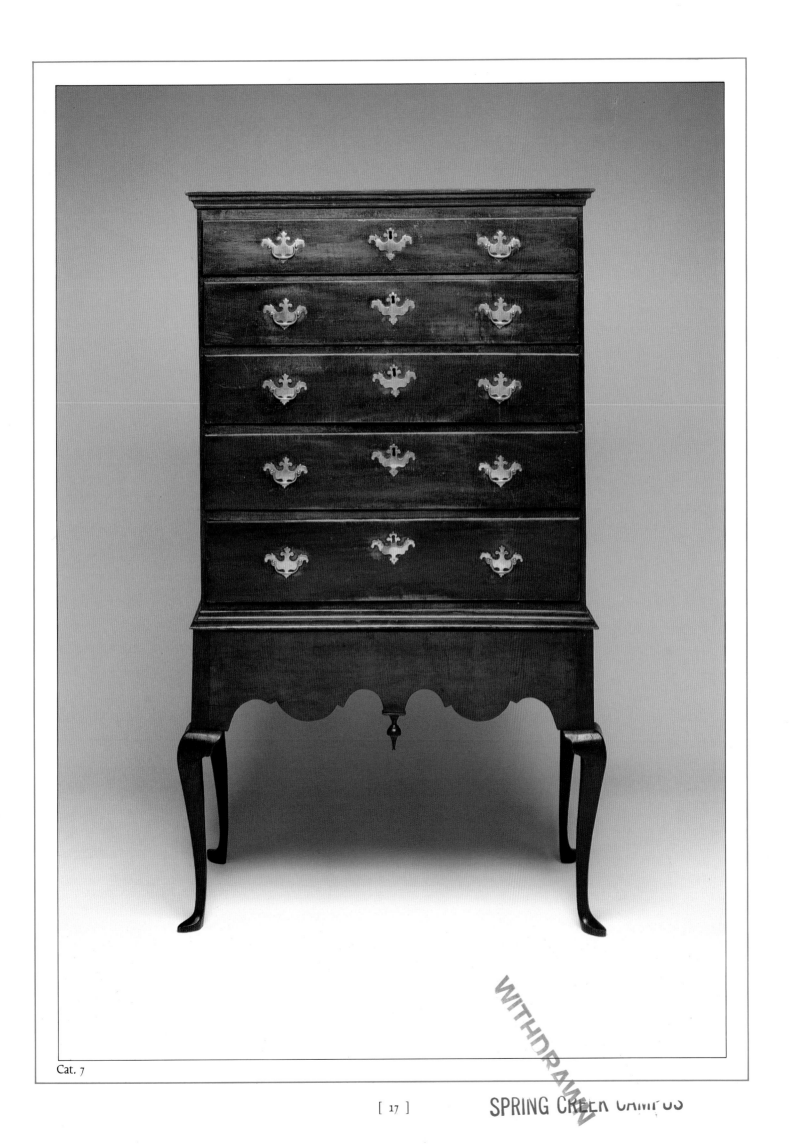

Cat. 7

The sides of the upper case consist of two vertical boards which dovetail into the top and bottom boards. The drawer runners are nailed to the sides of the case. The drawer dividers join the case sides with sliding dovetails. These joints are left exposed. The drawers are joined with relatively large and crude dovetails. Their chamfered bottoms fit into grooves run on their fronts and sides. They are nailed flush across the back. The backboards are nailed into the rabbeted edges of the top and sides. The midmolding is nailed to the upper section.

The exterior surface of this chest survives in good condition. The brown finish is original, as is the exterior hardware. Locks are missing on the third and fourth drawers. The lower drawer never had a lock and those on the upper two drawers are replacements. All but three drawer runners are replacements. Running strips along the bottom edges of all drawer sides are replacements. One drawer has a new side. The lower left corner of the backboard has been damaged and patched. The rear knee bracket on the right side is probably a replacement, as is the pendant drop. The bottom board has two new guide boards on its underside. The corners of the upper case have holes drilled in them which indicate that this section was once separated from its base and had feet attached to it.

WOODS: Drawer sides and bottoms, case top and bottom, chestnut; legs, case sides, drawer fronts, drawer dividers, knee brackets, soft maple.

DIMENSIONS: H. 65 (165.0); W. 38¾ (98.4); D. 20⅝ (52.4).

PROVENANCE: John Walton, Inc., Riverside, Conn.; Bybee Collection, 1954.

EXHIBITIONS AND PUBLICATIONS: Fairbanks 1967, 383; Fairbanks and Bates 1981, 112; MFA, H 1981.

1985.B22

1. For a list of joiners and cabinetmakers working in Newport between 1745 and 1775, see Vibert 1981, 91–93.
2. For examples of their most elaborate work, see Randall 1965, no. 62; Monkhouse and Michie 1986, nos. 39–40; Warren 1975, 135.
3. For examples with scrolled pediments, see Warren 1975, no. 124; Fales 1976, fig. 436; Heckscher 1985, no. 161.
4. Quoted in Vibert 1981, 71. Vibert also contains a discussion of Newport furniture exports.
5. For these related examples, see Ward 1988, no. 133; Sack 1981, 2:461.
6. For illustrations of this documented example, see Ott 1965, no. 57; Jobe and Kaye 1984, fig. I-38; Moses 1984, 37; Christies' 6320 (24 Jan. 1987): lot 291. For construction details, see DAPC 65.1039. For other related examples, see Levy brochure (Spring 1986): 25; Antiques 130:6 (Dec. 1986): 1272; SPB 5599 (26 June 1987): lot 177.

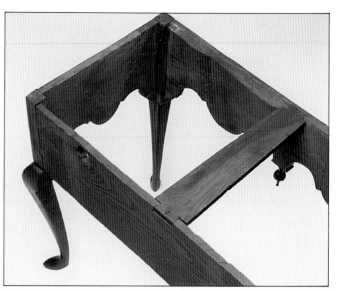

Cat. 7b

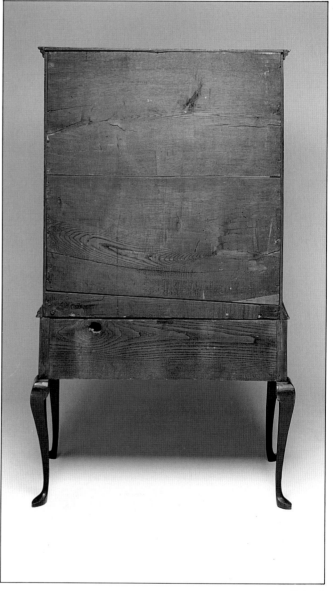

Cat. 7c

8

HIGH CHEST OF DRAWERS

1735–1757
Ipswich or Salem, Massachusetts

DESIGNED FOR the secure storage of expensive linens and wearing apparel, high chests were among the most costly of all furniture forms produced in the eighteenth century. The lavish use of solid walnut for the carved shells, moldings, and front legs, the walnut veneer and banding on its facade, and a labor intensive scrolled-pediment top made this example costly indeed. However, the original owners of this high chest could well afford such expense. When the Ipswich merchant, Daniel Staniford, died in 1757 his estate was valued at almost £ 570. His real estate included a "Mansion House[,] Barn & Garden in Ipswich Town." In the "Hall Chamber" was this "Case of Drawers" and its matching dressing table. In Staniford's inventory the pair was valued at 100s., the most expensive item in the house.[1]

Following her husband's death, Mary Burnham Staniford married a Harvard-educated minister, the Reverend John Rogers. Like Daniel Staniford, Rogers was a wealthy and important member of the community and had connections in Boston. At the time of his death in 1775, his "Mansion House, Barn & other out Houses with about seven acres of Land" were valued at the enormous sum of £ 400. Although his inventory lists several fashionable pieces of furniture, including a "Japan'd Tea Table" (12s.) and a "large Mehogany Table" (40s.), it does not list the high chest seen here.[2]

When Mary Staniford Rogers died four years later in 1779,

however, she still owned this high chest, as well as the furniture she had inherited from Nathaniel Rogers. Her inventory lists a "Case of Drawers & Chamber Table £ 50."[3] In keeping with eighteenth-century social and legal customs, Mary Staniford Rogers was considered the sole owner of this high chest since she brought it to her second marriage. Hence, it appropriately was included in only Mary's estate inventory and not her second husband's.

This high chest is part of a large group of pieces which originated in Essex County, Massachusetts. Characteristic of this group are the "ankeled" foot, leg profile, incurving knee respond, compressed cornice scrolls, and trapezoidal bonnet construction (cat. 8c) seen on this example. Beyond these basic features, however, numerous options were available. One could request deeply carved shell drawer fronts, as here, or gilt or inlaid ones—or no shells at all. A customer could get a walnut veneered and banded facade on his chest or have it made in solid wood. One could have drops on the skirt or simply have those pendant areas rounded off (fig. 1). By midcentury, the same shop could also provide claw-and-ball and hairy paw feet and carved knees. Besides these decorative options, major variations in form were available. This shop produced not only bonnet-top high chests and dressing tables, but flat-top high chests and bonnet-top chest-on-chests.[4]

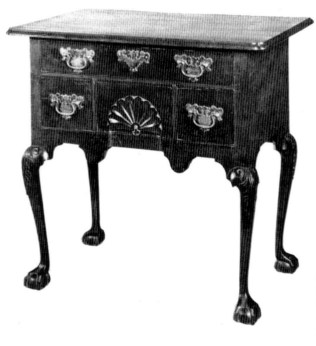

Fig. 1. Dressing table, Ipswich or Salem, Massachusetts, 1745–1780. Mahogany; H. 31 (78.4), W. 33½ (84.8). From *Colonial Furniture, Silver & Decorations . . . The Collection of the Late Philip Flayderman* (New York: American Art Association, Anderson Galleries, Inc., sale no. 3804, 2–4 January 1930), lot 422.

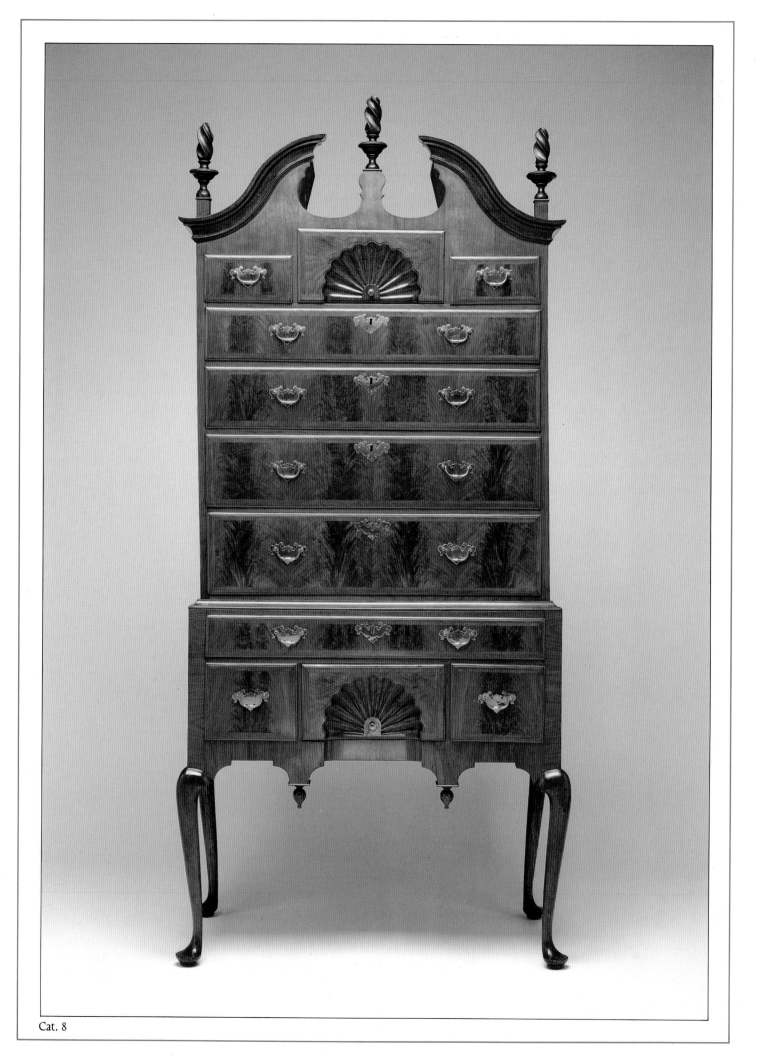

Cat. 8

Unfortunately, no piece in this large group has been documented to a specific Essex County maker. The towns of Ipswich, Newburyport, and Salem were all prosperous during this period and supported many fine cabinetmakers. Given its family history, this chest may have been made in Ipswich. In fact, Daniel Staniford owed the Ipswich cabinetmaker Nathaniel Dutch (1704–1795) 8s.8d. when he died in 1757.[5] Although Dutch could have made this high chest, it is logical to consider an origin outside of Ipswich as well. The town of Salem, for example, could certainly be the source of this entire group of furniture. Due to the large number of wealthy merchants living in Salem in the eighteenth century, the town supported a great number of craftsmen. In the early 1760s, for example, Salem had at least seventeen furniture makers working in it. Certainly some of these artisans would have been capable of producing such a high chest. Joseph Gavet (1699–1765), for example, ran a large shop with several workmen including his son, Jonathan (1731–1806), and Henry Rust (see cat. 28). Furthermore, his shop was exceptionally well-supplied with tools. When Joseph Gavet died in 1765, his shop had scores of tools, including veneering saws and veneering weights.[6] Given the sophisticated nature of this high chest and the number of variations which exist within the entire group, it is likely that these pieces were produced in a shop like Gavet's—one that had both a highly skilled master and journeymen and a complete complement of tools and raw materials.

Whoever made this high chest may well have apprenticed in Boston during the early eighteenth century. The use of walnut veneer, herringbone banding, and carved and sometimes gilt shells closely relates to Boston examples from the 1730s. The presence of engaged pilasters and blocking on other members of this group also suggests a strong Boston connection. As often happened, the maker of this high chest could have trained in Boston, only to be forced home to Essex County when Boston's economy began to stagnate during the second quarter of the eighteenth century.

STRUCTURE AND CONDITION: The upper case is ½" (1.2 cm.) shallower than the base. It rests on the lower case's stiles and rails. These members are mortise-and-tenoned together and pinned in place. The midmolding is attached to the base section. The inner surfaces of the case have been smoothed with a veneering plane. The rear legs retain saw marks and were not smoothed like the front legs. The backboards have an extremely uneven surface from pit sawing.

The drawer runners and dividers fit into grooves run on the case sides. Facing strips cover these joints on the front surface. The upper tier of drawers is separated from the rest of the case by a full dustboard. There is a medial brace running beneath the top drawer of the lower section. The drawer fronts with carved shells are 1½" (3.8 cm.) thick. The other drawer fronts are veneered. The drawers are joined with large dovetails. Their chamfered bottoms fit into rabbets along the front and are nailed in place along the sides and backs as in early eighteenth-century work. Running strips are glued on the drawer bottoms along the outside edges.

The high chest is in good condition. The finials, drops, and drop-plates are replacements. The hardware is original. A horizontal brace has been added to both sides of the lower case. The base's upper left rail which supports the upper case has been replaced. Areas of veneer on the bonnet and drawer fronts were relaid following heat exposure in 1972.

WOODS: Veneer, drawer fronts with shells, bonnet cornice molding, front legs, and two side finials (replacements), American black walnut; top of bonnet, backboards, and drawer linings, eastern white pine; back legs and case sides, soft maple; central finial (replacement), mahogany.

DIMENSIONS: H. without finials 82 (208,0); W. 40¼ (102,3); D. 23 (58.4).

PROVENANCE: Daniel (d. 1757) and Mary Burnham Staniford (d. 1779), Ipswich, Mass., pre-1757; the Rev. Nathaniel (1701–1775) and Mary B. Staniford Rogers, Ipswich, Mass., 1757–1779; Jacob (d. 1815) and Martha Rogers Treadwell (d. 1780), Ipswich, Mass., 1779–1815; Nathaniel (1750–1826) and Hannah Treadwell Wade, Ipswich, Mass.; Nathaniel Wade, Jr., Ipswich, Mass.; William Foster Wade, Ipswich, Mass.; Nellie Wade, Ipswich, Mass.; Harry Arons, Ansonia, Conn.; Israel Sack, Inc., New York, N. Y.; Bybee Collection, 1950.

EXHIBITIONS AND PUBLICATIONS: *Antiques* 58 : 4 (Oct. 1950): 223; Fairbanks 1967, 833; Fairbanks and Bates 1981, 117; MFA, H 1981; H. Sack 1988, 1122.

1985.B18

1. Daniel Staniford will and inventory (1757), docket 26177, Essex County Probate Records (hereafter ECPR), Essex County Courthouse, Salem, Mass.

2. Nathaniel Rogers will and inventory (1775), docket 24045, ECPR.

3. Mary Staniford Rogers will and inventory (1779), docket 24031, ECPR. When this high chest was acquired, it was accompanied by a late nineteenth-century document which stated that "Rev. Mr. Rogers gave this case of drawers to his daughter Martha who married Mr. Jacob Treadwell. Their daughter married Col. Nathaniel Wade and received the case of drawers. Her son Nathaniel Wade next received them and they belonged in 1888 to his children, the Wades of Ipswich. Highboy in Kitchen 1897." Although it was Mary Staniford Rogers who must have given the high chest to her stepdaughter, Martha Rogers (d. 1780), the rest of this information is correct. When Martha's husband, Jacob Treadwell, died in 1815, the out-of-fashion pieces were listed in his inventory as "Case of drawers $5—dressing base etc. $2." Part of Treadwell's possessions were sold at public auction, including a "case of drawers [for] $4" (docket 28093, ECPR). Apparently this high chest was purchased at the auction by Treadwell's oldest daughter, Hannah, wife of Capt. Nathaniel Wade. Wade's 1826 inventory lists "1 case of drawers $3.00" (docket 28636, ECPR).

4. For the closest related example to this chest, see Fales 1976, no. 437. The construction of the Deerfield example suggests that it had to be veneered when finished. It was probably executed early in this series. Although veneered, the Bybee example is constructed like those in solid wood, suggesting a slightly later date than the Deerfield example. For an example with inlaid shells, see *Antiques* 54 : 6 (Dec. 1948): 377. For one with no shells, only recessed arches, see *Antiques* 100 : 6 (Sept. 1971): 287. This example is reported to have "the names of two Ipswich families within." For one with applied pilasters, claw-and-ball feet, and carved knees, see *Antiques* 63 : 1 (Jan. 1953): 11. For a dressing table with hairy paw feet, see *Christie's* 6742 (Jan. 20–21, 1989): lot 607. For apparently unveneered examples, see Sack 1981, 1 : 103, 167, 2 : 394; DAPC 71.248, 70.941. Another example which descended in the Gay family of Damariscotta, Me., is in a private Ohio collection. A heavily reworked example (1942.3070) is at Beauport, Gloucester, Mass., SPNEA. For dressing tables, see *Antiques* 63 : 1 (Jan. 1953): 10 (probably same piece as in fig. 1); Sack 1981, 4 : 1644; Rodriguez Roque 1984, no. 15. Another is in a private Ohio collection. For flat-top high chests, see Sack 1981, 3 : 694, 5 : 1305; Levy brochure 14 (Spring 1984). For a blockfront chest-on-chest, see Sack 1981, 5 : 1202-1203.

5. Daniel Staniford will and inventory, docket 26177, ECPR.

6. For an excellent discussion of Salem craftsmen working around 1760, see Forman 1971. Joseph Gavet and his inventory are discussed at length on pp. 73–77.

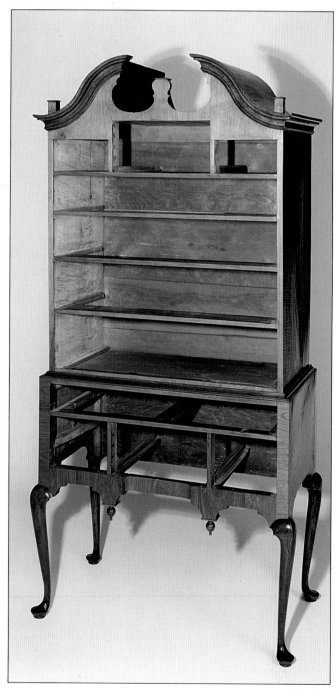

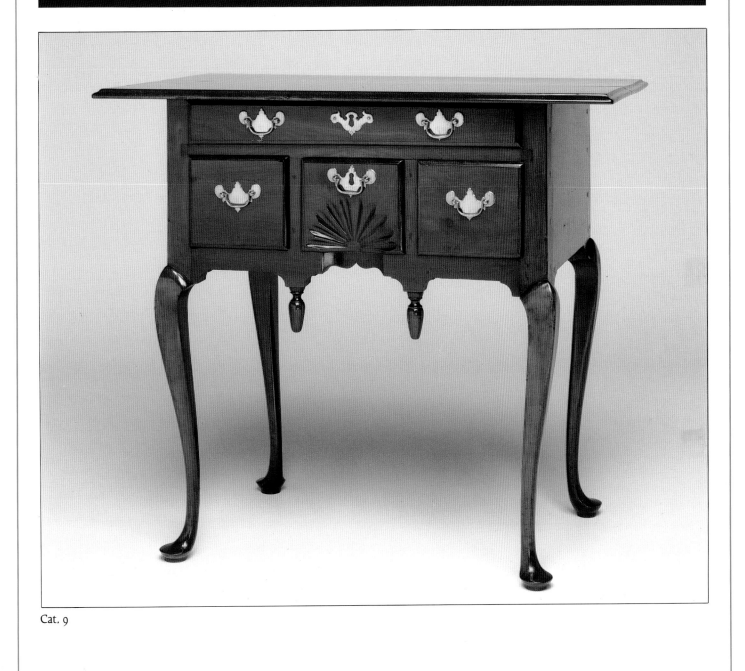

Cat. 9

DRESSING TABLES were often made in conjunction with high chests (see cat. 8). Placed in a bedchamber, the high chest held one's linens and wearing apparel, while the dressing table contained personal items such as combs, jewelry, hair ribbons, and cosmetics. In accordance with their function, looking glasses were commonly placed above and chairs in front of these tables.

This example is part of a large group of dressing tables which was made along the Connecticut River. Typical of this regional tradition are legs which bend only slightly at the knee, carved shells on the central drawer with a concave area below, and a widely overhanging top. However, those examples made up river in the Hartford-Wethersfield area usually have scalloped skirts and occasionally scalloped tops as well.[1]

This particular dressing table relates most closely to a small group of furniture from the Lyme-Saybrook area at the mouth of the Connecticut River. Examples from this group are known which have virtually identical legs, knee responds, carved shells, and no upper rail as here.[2] The extensive use of mahogany in this dressing table also suggests a coastal Connecticut origin. Mahogany was easier to obtain on the coast due to the extensive shipping which occurred along Long Island Sound.

STRUCTURE AND CONDITION: The sides, backboard, and lower front rail are mortise-and-tenoned into the upper portion of the legs and pegged in place. The sliding dovetails of the drawer divider are left exposed. The medial drawer dividers are slotted into the backboard and nailed into notches in the lower rail. The front ends of the medial dividers are faced with ½" (1.3 cm.) mahogany strips which are glued and nailed in place. The drawer runners are nailed in place. There is no upper rail above the top drawer.

The drawers are constructed with wide dovetails. Their chamfered bottoms fit into grooves run along the drawer fronts and sides and are nailed along their rear edges. The drawer with the carved shell is the only exception. Its bottom is nailed flush onto the bottom edges of the four drawer sides.

The piece is in good condition. The top has been off to repair a crack. The drops might be original. The hardware is original; the crudeness of the brass from which it is made may indicate an American, rather than an English, origin.

INSCRIPTIONS: The backboard and drawer sides have several illegible chalk inscriptions on them.

WOODS: Drawer fronts, top, case sides and drops, mahogany; drawer linings, drawer runners and backboard, yellow poplar; legs, cherry; medial drawer dividers, sycamore.

DIMENSIONS: H. 30⅞ (78.3); W. 35 (89.0); D. 21⅜ (54.2).

PROVENANCE: John Walton, Inc., Riverside, Conn., ca. 1948–1954; Bybee Collection, 1954.

EXHIBITIONS AND PUBLICATIONS: *Antiques* 53:6 (June 1948): 397; Fairbanks 1968, 76; MFA, H 1981.

1985.B19

1. For information on this regional tradition, see Kirk 1967, nos. 178–179; Brown 1980; K. Sweeney 1984.
2. For the closest example known to date, see Myers and Mayhew 1974, no. 16; a tea table (no. 17) also has legs similar to the Bybee dressing table.

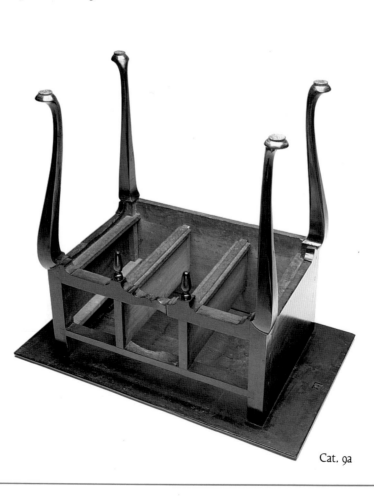

Cat. 9a

10
DROP-LEAF TABLE

1740–1770
Eastern Massachusetts

SMALL DROP-LEAF TABLES such as this example had a variety of uses in the eighteenth century. Their size allowed them to be used for breakfast, like Pembroke tables (see cat. 29), as well as for taking tea or playing cards. However, despite their usefulness, such tables were apparently not made in large quantities. Few survive today, especially ones made of mahogany.

This example relates to a small group of tables which are believed to be from eastern Massachusetts. Characteristic of these tables is the semicircular profile of the skirt ends and the attachment of the swing-legs' knee brackets to the skirt.[1] The exceptionally flat feet with crisp pads are also distinctive features of this table.[2]

STRUCTURE AND CONDITION: The skirt frame is mortise-and-tenoned together. The knee brackets for the swing legs are attached to the ends of the skirt. The top is secured with glue blocks and screws from below. The underside of the top has been roughened with a toothing plane. The leaves meet the top in ruled joints.

The table has traces of an old finish. One of the hinges under the top is in its original position, but the other three have been reset. The leaf which has had both of its hinges reset shows no signs of the original hinge position and is probably a period replacement. It is cut from dense mahogany like the rest of the table and has similar coloring on its underside.

WOODS: Legs, top, skirt ends, mahogany; skirt sides, soft maple; gate-hinge pintles, hickory; inner rails, glue blocks, eastern white pine.

DIMENSIONS: H. 26⅝ (67.6); W. open 36¼ (92.1); W. closed 11 ½ (29.1); D. 30½ (77.5).

PROVENANCE: Maurice Rubin, Boston, Mass.; Israel Sack, Inc., New York, N. Y.; Bybee Collection, 1954.

EXHIBITIONS AND PUBLICATIONS: Fairbanks 1967, 832; MFA, H 1981.

1985.B16

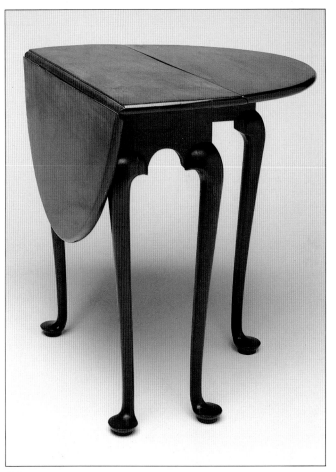

Cat. 10

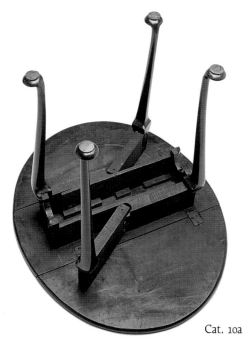

Cat. 10a

1. For tables with these features, see Lockwood 1926, 2: fig. 726; Fales 1976, no. 249. For a rectangular table by George Bright of Boston with swing-leg knee brackets attached to the frame, see Jobe and Kaye 1984, no. 63. For a related table with a semicircular skirt end, see A. Sack 1950, 246.
2. For a table with similar leg and foot profiles, see Fales 1976, no. 247.

11
SIDE CHAIR (one of a pair)

1740–1770
Newport, Rhode Island, or Boston, Massachusetts

CHAIRS with curved rear stiles, vase-shape splats, cabriole legs, and carved shells on their crest rails and knees were being made in England as early as 1710.[1] Through the importation of such chairs and the immigration of British-trained chairmakers, this type of chair was transplanted to colonial America in the second quarter of the eighteenth century. Chairs decorated with shells, similar to those seen here, were made in New York, Newport, and Boston.[2]

The Bybee chairs are part of a large group which has traditionally been attributed to Newport.[3] However, several chairs of this type have histories of ownership in the Boston area.[4] Such chairs were probably made in both cabinetmaking centers. At present, it is not possible to distinguish with certainty the products of the two towns.

Although this chair is a finely crafted example, with the rear stiles being cut from solid walnut, it is less elaborate than many related chairs. By paying more, the original owner of this chair could have had additional shells carved on its knees and claw-and-ball feet added to the front legs.

STRUCTURE AND CONDITION: This chair is joined with mortise-and-tenon construction throughout. The rear stiles are cut from the solid. Their inside rear corners are chamfered below the inward curve. The splat is shaped to follow the contour of the sitter's back. The side stretchers terminate in rectangular tenons which fit into mortises in the legs. There is little shaping to the inside surfaces of the front legs, suggesting that the chair was assembled before the final smoothing of the parts was completed.

This chair and its mate are in good condition. The crest rails have been off and re-pinned. Both slip seat frames are replacements. At one point in their history, these chairs were upholstered over the rails, as evidenced by the presence of nail holes along the underside of the seat rails and below the shoes. Losses to the front and left knee brackets of this example have been replaced. The corner blocks bracing the seat frame appear to be original. Its mate has replaced corner blocks.

INSCRIPTIONS: This chair is incised "II" on the inside of the front seat rail. It also carries five triangular chisel marks on the same rail. The inside of the right seat rail is marked "10" in chalk. The mate to this chair is incised "I" on its front rail.

WOODS: All exterior surfaces, American black walnut; corner blocks, eastern white pine; replacement slip seats, Sylvester's pine.

DIMENSIONS: H. 41⅛ (104.4); S.H. 16½ (41.9); W. 21½ (54.6); D. 20½ (52.1).

PROVENANCE: Bybee Collection, 1950s.

EXHIBITIONS AND PUBLICATIONS: Fairbanks 1968, 77; MFA, H 1981; *Antiques* 129:5 (May 1986): 956.

1985.B10

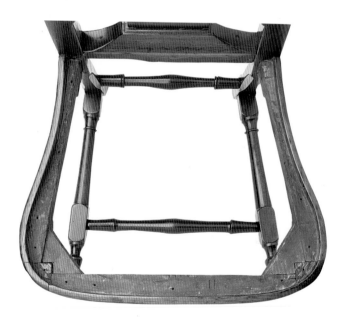

Cat. 11a

1. For English versions, see Kirk 1972, 97, and Price 1977, fig. 2. The Price example is almost identical to the group traditionally associated with Newport. For citations of other English prototypes, see Jobe and Kaye 1984, no. 99, n. 5.

2. For New York examples, see Downs 1952, no. 106; Kirk 1972, no. 126; Fales 1976, 47; Fairbanks and Bates 1981, 94; Heckscher 1985, nos. 21–22. For examples believed to be from New England, see Nutting 1928, 2:no. 2130; Downs 1952, nos. 101, 103; Carpenter 1954, nos. 7, 10; *Antiques* 99:5 (May 1971): inside front cover; Warren 1975, no. 40; Fales 1976, nos. 78–79; Sack 1981, 3:677; Fairbanks and Bates 1981, 93; Jobe and Kaye 1984, no. 99; Moses 1984, 205; Heckscher 1985, nos. 6–8; Flanigan 1986, no. 1.

3. Chairs of this type are attributed to Newport by Carpenter 1954, no. 5; Ott 1965, no. 7.

4. For an excellent discussion of examples with Boston-area histories, see Jobe and Kaye 1984, no. 99, especially n. 1–3.

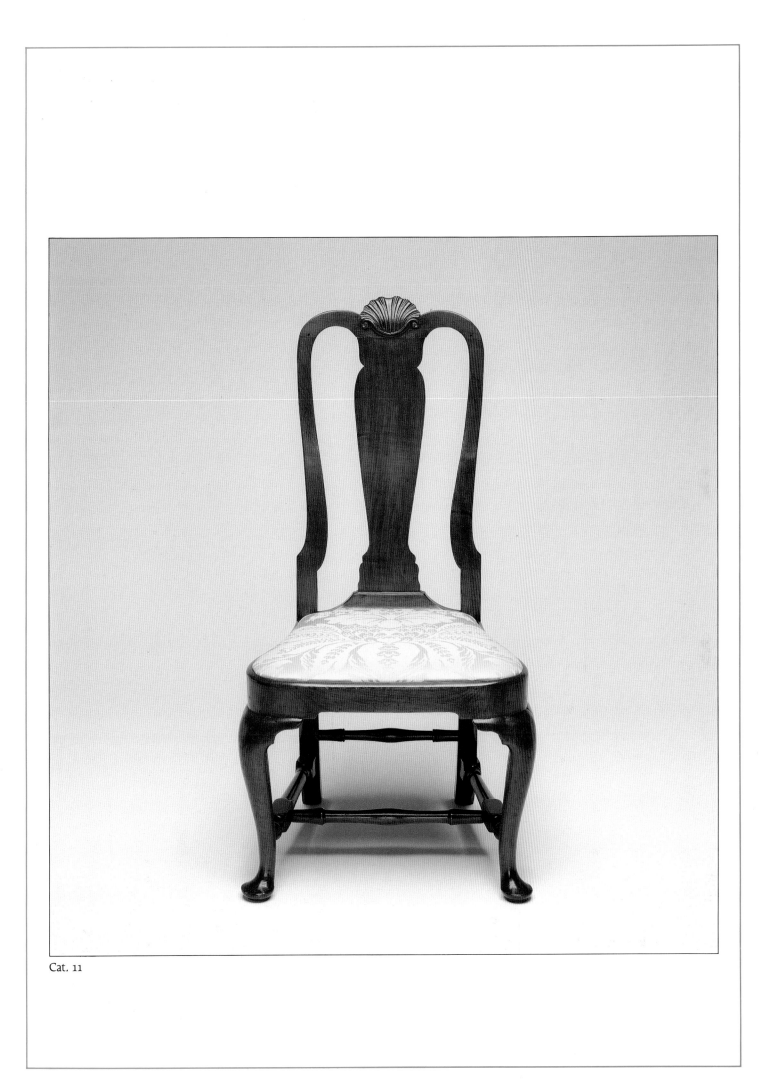

Cat. 11

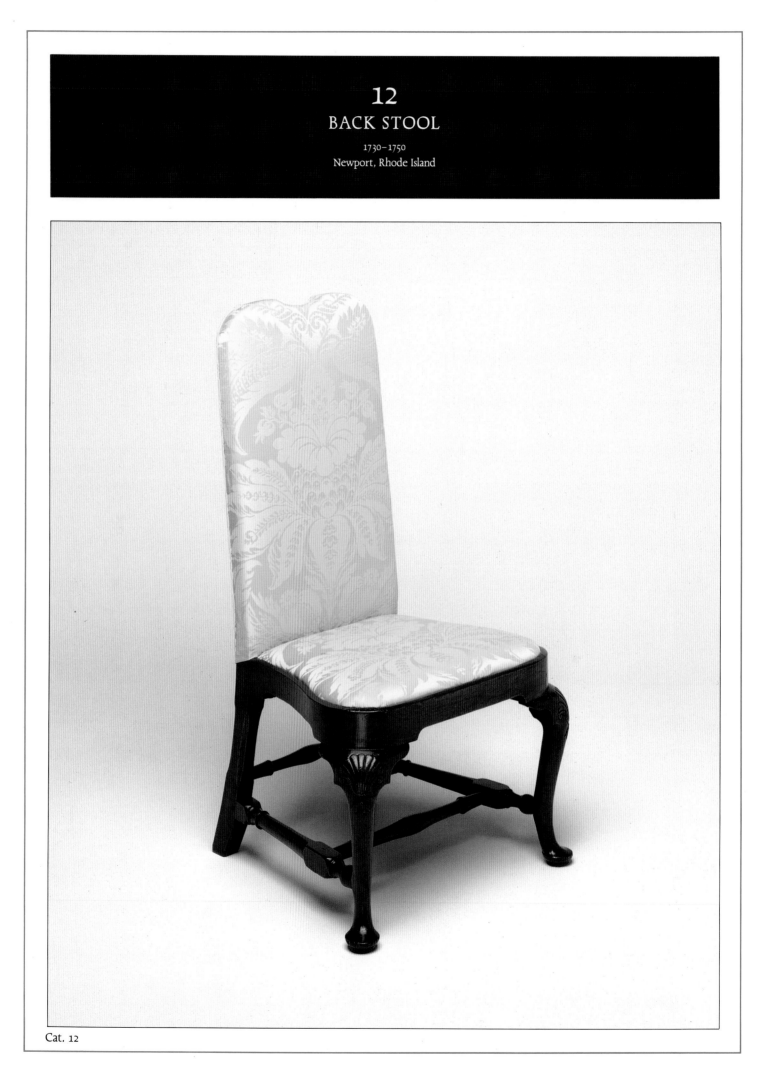

Cat. 12

IN ENGLAND and on the Continent chairs with upholstered backs such as this example were not uncommon among the aristocracy. Unlike middle- and lower-class consumers, the elite could afford the great expense of upholstery fabrics. In their lavish European country and town houses, the rich used back stools in a variety of rooms from at least the mid seventeenth century. Often bought in large sets, back stools were placed along the walls of bedchambers and reception rooms in order to create a formal atmosphere of luxury and comfort.[1]

Back stools were popular in Great Britain throughout the eighteenth century. In 1765, for example, the London cabinet-maker Robert Manwaring included four designs for upholstered back stools in *The Cabinet and Chair-maker's Real Friend and Companion*.[2] Due to their comfortable, upholstered backs and bottoms, eighteenth-century back stools were used by the elite in situations which required prolonged periods of sitting. In contemporary paintings and prints, back stools are shown most frequently next to dressing tables and candlestands, around card tables, and in dining rooms.[3] A painting in William Hogarth's series *Marriage-à-la-Mode* (ca. 1745), for example, depicts a great hall and antechamber furnished with a large set of back stools similar to the one seen here (fig. 2). The chairs are shown next to card and breakfast tables. Both the exhausted bride and groom repose in such chairs. Back stools were not made solely for the comfort of women as has been suggested, but rather were highly versatile and comfortable chairs for the use of both sexes.[4]

In America back stools were seldom used. With rare exceptions, the colonies simply did not possess the aristocratic level of wealth and refinement which characterized the European use of such objects. Only in a few urban centers did significant capital and social pretensions combine to produce these elitist objects.[5] Newport was the most important of these urban centers. More back stools survive from Newport than any other colonial cabinetmaking center.[6] This simple fact suggests that

Newport's elite strongly identified with their English counterparts. The early architecture of the town further supports this hypothesis. Structures such as the Redwood Library (built 1748), for example, could not be more in keeping with English upper-class aesthetics of the period.[7]

The Bybee back stool originally belonged to a larger set of chairs. This example is numbered IIII and another virtually identical chair survives with the number VI on its seat frame. This second chair has an oral tradition of having belonged to the Maynard and Hazard families of Newport. In addition, two similar armchairs are also known (fig. 3).[8] The illustrated chair is numbered VII. The other armchair, which is unnumbered, has probably had its arms replaced. All four of these chairs are identical in size, proportions, construction, materials, and carving. Their seat frames are all roughly relieved as on the Bybee example (cat. 12a).

Since the Bybee chair has blocks for holding a chamber pot frame, it is possible that the set of back stools from which it came was used in a bedchamber. In eighteenth-century England and America, bedchambers functioned as dressing and breakfast rooms, as well as entertainment areas for one's closest friends. A set of comfortable back stools which included a toilet chair would have been a potent symbol of wealth and aspiration for a member of Newport's elite.

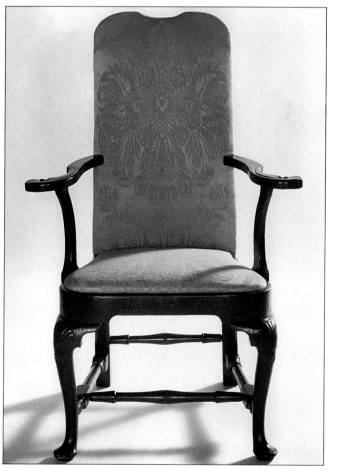

Fig. 2. William Hogarth (1697–1764), plate 2 from the series *Marriage-à-la-Mode*, London, ca. 1745. Engraving; image H. 13¾ (35.3), W. 17¾ (44.9). (Winterthur Museum [67.2240].)

Fig. 3. Armchair, Newport, Rhode Island, 1730–1750. Walnut; H. 41⅛ (104.1), W. 29¼ (74.0), D. 23 (58.2). (Winterthur Museum [68.771].)

STRUCTURE AND CONDITION: This chair is joined with pinned, mortise-and-tenon construction. The turned stretchers have rectangular tenons on their ends. The structure of the back was not examined. The inner surfaces of the seat rails are roughly relieved. There are no traces of glue blocks. Six small, rectangular blocks on the inner surface of the rail supported a toilet seat frame.

The chair retains traces of its original finish and its slip seat frame is probably original. The right stretcher has been cracked and repaired. The top edge of the seat frame has been damaged in several places. This chair is currently upholstered in a reproduction silk damask. Originally, this chair would more likely have been covered in a woolen fabric.

INSCRIPTIONS: The front seat rail is incised "IIII."

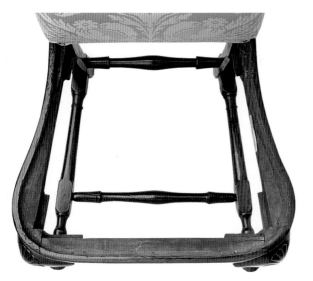

Cat. 12a

WOODS: Front legs, front stretcher, front and side seat rails, American black walnut; rear legs, back and side stretchers, lower horizontal member of the back, soft maple; toilet seat blocks, slip seat frame, eastern white pine.

DIMENSIONS: H. 41⅞ (106.0); S.H. 16 (40.5); W. 22 (55.9); D. 18⅜ (46.7).

PROVENANCE: Possibly James L. Little, Sr., Mass., 1830; Little family descendant, Matthews Court House, Va., 1953; John S. Walton, Inc., Riverside, Conn.; Bybee Collection, 1954.[9]

EXHIBITIONS AND PUBLICATIONS: Antiques 64:6 (Dec. 1953): 426; Carpenter 1954, no. 23; Fairbanks and Bates 1981, 107; MFA, H 1981.

1985.B15

1. For depictions of European back stools in use, see Thornton 1978, 99, 186, 189, 191; Girouard 1978, 131.

2. Manwaring 1765, pls. 22–23.

3. Gloag 1956, 270; Antiques 131:6 (June 1987): 1267–1275.

4. Downs 1952, no. 97, is an early reference to the back stool as a woman's furniture form. While some abnormally low examples may have been made especially for women (see Downs 1952, no. 95), most have seats of normal height as does the Bybee example. For related British examples, see Singleton 1901, 4:628a; Lockwood 1907, 72; Fitz-Gerald 1969, pl. 29; Hinckley 1971, 45–47; Gilbert 1978, 1: no. 59.

5. For non-Newport examples, see Downs 1952, nos. 96–97; Antiques 53:5 (May 1948): 313; 62:2 (Aug. 1952): inside front cover; 62:4 (Oct. 1952): 254; 81:3 (Mar. 1962): 253.

6. For closely related Newport back stools, see Antiques 40:1 (July 1941): 37; SPB 1157 (29 Apr. 1950): lot 163; Downs 1952, no. 95, 98; SPB 2026 (24–25 Mar. 1961): lot 236; Hagler 1976, 26; Moses 1984, fig. 1.53; SPB 5599 (26 June 1987): lot 153. See also Ott 1981, 669–673.

7. See Pierson 1986, 1:142–144.

8. For illustrations of the other three chairs, see Hummel 1970, 902–903; Stockwell 1981, 1103. The Stockwell chair was purchased ca. 1950 from Harry Arons, Ansonia, Conn. Arons stated that he had acquired the chair from a descendant of the Maynard-Hazard families of Newport. Information contained in David Stockwell, letter to the author, 2 Mar. 1987, DMA files. The armchair illustrated here as fig. 3 has a history of ownership in the Ellis family of Dedham, Mass.

9. Research suggests that the James L. Little whom Walton listed as an early owner may in fact be the late nineteenth-century antiquarian, James Lovell Little, Jr. (1845–1914). Little was active in the Boston area and collected American furniture. His property and collection descended to his daughter, Laura Revere Little. The furniture collection was sold at auction following her death in the 1940s. See Clunie 1980, 6; Greenlaw notes, DMA files; "Family of James Lovell Little," Arthur Little Collection, SPNEA. If this chair was purchased as used furniture in 1830, it may have been bought by James Lovell Little, Sr., who moved to Boston from Marshfield, Mass., in 1825.

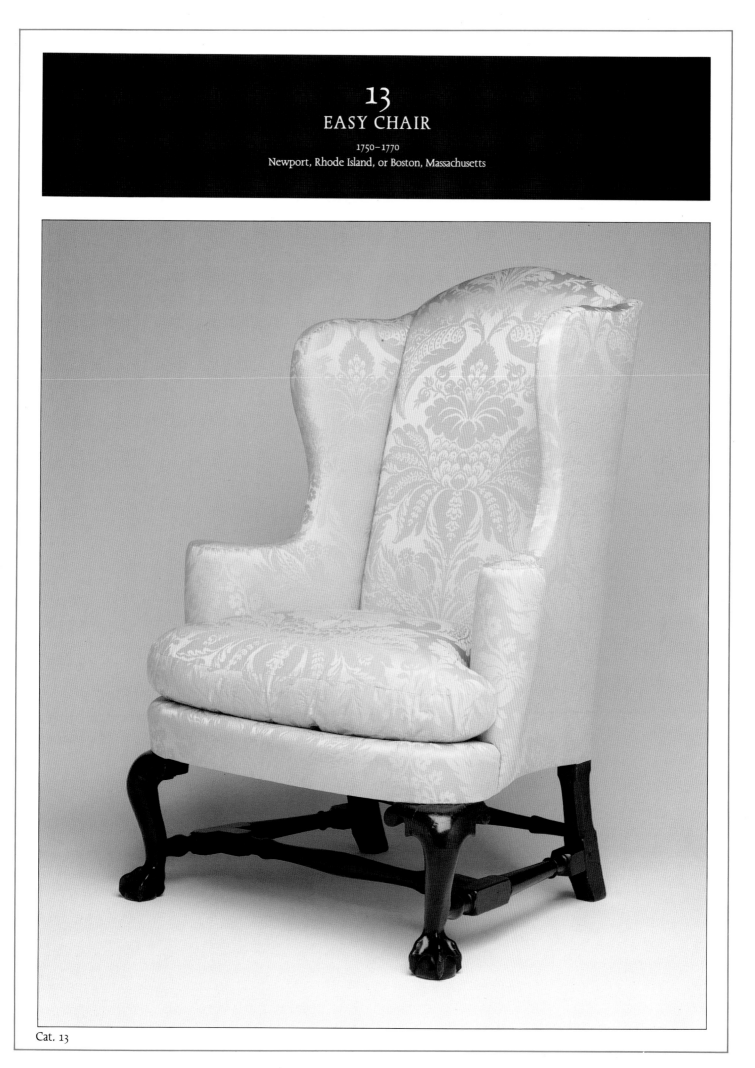

Cat. 13

BY ATTACHING side panels to straight-back chairs, easy chairs were developed in Europe during the seventeenth century as a means to protect the sitter from cold drafts. In both Great Britain and colonial America, such chairs were expensive pieces of furniture due to the high cost of upholstery fabric. For those few who could afford such luxuries, easy chairs were usually placed in a bedroom and were often fitted with chamber pots beneath their cushions.[1]

This easy chair has traditionally been associated with Newport, Rhode Island. However, features such as the compressed balls and webbed talons of the feet and the triple-swelled, medial stretcher are known on chairs from eastern Massachusetts as well.[2] Furthermore, all these details can be found on English pieces.[3]

Regardless of its exact origin, the Bybee chair is a particularly fine example. Its turned and carved elements are well-defined and the overall design is finely proportioned. The "compass" or arched front seat rail seen on this chair was most popular on English examples during the second quarter of the eighteenth century.[4] Consequently, this easy chair may have been made soon after 1750, although it could have been produced as late as 1770. With its boldly carved feet, unusual scrolled knee brackets, darkly stained legs, and brightly colored upholstery, this chair must have spoken eloquently of the power and wealth of its original owner.

STRUCTURE AND CONDITION: The structure under the upholstery was not examined. The front and side seat rails are lap-joined together. The side stretchers join the legs with rectangular tenons. The knee brackets are nailed and glued to the seat frame. The lower section has been refinished, and the chair once had casters.

WOODS: Front legs and center stretcher, mahogany; rear legs, rear stretchers and seat frame, soft maple; side stretchers, cherry; under frame, not tested.

DIMENSIONS: H. 48¼ (122.5); S.H. 14¼ (36.2); W. 34⅛ (86.6); D. 31 (78.7).

PROVENANCE: John S. Walton, Inc., Riverside, Conn.; Bybee Collection, 1960.

EXHIBITIONS AND PUBLICATIONS: Fairbanks 1968, 78; MFA, H 1981.

1985.B26

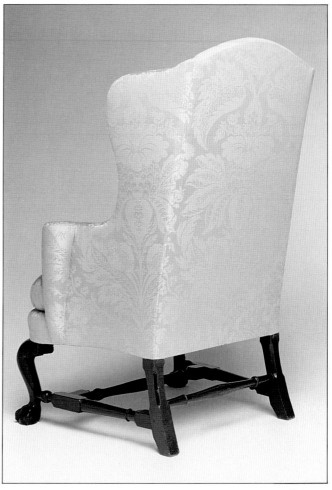

Cat. 13a

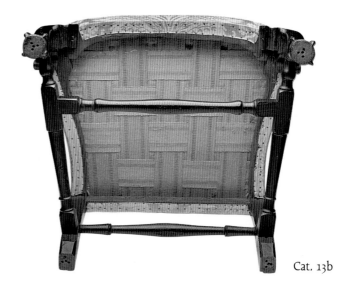

Cat. 13b

1. For discussions of the development and use of the easy chair, see Heckscher 1, 1971; Heckscher 2, 1971; Heckscher 3, 1971.

2. For a similar chair possibly by the same maker, see DAPC 76.354. For a discussion of the difficulties in attributing this group of furniture, see Jobe and Kaye 1984, no. 103; see also cat. 11 in this volume. For Newport and Boston examples which use this type of medial stretcher, see Downs 1952, nos. 95, 103, 160; *Antiques* 66:4 (Oct. 1954): inside front cover; Bishop 1972, 82; Warren 1975, nos. 90, 94; Heckscher 1985, nos. 7–8.

3. For a related English stretcher, see Jobe and Kaye 1984, no. 90. For related English feet, see Kirk 1982, nos. 867, 870. For the use of similar feet in a Williamsburg, Va., chair, see Kirk 1982, no. 925.

4. For a related English chair with compass seat, see Kirk 1982, no. 1152.

14
EASY CHAIR
1750–1790
Probably Boston, Massachusetts

AS WITH the other easy chairs in this volume (cats. 13, 80), this example has many features which are characteristic of New England products. Easy chairs from this part of the country usually have vertically rolled arms like those seen here. Furthermore, the ball-and-claw feet which have retracted or raked-back side talons are most often found on Boston work in this country.[1]

However, in spite of these typical characteristics, this chair has several features which are extremely unusual. Although exceptions do exist, New England craftsmen preferred to use stretchers beneath their chair seats (see cats. 11, 12, 15), especially on easy chairs.[2] Therefore, the lack of side and medial stretchers between the legs of this chair is highly unusual. However, even more puzzling is the presence of rear cabriole legs. In England the use of curved rear legs on easy chairs was a common practice and English examples which have legs that extend as far back as these do are known.[3]

Unlike their English counterparts, colonial American chairmakers seldom used rear cabriole legs on their easy chairs. Only in Philadelphia were they used to any extent and then only on a small percentage of the most expensive and elaborate easy chairs.[4] Outside Philadelphia, rear cabriole legs were almost never used on easy chairs. To date, this example is the only New England easy chair known with curved rear legs. Perhaps it was made by an English-trained chairmaker working in Boston or for a client who desired a chair which was as close to London examples as possible and was willing to pay the extra costs for rear cabriole legs.

STRUCTURE AND CONDITION: The frame is constructed with mortise-and-tenon joints. Square shafts extend up from the rear legs and join the back on a diagonal (see cat. 14b). A large sliding dovetail atop each front leg is slotted into the corners of the front rail (see cat. 14a). The knee brackets are held in place with rosehead nails.

Given that this chair has been upholstered at least six times in the past, the chair is in good condition. "Tuck-away" braces were added to the rear of the wings, but have recently been removed. The lower edge of the side seat rails and the top and bottom edges of the front rail have strips inserted into them to compensate for the destruction of the original wood through repeated reupholstering. On other areas of the frame a mixture of glue and sawdust has been used to fill tackholes. The corner blocks behind the rear legs are replacements.

WOODS: Legs, mahogany; front seat rail, ash; remaining seat rails, soft maple; underframe, eastern white pine.

DIMENSIONS: H. 47 (119.3); S.H. 13 (33.0); W. 35½ (90.1); D. 28 (71.1).

PROVENANCE: John Walton, Inc., Riverside, Conn.; Bybee Collection, 1950s.

EXHIBITIONS AND PUBLICATIONS: Fairbanks 1968, 78; MFA, H 1981.

1985.B25

1. For a discussion of the regional characteristics of Massachusetts chairs, see Kirk 1972, 36–42. Chair no. 104 in this work has feet closely related to this chair's, as well as English-type blocks on the rear feet.
2. For Massachusetts side chairs without stretchers, see Kirk 1972, 104–109.
3. For such an English easy chair, see Rogers 1923, fig. 42.
4. For Philadelphia examples, see Downs 1952, nos. 77–78; Bishop 1972, fig. 141; Warren 1975, no. 55.

Cat. 14a Photo: David Bohl

Cat. 14b Photo: David Bohl

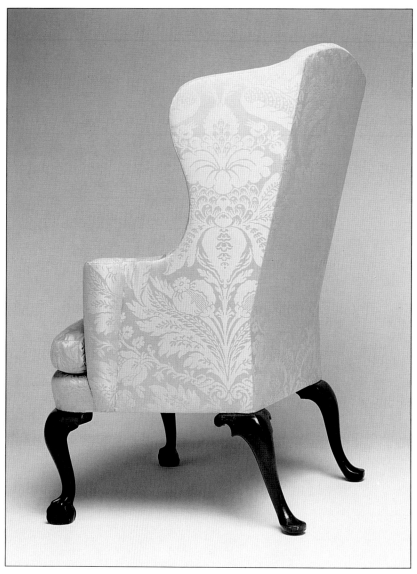

Cat. 14c

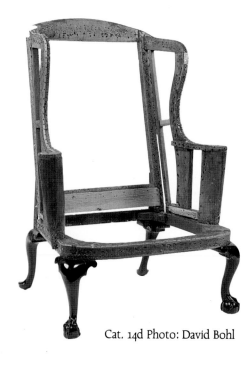

Cat. 14d Photo: David Bohl

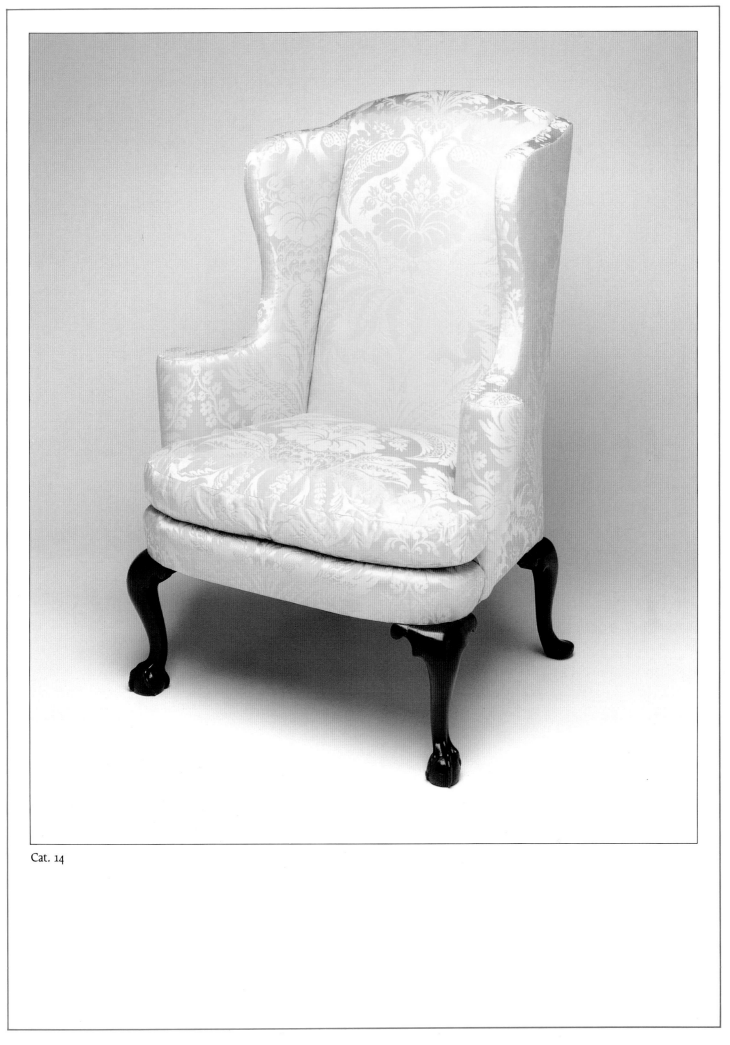

Cat. 14

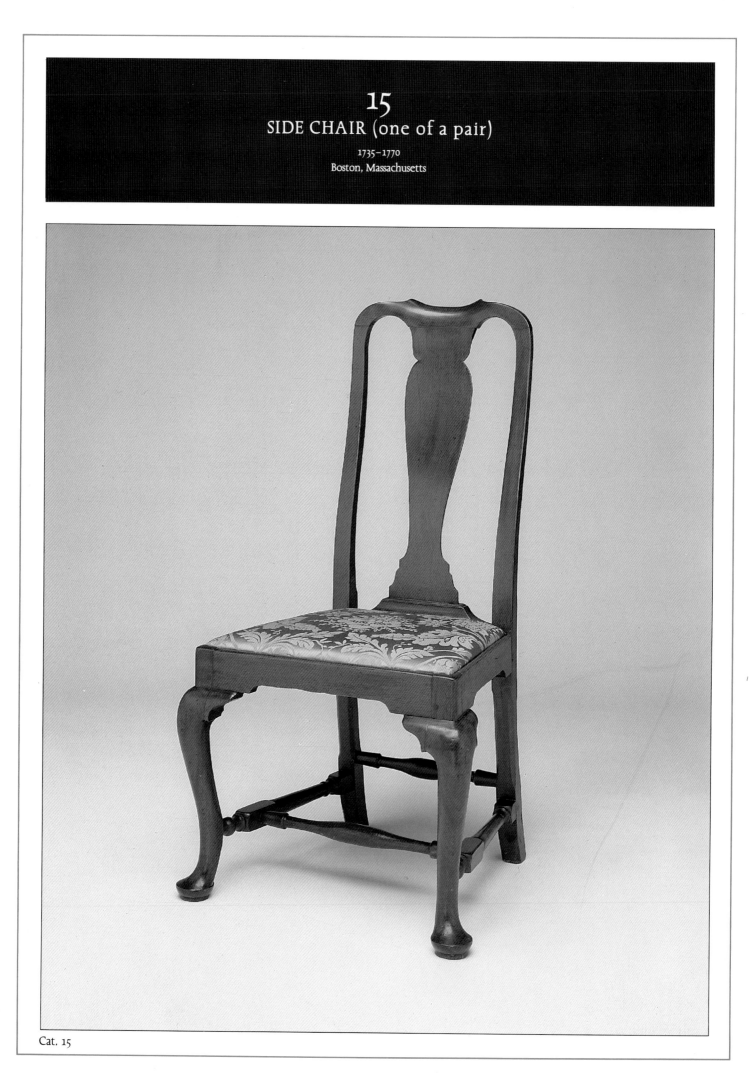

Cat. 15

CHAIRS WITH CABRIOLE LEGS were first introduced into Boston in the 1720s.[1] By the 1740s, chairs with yoke-crests, solid splats, and curved legs were being purchased in large numbers by New England's upper class. To accommodate this demand, Boston chairmakers organized their shops to produce great quantities of standardized chairs. Beyond the general design of this chair, details such as the rectangular tenons on the ends of the side stretchers and the lack of shaping where the stretchers meet the front legs are indicative of Boston work.[2]

In the eighteenth century, Boston chairmakers exported large numbers of these chairs to the rest of New England. This particular pair of chairs was probably once part of a set of eight owned in Barrington, Rhode Island, by Enoch Remington (1728–1811).[3]

As Boston-made chairs were distributed to various parts of New England, they often had a major impact on locally made products. Numerous Connecticut chairs, for example, are virtual copies of standard Boston work.[4]

STRUCTURE AND CONDITION: This chair is typical in its construction. The splat is spooned and the crest rail is relieved in the rear on either side of the central indentation. The rear legs are chamfered in their lower section. The mate to this chair is missing its corner blocks. Both chairs have slight losses on the side stretchers. Both slip seats are probably original.

INSCRIPTIONS: A plaque on the rear seat rail of one of these chairs reads "Pair of Queen Anne Side Chairs Descended in the Family of ENOCH REMINGTON BARRINGTON R. I. Born 1730." These chairs are numbered "III" and "IIII" on their rear rails, respectively.

WOODS: All exterior surfaces, American black walnut; corner blocks, eastern white pine; slip seat frame, soft maple.

DIMENSIONS: H. 40½ (103.0); S.H. 16¾ (42.6); W. 22 (55.9); D. 21 (53.3).

PROVENANCE: Enoch Remington I (1728–1811), Barrington, R. I.; Enoch Remington III (1792–1864), Barrington and Providence, R. I.; Jeremiah Remington (b. 1827), Providence, R. I.; Nellie Remington Filder (b. 1857), Providence, R. I.; Marguerite Filder Howard (b. 1889), Providence, R. I.; Israel Sack, Inc., New York, N. Y. (1967); Bybee Collection, 1967.

EXHIBITIONS AND PUBLICATIONS: MFA, H 1981.

1985.B8

1. Whitehill 1974, 42.
2. For similar examples, see Whitehill 1974, 45–46; Randall 1965, nos. 35–36; Kirk 1972, 96; and Kane 1976, nos. 53–54.
3. Besides the plaque on the rear seat rail (see *Inscriptions*), Remington genealogical data accompanied these chairs. Enoch Remington's 1811 will lists "Eight old chairs, $2.50." For comparison "A High Chest of Drawers" was valued at $5.50; Enoch Remington will and inventory (1811), docket 4:46, Barrington County Courthouse, Barrington, R. I. While it is impossible to be certain that the Bybee chairs are the "old chairs" listed in Remington's inventory, such a description would have fit these no-longer-fashionable chairs in 1811.
4. See Trent 1, 1985, 98–100.

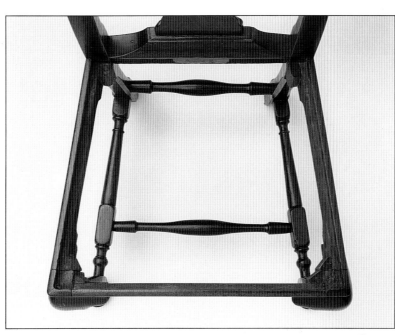

Cat. 15a

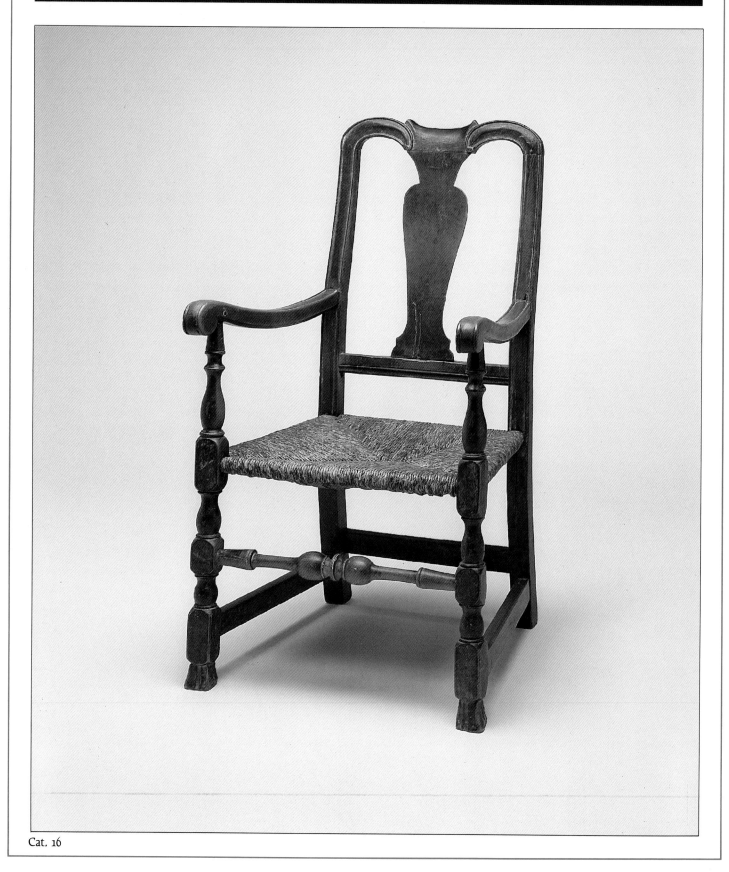

16
ARMCHAIR

1740–1760
Eastern Massachusetts or coastal New Hampshire

Cat. 16

WHEN NEW, this chair functioned as both a place to sit and as a symbol of patriarchal power. During the seventeenth and early eighteenth centuries, chairs were not plentiful among most colonial American families. Large and relatively elaborate chairs, such as this example, would have been used by the head of a household. His wife may have had a lesser version of the same chair, while children probably sat on benches, stools, or even tree stumps.

In the seventeenth century, armchairs were often constructed of turned parts, not unlike cat. 4. However, by the early eighteenth century, cabinet- and chairmakers who employed a variety of joinery techniques had come to dominate the furniture-making trades. Turners who incorporated only turned elements in their products either learned to use these new joinery techniques, or were relegated to producing the most inexpensive and less desirable types of furniture.

This armchair reflects the impact of the cabinetmaker on the ancient profession of turning. While the rush seat, turned front stretcher, and vertical stiles are typical of earlier work, the rest of the chair is totally of framed construction. The side and rear stretchers, rear stiles, arms, back splat, and crest rail were all sawed out and then assembled with mortise-and-tenon joints. Even the turned front stiles have feet which were carved rather than turned.

One of the events which precipitated this shift from turned to framed chairs in the colonies was the appearance of framed chairs in Boston in the late 1720s. By the early 1730s, Boston chairmakers were producing framed chairs with cabriole legs, molded rear stiles, shaped crest rails, vase-shape splats, and scrolled arms (fig. 4). The exportation of such chairs throughout New England and to Philadelphia greatly influenced colonial American chairmaking.[1]

Due to the wide distribution of these Boston chairs, it is difficult to pinpoint the origin of chairs such as the Bybee example. Related examples are known from several areas in New England.[2] However, details such as the carved volutes of the crest rail, the turnings on the stretcher and front stiles, and the flat side and back stretchers suggest an eastern Massachusetts or coastal New Hampshire origin.[3] It is in fact possible that this chair represents the middle-level product of a Boston chairmaker. The carved crest rail, vase-shape splat, molded stiles, and scrolled arms are all similar to more elaborate Boston work. The absence of turned side stretchers, cabriole legs, chamfered rear legs, well-articulated feet, and a framed seat may simply reflect economic constraints. If this chair was made in Boston for a middle-class customer, it probably dates from the 1740s; it retains "paintbrush feet" which were most popular in urban areas between 1720 and 1740. However, a rural craftsman working for a more conservative clientele could have produced this chair as late as the third quarter of the eighteenth century.

STRUCTURE AND CONDITION: This chair is joined with mortise-and-tenon construction throughout. The feet are carved from the solid, not pieced out. It is in good condition. Although worn in areas, the chair appears to retain its original dark brown finish. The rush seat is old, but probably not original. The splat is cracked in its lower section, as is the turned stretcher. The front feet have been cut down slightly.

WOODS: All parts, soft maple.

DIMENSIONS: H. 38½ (97.7); S.H. 15⅞ (40.3); W. 22⅛ (56.2); D. 23¼ (59.0).

PROVENANCE: Purchased in Houston, Tex.; Bybee Collection, 1970s.

Gift of Faith P. Bybee, 1988.B70

1. For a discussion of the impact of Boston chairs on Philadelphia chair design, see Forman 1980, 63–64. See also cat. 18 in this volume.
2. For related chairs with possible Connecticut or western Massachusetts origins, see Lockwood 1926, 2:55; Warren 1975, no. 214; Jobe and Kaye 1984, fig. II-18, no. 92; Ward and Hosley 1985, nos. 123–124.
3. For closely related examples from the Boston area, see Greenlaw 1974, no. 43; Fales 1976, no. 50; Sack 1981, 4:999, 1009, 1063; Jobe and Kaye 1984, fig. 92b. For a related chair attributed to John Gaines of Portsmouth, N. H., see A. Sack 1950, 19.

Fig. 4. Armchair, Boston, Massachusetts, 1730–1750. Maple, oak; H. 43 (108.8), W. 24⅛ (61.0), D. 23½ (59.5). (Winterthur Museum [54.509].)

SLAT-BACK CHAIRS such as this example represent the blending of two distinct furniture traditions in the Delaware Valley. As Benno M. Forman has shown, the basic form of this type of chair was derived from a rural Germanic tradition. The gradual tapering of the four posts from bottom to top and the inverted cone turnings beneath the balls on the front legs, for example, are features found on Central European chairs. The use of two balls separated by a ring on the front stretcher, however, is not of Germanic origin. Rather, its use can be traced to the importation into Philadelphia of Boston-made chairs during the 1720s. Eastern Massachusetts turned chairs routinely have such stretchers (see cat. 16). By grafting the ball-and-ring stretcher of fashionable New England chairs onto a local tradition of Germanic slat-back chairs, Philadelphia chairmakers could more effectively compete in the marketplace.[1]

Due to its combination of desired stylistic features, its comfort, and its low cost, this hybrid chair proved to be extremely popular. In the Philadelphia area, chairmakers such as Solomon Fussell (ca. 1700–1762), for example, made enormous quantities of them from the 1730s onward.[2] In southern New Jersey, Maskell Ware (1766–1846) and twenty-two of his descendants produced slat-back chairs based on this Philadelphia form from the 1790s until the 1930s.[3]

As a consequence of its popularity, numerous examples exist today.[4] However, few of these chairs survive in as excellent state of preservation as the one seen here. The turnings on the bottom of this chair's front feet, for example, are of particular importance; most of these chairs have had these elements worn away. Furthermore, the rush seat appears to be old and may represent the rare survival of an original woven seat.

As important as its fine state of preservation is the quality of this chair's design and execution. The care with which the four posts taper upwards from thick to thin, as opposed to the harmonic progression from thin to thick of the back splats, indicate that this chair was designed by a master craftsman. Similarly, the bold and crisp turnings reveal the hand of an experienced and gifted turner probably working before 1750. While this chair form was made throughout the nineteenth century, the use of unattenuated ball-and-cone turnings in the front stretcher predominated in the earliest phase of this chair-making tradition.

STRUCTURE AND CONDITION: This chair has suffered little wear and is in excellent condition. The rush seat is old and may be original, as is the finish. The front left foot has had a small addition to its bottom.

WOODS: All parts, soft maple.

DIMENSIONS: H. 41⅜ (105.0); S.H. 17½ (44.5); W. 18¼ (46.3); D. 16¾ (42.5).

PROVENANCE: Probably purchased in Houston, Tex.; Bybee Collection, 1970s or early 1980s.

Gift of Faith P. Bybee, 1988.B69

1. For a discussion of Delaware Valley chairs, see Forman 1980, 53–57; Swank 1983, 104–106.
2. For a discussion of Fussell, see Forman 1980, 53–57, and cat. 18 in this volume.
3. For a biographical study of the Ware family, see Waters 1979.
4. For chairs closely related to the Bybee example, see Nutting 1928, 2:nos. 1897–1898; Warren 1975, no. 212. For other examples of Delaware Valley chairs, see *Antiques* 9:5 (May 1926): 307; 12:2 (Aug. 1927): 91; 117:6 (June 1980): 1237; AAA 3878 (8–10 Jan. 1931): lots 264–265; Randall 1965, no. 141; Kindig 1978, no. 28; Sack 1981, 3:782, 5:1133; SPB 5551 (28–31 Jan. 1987): lot 309.

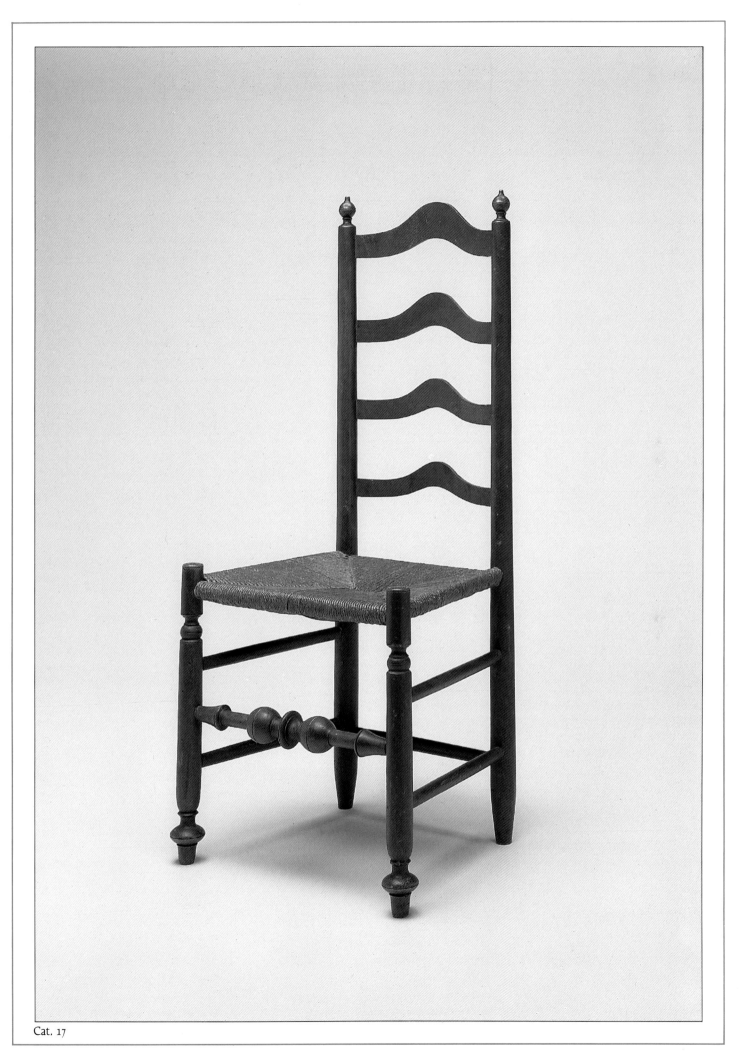

Cat. 17

18
ARMCHAIR
1745–1760
Attributed to the shop of William Savery (1721–1788)
Philadelphia, Pennsylvania

IN THE HISTORY of American furniture, Philadelphia is generally known for elaborate walnut and mahogany chairs which its craftsmen made in the late-baroque and rococo tastes (see cat. 19). However, during the eighteenth century the vast majority of Philadelphians could not afford such objects. To serve the needs of the middle class, Philadelphia chairmakers produced thousands of rush-bottom maple chairs.

Two of the most prolific producers of this type of seating furniture were Solomon Fussel (ca. 1700–1762) and William Savery. In an exceptional essay, Benno M. Forman outlined the nature of Fussell's shop and the relationship between him and his apprentice, Savery.[1] To produce a rush-bottom chair, Fussell employed the services of numerous craftsmen. In general, the turned elements, seat lists, and rush bottoms were made by workmen other than Fussell and were often fashioned outside of his shop altogether. By using outside labor, Fussell was able to stockpile chair parts for future assembly in his shop. While apprenticed to Fussell during the 1730s, Savery would have learned to make chairs as his master did—by streamlining production for increased efficiency and higher output.

The armchair seen here reflects this link between master and apprentice. For at least a decade following his departure from Fussell's shop in 1742, Savery made Fussell-type chairs, the design of which was originally based on imported Boston examples. The swelled stretchers (much larger than on Boston chairs), square "crooked feet," and splat shape all relate to Boston chairs (see fig. 4).

Fussell's shop was making Philadelphia versions of Boston chairs with cabriole legs by the 1730s. Typically, armchairs such as this example cost between 25 and 50 percent more than side chairs and were almost always "colored or dyed." Brown, black, red, and orange were popular colors. This particular example shows evidence of having been a dark reddish-brown originally.

Unlike his master, William Savery labeled much of his furniture.[2] On rush-bottom chairs he often applied the label to the lower, back side of the splat. The Bybee example retains a rectangular area of glue residue approximating the size of a Savery label on its splat.[3] More important, this armchair is strikingly similar to labeled Savery chairs.[4] Its splat, scooped crest rail, seat skirt, stretchers, cabriole legs, and rear posts all suggest a Savery attribution.

STRUCTURE AND CONDITION: The front and rear seat skirts are replacements. The side skirting boards have been off, but are original. There are small glue blocks attached to the inside of the side skirts. These blocks are also original. The chair was initially stained a dark reddish-brown. Except for the area surrounding the glue residue on the splat, the chair has been refinished and the seat rerushed.

WOODS: All exterior surfaces, soft maple; glue blocks, Atlantic white cedar; front and rear seat skirts (replacements), yellow poplar.

DIMENSIONS: H. 41½ (105.4); S.H. 16 (40.6); W. 27½ (69.8); D. 23¾ (60.3).

PROVENANCE: Joe Kindig, Sr., York, Pa.; Bybee Collection, 1950s.

EXHIBITIONS AND PUBLICATIONS: Fairbanks 1967, 838; Fairbanks and Bates 1981, 91 (although the entry is for this chair, the photograph is that of a similar, but different, chair); MFA, H 1981.

1985.B23

1. All of the information presented here on Fussell and Savery is taken from Forman 1980.
2. For an illustration of six Savery labels, see Hornor 1935, 77.
3. The rectangle of glue residue measures 1½″ (3.8 cm.) by 2¼″ (5.7 cm). An attempt with ultraviolet light to read any staining left in the glue residue or wood by the label proved unsuccessful in the 1960s.
4. For similar, labeled chairs, see Forman 1980, 47; DAPC 65.1616. For related undocumented chairs, see Blades 1987, 16, 27; Warren 1975, no. 213; Downs 1952, no. 25; Antiques 55:3 (Mar. 1949): 157; 62:1 (July 1952): inside front cover.

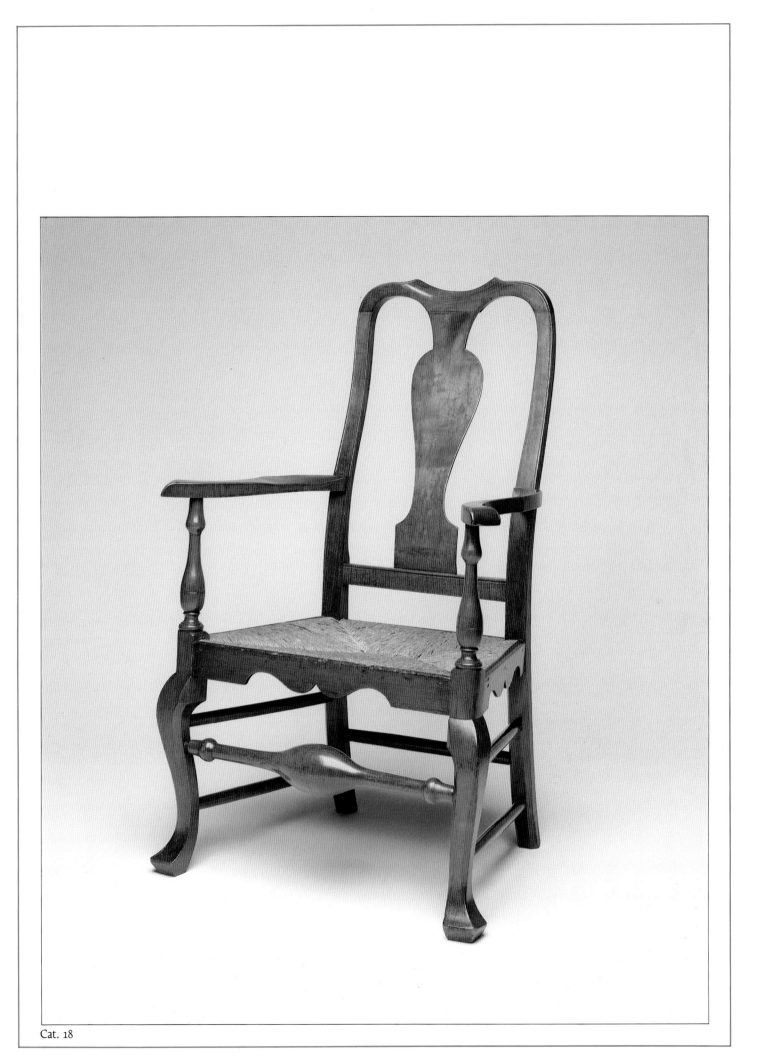

Cat. 18

19
ARMCHAIR

1740–1760
Philadelphia, Pennsylvania

DURING the mid eighteenth century, Philadelphia chairmakers made a wide variety of chairs for a varied clientele. Inexpensive turned chairs (see cat. 17) were available for use in lower and middle-class homes and for the service areas of opulent mansions. Framed chairs with rush seats (see cat. 18) were also supplied to those who could pay more. However, the most fashionable and costly of all Philadelphia chairs made during this period were similar to this example.

The high cost of these chairs was due to the quality of materials used and the quantity of labor needed in construction. This example is completely made of expensive black walnut and imported upholstery fabric. Before assembly and finishing could begin, the chairmaker had to saw out and smooth approximately twenty hand-shaped parts. Given the curvilinear design of this chair, the production and fitting of these varied elements took great skill and many hours. Accordingly, such chairs cost the large sum of £ 2 to £ 3 when new.[1]

The controlled use of undulating lines and the interaction between positive and negative space seen in this chair represent one of the finest adaptations of late-baroque design in colonial America. The basic chair form with compass (rounded) seat, cabriole legs, and curved rear stiles was derived from early eighteenth-century English chairs.[2] However, the use of slipper-feet with "tongue"-shaped ridges and the joining of the seat rails with round tenons extending up from the front legs may be evidence of Irish and German chairmaking traditions in Philadelphia.[3]

Once this chair form was developed in the 1730s or early 1740s, it became popular among Philadelphia's elite. Numerous variations incorporating several splat patterns, crest rail designs, and feet shapes are known.[4] Although few other armchairs exactly like this example have been identified, several side chairs exist which have the same options as this chair.[5] The existence of a I on the frame of this chair and a II on its slip seat suggests that this example once was part of a set of chairs which contained at least one other armchair.

STRUCTURE AND CONDITION: This chair is constructed in the typical Philadelphia fashion. The seat frame is mortise-and-tenoned together and the front legs tenon up through the seat rails. The round tenons of the legs are wedged. The lower, inward-curving section of the rear stiles is pieced on. The side rails pass through the rear stiles and are wedged in place. The lip around the seat frame is applied along the side rails, but carved from the solid in the front. The arm supports are screwed to the seat frame. The splat is veneered, as is the front seat rail. The splat is chamfered along its back edge and fits into a shoe that is glued in place. The knee brackets are glued and nailed in place with rosehead nails.

This chair is in good condition. Screws have been inserted next to the round tenons of the legs for added strength. The arms have been off more than once. New screws have been added to the bottom of the arm supports and the rear of the arms. These screws have been countersunk and the holes plugged. The rear rail of the slip seat is replaced.

INSCRIPTIONS: Incised on the front and rear seat rails is "I." "4" is written in chalk on the inside of the front seat rail. The slip seat bears an incised "II." The slip seat, which does not fit exactly, was presumably switched with that of a now lost mate.

WOODS: All parts, American black walnut.

DIMENSIONS: H. 42⅜ (107.5); S.H. 16¾ (42.6); W. 31¼ (80.7); D. 22 (55.9).

PROVENANCE: Joe Kindig, Jr., and Son, York, Pa.; Bybee Collection, 1950.

EXHIBITIONS AND PUBLICATIONS: *Antiques* 57:2 (Feb. 1950): inside front cover; A. Sack 1950, 27; Fairbanks 1968, 79; MFA, H 1981.

1985.B14

1. For a discussion of late eighteenth-century costs of similar chairs and other Philadelphia furniture, see Weil 1979, especially 182.

2. For related English chairs, see Kirk 1982, nos. 827–828.

3. For the best discussion of the influence of German chairmakers in Philadelphia and the historical significance of their migration to England and Ireland, see Caldwell 1985. Information on Irish prototypes for certain details on Philadelphia furniture of this period is given in Stockwell 1961.

4. Dozens of related chairs are recorded in the literature. For arm- and side chairs which have the same splat pattern, but differ in other options, see *Antiques* 32:6 (Dec. 1937): 273; Downs 1952, no. 28; Randall 1965, no. 137; Warren 1975, no. 44; Sack 1981, 1:80; Fairbanks and Bates 1981, 104; Heckscher 1985, no. 36.

5. The closest related armchairs to this example are illustrated in E. Miller 1937, 1:fig. 62; *Antiques* 75:4 (Apr. 1959): 309; Winchester 1961, 150. For side chairs that have the same detail as this example, see Hornor 1935, pl. 315; *Antiques* 64:4 (Oct. 1953): 273; Elder and Stokes 1987, 22.

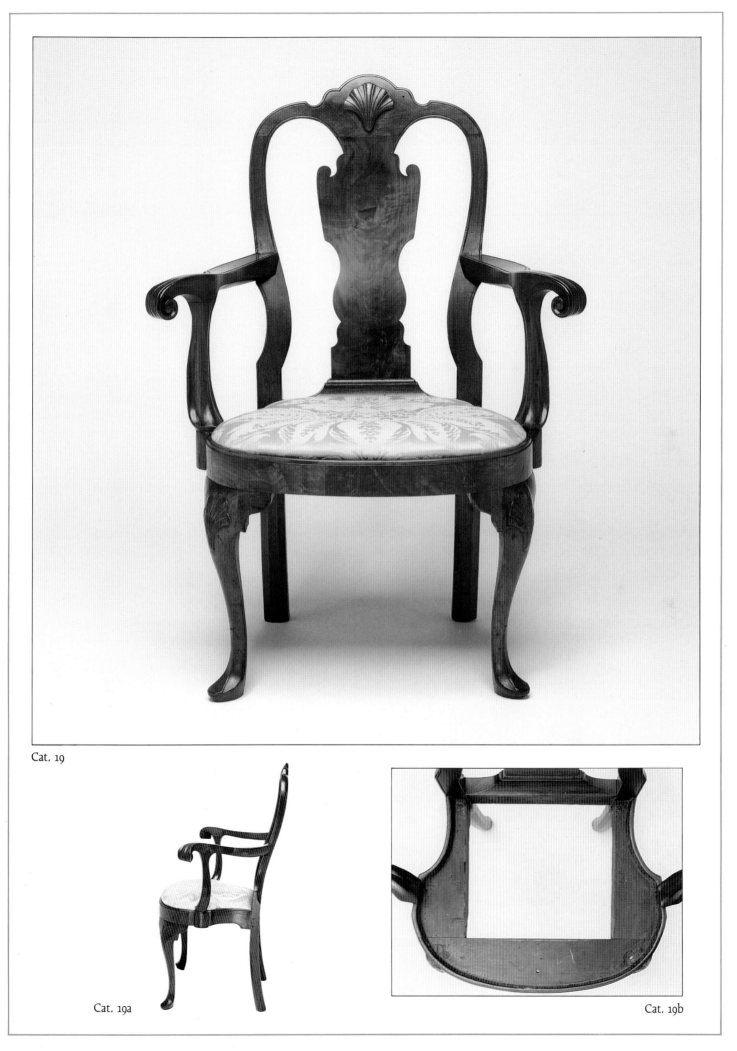

Cat. 19

Cat. 19a

Cat. 19b

20
CANDLESTAND
1770–1800
Possibly northern New England

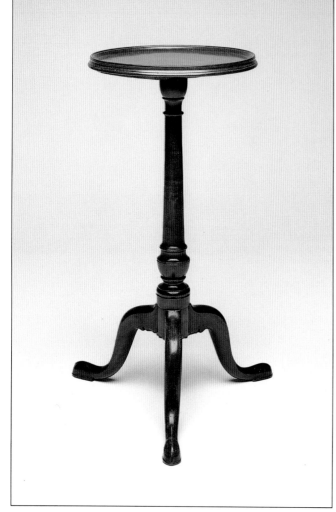

Cat. 20

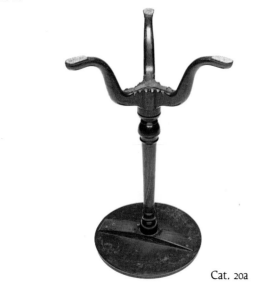

Cat. 20a

STANDS such as this one were popular during the eighteenth century. They were used to hold everything from candlesticks to wineglasses, and from teapots to sewing implements. Furthermore, their light weight and small-scale design allowed them to be moved from room to room as needed.

Where this stand was made is not known, although it has several distinctive features. The deeply turned rim of the top is uncommon, for example. Also, the highly arched knees of the legs are unusual. To date, however, no shop has been identified which incorporated these features into its stands. The only clues that help one in identifying the origin of this piece are the use of birch as a secondary wood and the scalloping under the base. In this period, birch was used most frequently in northern New England, and the type of scalloping seen here relates to that on examples from the North Shore of Massachusetts. If this stand does come from that region, numerous craftsmen in towns like Ipswich, Newburyport, and Salem or in outlying areas could have made it.[1]

STRUCTURE AND CONDITION: The legs are joined to the pedestal with sliding dovetails. Their joints were strengthened through the addition of three iron strips which are nailed on. The cross brace into which the pedestal is joined is screwed to the top. The turned rim is integral with the top.

The stand is in good condition. The scribe lines and lathe marks are still visible under the top. The iron strips under the pedestal are original, although the screws beneath the top have been disturbed.

WOODS: Legs, pedestal, and top, mahogany; brace under top, birch.

DIMENSIONS: H. 27⅞ (70.8); Diam. top 14½ (36.9).

PROVENANCE: John Walton, Inc., Riverside, Conn.; Bybee Collection, 1954.

EXHIBITIONS AND PUBLICATIONS: Fairbanks 1968, 77; MFA, H 1981.

1985.B17

1. The relationship between the scalloping seen here and that on North Shore examples was pointed out by Brock Jobe in a conversation with the author, 15 Mar. 1988. For a related example attributed to Newport, Rhode Island, see Sack 1981, 5:1230.

21
FOLDING STAND
1750–1790
Philadelphia, Pennsylvania

CIRCULAR TABLES with tripod bases and tilting tops were extremely popular among wealthy Philadelphians during the last half of the eighteenth century. Numerous examples survive today.[1] Within this large group, tables which incorporate a compressed ball and Doric column into their pedestal design, such as this example, are the most common (see cats. 22, 23).

With its small top (less than 22" [55.9 cm.] wide), uncarved pedestal and legs, and plain feet, this example was one of the simplest, yet fashionable, folding tables available in eighteenth-century Philadelphia. A 1772 cabinetmaker's price book describes such a mahogany "folding Stand" as "22 inches with a box plain top & feet £ 1.15.0." Labor costs were 11s.[2] Although such stands were unembellished beyond their fine turning and proportions, they were not inexpensive.

The description of this type of small table as a "folding stand" indicates that it was used for a variety of purposes. The wide top, for example, is large enough to serve tea to one or two people, or to hold candlesticks, books, and wineglasses. The table's small size and lightweight construction also allowed it to be moved throughout a house as needed.

STRUCTURE AND CONDITION: The legs are slotted into the pedestal. Original iron strips brace these joints. The top of the pedestal passes through the bird cage. A circular collar fits around the pedestal inside the bird cage. A triangular key fits into a mortise in the pedestal above this collar, thereby securing the pedestal to the top section. The bird cage's four balusters are wedged in place. The cleats are screwed to the top and pinned to the bird cage. They have been moved slightly to one end and reattached. The top, turned from a single piece of mahogany, retains four marks on its underside which indicate where it was attached to the lathe-head for turning.

This table is in excellent condition. The hardware is original and traces of an old finish survive. Four thumbtacks have been inserted into the top of the bird cage to stabilize the top.

WOODS: All parts, mahogany.

DIMENSIONS: H. 26⅝ (67.6); Diam. top 22 (55.8).

PROVENANCE: Harry Arons, Ansonia, Conn.; Israel Sack, Inc., New York, N. Y.; Bybee Collection, 1960.

1985.B20

1. For an example of similar size, see Heckscher 1985, no. 120. Related examples with compressed ball and Doric-column pedestals are illustrated throughout the literature.

2. Weil 1979, 187. This manuscript price list was apparently derived from a now lost printed version. The same price and description for a folding stand are listed in the Benjamin Lehman price list; see Gillingham 1930, 299.

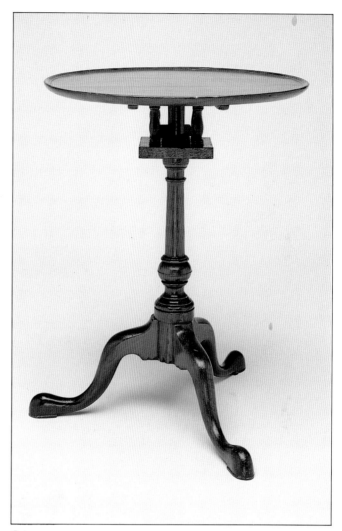

Cat. 21

Cat. 21a

22
FOLDING STAND

1750–1790
Philadelphia, Pennsylvania

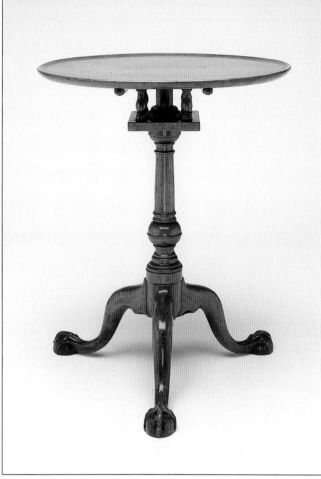

Cat. 22

Cat. 22a

WHEN COMPARED to the previous example (cat. 21), this stand is strikingly similar. In terms of construction they are almost identical. In their decoration they differ only slightly. The pedestal or "pillar" on this example is somewhat more complicated, having additional ring-turnings above and below the compressed ball. Also, the feet on this stand are carved in the form of animal claws. Such feet were a costly option. The 1772 Philadelphia price list records that a stand with claw-and-ball feet cost 7s.6d. more than one with plain feet. The total cost of a table like this example was £2.2.6. For still more money one could order a stand "with Leaves on the Knees" and a fluted "pillar." Cheaper versions with fixed 18" (45.7 cm) tops were available in mahogany for £1.4.0.[1]

STRUCTURE AND CONDITION: This example is constructed exactly like cat. 21. Although one of the feet has been broken and repaired, this table is in good condition. Nineteenth-century casters were once added to the feet and subsequently removed. The edge of the table top has been broken off and reattached; screws were added through the cleats to strengthen this repair. The metal lock and catch are original.

WOODS: All parts, mahogany.

DIMENSIONS: H. 28 (71.1); Diam. top. 23¾ (60.3).

PROVENANCE: John Walton, Inc., Riverside, Conn.; Bybee Collection, 1954.

EXHIBITIONS AND PUBLICATIONS: Fairbanks 1968, 79; MFA, H 1981.

1985.B30

1. Weil 1979, 187.

23
TEA TABLE
[1750–1790]
Philadelphia, Pennsylvania

ALTHOUGH THIS TABLE is constructed in the same manner as the previous two stands, its larger top reflects a more specialized function. This table was designed for serving tea or other refreshments to several guests at a time. The raised rim of the top helped to prevent damage to expensive porcelain and silver equipage. Furthermore, the top's ability to turn allowed the hostess to serve her guests by simply rotating the table top. However, the presence of linen on the upper end of the post suggests that this particular table may have rotated all too easily when new. The linen was probably used to increase friction on the pedestal and to slow the top's rotation (cat. 23b).

As with many Philadelphia tea tables of this period, this example is exceptionally well-designed and executed. The turner who produced this table's pedestal and enormous top was a master at his craft. The feet with their characteristic Philadelphia-type swollen knuckles are the work of a highly skilled carver. The consistency with which such details appear on Philadelphia-made stands and tables of this kind (compare cats. 21–23) suggests that one or more large cabinetmaking shops specialized in producing round table forms. It is also possible that a few shops procured various components from several specialty craftsmen for assembly and finishing in their own shops.

For example, a turner could easily have produced standardized tops and pedestals in large quantities for one or more cabinetmakers. If a customer wanted a more elaborately ornamented table, customized blanks could be produced for carving and shaping. At an added expense, one could obtain a table which featured a scalloped top, carved and fluted pedestal, and carved legs.[1] Such tables cost approximately £6; this plainer example cost £3.5.0. Labor for making this table cost 12s.6d.[2]

STRUCTURE AND CONDITION: This table is constructed in the same fashion as cat. 22. The table is in excellent condition. The top is turned from a single piece of mahogany and is slightly warped. Where the pedestal meets the bird cage, the top of the pedestal is wrapped with coarse linen soaked in glue. New wood screws secure the cleats to the top. The feet once had casters. The iron plate which braces the pedestal and leg joints is original.

WOODS: All parts, mahogany.

DIMENSIONS: H. 27⅛ (68.9); Diam. of top, 32¾ (83.2).

PROVENANCE: Helen Temple Cooke (1865–1955), Wellesley, Mass.; Philip Budrose, Marblehead, Mass.; Israel Sack, Inc., New York, N. Y.; Bybee Collection, 1960.

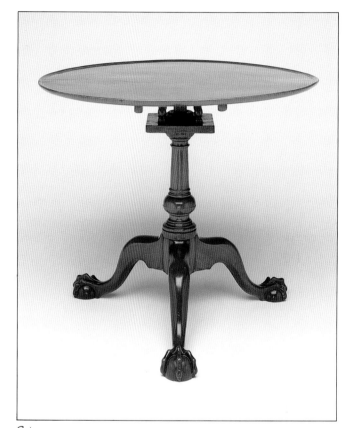

Cat. 23

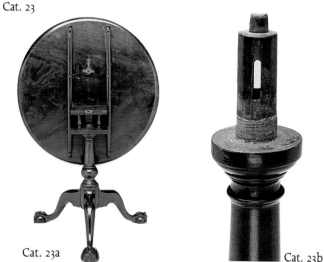

Cat. 23a

Cat. 23b

EXHIBITIONS AND PUBLICATIONS: Fairbanks 1968, 79; MFA, H 1981.

1985.B29

1. For a highly decorated example, see Heckscher 1985, no. 123.
2. For information on the cost of such tables and the options available, see Weil 1979, 187; Gillingham 1930, 299.

24
DINING TABLE

1740–1780
Probably Philadelphia, Pennsylvania

ROOMS ESPECIALLY DESIGNED for eating were not common in English or colonial American homes until the early nineteenth century. Consequently, dining tables such as this example were constructed so that they could be folded up and moved out of the way when not in use. Likewise, the chairs which surrounded these tables were commonly placed along the walls of the room after dinner.

Family tradition holds that this table was made "about 1740 from a tree which grew near Colestown, [New Jersey]."[1] Although 1740 would be an early date for such a table to have been constructed, it is not impossible.[2] Cabriole legs were introduced into the colonies in the 1720s and early 1730s. However, substantiating a Colestown, New Jersey, origin is more problematic.

Colestown (near Camden, New Jersey) lies directly across the Delaware River from Philadelphia. While there were cabinetmakers in southern New Jersey during this period, Philadelphia was without question the stylistic and economic capital of the region. Consequently, Philadelphia supported numerous cabinetmakers capable of making this table. Furthermore, numerous related tables are known from the Philadelphia area.[3] The survival of such tables in Philadelphia, as well as in adjacent areas, suggests that they were probably made by several cabinet shops in the city for members of both the urban and rural elite of eastern Pennsylvania and southern New Jersey.

If, however, this table was made from a tree in Colestown, New Jersey, two possibilities exist. The Philadelphia cabinetmaker who made this table could have been supplied with walnut cut on land in Colestown by a New Jersey customer. Or, a Philadelphia-trained cabinetmaker could have moved to Colestown and produced tables in a Philadelphia fashion.

STRUCTURE AND CONDITION: The inner skirt is dovetailed to the scalloped ends. The swing legs are mortise-and-tenoned to the outer skirt. The double side rails have been strengthened with an upper and lower cross brace which is dovetailed and nailed in place. The top is attached to the frame with screws. Each section of the top consists of two boards glued together. The sections meet in ruled joints.

The top has been off and reattached with modern screws. The top's hinges also have new screws in them. One leaf has been cracked and repaired. The two diagonal cross braces have been off recently and reattached with wire nails. They are old, but not original. A knot in one leg has been filled with a rectangular insert. Another leg has had a crack repaired. Several knee brackets have been reattached with wire nails and metal caps have been added to the feet.

WOODS: All exterior surfaces, American black walnut; swing legs and outer skirt rails, white oak; inner rails, upper and lower cross brace, glue blocks, Atlantic white cedar.

DIMENSIONS: H. 29⅛ (74.0); W. open 56 (142.2); W. closed 20⅛ (51.1); D. 48 (122.2).

PROVENANCE: Unidentified private collection, N. J., ca. 1900; Mr. and Mrs. Ephraim Tomlinson Gill, Haddonfield, N. J., ca. 1900–1930s; John Gill VII, Haddonfield, N. J., 1950s; Bybee Collection, 1960s.

EXHIBITIONS AND PUBLICATIONS: Hopkins and Cox 1936, pl. 16; White 1958, no. 14; Fairbanks and Bates 1981, 127; MFA, H 1981.

Gift of Faith P. Bybee, 1988.B67

1. This tradition is recorded in Hopkins and Cox 1936, 37.
2. This table could also have been made much later. Some related tables are branded by the Philadelphia cabinetmaker, David Evans (active 1774–1811); see Hummel 1955, 28; Antiques 102:4 (Oct. 1972): 505.
3. For related tables, see AAA 3878 (8–10 Jan. 1931): lot 143; SPB 599 (8–11 Nov. 1944): lot 793; Antiques 115:5 (Mar. 1979): 911; M. Schiffer 1980, 96; Sack 1981, 3:726; SPB 5500 (24–25 Oct. 1986): lot 257; SPB 5551 (28–31 Jan. 1987): lot 1326.

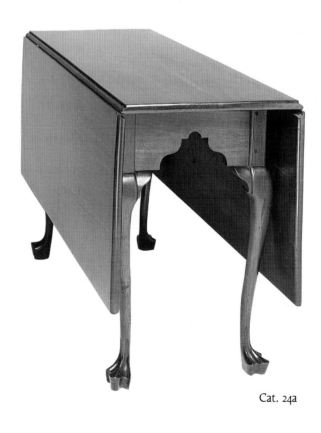

Cat. 24a

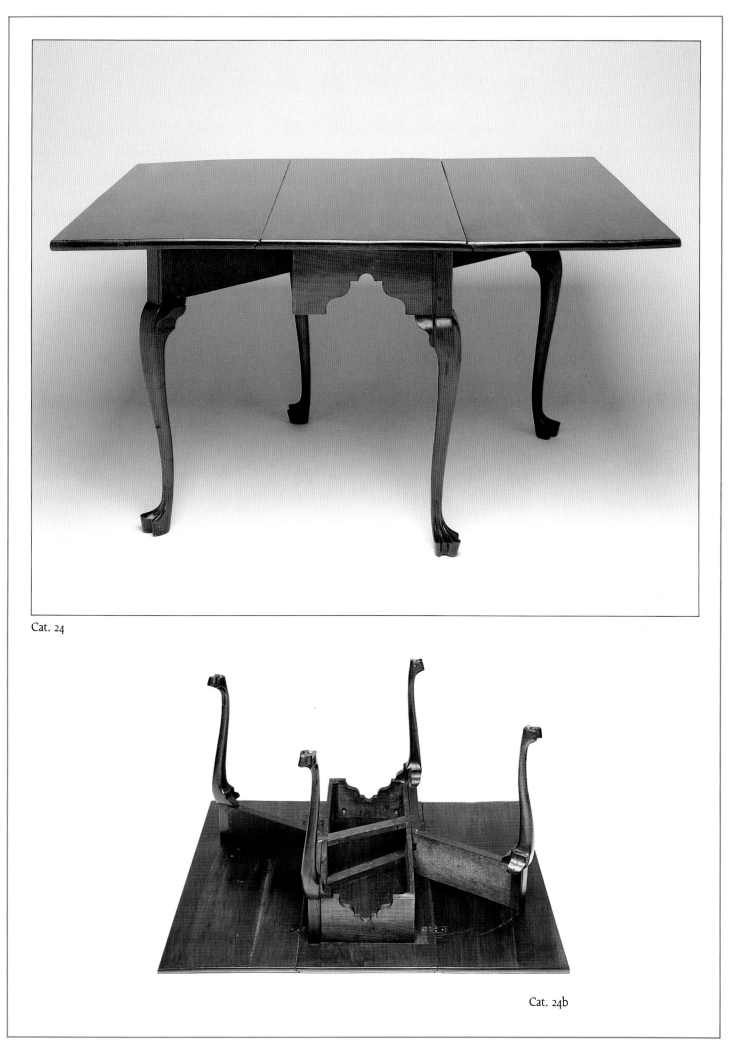

Cat. 24

Cat. 24b

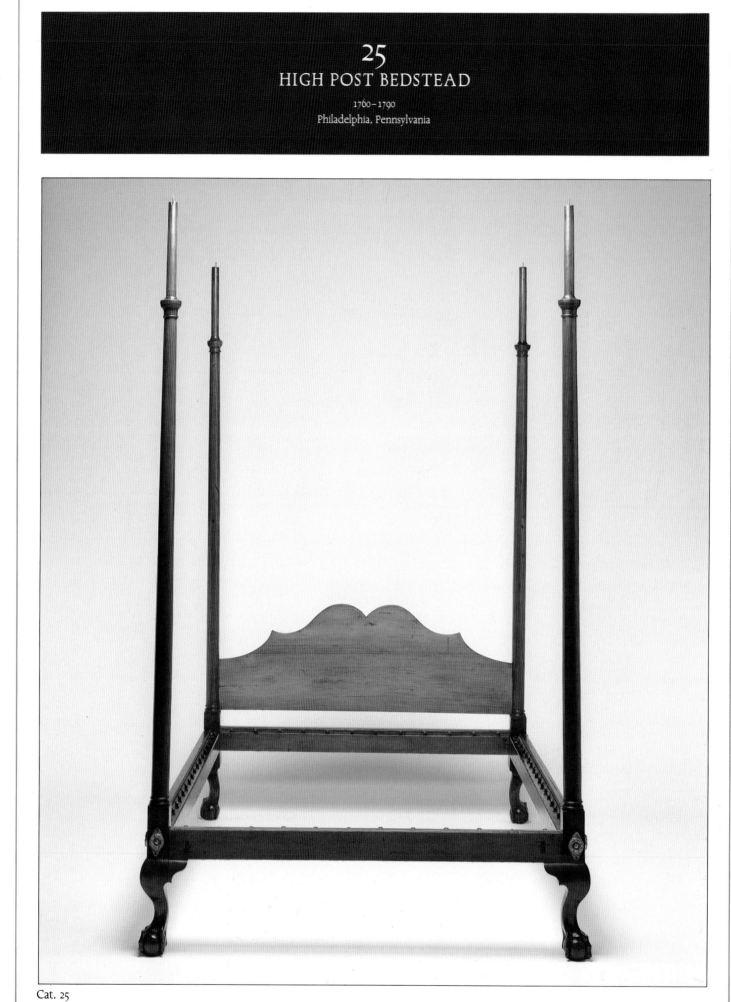

25
HIGH POST BEDSTEAD

[1760–1790]
Philadelphia, Pennsylvania

Cat. 25

IN THE EIGHTEENTH CENTURY, beds such as this example were rare and expensive objects.[1] Not only did the owner of this bed have to pay a cabinetmaker and turner for the mahogany frame, but also an upholsterer for fitting it with textile hangings. Since hangings cost far more and obscured the wooden frame, the work of the upholsterer was the most important.

Judging from evidence on the frame and the height of the posts, this bed originally had elaborate hangings. The knobs along the rails anchored a linen and cord sackcloth which provided a taut foundation for the mattresses. Upon the sackcloth was placed a stiff mattress made of horse or pig hair. Atop it went a thick feather mattress. A cylindrical bolster was put at the head of the feather mattress to support the feather pillows at the proper height. Once these elements were completed, the tester frame and lower rails were concealed with valances and a spread made to cover the mattress and sheets. Based on the presence of holes on each of the four posts, this bed had at least two curtains at its end and sides. These curtains could be raised or lowered at will, their cords being tied around cleats on the posts. Because numerous hours and large quantities of hair, feathers, and linen, as well as fifty to seventy yards of finishing fabric and trim, were needed to complete this bed, it must have belonged to an extremely wealthy person.[2]

Although no conclusive documentation has been found, oral tradition states that the original owners of this bed were Governor Thomas (1744–1800) and Sarah Morris Mifflin of Philadelphia.[3] Thomas's father was the wealthy merchant John Mifflin. Sarah was the daughter of the successful Morris Morris. Given the wealth of both their families and the presence of claw-and-ball feet, the couple could have received this bed as a wedding gift in 1767. However, Thomas Mifflin was successful until shortly before his death and could have purchased it anytime before the 1790s, when furniture designs became more neo-classical in inspiration.[4]

Even though the Mifflins appear to have been less extravagant than some other wealthy Philadelphians, they nevertheless spent large sums on their clothing, homes, and furnishings.[5] The couple owned both a town house on High Street and a country estate. Following Thomas Mifflin's death in 1800, his estate was described as:

> That beautiful and elegant Country Seat, situate at the Falls of Schuylkill, 5 miles from Philadelphia, and about two from German-town, consisting of a large and commodious House furnished in the modern taste with a Barn, Stables, and out Houses, 22 acres of highly improved Meadow Land, an Orchard of the best grafted Fruit Trees, and a Garden of Fruit and Vegetables in an excellent exposure.... The house is seated on an elevated hill, surrounded with willow and other ornamental trees of the best growth, and commands an extensive view of the Falls and meadows of the Schuylkill.[6]

Fully hung with wool or possibly silk hangings and placed within such a setting, this bed was a poignant symbol of the Mifflins' wealth and his importance as the governor of Pennsylvania (1790–1799).

STRUCTURE AND CONDITION: The carved feet are integral with the turned posts above. The knee brackets are cut from two pieces of wood glued together and are nailed in place. The rails are shaped from single pieces of wood and tenon into mortises cut in the posts. Iron bolts run through the posts into each rail and thread into nuts countersunk into the rails. Rectangular plugs cover these nuts. Turned hickory knobs line the rabbeted upper edges of the rails. The headboard is glued up from two pieces of mahogany and fits into slots cut in the rear posts. Each post originally had a cleat around which to wind curtain cords.

The bed is in excellent condition. The hickory knobs on the rails are original. The bolt covers (ca. 1825) are replacements. Two cleat holes have been filled on each post. At one time metal brackets were added to the rails to support box springs.

INSCRIPTIONS: The posts and rails have incised Roman numerals on them to aid assembly.

WOODS: Sacking knobs, hickory; all other parts, mahogany.

DIMENSIONS: H.96½ (245.1); W. 59½ (151.1); D. 80⅞ (205.4).

PROVENANCE: John Walton, Inc., Riverside, Conn.; Bybee Collection, ca. 1950s.

EXHIBITIONS AND PUBLICATIONS: Fairbanks and Bates 1981, 163.

1985.B32

Cat. 25a

1. For related beds, see Nutting 1928, 1:1483; Downs 1952, no. 3; Antiques 84:5 (Nov. 1963): 490

2. For a discussion of bedhangings, see Cummings 1961; Cooke 1987, 163–186.

3. When the Bybees purchased this bed, they were told that it had belonged to Thomas and Sarah Mifflin. Sarah left no will or inventory. When Thomas died in 1800, he was in financial ruin, having overextended himself in land speculation. As a result, most of his property was sold at public auction. Unfortunately, no inventory of the pieces sold was made; only a debit is recorded for "furniture made ready for sale." However, besides those things sold at auction, Mifflin left his sister-in-law, Susannah Morris, "my portrait by Copley, also a portrait of her friend Mr.... by Pine with furniture complete for a Chamber." The entire estate was valued at $51,276.44. Mifflin will and inventory, 1800:16, Philadelphia City Hall Annex (hereafter PCHA), Philadelphia, Pa.

Consequently, this bed could have been sold out of the family in 1800, but survived with an oral tradition of original ownership; it could have been part of the furniture left to Susannah Morris. For a chair, high chest, and dressing table by Thomas Affleck which descended in the Mifflin-Morris-Hacker family, see Hornor 1935, pls. 130, 131, 132. Susannah Morris's inventory (1821:16, PCHA) lists a "Bedstead, Bed and Curtains" in both the front and rear chambers. Also, an unitemized "Residue of Household and Kitchen furniture" was left to her daughter, Sarah Morris. Sarah and her husband, Isaac W. Morris, owned several mahogany "highpost bedsteads" in their town house and country seat, Cedar Hill. See Isaac Morris's will and inventory, 1831:98, PCHA. Any of these beds could be this example, but none of the descriptions are detailed enough to be positive.

4. For a brief biography of Thomas Mifflin, see Dictionary of American Biography, s.v. "Mifflin, Thomas."

5. The Mifflins' conservative nature was discussed by David Barquist in his lecture "Taste and Cultural Aspirations in Philadelphia, 1750–1800," given at the 1987 Winterthur Conference, entitled "Shaping a National Culture: The Philadelphia Experience, 1750–1800." The conference proceedings are in the process of publication.

6. Philadelphia Gazette (28 Feb. 1800).

26
LOOKING GLASS
1740–1770
England

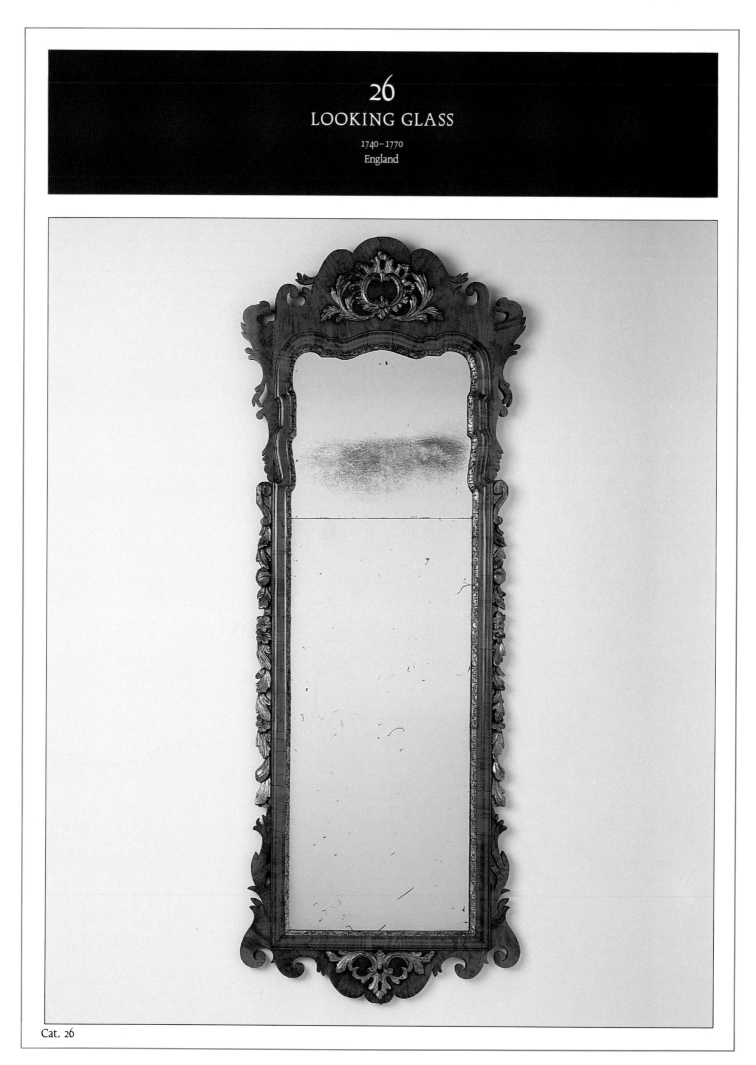

LARGE FLAT SHEETS of plate glass were not produced in America until the nineteenth century. Consequently, wealthy Americans who wished to furnish their houses with looking glasses had to import them from Europe. Although many of the looking glasses used in colonial America came from England, glasses from northern Europe were sometimes imported as well. Furthermore, unframed (or simply framed) glass plates were often imported into the colonies and framed by American frame makers.

This particular example was made in England and shipped to the colonies.[1] Its vertical proportions, scrolled and gilt decoration, and two-part glass are all typical of middle-level English work of the mid eighteenth century. Also, the use of European walnut veneer and spruce in this glass is characteristic of English work. What is especially interesting about this particular example, however, is the use of yellow poplar for the top and bottom gilt ornaments (see cats. 26b and c). At present it is believed that yellow poplar was not exported to England, as was black walnut and eastern white pine. However, the presence of period decoration carved from yellow poplar on an English looking glass suggests that this wood may in fact have been sent to England, if only in limited quantities. It is also possible that this glass was sent to the colonies without top and bottom ornaments and that these were added by an American carver. Certainly, American towns like Philadelphia, New York, and Boston had numerous carvers capable of executing such rococo elements, as well as a mercantile class anxious to proclaim their success and status through opulent furnishings.

STRUCTURE AND CONDITION: The two pieces of glass are held in a rectangular frame which is mitered at the corners. The scrolled top and bottom elements are glued to the face of this frame and supported by vertical and horizontal glue blocks in the rear. The two carved side decorations are nailed to the frame. The front molding which surrounds the glass is composed of numerous short sections of wood that are glued in place. The glass is held in place by thin sheets of wood which are nailed and taped to the rear of the frame.

The looking glass is in good condition. The glass is original, as are the backboards which hold it in place. The scrolled cut-outs have some minor replacements. The gilt decoration has been retouched with bronze powder and the gilt molding around the glass has been removed and reglued in place. The glass has had several hangers attached to it.

WOODS: Veneer, European walnut; framing members, spruce; gilt side ornaments, Sylvester's pine; top and bottom carved ornaments, yellow poplar.

DIMENSIONS: H. 62⅞ (158.4); W. 23⅝ (60.0); D. 1½ (3.8).

PROVENANCE: John Walton, Inc., Riverside, Conn.; Bybee Collection, 1954.

EXHIBITIONS AND PUBLICATIONS: Fairbanks 1968, 77; MFA, H 1981.

1985.B21

1. This form of looking glass was popular among America's wealthy elite. For closely related examples, see Hipkiss 1950, nos. 130, 204; Rodriguez Roque 1984, no. 11.

Cat. 26a

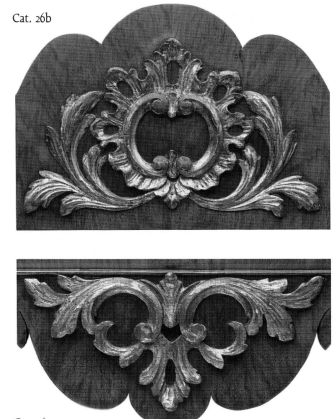

Cat. 26b

Cat. 26c

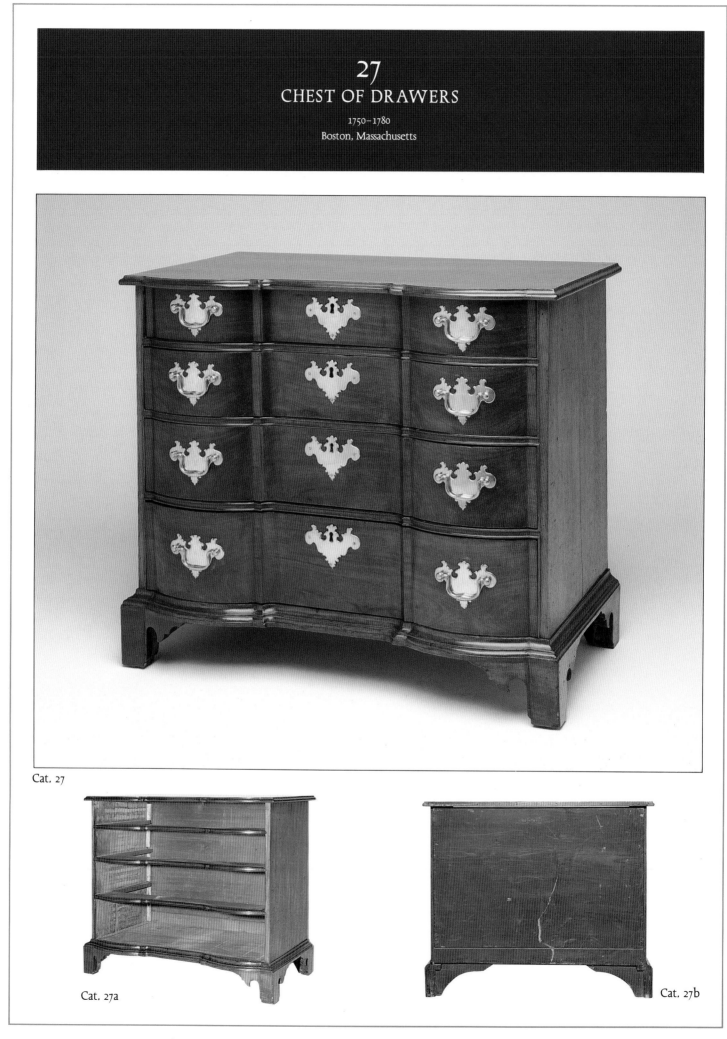

Cat. 27

Cat. 27a

Cat. 27b

ALTHOUGH THIS TYPE of chest of drawers was originally a costly piece of furniture due to the use of imported mahogany and a labor-intensive blocked facade, it was quite popular among Boston's upper class. Since large numbers of them survive which differ in construction and design details, it is likely that several Boston shops produced this form of blocked or "swelled" chest of drawers.[1] At present two of these shops have been identified. One was the large Charlestown workshop of Benjamin Frothingham (1734–1809) across the river from Boston, the other that of George Bright (1726–1805).

Aspects of this chest relate to documented examples from both of these shops. For example, the overall proportions, straight bracket feet, and lack of a giant dovetail are seen in the work of Frothingham. The use of shaped rear foot braces which are inset from the back of the case, slotted into the rear legs, and cut to fit around the horizontal support blocks, are known on a documented chest by Bright.[2] However, since both these shops trained numerous apprentices who undoubtedly worked in more than one Boston shop, all of these features were probably used in several shops simultaneously. Consequently, this chest cannot be attributed to any particular Boston shop at present.

Besides characteristic construction details, other aspects of this chest of drawers indicate a Boston origin. The mid-nineteenth-century Boston and Worcester newspapers which line the drawers suggest that the piece was owned in the Boston area. Furthermore, the back of the chest is branded "D. SCOTT." While the identity of D. Scott is not indisputable, it is likely that the brand is that of Daniel Scott, a wealthy Boston apothecary. When Scott died in 1782, an extensive inventory of his estate was taken. Listed among his household furnishings was "1 Beaureau £ 150," "1 Case Drawers £360," and "1 old Case Drawers [£]9."[3] According to a 1770 bill for a similar chest of drawers, the word bureau was used to describe such pieces, along with the terms bureau table, dressing table, low case of drawers, and low chest of drawers.[4] Consequently, either the "Beaureau" or case of drawers listed in Scott's inventory could describe this chest.

STRUCTURE AND CONDITION: The base is not constructed with a giant dovetail. The molded bottom rail fits flush against the bottom board. No central drop was ever attached to the bottom rail. Glue blocks brace the side moldings and the rear brackets are slotted into the back feet. The case sides are dovetailed to the bottom board. The drawer runners and dividers slide into grooves run on the inside of the case sides. Facing strips cover these joints on the front facade. The drawers are graduated from bottom to top. The backboards are nailed into rabbets along the sides. The upper edges of the case sides are sliding dovetails which fit into grooves run into the top. Plugs cover the ends of these sliding dovetails in the rear.

The drawers are constructed with small dovetails. Their bottoms are nailed into rabbets along the front and sides. They are nailed flush across the back. The original running strips were cut on a 45 degree angle in the rear. The blocked drawer fronts are cut from the solid.

The chest is in good condition, with original hardware and an old finish. The scroll tips of both bracket feet on the left side have been replaced. The running strips on the bottom of the drawers are replacements; the original ones had typical diagonally cut ends. The rear plugs covering the sliding dovetails where the side joins the top are replacements, as are the drawer stops. The feet were once fitted with casters which have been removed.

INSCRIPTIONS: Branded on the back of the chest is "D. SCOTT." "M" is scratched twice into the underside of the chest. The drawer dividers are incised "I" to "III" from top to bottom. The drawers have various chalk marks on them. On the bottom of the top drawer is chalked "18½ / 17 / 16 . . . 0." The drawers are lined with pages from the Boston Evening Transcript (2 June 1862) and the Worcester Daily Spy (28 May 1862). Under the bottom drawer's lining are earlier (1840s) newspaper pages. On one paper is written "State Mut[ual] Ins[urance] Co."

WOODS: All exterior surfaces, mahogany; all secondary elements, eastern white pine.

DIMENSIONS: H. 30⅜ (77.2); W. 36⅛ (91.9); D. 20⅜ (51.7).

PROVENANCE: Harry Arons, Ansonia, Conn.; Israel Sack, Inc., New York, N. Y.; Bybee Collection, 1961.

EXHIBITIONS AND PUBLICATIONS: Fairbanks 1968, 80; MFA, H 1981.

1985.B31

1. For discussions of blocking in Boston and Newport and the period term "swelled," see Whitehill 1974, 77–137; Jobe and Kaye 1984, nos. 14–15. For closely related chests, see Antiques 67:1 (Jan. 1955): 5; 133:5 (May 1988): 998; SPB 5599 (26 June 1987): lot 88. For examples which are similar, but differ in construction or design details, see Bowdoin 1974, no. 13; Antiques 130:6 (Dec. 1986): 1194 (dated 1759); Elder and Stokes 1987, no. 66.

2. For a discussion of such chests and the Frothingham and Bright shops, see Jobe and Kaye 1984, nos. 14–15. For further information on Frothingham, see Spalding 1928; Swan 1944; Comstock 1953; Swan 1952; Jobe 1976.

3. Daniel Scott will and inventory (1782), docket 17225, Suffolk County Probate Records, Suffolk County Courthouse, Boston, Mass. Scott's inventory must be one of the most complete for an eighteenth-century apothecary. The high evaluation for these pieces reflects the extreme rate of inflation which existed in Boston during the Revolution. Brands were often used on furniture so that one's belongings could be returned following a fire.

4. For a discussion of period terminology for this type of chest of drawers and a bill from George Bright, see Jobe and Kaye 1984, no. 15.

Cat. 27c

DESK AND BOOKCASES such as this one were extremely rare in colonial America. Not only were they labor intensive to construct, requiring the shaping and fitting of dozens of parts, but they consumed large quantities of imported mahogany. Consequently, the only persons who could afford them were members of America's mercantile elite. Placed in one of the finest parlors of a house, such desks functioned simultaneously as symbols of wealth and power and as organizational centers of one's business activities. The upper bookcase section held the numerous ledgers which recorded business transactions, while the lower portion provided storage for correspondence and important documents. Its fall front acted as both a writing surface and a security barrier. A variety of things, from rolled maps and sea charts to sheets and clothing, could be placed in the bottom drawers.

The original owner of this desk and bookcase was probably Col. Joseph Sprague (1739–1808) of Salem, Massachusetts. Sprague was one of Salem's most prominent merchants during the second half of the eighteenth century. Not only did he operate an import-export business, he owned a distillery and two farms as well. He also held stock in the Danvers Iron Factory, Andover Bridge, Union Star Insurance Company, and the Salem and Dan-

Cat. 28a

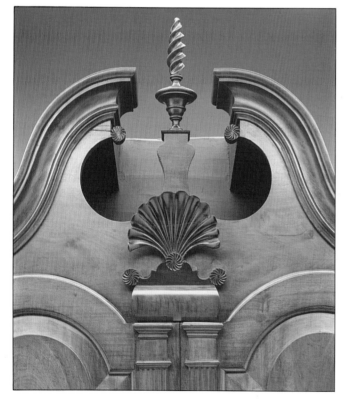

vers Aqueduct. Upon his death in 1808, Sprague's total property was worth the enormous sum of $86,925.69. Among his holdings was a well-furnished "mansion house" at 384 Essex Street.[1] Besides 195 troy ounces of silver plate, this house contained a "Book Case" worth $31. This item was by far the single most expensive piece of furniture in Sprague's home and was probably the mahogany desk and bookcase seen here.[2]

Upon Col. Sprague's death in 1808, his house and its contents passed to his daughter, Sarah White Sprague (1764–1844), and her husband, Dr. William Stearns (1754–1819). Born in Cambridge, Massachusetts, Stearns graduated from Harvard in 1776. After studying medicine with Dr. Joshua Brackett of Portsmouth, New Hampshire, Stearns moved to Salem where he opened an apothecary and grocer's shop. In 1781 Stearns's success enabled him to marry Sarah White Sprague, the daughter of one of Salem's richest and most prestigious families.

When Stearns's inventory was taken following his death in 1819, his furniture was grouped together as "House-hold Furniture" along with other items, including clothing and his horses and chaise. The total sum of his combined property and business investments was almost $60,000. The home his wife had received from her father was worth $4,000 alone.[3]

Although it too does not list furniture separately, the inventory of Sarah White Stearns provides a clearer picture of the character of the Sprague-Stearns family furnishings. This 1844 document lists each room in the Essex Street house separately along with the total value of their contents. While the entire house was well furnished, the more expensive and impressive pieces were concentrated in the most public rooms, the two front parlors. In the "Eastern front room" there was $175 worth of furniture. The "Western front room" contained pieces valued at the enormous sum of $300.[4] By investing in impressive furniture and placing it on view in their front parlors for others to see, the Stearns emphasized their high standing in the social and economic hierarchy of Salem.[5]

This desk and bookcase is part of a large group of block-front furniture from the North Shore of Massachusetts.[6] Although strong similarities between these pieces indicate that this design tradition was one followed by numerous cabinet-makers in this part of New England, this particular example is part of a distinct group of exceptional case pieces made in Salem. At present this group includes three blockfront desk and bookcases and five desks.[7]

Besides having virtually identical proportions, carved shells on their base drops and/or bonnets, claw-and-ball feet, base molding and blocking profiles, and interior layouts, all of these case pieces are constructed in the same manner. The bottom

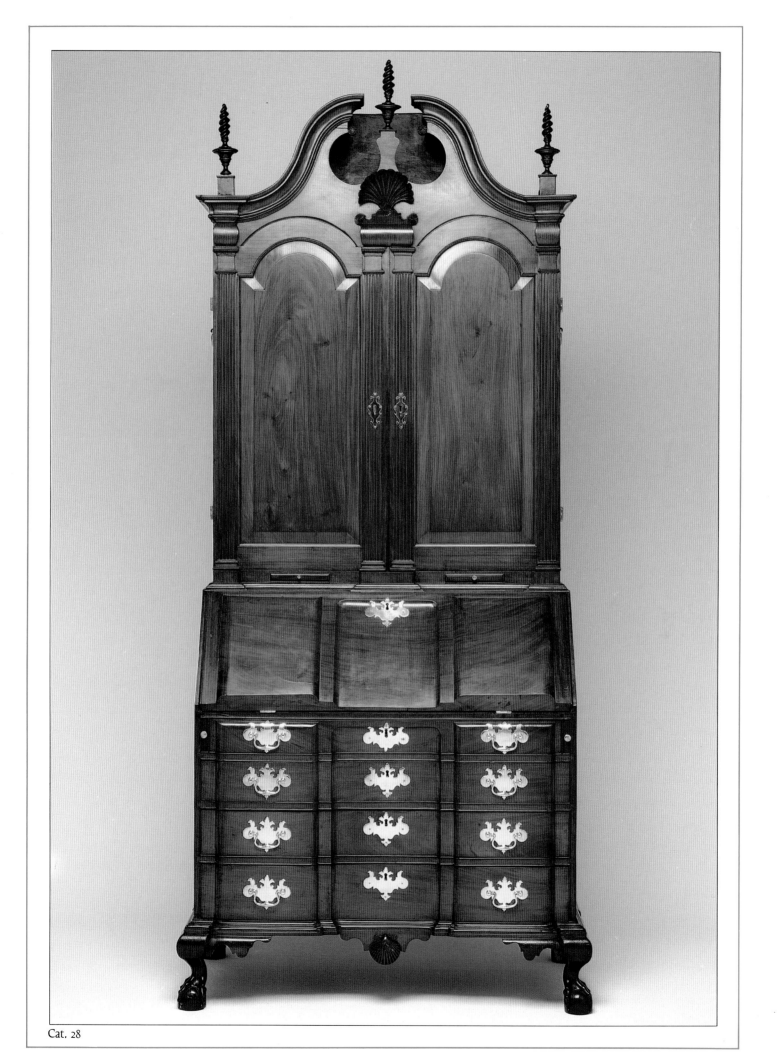

Cat. 28

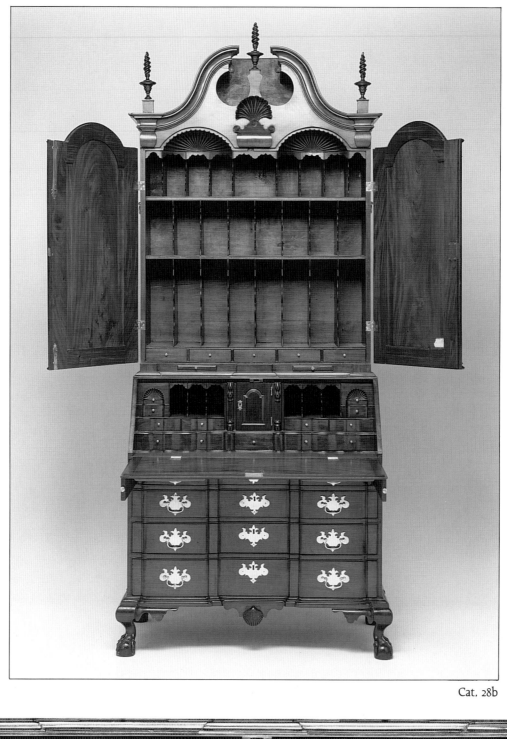

Cat. 28b

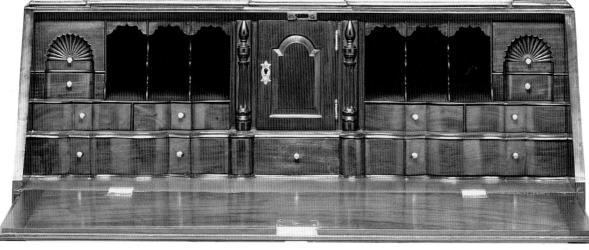

Cat. 28c

boards are single wide boards; the glue blocks are thick and shaped; the rear ones are cut on a diagonal; the solid drawer fronts are relieved on the inside; the sliding dovetails of the drawer dividers are left exposed; the drawer sides are finished with a double-bead apparently made by the same molding plane; they all lack giant dovetails behind their base molding; and they have stock cut to the same thicknesses and used in the same directions.

Although variations occur in decorative details on the interiors, the knee brackets, and blocking (the top corners could either be squared or rounded), the only major construction feature that varies is the base's framing.[8] Two methods were used—either the feet and glue blocks were applied directly to the baseboard as here (see cat. 28e) or framing members were inserted between the blocking and the baseboard along the front and sides.[9]

What is most interesting about the shop that produced these exceptionally well-designed and finely blocked case pieces is that it simultaneously made equally impressive bombé furniture.[10] Although the three known bombé desks and two chest of drawers from this shop have curved sides and front facades, rather than blocking, they are constructed in basically the same manner. The two methods of base framing are found on these pieces, as well as identical base moldings, glue blocks, feet, shells, and proportions. The bombé desks' interiors are basically the same as those of the blocked examples. One intriguing difference between the blocked and bombé case pieces is in the dovetailing of their drawers. On the blocked examples the drawer sides are straight and the rear dovetails are exactly like those in the front of each lower drawer. However, in the bombé pieces the drawer sides are curved to follow the shape of the case sides and the pins and tails of the rear dovetails are reversed in comparison to the front corners. The reason for this reversal is at present unclear.

Although a desk and bookcase identical to this example has recently been published as from the workshop of Nathaniel Gould, it is more probable that they were made in the Salem cabinetshop of Henry Rust.[11] The existence of three inscribed pieces of furniture support this conclusion. The first of these is a relatively plain desk which is neither blocked nor bombé, but has a closely related interior, bracket foot profile, and overall construction. On the document drawers are numerous ink inscriptions including: "This Desk / Made By / Henry Rust / of / Salem. . . . Salem New England / one Thousand seven Hundred and / Seventy."[12] The signature is the same as that on Rust's 1812 will. The second case piece is a blockfront desk which is like the lower section of the Bybee desk and bookcase. On the bottom of this fall-front desk is the chiseled inscription "H x Rust."[13] The final example is a desk and bookcase identical to the one seen here. Although not signed by Rust, this piece carries on the top of its lower section the inscription, "Nath Gould not his work" and the date 1779. A comparison between this inscription and the lengthy, signed ones on the document drawers of the first desk suggests that they were all done by the same hand—that of Henry Rust.[14]

Born in 1737, Henry Rust was the son of an Ipswich tanner, John Rust (1707-ca. 1750).[15] Shortly after his father's death, Henry

was sent to Salem, where he was apprenticed to a cabinetmaker. According to the early Salem historian, Col. Benjamin Pickman, Rust was bound over to the "joiner" Jonathan Gavet.[16] However, Jonathan Gavet (1731–1806) would only have been about nineteen years old when Rust arrived in Salem around 1750. Also, he was primarily a turner by trade, not a cabinetmaker. It is far more likely that Rust was apprenticed to Jonathan's father, Joseph Gavet (1699–1765).

Joseph Gavet ran one of Salem's most sophisticated cabinetmaking shops. At his death in 1765, the shop contained an enormous quantity of specialized tools and three workbenches.[17] During his tenure in the Gavet shop, Rust would have learned to use this wide range of tools and to perform various joinery techniques. Given Joseph Gavet's family connections, he may have also absorbed a design aesthetic which was heavily influenced by that of Newport, Rhode Island.

Joseph Gavet was the son of a joiner, Philip Gavet (d. ca. 1714). Although Philip was probably born in Essex County, Massachusetts, he moved to Westerly, Rhode Island, around 1713 to live with his oldest son Ezekiel (also a joiner) who had moved there about 1700. Since Joseph Gavet was about fifteen years old at the death of his father, it is possible that he was sent to Rhode Island for training by his woodworker brother, Ezekiel, or by someone in Newport.[18] If this is the case, Joseph Gavet could be responsible for introducing various "Newport" design and construction features into Salem-area furniture through his own work and that of his numerous apprentices, including Henry Rust. Newport-type characteristics of this desk and bookcase include the blocked fall-front, the stepped interior, the lack of beading strips on the front edges of the case sides, and the absence of a giant dovetail.[19]

When he married Lydia Janes (1740–1808) in 1759, Henry Rust had probably completed his apprenticeship with Joseph Gavet. By the early 1760s, he had established himself as an independent cabinetmaker. In 1762, for example, he was re-

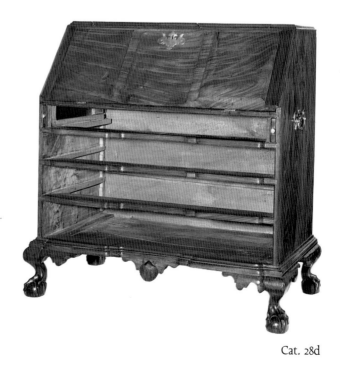

Cat. 28d

corded on a list of Salem's master craftsmen, along with Gavet.[20] Three years later in 1765, Rust purchased a house and shop on the corner of Federal and Washington streets from the cabinetmaker Thomas Needham, who had evidently moved to Marblehead.[21] When Rust's former master, Joseph Gavet, died the same year, his estate was indebted to Rust for 10s.4d. Nathaniel Gould, who inventoried Gavet's shop, was also owed 14s. by the estate.[22]

During the turbulent 1770s, Rust was successful enough to invest in shipping ventures. Probably aided by the connections of his mariner brother, John of Gloucester, and ones he himself made in Boston, Rust "made his money in the Revolutionary war, by considerable risks."[23] In 1779, while still considered a cabinetmaker by local authorities, Rust was a co-defendant in a legal dispute over the schooner *Canso*'s cargo. In the same year he purchased the hull of the *William* for £1,600, presumably for refurbishing.[24]

Rust's trading investments in commodities, such as boards, hogsheads, tobacco, fish, cotton, raisins, and currants, were apparently profitable. By the early 1780s court records and property deeds no longer list Rust's profession as cabinetmaker, but rather as merchant.[25] In 1786, he and his business partner, Benjamin Brown, built a brick store on Essex Street. Besides building a store, Rust purchased numerous pieces of land throughout the last two decades of the eighteenth century, while lending money to various persons. As his wealth increased, so too did his social standing. In 1783 Rust served as a representative to the General Court in Salem and in 1792 and 1793 was a member of the state legislature.[26]

By the time he died in 1812, Henry Rust had amassed an estate of over $40,000. Besides his extensive local property holdings, Rust owned houses and land in Gloucester and over 2,000 acres of land in and around Rustfield (now Norway), Maine. In Maine he also had a gristmill, sawmill, and tannery. Other than a "Building in County Street improved as a work Shop with the land," "Two pit saws & gear," and "Four thousand feet of clear Boards," there is nothing in Rust's inventory that reflects his cabinetmaker origins. Rust had probably ceased working as a cabinetmaker in the 1780s, when his mercantile interests be-

came paramount. However, judging from the furnishings in his home at the time of his death, Rust did not repudiate his former profession. The most valuable piece of furniture he owned was "One Mahogany Desk & Book Case" worth $36.[27] Like the one owned by his fellow merchant, Joseph Sprague, seen here, Rust's towering desk and bookcase silently proclaimed his wealth and power to all those who saw it.

STRUCTURE AND CONDITION: The bottom board is a single wide board. The front base molding is applied to the edge of the bottom board. There is no giant dovetail. The feet are braced with wide, horizontal glue blocks which are shaped to follow the scalloped outline of the knee brackets. The rear legs are braced with unrelieved blocks cut at a diagonal along their inside edge. The lower case sides dovetail into the top and bottom boards. The drawer runners are attached to the case sides with rosehead nails. The drawer dividers which are faced with strips of mahogany join the sides with sliding dovetails. These joints are left exposed. The perimeters of the front moldings and drawer dividers are beaded. The drawer facades and the desk's fall-front are shaped from thick, single pieces of mahogany. The drawer fronts are relieved on the interior to reduce weight. The blocked areas on the fall are not applied.

The backboards of both the upper and lower sections are nailed in place along the rabbeted edges of the case sides with rosehead nails. Incised lines on the upper part of the backboard show how the pediment and arched doors were laid out with a compass and straightedge (see cat. 28f). The doors of the upper sections are mortise-and-tenoned frames inset with panels. The cornice moldings are nailed and glued in place. The top of the pediment is covered with 2" (5.1 cm.) strips of wood running front-to-back. The central shell is applied onto the front surface. The interior partitions slide into grooves.

The exterior of the case survives in excellent condition. The brasses are original. The hinges on the prospect door are replacements. Metal furniture pads have been added to the feet. The finials and the scalloped bracket above the far left interior pigeonhole are replacements. The central, freestanding shell has cracked and been glued back together. The interior parti-

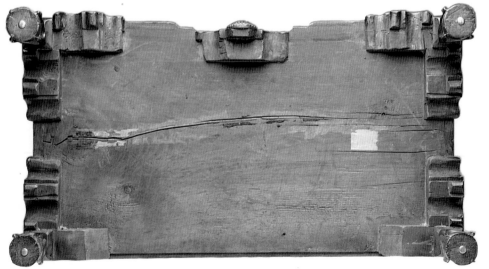

Cat. 28e

tions in the upper section have been rearranged and all the drawers, excluding the document drawers, have been relined earlier in this century. All the drawer fronts are original.

INSCRIPTIONS: On the upper backboards is an inscribed layout for the bonnet (see cat. 28f). The piece also retains several paper loan tags from the Museum of Fine Arts, Boston.

WOODS: All exterior surfaces, mahogany; backboards, southern yellow pine; remaining parts of case and document drawer linings, eastern white pine; all remaining drawer linings (replacements), yellow poplar.

DIMENSIONS: H. without finials 97¾ (248.2); W. 45⅜ (105.2); D. 24½ (62.2).

PROVENANCE: Major Joseph (1739–1808) and Elizabeth White Sprague (1743–1807), Salem, Mass., ca. 1760–1808; Dr. William (1754–1819) and Sarah Sprague Stearns (1764–1844), Salem, Mass., 1808–1844; Richard (1802–1840) and Marianne Theresa St. Agnau (b. 1806), Salem, Mass.; William (1822–1905) and Hannah Emily Whiteman, Salem, Mass.; Richard S. Stearns, Sr., Salem, Mass.; Emily St. Agnau Stearns, Salem, Mass.; Swett's Auction Gallery, Boston, Mass., 1958; Israel Sack, Inc., New York, N. Y.; Bybee Collection, 1958.

EXHIBITIONS AND PUBLICATIONS: MFA, B 1926–1951; Hipkiss 1929, n. p.; *Antiques* 93:1 (Jan. 1968): 74; Fairbanks 1968, 77; Theta Charity Antique Show, Houston, Tex., 1979; Sack 1981, 1:16, 25; MFA, H 1981; *Antiques* 129:5 (May 1986): 956.

1985.B27

1. This house still stands in Salem. For a photograph of it, see Tolles 1983, 155. The Essex Institute in Salem owns early twentieth-century interior views (neg. nos. 9505–9507) of this house which document much of the Sprague-Stearn's collection. This desk and bookcase is not among the pieces in these photographs.
2. All information about Col. Sprague's property and business investments is taken from his estate inventory; see Col. Joseph Sprague will and inventory (1808), docket 26033, Essex County Probate Records (hereafter ECPR), Essex County Courthouse, Salem, Mass. The Essex Institute has numerous Sprague and Stearns family and business papers and ledgers. No mention of this desk is made in any of these papers. See note 27 below.
3. William Stearns will and inventory (1819), docket 26266, ECPR. For an extensive biography of Stearns and a portrait, see Stearns 1928. For history of the Stearns family, see Van Wagenen 1901.
4. The total of Sarah Stearns inventory is $20,344.96; Sarah White Stearns will and inventory (1844), docket 54093, ECPR.
5. Following Sarah Stearns's death, the desk apparently passed to the widow of her youngest son Richard, Marianne Theresa St. Agnau. It descended through this line and was placed on loan at the Museum of Fine Arts, Boston, in 1926. Numerous other family pieces also were loaned to the Essex Institute. A detailed list of the objects loaned is retained by the Essex Institute. The bulk of these items, including other bow- and blockfront case pieces, were sold in 1953; see SPB 1424 (1–4 Apr. 1953).
6. For related pieces, see AAA 3940 (9 Jan. 1932): lot 71; SPB 1343 (3 May 1952): lot 177; Downs 1952, nos. 225, 229; Heckscher 1985, no. 181; Louis and Sack 1987, 1318–1325; Elder and Stokes 1987, no. 74. For a closely related desk and bookcase which is probably not by the maker of the Bybee example, but possibly by someone trained in his shop, see Rogers 1947, fig. 45–46. Another related desk is on loan to Historic Deerfield.
7. For the desk and bookcases, see Shephard 1978, 244–245 (this piece has been heavily reworked); Heckscher 1985, no. 181. For fall-front desks, see Sack 1981, 2:393, 6:1438; *Antiques* 55:6 (June 1949): 399; 111:5 (May 1977): 845; 128:2 (Aug. 1985): 156.
8. The knee brackets and central drops appear to have been laid out with a compass and straightedge rather than a template. They are all identical in handling, but vary in length and profile.
9. This information is based on the author's ongoing survey of furniture from this group. While almost all of the pieces cited here have been examined, several have not as yet. Upon completion, this research will probably be published as an article.

10. For bombé desks, see Whitehill 1974, 194; Sack 1981, 595 (now in the State Department collection). Another desk is in a private collection in Maryland. For the two bombé chests, see Downs 1952, no. 166; Warren 1975, 127. These are compared in Whitehill 1974, 192–193.
11. See Heckscher 1985, no. 181.
12. For an illustration of this desk and the Rust inscriptions, see Sack 1981, 4:898–899. The construction of this desk supports an attribution of the Bybee desk and bookcase to Rust. It has closely related blocking behind the feet and bottom molding, has the distinctive double-bead on the drawer sides and interior, and has a very similar interior layout. The pins and tails of the rear dovetails of the larger drawers are reversed as in the bombé examples in this group.
13. For illustrations of the desk and its inscription, see *Antiques* 111:5 (May 1977): 845, or Whitehill 1974, figs. 84–85. Although unusual, the chiseled inscription has oxidized like the rest of the bottom board and appears to be authentic.
14. For a discussion of this piece, see Heckscher 1985, no. 181. The inscription is illustrated on p. 366.
15. For a history of the Rust family, see Rust 1891, especially pp. 56, 90–94.
16. Pickman 1864, 103.
17. For an analysis of his tools and supplies, see Forman 1971, 73–77.
18. For information on the Gavets, see Gavit 1923, especially 34–41. Philip's father came to Essex County in 1647 from the Isle of Jersey and was of French descent. Joseph was in Salem in 1725 when he married Mary Williams.
19. For a discussion of the "Newport" character of Essex County case pieces, see Whitehill 1974, 77–135.
20. See Forman 1971, 65.
21. Henry Rust deed (2 Aug. 1765), 116:49, Essex County Registry of Deeds (hereafter ECRD), Essex Country Courthouse, Salem, Mass. The property was originally purchased by Rust and Benjamin Daland, carter, jointly. However, in October Rust bought out Daland; see Rust deed (28 Oct. 1765), 118:103, ECRD. The Essex Institute owns two late nineteenth-century views of Rust's house and shop.
22. Joseph Gavet will and inventory (1765), docket 10689, ECPR.
23. Quoted from Pickman 1864, 103. Henry Rust inherited his brother's property, including a "mansion house" in Gloucester when John died in 1809. John's house contained a "Mahogany desk [$]12.00." See John Rust will and inventory (1809), docket 24457, ECPR. William Bentley first met Rust in Boston in 1773; see Bentley 1962, 4:119. He also met Rust in Beverly. It has been stated that Rust practiced cabinetmaking in these locations, but it does not appear that he ever lived in either Boston or Beverly for extensive periods of time, although he had a house in Beverly by 1782.
24. Rust is listed as a "cabinetmaker" in Rust deed (20 Mar. 1779), 137:26, ECRD. For records concerning court action over the *Canso*, see Derby et al. vs. Harriden et al. (July 1779), 6:520, and (July 1780), 7:7, Essex County Court of Common Pleas Records (hereafter ECCCPR), Essex Institute Library, Salem, Mass. Joseph Sprague, the original owner of this desk, was also a co-defendant with Rust. Sprague and Rust invested in the same adventures on several occasions; see Harriden vs. Ingersoll et al. (Sept. 1784), 9:285, ECCCPR. Rust sued Sprague over an outstanding debt; see Rust vs. Sprague (Nov. 1793), 15:20, ECCCP.
25. See Rust deed (9 Aug. 1782), 137:95, ECRD; and Harriden vs. Williams et al. (Sept. 1784), 9:285, ECCCPR.
26. For a brief biography and portrait of Rust, see Rust 1891, 90–94.
27. See Henry Rust will and inventory (1812), docket 24453, ECPR. The 1812 appraisal of Rust's desk and bookcase at $36 compares favorably with that of Joseph Sprague's "Book Case" ($31). Rust's personal desk and bookcase reappears in the 1823 inventory of his second wife, Abigail, as "1 Mahg. Desk and book Case . . . $20"; see Abigail Rust will and inventory (1823), docket 24442, ECPR.

Cat. 28f

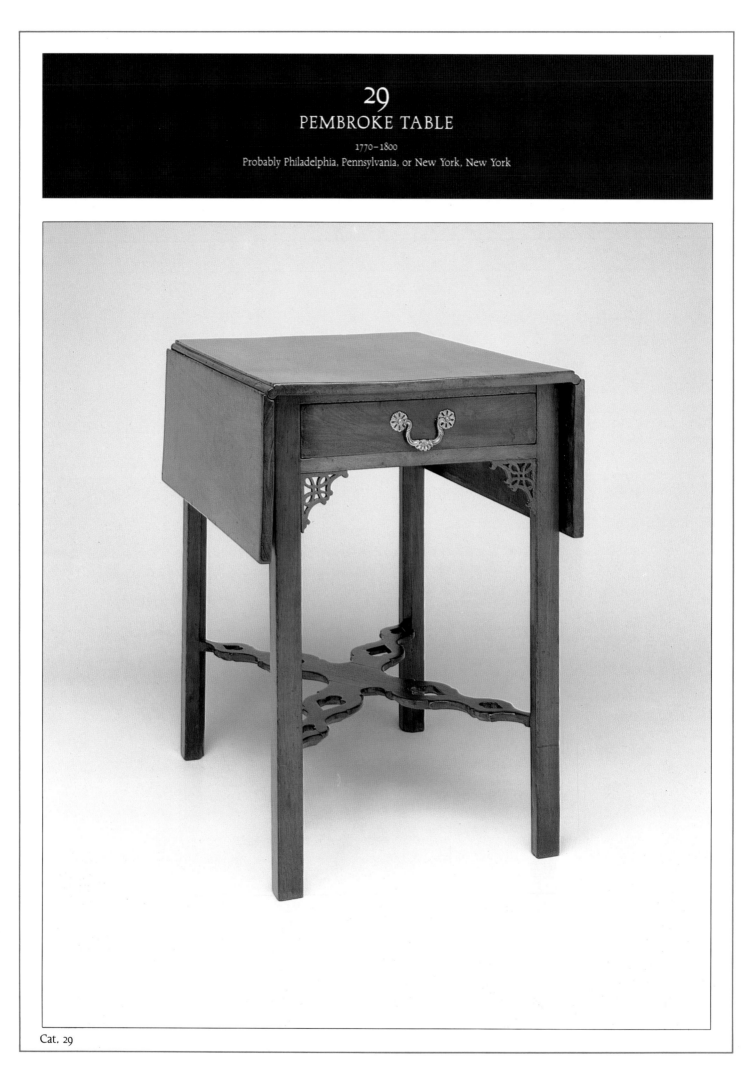

Cat. 29

DURING the mid eighteenth century, English furniture makers introduced this form of small table with two folding leaves. In 1754 the English cabinetmaker Thomas Chippendale published designs for a related "breakfast" table in his *Director* (see fig. 5). By the 1770s, the terms breakfast and Pembroke table were being used interchangeably in colonial America.[1] However, besides providing a surface upon which to eat breakfast, such tables must have been used for a variety of activities. The scissors marks on the top of this example indicate that sewing was done on it.

Pembroke tables were made by numerous cabinetmakers during the late eighteenth and early nineteenth centuries.[2] Although this table has no family history, the use of oak and yellow poplar in its construction suggests that it was made in either Philadelphia or New York City. Furthermore, the character of the pierced frets relates to urban work from this region, especially that of Philadelphia.[3]

Regardless of where this table was made, however, it is exceptionally well designed and constructed. Attention to details, such as the use of hardware posts for leaf-support pulls and the application of semicircular strips under the edges of the top to give a circular look to the rule joints, indicates that the shop which made this table produced them in some quantity.

STRUCTURE AND CONDITION: The sides of the skirt consist of inner and outer rails. The leaf supports are part of the outer rails and pivot on wooden pintles. The posts from a bail handle serve as pulls for the leaf supports. The entire frame is mortise-and-tenoned together. The drawer runners are nailed to the inner rails. The X-shaped stretcher consists of two members joined with a half lap one atop the other. The pierced corner frets are secured with T-head nails. The top is screwed to the frame from below. The leaves meet the top with ruled joints.

Half-round strips have been added beneath each rule joint to give the joint a circular appearance. The drawer is constructed with medium-size dovetails. Its chamfered drawer bottom fits into grooves run on the drawer front and sides. It is nailed in place across the rear edge with four rosehead nails. The upper edge of the drawer sides is slightly rounded.

One of the stretchers has been cracked and repaired. The drawer pull and one of the corner blocks has been replaced. The top has been off and reattached with new screws. The top has numerous scratches on it which appear to have been made by scissors. The frets are original.

INSCRIPTIONS: Glued to the interior of the drawer is a fragment of an unidentified newspaper from 1888.

WOODS: Top, legs, drawer front, skirt ends, and frets, mahogany; drawer linings and drawer runners, yellow poplar; outside rails and leaf supports, white oak; inner skirt frame, cherry.

DIMENSIONS: H. 28¾ (73.0); W. open 37⅝ (95.5); W. closed 20¼ (51.4); D. 28½ (72.4).

PROVENANCE: Unidentified Philadelphia dealer; Bybee Collection, early 1960s.

EXHIBITIONS AND PUBLICATIONS: MFA, H 1981.

1985.B35

1. For a discussion of the use of these terms in America, see Jobe and Kaye 1984, no. 66.
2. For examples from Rhode Island, Connecticut, and New Jersey, see SPB 561 (26–29 April 1944): lot 341; SPB 1948 (5–6 Feb. 1960): lot 172; Sack 1981, 2:394. For a related undocumented example, see SPB 404 (7 Nov. 1942): lot 166. For a New Jersey example made during the second quarter of the nineteenth century, see New Jersey State Museum 1970, no. 13.
3. For a closely related Philadelphia example, see *Antiques* 64:5 (Nov. 1953): 325. For a related New York example, see Williamsburg 1966, no. 31.

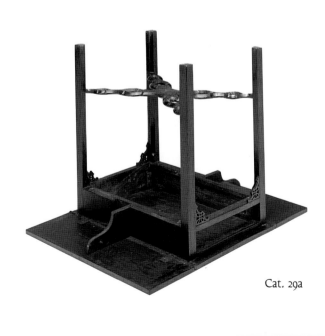

Cat. 29a

Fig. 5. Design for a breakfast table. From Thomas Chippendale, *The Gentleman and Cabinet-Maker's Director*, 3d ed. (London, 1762), plate 53. (Winterthur Museum Library.)

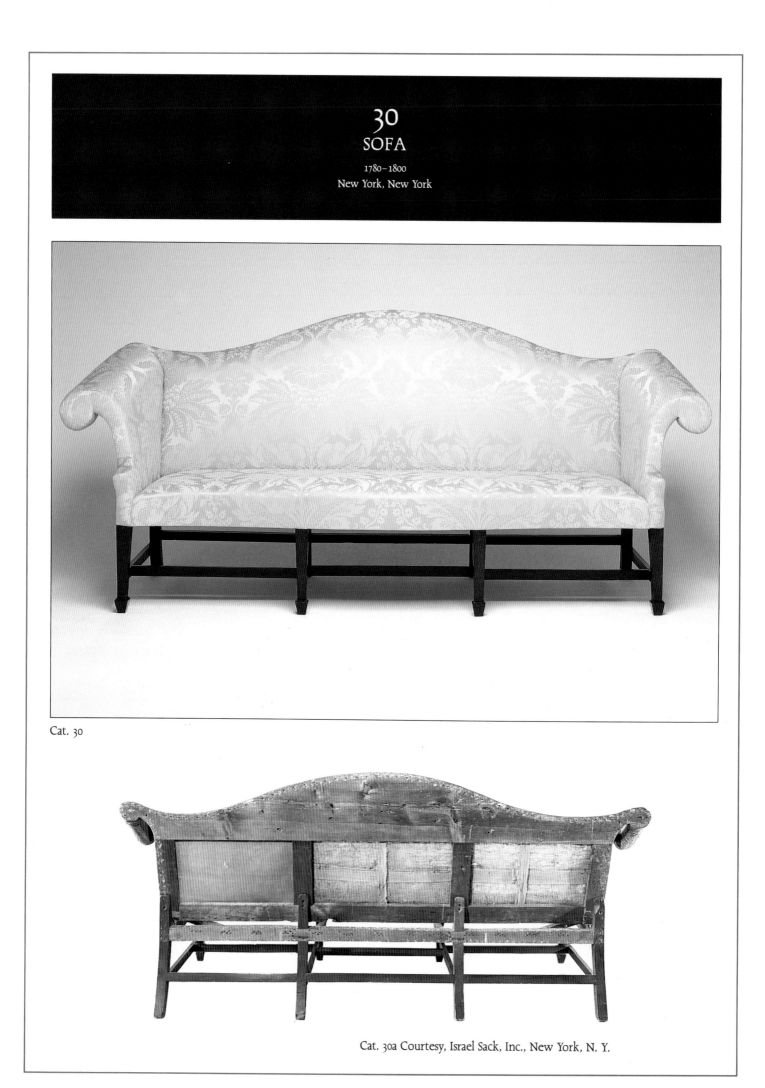

30
SOFA

1780–1800
New York, New York

Cat. 30

Cat. 30a Courtesy, Israel Sack, Inc., New York, N. Y.

ALONG WITH fully hung beds and easy chairs, sofas were one of the most expensive furniture forms produced during the eighteenth century. Consequently, only the wealthiest families, such as the Van Deursens who owned this sofa, could afford these sumptuous objects for their parlors and dining rooms.[1]

The original owners of this sofa were Willem (1752–1824) and Martha Whittelsey Van Deursen (1756–1839) of Middletown, Connecticut. Willem Van Deursen was born and raised in New York City. Apparently he trained as a ship captain and moved to the New Haven area as a young man. In 1778 he married the daughter of Chauncey Whittelsey, a prominent New Haven minister and merchant. During the Revolution, Van Deursen prospered as the captain of the ship *Middletown*, which was assigned to capture and confiscate British ships and property. By 1786, Van Deursen was able to purchase substantial acreage in Middletown, Connecticut, upon which he and his wife built their home.[2]

Given the tapered legs and spade feet of this sofa, it is likely that the Van Deursens had this piece made for their new home in the late 1780s.[3] From whom the sofa was ordered is unknown, however. Considering only the frame, a Connecticut origin is not inconceivable. Similar spade feet are known on a sofa made by Patrick Robertson of New London in 1790 and mahogany was used by cabinetmakers along the Connecticut coast of Long Island Sound.[4] However, the sophistication of the original upholstery suggests an urban style center as the place of origin. Holes drilled in the back framing members (see cats. 30a, 30b) indicate that the sofa's back (and probably the sides and seat) was originally decorated with tufts in a diagonal pattern. In accordance with London tastes, this piece was probably further accented with cylindrical bolsters at each end and possibly a brass tacking pattern along the arms and seat rail.[5]

Since Willem Van Deursen came to Connecticut from New York and still had parents and siblings living in the city while he was building his new home, it is probable that he ordered this sofa from a New York upholsterer and simply had it shipped to Middletown.[6] When Van Deursen died in 1824, his inventory notes that this sofa (then about forty years old) was still one of his two most valuable pieces of furniture. It and a looking glass were valued at $20 apiece.[7]

STRUCTURE AND CONDITION: The sofa is primarily constructed with mortise-and-tenon joints. The side panels are attached to the lower section by means of an iron bolt at either end. The cross and corner braces join the seat rails with sliding dovetails. The cross stretchers are joined to the front-to-back stretchers with sliding dovetails. The center cross stretcher is placed farther back than the side stretchers in order not to overly weaken the two central front-to-back stretchers.

The sofa survives in good condition. The back retains part of its original under-upholstery. A series of holes in the backboard allowed tufting cords to pass through it. One stretcher is cracked and the feet have minor losses.

WOODS: Legs and stretchers, mahogany; arched seat and corner braces, sycamore; seat rails, ash; although the underframe was not tested, the frame appears to be made of pine and ash.

DIMENSIONS: H. 41¾ (106.1); S.H. 16½ (41.9); W. 98¼ (249.5); D. 35½ (90.1).

PROVENANCE: Willem and Martha Whittelsey Van Deursen, New Haven and Middletown, Conn., ca. 1780–1839; William (1783–1833) and Mary Cranston Van Deursen (1791–1892), Middletown, Conn., 1840–1892; William Walter Van Deursen (1833–1901) and Margaret Morris Van Deursen (1831–1913), Middletown, Conn, 1893–1913; Middlesex County Historical Society, Middletown, Conn., 1914–1960; Liverant and Sons, Colchester, Conn., 1961; Israel Sack, Inc., New York, N. Y., 1961–1962; Bybee Collection, 1963.

EXHIBITIONS AND PUBLICATIONS: *Antiques* 79:3 (Mar. 1961): inside front cover; Fairbanks 1968, 79; Sack 1981, 1:114; MFA, H 1981.

1985.B28

1. For an illustration of a sofa used in a dining room, see Hepplewhite 1794, pls. 124–125.

2. Van Deusen 1912, 1:71–72, 114–115.

3. For a closely related "Comon English Sofa" made in 1788 by the English firm of Gillows and Co., see Kirk 1982, no. 1189.

4. For the sofa by Robertson, see Myers and Mayhew 1974, no. 94. A good example of a Connecticut cabinetmaker using mahogany is Timothy Boardman, Jr. (1727–1792), of Middletown. At the time of his death Boardman owned twelve feet of mahogany boards. For information on Boardman, see Ward and Hosley 1985, 219–220.

5. For examples of contemporary sofas with tufts and bolsters, see Kirk 1982, no. 1189, and Thornton 1984, 132, 175. At present the frame has not been examined for traces of a decorative nailing pattern. For a discussion of how these pieces were originally upholstered, see Cooke 1988.

6. For sofas which might be from the same shop, see Comstock 1962, no. 349; Cooke 1987, 112–113. For other related sofas from New York, see Downs 1952, nos. 275–276; Sack 1981, 4:859; Hummel 1976, 35; SPB 634 (13–17 Feb. 1945): lot 1662; SPB 5551 (28–31 Jan. 1987): lot 1254.

7. Willem Van Deursen will and inventory (1824), docket 1788.176, Middlesex County Probate Records, Middlesex County Courthouse, Middletown, Conn.

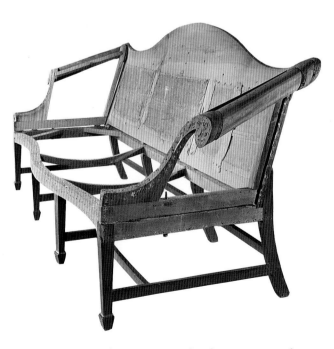

Cat. 30b Courtesy, Israel Sack, Inc., New York, N. Y.

31
WINDSOR SETTEE

1770–1785
Philadelphia, Pennsylvania

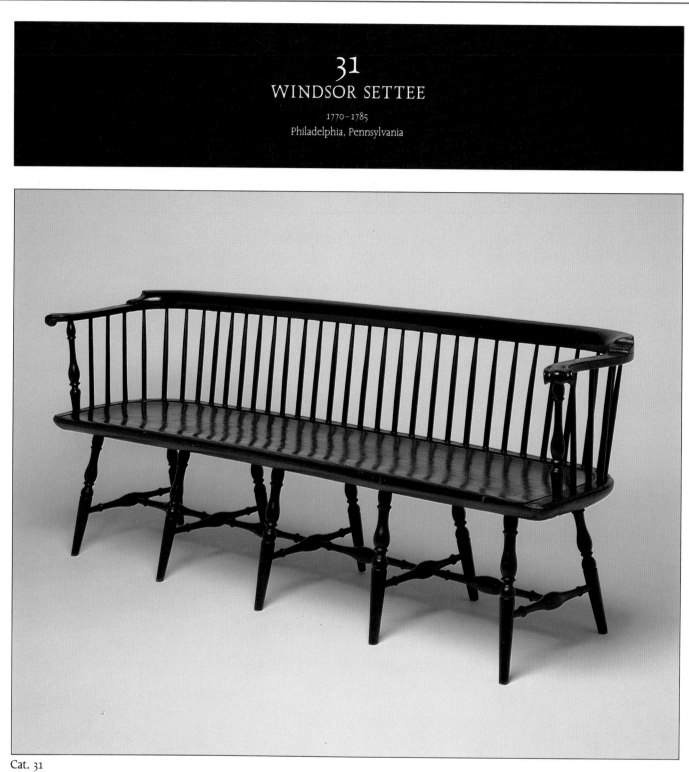

Cat. 31

PHILADELPHIA WAS the colonial center of Windsor chair production. English Windsors were first imported into the town in the 1720s. By the 1740s, Philadelphia chairmakers were producing their own chairs and exporting them to other colonial towns.

Before the Revolution, a Windsor chair cost two to three times the amount of a simple, rush-bottom chair. Consequently, Windsors were primarily purchased by the wealthier members of society. Windsor furniture was used along with more elaborate furniture in many of the finest homes, as well as in taverns where durability was of great concern. Windsors were easy to repaint and their seats never had to be renewed.

By 1775, Philadelphia Windsor makers were mass-producing chairs. In large shops, several turners might supply parts to the chairmaker who would stockpile them until they were needed to fill an order. The chair could then be assembled and painted or the parts could be shipped "knocked down" for assembly by the purchaser. During the last quarter of the eighteenth century and in the early nineteenth century, Philadelphia makers produced thousands of Windsor chairs which were sent to customers from Maine to New Orleans.[1]

Windsor settees were designed for structures in which large numbers of people gathered, such as public buildings, churches, and taverns. Due to their large size and high cost, such settees were much less frequently made than Windsor chairs in the eighteenth century. Consequently Windsor settees are extremely rare today, especially those with ten, rather than eight, legs.[2]

Judging from the character of its turnings, the Bybee settee was probably made around the time of the American Revolution. The short, thick-necked turnings of the legs, for example, were popular during the 1770s and 1780s. Since numerous chairmakers purchased turnings from the same turner, it is difficult to identify the shop(s) which made and assembled the Bybee settee. However, a closely related example by Francis Trumble is known, as are related chairs by William Widdifield.[3]

STRUCTURE AND CONDITION: The seat is shaped from one piece of wood. The legs are tenoned through the seat and are wedged in place. The rear rail and arms are lap-joined and pinned. The "knuckle" handgrips are carved from two pieces of wood glued together.

Structurally, the settee is in excellent condition. The coat of dark green paint is not original. The previous coat of paint was a grayish brown. The right arm has cracked and been reglued. A hole or knot in the seat has been filled with a wooden plug.

WOODS: Seat and rear rail, yellow poplar; spindles, hickory; arms, white oak; legs and arm supports, soft maple.

DIMENSIONS: H. 32 (81.3); S.H. 18 (45.7); W. 81½ (207.0); D. 19⅛ (48.6).

PROVENANCE: Israel Sack, Inc., New York, N. Y.; Bybee Collection, 1951.

EXHIBITIONS AND PUBLICATIONS: Fairbanks 1967, 837; Antiques 129:5 (May 1986): 956.

1985.B62

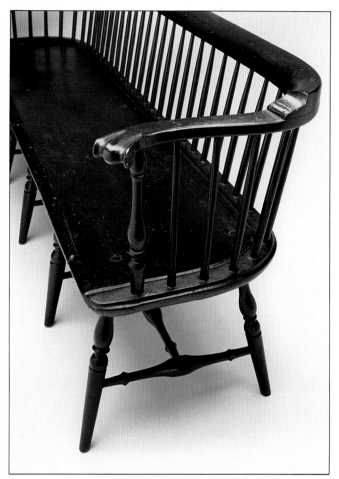

Cat. 31a

1. This brief summary of Windsor production in Philadelphia is taken from a lecture entitled "The Philadelphia Chair: A Commercial and Design Success Story" given by Nancy G. Evans at the 1987 Winterthur Conference, "Shaping a National Culture: The Philadelphia Experience, 1750–1800." This information will be included in Evans's forthcoming comprehensive study of Windsor seating furniture in America to be published by Winterthur Museum.

2. For similar settees, see Hornor 1935, pl. 485, and Santore 1981, 183–184.

3. Analysis of the Bybee settee and related examples provided by Nancy G. Evans, letter to the author, 27 Aug. 1986. The Trumble example is at MESDA.

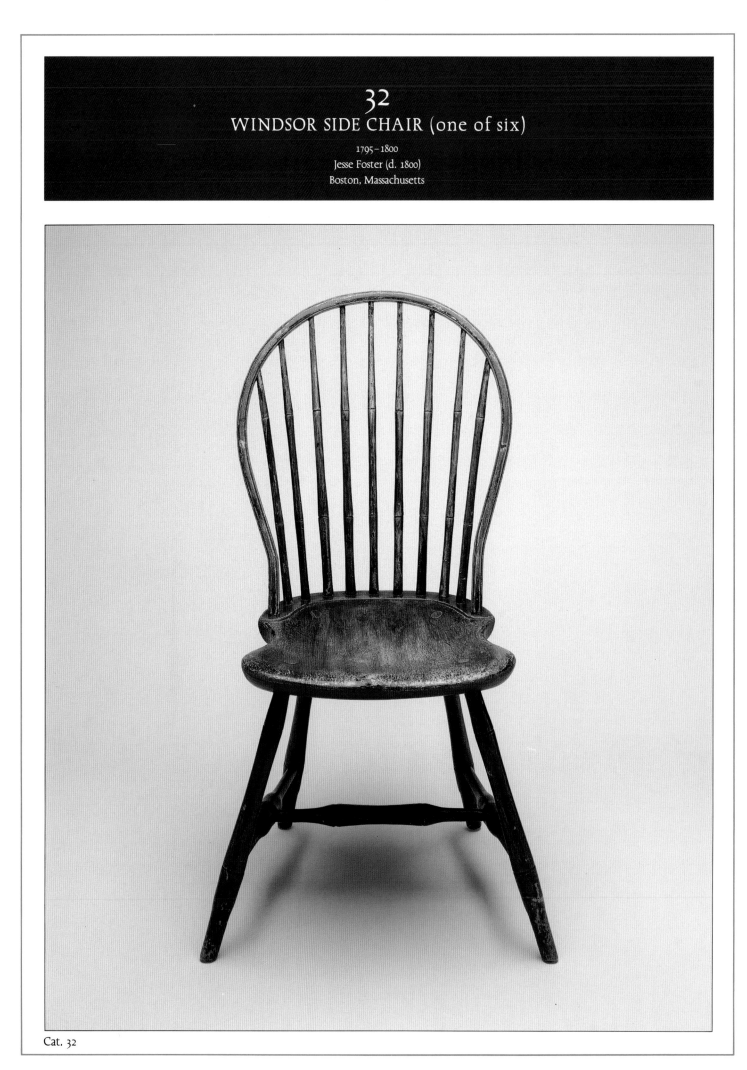

Cat. 32

WITH THE EXCEPTION of Rhode Island, Windsor chairs were not made in New England before the American Revolution. New Englanders simply imported their Windsors from Philadelphia where they were made in huge quantities. In the 1780s, however, some New England chairmakers began to produce their own Windsors based on imported Philadelphia examples.[1] Jesse Foster was such a craftsman.

Foster worked in Boston between 1795 and 1800. In his shop on Water Street he produced and branded the set of six bow-back Windsor side chairs with "bamboo" turnings, from which this chair comes.[2] While the English were the first to make this type of lighter, Chinese-influenced chair, Philadelphia makers were producing them by the 1780s. Foster patterned his chairs on Philadelphia examples which had been shipped north.[3] The stout legs, medial stretcher with double swells, centrally swelled side stretchers, and articulated grooved spindles seen here are all characteristic of Boston work. By 1800 this type of bow-back Windsor was made in many areas and was the most popular chair form in America.[4]

STRUCTURE AND CONDITION: This chair, and the set from which it comes, is in excellent condition. It has never been refinished and retains numerous coats of paint. The seat of the illustrated side chair is cracked. The seat is shaped from a solid piece of wood. The legs pass through round holes in the seat and are wedged in place. The hoop-shaped back rail is bent from a long thin strip of wood.

INSCRIPTIONS: All six chairs are branded "J. FOSTER" underneath their seats. "Crack" is written in chalk on the bottom of the illustrated side chair. The metal caps on the feet are not original.

WOODS: Seat, eastern white pine; hoop-back, oak; back spindles, ash; legs and side strechers, soft maple.

DIMENSIONS: H. 37⅞ (96.2); S.H. 17½ (44.5); W. 22½ (57.2); D. 18⅛ (46.0).

PROVENANCE: Amos Kingsbury estate, Milford, Mass.; Marguerite Riordan, Stonington, Conn.; Bybee Collection, 1985.

EXHIBITIONS AND PUBLICATIONS: *Antiques* 128:3 (Sept. 1985): 319.

Promised gift of Faith P. Bybee, 47.1987

1. Information on the post-Revolutionary development of the Windsor was taken from Nancy G. Evans, "The Philadelphia Chair: A Commercial and Design Success Story," a lecture given at the 1987 Winterthur Conference, "Shaping a National Culture: The Philadelphia Experience, 1750–1800."
2. The 1798 Boston city directory lists Foster as a chairmaker working on Water St. His home was on Devonshire St. More extensive data on Foster will be included in Nancy G. Evans's forthcoming study of Windsor seating furniture in America to be published by Winterthur Museum.
3. For related Philadelphia examples, see Santore 1981, 149–150.
4. An analysis of the Bybee chairs is provided in Nancy G. Evans, letter to the author, 13 Oct. 1986, DMA files. A closely related, upholstered set of Windsors is at Winterthur.

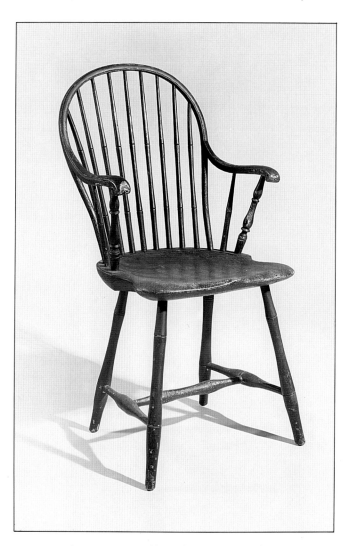

Fig. 6. Armchair, Jesse Foster (d. 1800), Boston, Massachusetts, 1795–1800. This chair was originally part of the same set as cat. 32. It is not branded. (Private collection: Photo, courtesy Marguerite Riordan.)

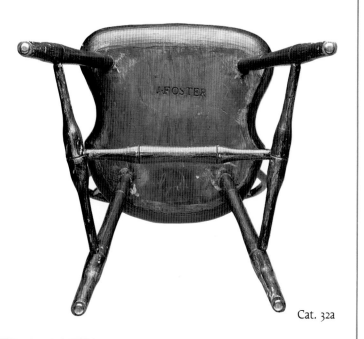

Cat. 32a

33
SIDE CHAIR
[1760–1800]
Southeastern New England

Cat. 33

IN THE CASE OF framed chairs, the primary visual emphasis is usually placed on the crest rail and back splat (see cats. 11, 15). However, in this turned chair, the crest rail appears to sag limply between the rear stiles. The back splat has been simplified into three slightly molded banisters. Of much greater interest is the finely turned decoration of the rear stiles, front legs, and central stretcher. Attesting to the skill of the turner who made this example, the turned forms are elegantly proportioned and crisply executed.

The origin of this chair is not certain. However, recent work suggests a southeastern New England provenance. Other examples are known from that area, and the central section of the turnings on the rear stiles closely relates to the side stretchers of contemporary Boston and Newport framed chairs (cats. 11a, 15a).[1]

STRUCTURE AND CONDITION: The chair is joined with mortise-and-tenon construction. The crest rail has been off. The right back banister is slightly wider than the other two and may be a replacement. However, it might simply have been moved from the center position at some point. The front stretcher has had severe wear and been rotated slightly. The chair may originally have been painted red. The frame is now black and the rush seat has traces of yellow paint, indicating that this chair was once painted in imitation of early nineteenth-century "fancy" chairs.

WOODS: Crest rail, banisters, and legs, soft maple; three seat lists and lower back rail, ash; left seat list, white oak.

DIMENSIONS: H. 38¾ (98.4); S.H. 15¼ (38.8); W. 18⅝ (47.3); D. 15¾ (40.0).

PROVENANCE: Bybee Collection, 1970s or early 1980s.

Gift of Faith P. Bybee, 1988.B73

1. The research of Brock Jobe and Myrna Kaye suggests a Rhode Island-area origin for these chairs. For a closely related example, see Jobe and Kaye 1984, fig. 89a.

WITH THE INTRODUCTION OF rococo and neoclassical designs during the last half of the eighteenth century, American craftsmen began making chairs with pierced back splats and tall, thin proportions. In urban areas, such chairs were sometimes inspired by imported English examples or pattern book illustrations (see fig. 7). In rural areas, however, these new design impulses were often distorted due to poor communications or intentionally rejected by chairmakers or customers. Consequently, rural craftsmen simultaneously produced some of the most retardataire and inventive furniture ever made in this country. The armchair seen here is an excellent example of such a duality.

In terms of its pierced splat and attenuated turned elements, this armchair reflects the influence of Boston chairs.[1] However, the exceptionally large piercings in the splat and the wide gap between the splat and the rear seat rail suggest that the maker of this chair was only vaguely familiar with urban products. Nevertheless, this chair is not uninspired. The quality and placement of its turnings, for example, are extremely high. The repetition of turnings on rear posts, arm supports, and front legs serves to unify the chair's composition. Similarly, the use of set-back arms provides a visual middle ground between the disproportionately high crest rail and low seat.[2]

The manner in which this chair is constructed is also imaginative. The fashion in which the arm supports are secured to the side seat rails is unusual and may be unique to this particular chairmaker. Furthermore, the low level of the seat is exceptional. However, this chair's feet retain evidence of having once had rockers attached to them. Originally the rockers may have elevated the seat to a normal level.

Although not common, other chairs with eccentric proportions, pierced splats, and through arm supports are known.[3] This particular example was collected in Fairfield County, Connecticut, and is believed to have originated in that area.[4]

STRUCTURE AND CONDITION: The chair is completely joined with mortise-and-tenon construction. The arm supports tenon into both the side seat lists and stretchers.

This chair was painted black, the seat re-rushed, and the bottom turnings on the front legs restored by the former owner. Grooves in the rear post for holding rockers have been filled.

WOODS: Most parts, soft maple; arm supports and upper side stretchers, ash.

DIMENSIONS: H. 41½ (105.4); S.H. 14⅞ (37.8); W. 25 (63.5); D. 16½ (41.9).

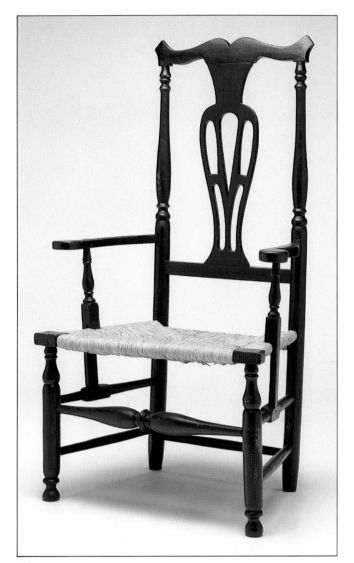

Cat. 34

PROVENANCE: Purchased in Ridgefield, Conn.; Robert F. Trent, Boston, Mass.; Bybee Collection, ca. 1980.

EXHIBITIONS AND PUBLICATIONS: Trent 1977, 79.

Gift of Faith P. Bybee, 1988.B79

1. See Randall 1965, no. 147.
2. Trent 1977, 80, states that step-backed arms became common on turned chairs in coastal Connecticut after the Revolution.
3. For armchairs, see Trent 1977, 80; Jobe and Kaye 1984, no. 129. For side chairs, see Lockwood 1926, 84–85; Davidson 1969, 230–231; Ward and Hosley 1985, 241; Antiques 119:1 (Jan. 1981): 4.
4. Although this chair has no documented history before it was collected in Fairfield County, it is believed to have originated in that area due to the existence of similar examples there. See Trent 1977, 78–80; Robert F. Trent, letter to the author, 25 Mar. 1987, DMA files.

35

SET OF TWO ARMCHAIRS AND TWELVE SIDE CHAIRS

1803
James Woodward (d. 1839)
Norfolk, Virginia

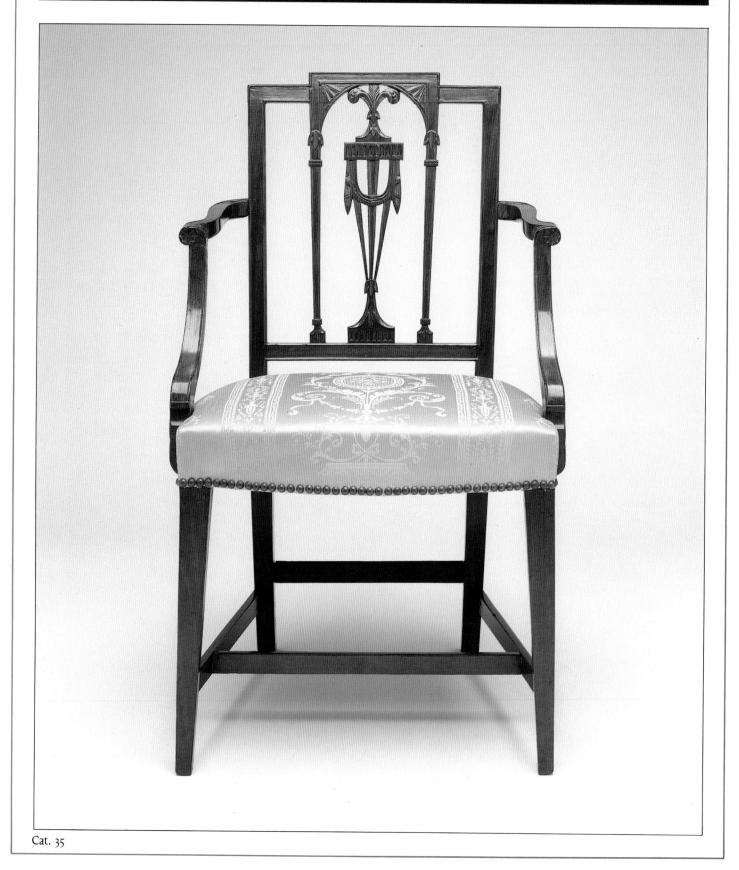

DURING THE THIRD QUARTER of the eighteenth century, neoclassicism became popular among England's elite. The work of Robert Adam (1728–1792) in the 1760s and 1770s exemplifies the most elaborate uses of this new stylistic impulse. However, by the 1780s, neoclassical designs had also become popular among England's middle class. To take advantage of this widespread popularity, several craftsmen published books of furniture designs. One of the most influential of these publications was *The Cabinet-Maker and Upholsterer's Drawing Book* (London, 1793) by Thomas Sheraton (1751–1806).

Sheraton's *Drawing Book*, as well as *The Cabinet-Maker and Upholsterer's Guide* (London, 1788) by George Hepplewhite, were extremely influential in Great Britain. Northern Europe and the United States also proved to be particularly receptive to these neoclassical ideas. This set of chairs is an excellent example of this cultural transferral.

On 18 June 1803, the Norfolk, Virginia, cabinetmaker and undertaker James Woodward billed General John Hartwell Cocke (1780–1866) for several pieces of furniture including "12 Mahogany Chairs at 10 Dol. Each . . . $120.00" and "2 Elbow Chairs at 15 Dol. Each . . . $30.00." Concerning the shipment of the chairs to Cocke's plantation at Swan's Point, Surry County, upriver from Norfolk, Woodward commented on the bill:

> Sir. Delivered the furniture in good order but I am afraid it met with a small accident aboard of the Vessel[. T]he Night it was put a board it came on to raine, Next Morning I went aboard I discovered Some of it got wet by the Hatches leaking[. I]f you find it spoted by water I recommend it to be well corked to take the spots out, and after oild with linseed oil.[1]

The chairs evidently arrived at Swan's Point without further incident. However, around 1809 they were presumably shipped once again up the James River to the family's new 3,284-acre estate in Fluvanna County.[2] Placed within the strict, neoclassical setting of Bremo's dining room, these chairs symbolized both the economic and intellectual power of the Cocke family, just as nearby Monticello did for Thomas Jefferson.

James Woodward, who owned the shop in which these chairs were produced, was Norfolk's most important cabinetmaker from the late eighteenth century until his death in 1839.[3] In 1795 Woodward advertised that he

> has procured at considerable expense, the best Workmen from *Philadelphia and New York*, and from *Europe*, which will enable him always to have on hand AT HIS MANUFACTORY *On the Main Street, near the New-Theatre*, A great variety of elegantly finished Cabinet Work. Such as *Chairs, Sideboards*, sets of *Card, Pier, Pembroke, Tea, Dining Tables*, elegant *Sophas, Secretaries and Book Cases, Ladies Dressing Tables*, mahogany 4 post *Bedsteads, Clock Cases*, with clocks or without, and a number of other articles.[4]

Judging from this and other advertisements, Woodward was capable of producing most forms of furniture in the current tastes. What he could not make, he no doubt was able to import for his clients through the port of Norfolk.

When Woodward made this particular set of chairs, he relied upon a plate which Sheraton had published in the *Drawing Book* (see fig. 7). This particular back design was very popular among American cabinetmakers and their customers. Consequently, chairs incorporating the neoclassical motifs of urns,

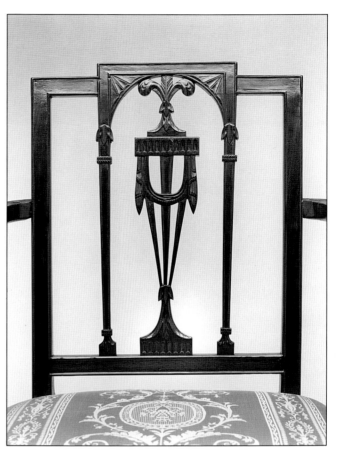

Cat. 35a

Fig. 7. Design for a chair back. From Thomas Sheraton, *The Cabinet-Maker and Upholsterer's Drawing Book*, 3d ed. (London, 1802), plate 36. (Courtesy, Dover Publications, Inc.)

swags, feathers, and columns were made in many American cities, especially Philadelphia and New York. Given that Woodward employed journeymen from both of these places, it was not necessary for him to have owned a copy of Sheraton's pattern book. His workmen carried this English image, as well as others, in their minds with them to Norfolk. The carved rosettes and leaves on the arms, as well as the flat stretchers, are features known on New York and Philadelphia chairs.[5]

STRUCTURE AND CONDITION: These chairs are constructed with mortise-and-tenon joints. Two exceptions to this practice are the corner cross-braces of the seat frame, which join the seat rails with sliding dovetails, and the central stretcher, which is also attached with sliding dovetails. The arms and supports are joined to the seat frame and the back posts, respectively, with screws. This construction and the fact that the armchairs are identical in size to the side chairs suggest that Woodward's

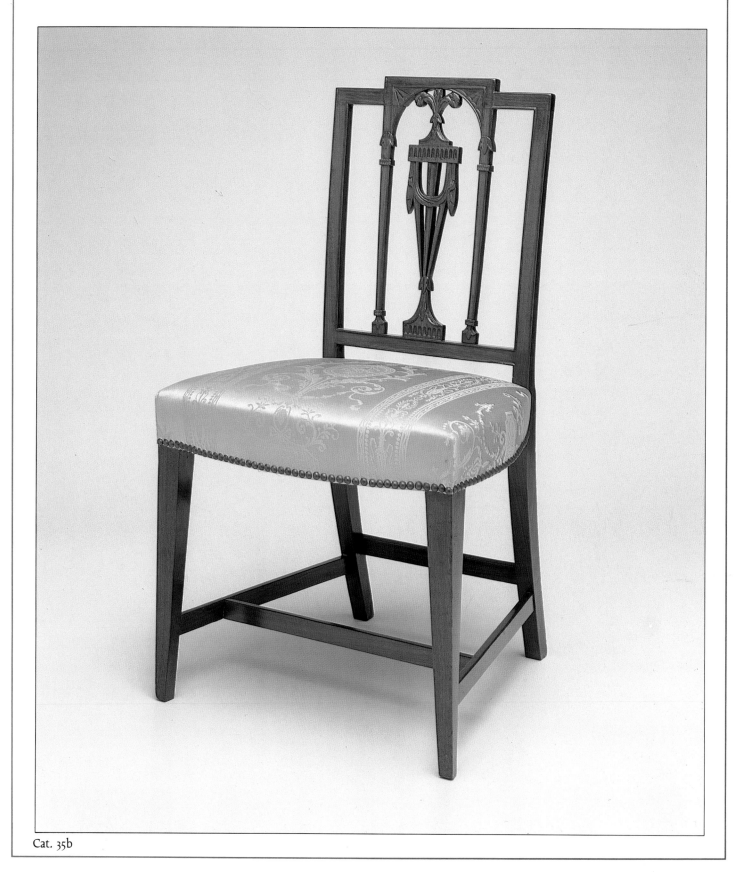

Cat. 35b

shop simply added arms to side chairs to fill this order. The lack of integration between the rear of the arms and the back posts supports this assumption (see cat. 35d).

The entire set is in excellent condition. An early twentieth-century photograph of one of the side chairs reveals that the chairs were previously upholstered in leather with a row of tacks along the perimeter of the front seat rail. The same illustration indicates that one of the side chairs was missing its cross-stretcher in the 1920s.[6] The stretcher has subsequently been replaced. Three of the chairs have eleven vertical channels in the upper splat; the others have ten.

WOODS: All exterior surfaces, mahogany; seat frame, ash; corner cross-braces of seat, yellow poplar.

DIMENSIONS: Armchair: H. 36⅛ (91.6); S.H. 18 (45.7); W. 22½ (57.2); D. 19 (48.2). Side chair: H. 35⅞ (91.1); S.H. 18¼ (46.3); W. 20½ (52.0); D. 19 (48.2).

PROVENANCE: James Woodward, Norfolk, Va.; General and Mrs. John Hartwell Cooke, Swan's Point, Surry County and Bremo, Fluvanna County, Va.; Dr. and Mrs. Cary Charles Cooke, Bremo, Va.; Lelia B. and May B. Cooke, Bremo, Va.; Valentine Auction Company Sale, 18 Nov. 1926, lot 429, Bremo, Va.; Cecil Backus, Wilmington, Del.; Ardis Leigh, Princeton, N. J.; Israel Sack, Inc., New York, N.Y.; Bybee Collection, 1964.

EXHIBITIONS AND PUBLICATIONS: Valentine 1926, lot 429; *Richmond News Leader*, "Auction at Bremo," (19 Nov. 1926); *Antiques* 86:2 (Aug. 1964): inside front cover; Fairbanks 1968, 81; MFA, H 1981.

1985.B37.1–14

Cat. 35c

Cat. 35d

1. Evidently, burnt cork was used to cover water stains in the eighteenth century. In addition to this set of chairs, the bill lists a sofa, enclosed basin stand, open basin stand, oval tea table, carved mahogany bedstead, and two stained bedsteads at a total cost of $289.33 (Cocke family papers [hereafter CFP], MS 1480, box 1, 1803, Alderman Library, University of Virginia, Charlottesville, Va.). An 1815 tax appraisal of Bremo Recess's furnishings valued the chairs as $116.00 (MS 640, box 9, 1815, CFP). The 1815 receipt for payment of taxes lists "15 Chairs of Mahogany." The count of fifteen rather than fourteen may have been an error (MS 1480, box 9, 1818–1822, CFP).

2. When the family first arrived in Fluvanna County, they moved into a wood-framed house called "Bremo Recess." The neoclassical, brick mansion of Bremo was begun in 1817 and completed in 1820. For information on Bremo, see Kimball 1949; Hodson 1967.

In August 1821 the Richmond merchants, Ellis and Allan, billed Cocke for shipping "14 Mahogany chairs" to Bremo (MS 640, box 15, 1820, CFP). This document is puzzling. Had the Bybee chairs been sent to Richmond for refurbishing before being moved into the new house, or had the chairs been left at Swan's Point for eleven years? The shipment of chairs may be explained by the presence of "Fourteen Mahogany Ladder Back Dining-Room Chairs [with] Leather Seats" at the sale of Bremo's contents in 1926 (Valentine 1926, lot 430).

Although the family ownership of two sets of fourteen mahogany chairs complicates the attribution of the Bybee set to James Woodward's shop, the existence of several virtually identical and related chairs with Norfolk-area histories strongly argues in favor of such an attribution. See MESDA files S-2371, 3625, 3631, 3804, and 6338 for similar Norfolk chairs. No "ladder-back" chairs with a Norfolk history are currently known (Ronald Hurst, letter to the author, 20 Nov. 1987, DMA files).

3. For information on James Woodward, see Hurst forthcoming.

4. *American Gazette* (Norfolk, 1 Sept. 1795). This and other Woodward advertisements are in the MESDA's Woodward files. Hurst forthcoming, 95–97, contains extensive citations on Woodward.

5. See Hornor 1935, pls. 384, 416, and Flanigan 1986, 120–122, for closely related examples. See Fales 1972, 110–111, for a painted example and Davidson 1969, 204, for a colonial revival one.

6. *Richmond News Leader* (19 Nov. 1926).

36
EASY CHAIR

1790–1810
New England

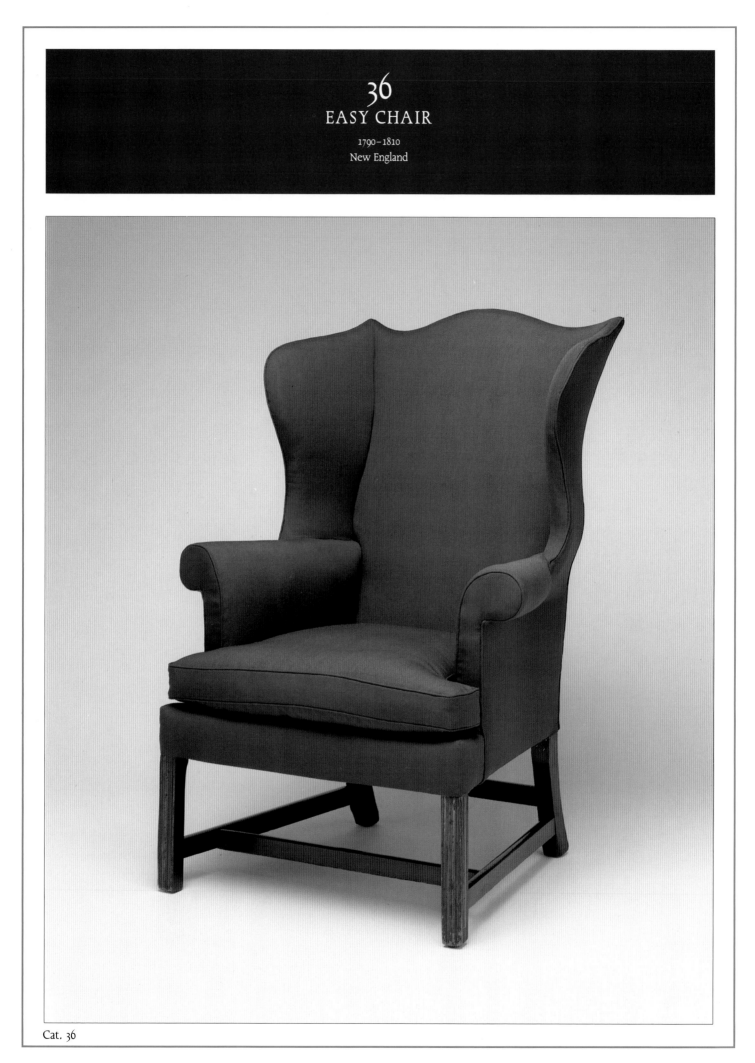

Cat. 36

IN 1794 the Englishman George Hepplewhite published a design for a chair such as this one (see fig. 8). Calling it a "Saddle Che[e]k, or easy chair," Hepplewhite noted that "they may be covered with leather, horse-hair; or have a linen case to fit over the canvas stuffing as is most usual and convenient."[1] The term *saddle cheek* refers to the shape of the wings which resemble the "cheeks" of a saddle. The same term was used in 1817 in *The New-York Book of Prices for Manufacturing Cabinet and Chair Work*. According to this book, for £1.3.0, a customer could order

AN EASY CHAIR

Two feet four inches long in front, two feet at the back, one foot ten inches from front to back, two plain legs in front, two sweeped ditto at the back, hard wood seat rails, pine back and cheeks, scrolls on the cheeks and top end of the legs, pine pieces glued on the cheeks over the joints.[2]

The inclusion of this type of chair in an 1817 price book indicates that they were made well into the nineteenth century by urban cabinetmakers.

Besides New York cabinetmakers, craftsmen all along the Atlantic seaboard made easy chairs similar to this example.[3] The extra wide seat on this chair, for example, is like those seen on Philadelphia easy chairs. However, the extensive use of yellow birch in this chair's frame suggests that it was produced in a New England cabinetmaking center such as Boston, Massachusetts, or Portsmouth, New Hampshire.

STRUCTURE AND CONDITION: The chair is mortise-and-tenoned together. Wooden pins secure the joints. The curved framing members of the back and wings are cut from single pieces of wood. The arms are tenoned through the rear stiles. There are no corner blocks in the seat frame.

The chair is in good condition. The seat has been fitted with springs. None of the original upholstery survives and vertical members have been added to the rear of both wings to anchor the upholstery fabric. Similar horizontal members have been added to the bottom of the arms.

WOODS: Legs and stretcher, mahogany; rear stiles, crest rail, top framing member of wings, soft maple; front stiles of wings, arm supports, seat frame, bottom rail of back, yellow birch.

DIMENSIONS: H. 48 (122.0); S.H. 15 (30.1); W. 34½ (87.6); D. 33⅛ (84.2).

PROVENANCE: Israel Sack, Inc., New York, N.Y.; Bybee Collection, 1964.

EXHIBITIONS AND PUBLICATIONS: Fairbanks and Bates 1981, 215; MFA, H 1981.

1985.B34

1. Hepplewhite 1794, 3 and pl. 15.
2. Quoted in Montgomery 1966, 168.
3. For related examples, see Montgomery 1966, nos. 125–128; SPB 5736 (23 June 1988): lot 353.

Fig. 8. Design for an "Easy Chair." From George Hepplewhite, *The Cabinet-Maker and Upholsterer's Guide*, 3d ed. (London, 1794), plate 15. (Winterthur Museum Library.)

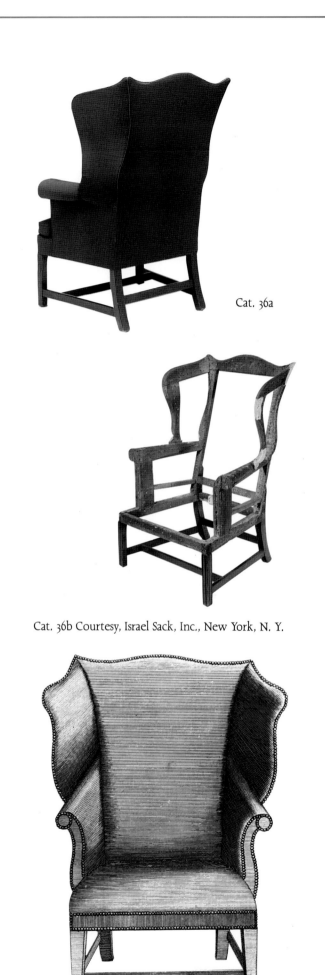

Cat. 36a

Cat. 36b Courtesy, Israel Sack, Inc., New York, N. Y.

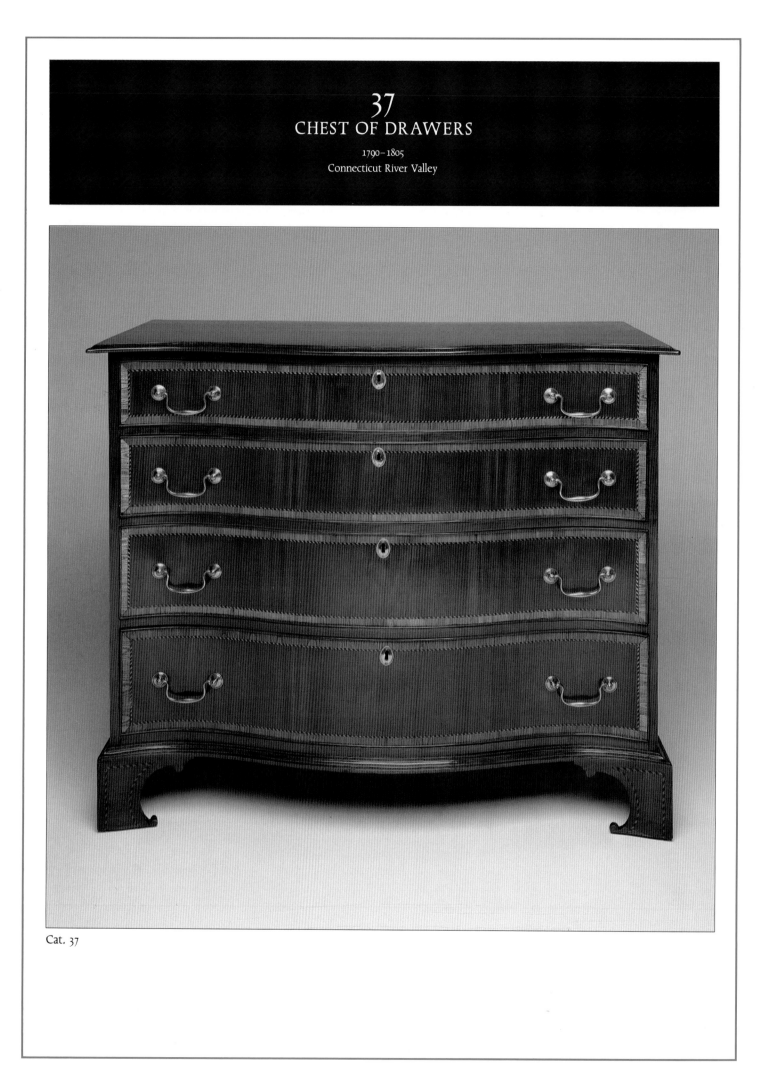

37
CHEST OF DRAWERS
1790–1805
Connecticut River Valley

Cat. 37

CONNECTICUT CABINETMAKERS have long been criticized for producing eccentric and unsophisticated furniture. This chest refutes this stereotype. The cabinetmaker who designed and built this chest of drawers was aware of the latest London fashion for serpentine-front chests with scrolled-bracket feet and banding around the drawers, top, and feet. Imported, late eighteenth-century English chests of drawers (see fig. 9) were probably the prototypes for this and other American examples.[1] Closely related chests were made in Charleston, South Carolina, and Portsmouth, New Hampshire.[2]

Based on the use of light-and-dark banding and scrolled bracket feet, this chest of drawers has long been associated with a bookcase from Providence, Rhode Island, and a small group of idiosyncratic Connecticut Valley pieces. Recent research, however, indicates that these pieces are not as cohesive a group as originally believed. For example, the label of the Providence cabinetmakers Webb and Scott which is on the "Rhode Island" bookcase is now thought to be a later addition. The piece is likely of Connecticut origin.[3]

Besides this desk and bookcase, this group contains two desk and bookcases and a chest of drawers.[4] These three pieces are all believed to be from the Connecticut Valley. However, a comparison between one of these bookcases at Winterthur and the chest of drawers seen here reveals numerous construction differences. This inconsistency suggests that the two were not made in the same shop.[5] Furthermore, the idiosyncratic inlays, relieved corners, and bracket profiles seen on the Win-

terthur desk and bookcase, as well as on the other related pieces, are not in keeping with the restrained English character of this chest. The existence of two other chests of drawers with possible Connecticut histories which are much closer in character to this example suggests that such chests of drawers were produced by an English-trained or influenced cabinetmaker working in an urban area such as Hartford.[6] Another shop working in a related, but distinct style, probably made the other pieces.

STRUCTURE AND CONDITION: All the feet are dovetailed together. A vertical and two horizontal corner blocks brace each foot. The base molding is the shaped front edge of a serpentine base rail. The bottom board abuts this base rail. The drawer dividers and runners are attached to the case sides with sliding dovetails. These joints are concealed by facing strips along the front edges of the sides. The top is screwed to the front and rear upper rails from below. The backboards are nailed into the rabbeted rear edges of the sides and along the top and bottom.

The drawer fronts are constructed of three to five laminated layers. The rear dovetails are relatively large; the front ones are covered by beading strips. The chamfered drawer bottoms fit into grooves along the front and sides and are nailed in place across the back.

The case has been taken apart. One drawer runner has been replaced, and the rest have been turned over. All drawer stops

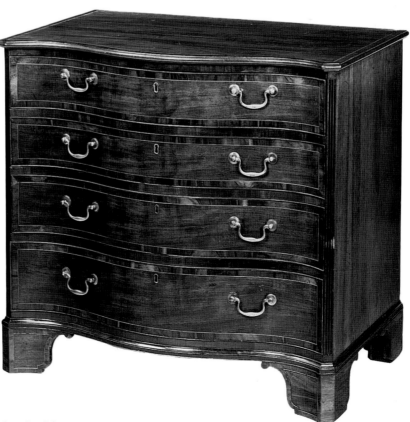

Fig. 9. Chest of drawers, England, probably London, 1780–1800. Mahogany; W. 36 (91.5). (Courtesy, Christie, Manson, and Woods, Ltd.)

are new. Following exposure to heat in a 1972 fire, the veneered drawer fronts were relaid. To accomplish this without removing the thin veneer and banding, dozens of tiny holes were drilled between the veneer and the laminated drawer fronts. Glue was injected and thin dowels forced into the holes to force the glue out behind the veneer. The scrolls on the bottom of the front and one side foot are replaced based on the surviving side examples. All the feet may have been shortened by ½" (1.3 cm.). The vertical corner blocks behind the feet are replacements; the horizontal ones are original. A crack in the top has been repaired. A left-to-right wooden brace has been added to the underside of the top for added stability. The brasses are period replacements. There has been some insect damage to the chestnut.

INSCRIPTIONS: On the inner surface of the backboards is a spurious chalk inscription reading "1717 A. D."

WOODS: Veneer, case sides, and lower front rail, cherry; drawer backs and sides, drawer dividers, and bottom board, southern yellow pine; laminated drawer fronts and vertical blocks behind feet, yellow poplar; horizontal blocks behind feet and drawer runners, eastern white pine; drawer bottoms and backboards, chestnut; light-wood inlay, possibly ash.

DIMENSIONS: H. 36⅜ (92.0); W. 45 (114.4); D. 22½ (57.2).

PROVENANCE: Horace Porter, Manchester, N. H.; Israel Sack, Inc., New York, N. Y.; Bybee Collection, 1959.

EXHIBITIONS AND PUBLICATIONS: Fairbanks and Bates 1981, 227; MFA, H 1981.

1985.B39

1. For related English examples, see *Antiques* 58:4 (Oct. 1950): 233; 68:4 (Oct. 1955): back inside cover; Christie's 3240–1 (7 Nov. 1985, London): lot 140.

2. For examples from Charleston, see Burton 1955, figs. 11–13 (fig. 12 has virtually identical feet); Montgomery 1966, no. 142 (this chest is now thought to be from Charleston); MESDA files S-1163, S-8740, S-8743. For a Portsmouth example, see Page and Garvin 1979, no. 2.

3. This piece is illustrated in AAA 3804 (Flayderman Sale, 2–4 Jan. 1930): lot 431. For information concerning the Webb and Scott label, see Christopher Monkhouse, letter to the author, 15 Oct. 1987, DMA files.

4. See Montgomery 1966, no. 177; CHS 1963, 68–69; *Antiques* 133:5 (May 1988): 940.

5. Differences between the Bybee chest and the Winterthur example include the lack of dovetails on the rear feet of the Winterthur chest, and the fact that the bottom front rail of the Winterthur desk is not molded or continuous with the bottom board. There are also differences in the blocks behind the feet on the two examples, and there are no bevels on the drawer bottoms of the Winterthur desk.

6. For illustrations of these two chests of drawers, see Nutting 1928, 1:no. 255; Lockwood 1926, 1:fig. 137.

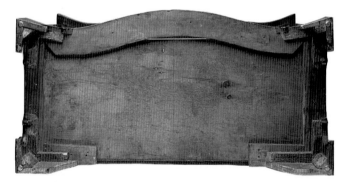

Cat. 37b

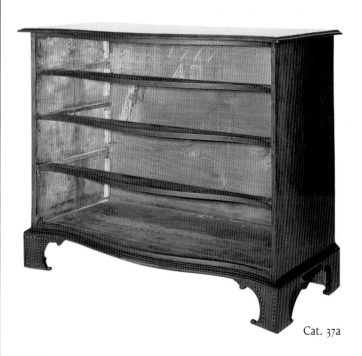

Cat. 37a

Cat. 37c

Cat. 38

WITH THE EMERGENCE OF the dining room as a specialized eating space during the late eighteenth century, new furniture forms like the sideboard were developed. In the dining room, sideboards served as staging and display areas for the elaborate dinners characteristic of upper-class entertaining during this period. One early nineteenth-century servant described the use of a sideboard as follows:

> In setting out your side-board and side-table, you must study convenience, neatness, and grandeur, as you cannot think that ladies and gentlemen have splendid and costly things without wishing them to be seen or set out to the best advantage. . . . Some persons will put out their things with such taste and neatness, that it will strike the eye of every person who enters the room with a pleasing sensation of elegance.[1]

To meet these needs, sideboards furnished ample space for the display, organization, and storage of knife boxes, dishes, and glasses. The deep drawer at the lower right of this example is fitted with dividers for holding liquor bottles. Some sideboards also contained chamber pots so that men could relieve themselves following their female companions' withdrawal from the room after the dinner.[2]

The reverse serpentine outline seen on this sideboard was developed by English cabinetmakers during the last quarter of the eighteenth century.[3] In America this shape was extremely popular. Examples which combine concave end sections with a convex central drawer above an inset pair of doors are known from Massachusetts, Connecticut, New York, New Jersey, and

Pennsylvania.[4] Several features found on this sideboard indicate that it was probably made in or near Boston. For example, the fan inlay of contrasting light and dark woods was favored by Boston cabinetmakers. Recent research has also shown that the unusually short tapered feet are most often found on Boston work.[5] However, since no documented Boston example like this is known, it is premature to rule out a possible origin in another eastern Massachusetts town, such as Salem, Newburyport, or Marblehead.[6]

Besides being a fine example of eighteenth-century taste, this sideboard has a fascinating early twentieth-century history. During the early years of this century, this piece was owned by the prominent colonial revival architect and collector, Arthur Little (1852–1925) of Boston. Little was one of the first American architects to actively integrate eighteenth- and early nineteenth-century design principles into the houses and furniture he created between 1880 and 1920.[7] In 1911 Little refurbished his own home at 35 Commonwealth Avenue at a cost of $22,917.64.[8] As evident from interior photographs of the house, Little combined English and American antiques with furniture of his own design to create the desired atmosphere. This sideboard was used in Little's dining room where it was covered with silver and flanked by side chairs of Little's own design (see fig. 10).

Cat. 38a

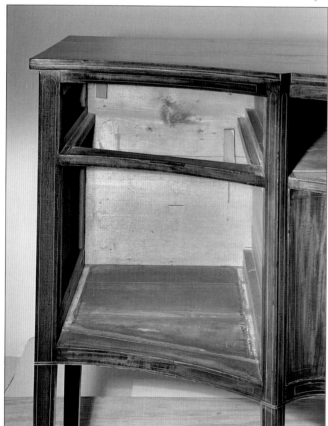

STRUCTURE AND CONDITION: The case bottom and back are single large boards. The front-to-back drawer dividers are tenoned through the backboard and are secured to the bottom board with rosehead nails. The upper and lower side rails and the medial drawer supports are glued and nailed to the side panels. The two center legs are pentagonal in section while the other four are square. The top is secured to the case with screws.

The drawers are put together with small dovetails which taper only slightly. The fronts are constructed of 2½" (6.4 cm.) laminated strips. The chamfered drawer bottoms fit into grooves run into the fronts and sides. The bottoms are nailed in place along their rear edges. The right lower drawer is fitted with dividers for the storage of bottles.

The sideboard is in good condition. Minor areas of stringing have been replaced and all drawer interiors have been varnished. Three thin strips have been glued to the bottom board behind the front lower rails to cover shrinkage cracks. The case retains its original glue blocks, drawer runners, and hardware.

INSCRIPTIONS: Twice branded on the rear of the case is "ARTHUR LITTLE."

WOODS: Veneer and legs, mahogany; drawer linings and backboards, eastern white pine; lower, front horizontal framing members, birch; front medial cross brace, soft maple; inlays, not tested.

DIMENSIONS: H. 39⅞ (101.2); W. 66⅝ (169.2); D. 27⅜ (69.6).

PROVENANCE: Arthur Little, Boston, Mass., ca. 1911; unknown collection; Israel Sack, Inc., New York, N. Y., 1952; Virginia and Nicholas Giannestras, Cincinnati, Ohio, 1952–1962; SPB 2028 (13 Jan. 1962): lot 154; Israel Sack, Inc., New York, N. Y., 1962; Bybee Collection, ca. 1962.

EXHIBITIONS AND PUBLICATIONS: Antiques 62:3 (Sept. 1952): 165; SPB 2028 (13 Jan. 1962): lot 154; Sack 1981, 1:202; Fairbanks 1968, 80; MFA, H 1981.

1985.B38

1. Footman's Directory 1823, 87.
2. For an illustration of a chamber pot being kept in a sideboard for male use only, see Stone 1977, fig. 17.
3. For English versions, see Hepplewhite 1794, pl. 29; Cabinet-Makers 1803, pl. 4 (plate engraved in 1788); Kirk 1982, nos. 1493–1500.
4. For examples from these various areas, see Antiques 58:1 (July 1950): 11; 58:3 (Sept. 1950): 160; 73:3 (Mar. 1958): inside front cover; 117:3 (Mar. 1980): 455; 119:6 (June 1981): 1221; AAA 3804 (Flayderman Sale, 2–4 Jan. 1930): lot 444; SPB 1202 (29 Nov.-2 Dec. 1950): lot 665; 2510 (28 Jan. 1967): lot 127; 5500 (24–25 Oct. 1986): lot 207; Cescinsky and Hunter 1929, 201; Hornor 1935, pl. 391; Hipkiss 1950, 81; Comstock 1962, nos. 510, 512; Greenlaw 1974, 131; Sack 1981, 6:44–45.
5. For a discussion of this feature as it relates to card tables, see Hewitt 1982, 61.
6. For the closest related sideboards located to date, see Antiques 12:6 (Dec. 1927): 436; A. Sack 1950, 219.
7. For more information on Little, see Sturges 1973.
8. Little and Brown account book, L-P, SPNEA Archives, Boston, Mass. SPNEA has the largest collection of manuscripts and drawings on Little in existence.

Fig. 10. Dining room of the Arthur Little house, 35 Commonwealth Avenue, Boston, Massachusetts. Photograph, ca. 1911. (Society for the Preservation of New England Antiquities.)

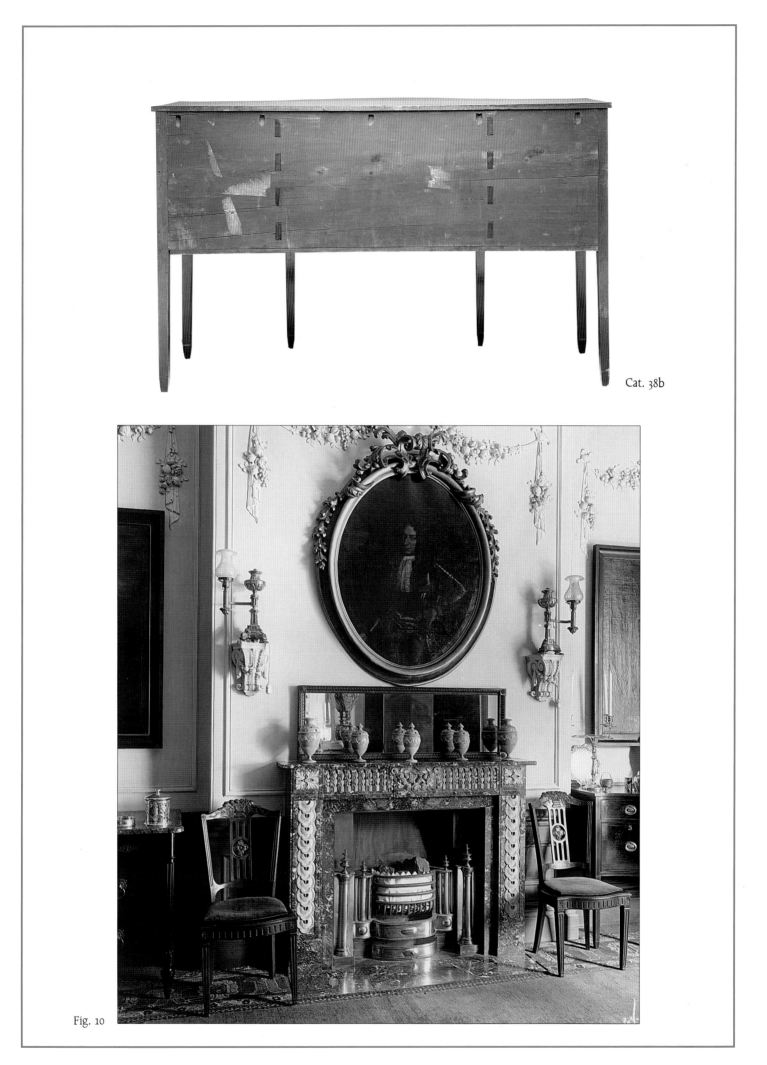

Cat. 38b

Fig. 10

BEFORE the early nineteenth century, few British or American homes were constructed with dining rooms. Rather, collapsible dining tables (see cats. 3, 24) which could easily be moved out of the way were used so that the room could serve a variety of functions. However, as dining rooms became more prevalent after 1800, large stationary tables came into use.

On the surface, this example would seem to be such a table. However, both sections of this table are designed so that they tip up once the metal locking mechanisms on their undersides are released. This feature, as well as the presence of casters, suggests that as late as 1820 many fashionable homes still required tables which could easily be stored away when not in use. This hypothesis is supported by the depiction of metal "table catches" in numerous English hardware catalogues dating between 1780 and 1830.[1]

Cat. 39a

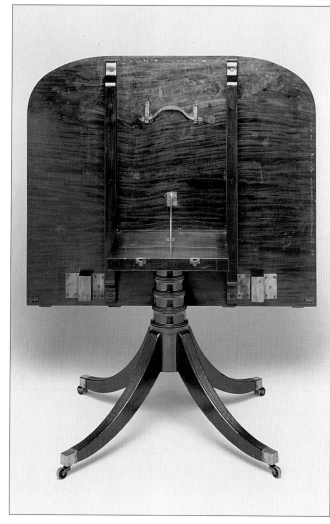

Where this table was made is unknown. Tables with splayed and fluted legs, metal-capped feet, and ringed pedestals were popular in both Britain and America during the early nineteenth century.[2] In America they seem to have been especially favored in New York City, where cabinet shops like that of Duncan Phyfe produced them.[3] However, the use of only imported mahogany in the construction of this table and the absence of any family history makes it impossible to substantiate an American origin for this particular example at present.

STRUCTURE AND CONDITION: The legs slide into grooves in the pedestal. Sheet-iron straps strengthen these joints. The pedestal joins the central block in a double tenon. This central block has cleats along both ends for stability. Screwed to the underside of each top section is a pair of cleats which act as hinges for the top. When down, the tops are locked in place with brass, spring-loaded catches. The brass U-brackets beneath the top receive rectangular members which support additional leaves.

The table is in good condition. Shrinkage cracks in the top have been closed with butterfly-shaped inserts in several places. Most screws have been replaced with machine-produced ones. The brass catches on the underside of the top of both sections are appropriate replacements. The originals were slightly larger. The sheet-brass brackets on the underside of the top are probably later additions. Small circular indentations surround the perimeter of the top along its underside. These were probably caused by the attachment of a vise-type pincushion or sewing box, commonly known as "sewing-birds." The casters are original.

WOODS: All elements, mahogany.

DIMENSIONS: H. 28¾ (73.0); W. without leaves 79¾ (202.6); D. 47⅞ (121.6).

PROVENANCE: John Walton, Inc., Riverside, Conn.; Bybee Collection, 1954.

1985.B36

1. An investigation of dozens of Birmingham and Sheffield hardware catalogues from this period at Winterthur Museum Library revealed that both single and double "table catches" of the type seen here were in common use during this period.

2. For closely related English examples, see *Antiques* 59:2 (Feb. 1951): 90; 128:4 (Oct. 1985): 260. For related examples of supposed American origin, see *Antiques* 52:6 (Dec. 1947): 389 and 71:6 (June 1957): 492; Sack 1981, 5:1297, 6:1460-1461.

3. For a table with similar mechanical works and a traditional Phyfe provenance, see SPB 745 (28 Feb. and 1–2 Mar. 1946): lot 599. For another closely related table with identical mechanical works, see DAPC 80.685.

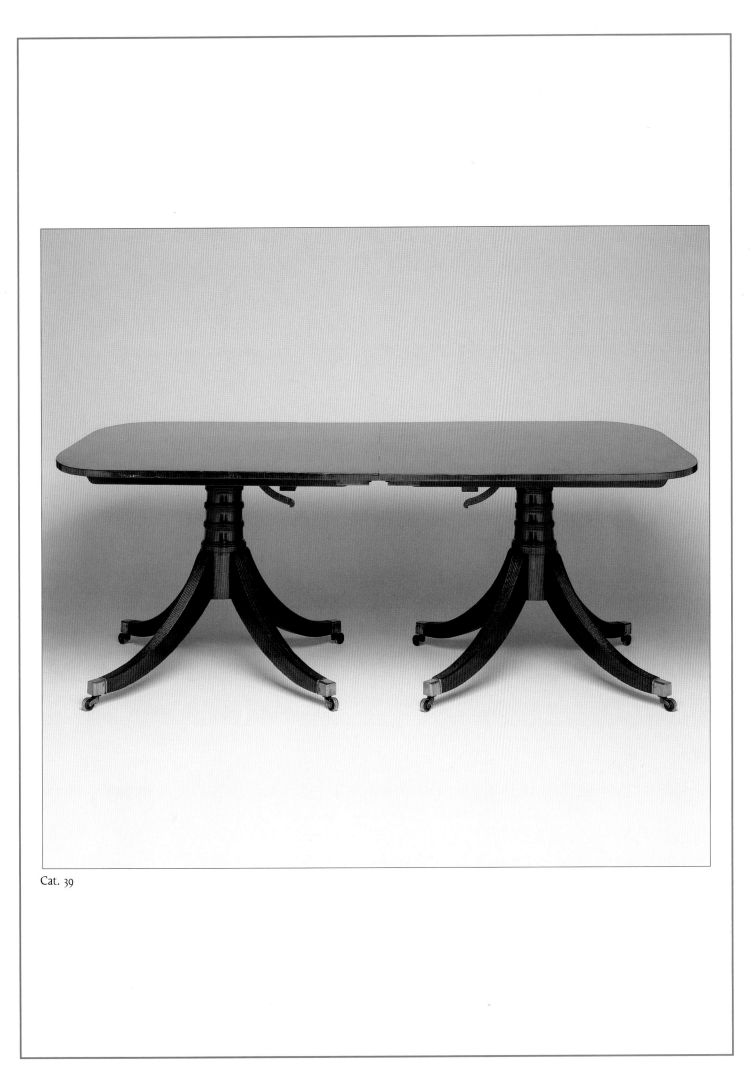

Cat. 39

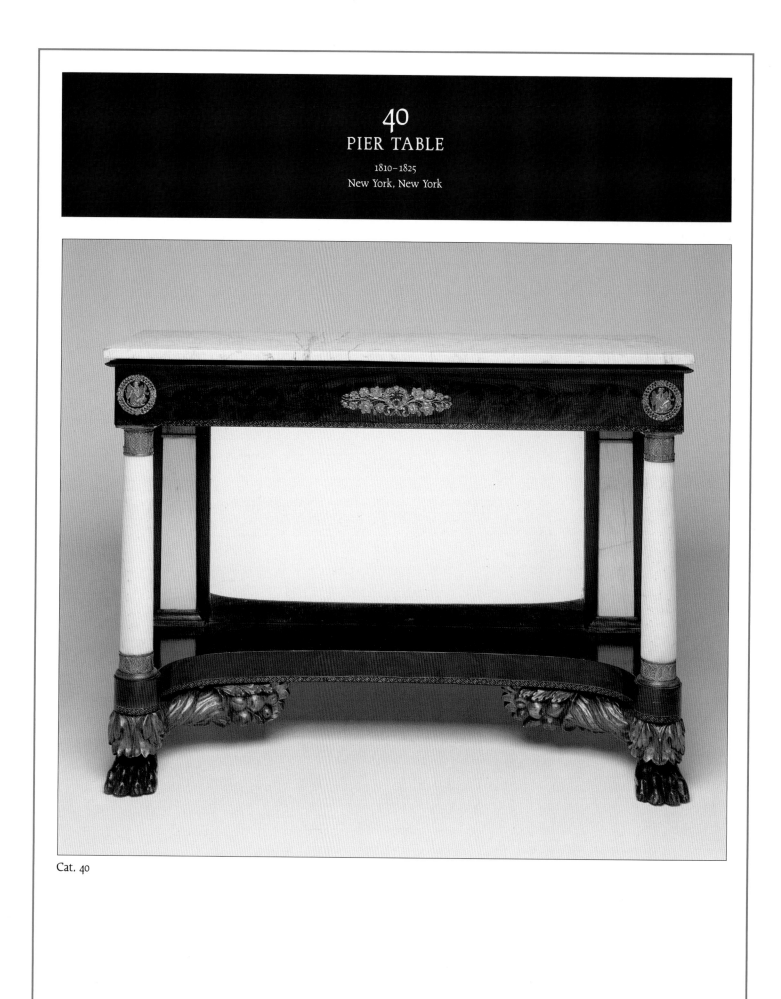

40
PIER TABLE

1810–1825
New York, New York

Cat. 40

ELABORATELY CARVED pier or console tables with marble tops were used symmetrically in pairs against "pier" walls on either side of windows during the eighteenth century. However, during the first decade of the nineteenth century, the Napoleonic court designers Charles Percier (1764–1838) and Pierre-François-Lénourd Fontaine (1762–1853) transformed the rococo and early neoclassical pier tables into the form seen here. Typical of their work and that of their imitators is this table's horizontal orientation, rectangular design, use of marble free-standing columns, rear marble pilasters, mirrored back, and ormolu brass mounts. The presence of ancient classical symbols, such as imperial victory wreaths, goddesses, Greek anthemia, cornucopia, and paw feet, are also characteristic of early nineteenth-century French court work.

Inspired by the arrival of continental cabinetmakers, such as Charles-Honoré Lannuier (1779–1819), and the importation of continental furniture and pattern books, New York craftsmen produced some of the most sophisticated neoclassical furniture in America. Rather than rely on exuberant carving or extensive gilding to convey a sense of opulence and wealth (compare with cats. 48, 55, 56), the maker of this pier table placed his emphasis on broad expanses of finely figured mahogany, white marble, and mirrored glass—all costly luxuries. Although of visual and symbolic importance, the gilt details are subordinate to the overall rectangular design.

Tables such as this were extremely popular among New York's expanding elite during the first two decades of the nineteenth century. Today numerous pier tables similar to this example survive. Unfortunately, few are documented to a particular cabinet shop.[1] The shop that made this particular example is unknown. However, several other tables are known which appear to be from the same establishment.[2]

STRUCTURE AND CONDITION: Three front-to-back braces run beneath the base. The marble columns are fixed in place by iron rods which extend from their ends. The top molding is nailed to the skirt which is dovetailed together. There is a central front-to-back brace beneath the top. Two boards have been inserted into the upper skirt to give added support to the top.

The marble top has cracked. A rectangular piece of plywood has been glued to the bottom of the top for added strength. Two front-to-back braces have also been added to the top of the frame to support the top. The backboard is a replacement, as is the mirror glass. The right pilaster base is new. All of the ormolu mounts and column capitals and bases appear to be original. Portions of the stenciled borders have been overpainted. The paw feet retain their original green-black paint which simulates antique bronze. The scrolled leaves above the feet and the cornucopias are finished with various colors of gold leaf and bronze powders.

WOODS: Veneer and top molding, mahogany; front feet and cornucopia, main rear framing members, top cross brace, interior blocks above columns, left pilaster base, eastern white pine; lower rear horizontal brace, ash; right pilaster base (replacement), Douglas fir.

DIMENSIONS: H. 38⅝ (98.2); W. 54⅛ (137.5); D. 22 (55.9).

PROVENANCE: Rozella Becker, Hyde Park, N. Y.; Israel Sack, Inc., New York, N. Y.; Bybee Collection, 1964.

EXHIBITIONS AND PUBLICATIONS: Fairbanks and Bates 1981, 267; MFA, H 1981.

1985.B43

1. For related tables by Michael Allison and Meeks and Sons of New York, see DAPC 74.656; Tracy 1970, no. 68, respectively.
2. See Warren 1975, no. 189; Stroup 1981, 1435. For another related table, see Rice 1962, 60.

Cat. 40a

41
DRUM TABLE

1810–1825
Probably New York, New York

SMALL, MOVABLE TABLES for serving tea or holding lighting devices were popular in early nineteenth-century America. However, circular ones such as this were not.[1] In Britain, where they were used extensively, tables like this were called drum tables. The presence of the word "Drum" on this example suggests that American cabinetmakers used this term in the early nineteenth century as well.

This table is exceptionally well-designed and crafted. High quality crotch mahogany and mahogany veneers are used throughout. To enhance the richness of the legs, rectangular sections of crotch mahogany are veneered onto the knees. Similarly, the carving on the pedestal and the feet is finely done. The existence of a virtually identical table with much coarser carving indicates that the table seen here represents the finest work done by this particular cabinetshop(s).[2]

The precise origin of this table is not known. However, it is likely that it was made in New York City. Dark mahogany furniture with neoclassical carving was popular in New York. Furthermore, several dining and sewing tables which use this unusual form of reverse-curve leg are known with New York histories.[3] Unfortunately, the inscription "Mendell / EM" which is on this table has not been positively identified. Presumably,

Cat. 41a

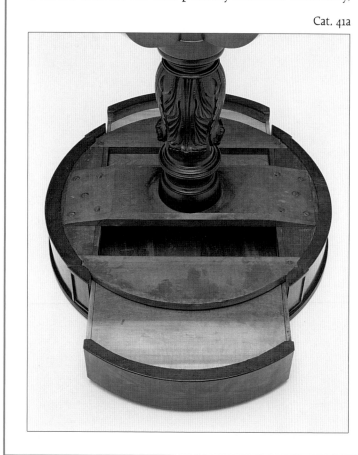

this notation refers to a former owner, but no corresponding person has been found in New York City directories for this period. To date the most likely match is in Albany, where an attorney by the name of Ephraim Mandell resided in the 1810s.[4] If Mandell was the original owner of this table, he could have ordered it from New York City or had it made locally in Albany.

STRUCTURE AND CONDITION: The legs are slotted into the pedestal with sliding dovetails. The knees are veneered with rectangular sections of crotch mahogany. The pedestal is secured to the cross brace with a double mortise-and-tenon joint. The solid curved side sections of the skirt are attached to the cross brace with three screws at each end. The presence of four pre-drilled, but unused, screw holes in the cross brace suggests that this type of cross brace, pedestal, and leg assemblage was produced in a specialized turning/carving shop and then sent to a cabinetmaker for use with a variety of tops. The two drawers are constructed with medium-size dovetails. The drawer fronts are built up from two laminated sections. Their flat bottoms are rabbeted and fit into grooves run along the drawer fronts and sides. The bottoms are nailed across the back.

This piece is in excellent condition, with only minor stress cracks. The casters may be original. The top is slightly warped.

INSCRIPTIONS: Written in pencil on the underside of one drawer is "Mendell / EM" followed by an illegible word beginning with "N." Written on the brace below this drawer is "Drum." The legs and their corresponding slots in the pedestal are marked "I" through "IIII."

WOODS: Veneer, top, pedestal, and legs, mahogany; drawer sides and bottoms, yellow poplar; central cross brace, cherry; skirt sides, eastern white pine.

DIMENSIONS: H. 28½ (72.4); Diam. top 21⅛ (53.7).

PROVENANCE: Harry Arons, Ansonia, Conn.; Israel Sack, Inc., New York, N. Y.; Bybee Collection, 1961.

EXHIBITIONS AND PUBLICATIONS: Fairbanks 1968, 82; Fairbanks and Bates 1981, 264; MFA, H 1981.

1985.B50

1. Drum tables appear rarely in the literature. For those known, see *Girl Scouts* 1929, no. 762; *Antiques Monthly* 20:5 (Apr. 1987): 3A; SPB 5599 (26 June 1987): lot 148.
2. This second table is in the Museum of Fine Arts, Boston (1986.806).
3. For New York tables which use this leg, see Ormsbee 1933, 226; McClelland 1980, 107; DAPC 73.732.
4. Mandell is listed in Albany's directories from 1813 to 1820.

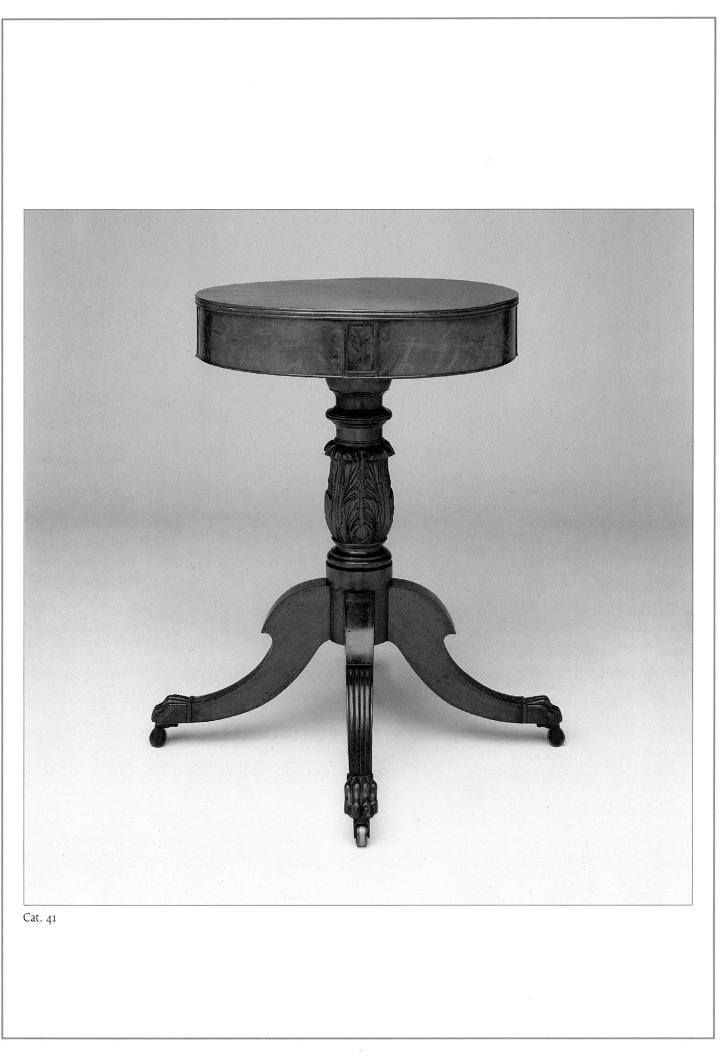

Cat. 41

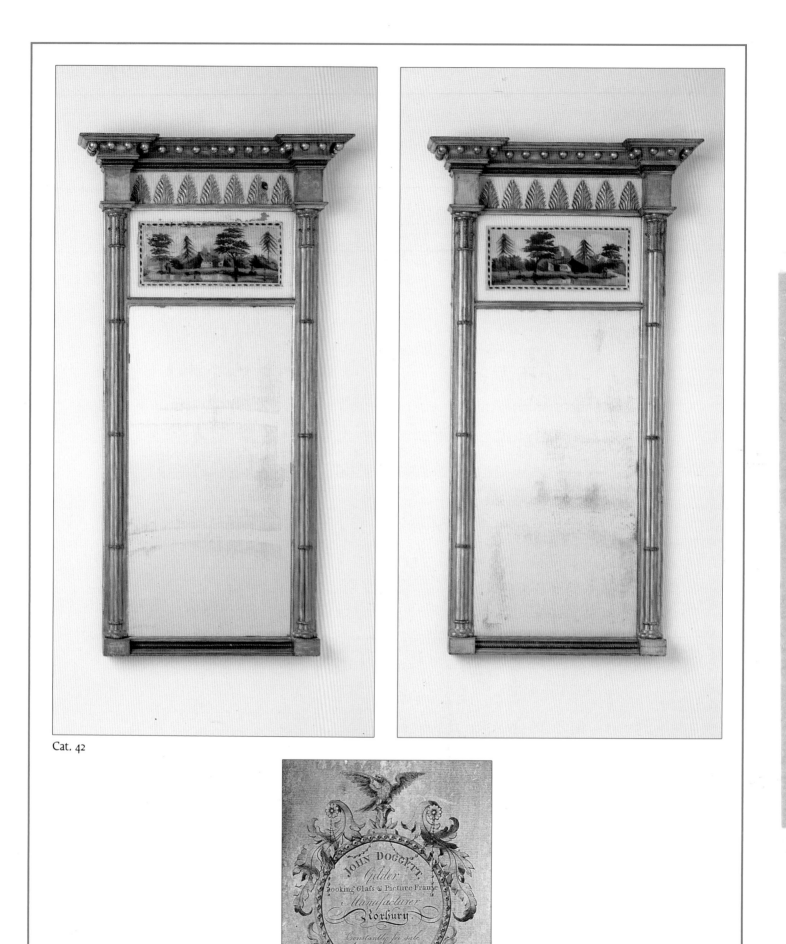

Cat. 42

Cat. 42a

IN 1806 John Doggett established a "Looking Glass and Picture Frame Gilding Factory" near Boston in Roxbury, Massachusetts.[1] During the next decade this enterprise grew into perhaps the largest firm of its kind in America. Probably trained as a cabinetmaker, Doggett undoubtedly did much of the framing, carving, and gilding of his products himself.[2] However, he also employed a substantial number of apprentices and specialty craftsmen. The decorative painter John Ritto Penniman (1782–1841), for example, probably painted the reverse paintings on glass in the tops of these looking glasses.[3]

Large, rectangular looking glasses like these with inset painted scenes and gilt neoclassical ornament were patterned on English examples.[4] The silvered glass they hold was often imported from Paris.[5] The use of imported glass, gold leaf, and many hours of labor meant that such glasses were expensive. In 1807, for example, Doggett recorded in his account book that he sold a pair of looking glasses identical in size to these to the wealthy Boston merchant, Andrew Cunningham. Cunningham paid the enormous sum of $327 for his pair.[6] Although expensive, looking glasses like those seen here and simpler versions of them were popular among America's wealthy elite. Numerous related examples have survived.[7]

The demand for such glasses allowed Doggett to sell his products outside the Boston area. Doggett's account books reveal that he sent numerous looking glasses on consignment to merchants in cities as far afield as Montreal and New Orleans. He also supplied raw materials such as gilt balls, gold leaf, glue, and glass to other looking-glass makers from Portland, Maine, to New York City.[8]

STRUCTURE AND CONDITION: The frames are mortise-and-tenoned together. The backboards are nailed in place. The columns are nailed and glued to the frames. The leaves on the cornice are plaster. The balls are attached with wires which pass through the cornices.

These glasses are in excellent condition. The gilding is original, as is the mirror glass. One of the reverse paintings on glass has some flaking areas. The hanging devices currently on the glasses are replacements.

INSCRIPTIONS: Both looking glasses bear Doggett's paper label on their versos. For label information see cat. 42a.

WOODS: All parts, eastern white pine.

DIMENSIONS: H. 56⅞ (144.5); W. 31 (78.7); D. 5⅝ (14.3).

PROVENANCE: John S. Walton, Inc., Riverside, Conn.; Bybee Collection, 1950s.

EXHIBITIONS AND PUBLICATIONS: Fairbanks 1968, 82; Fairbanks and Cooper 1975, 183–184. MFA, B 1975, 183–184; Cooper 1980, no. 55; Fairbanks and Bates 1981, 244, 246; MFA, H 1981.

1985.B40.1, .2

1. For a complete listing of Doggett's shop addresses and partnerships, see Ring 1981, 1183.

2. Doggett's master is as yet unknown. However, the records of the Massachusetts Charitable Mechanics Association to which Doggett belonged state that "J[ohn] D[oggett] probably served apprenticeship at Cabinet Making. He could do complete and finished work in that branch proving that he was a first rate workman. Gilding and Silvering Looking glass plates he probably learned subsequently. I have seen a finished model of the Bunkerhill Monument of Mahogany Blocks showing the extension and also interior which he made at his leisure. [signed] N. C." MCMA Biographical Notes (ca. 1860), box 3, bundle 2, Massachusetts Historical Society, Boston, Mass.

3. For information on Penniman, see Andrews 1981.

4. For a closely related English example, see Christie's 3360 (London, 1 May 1986): lot 77.

5. For a discussion of Doggett's importing and exporting of materials and finished products, see Montgomery 1966, 256.

6. John Doggett account book 1802–1809, 144 (7 Jan. 1807), Joseph Downs Manuscript and Microfilm Collection, Winterthur Museum Library. Even though the size of the Cunningham glasses is identical to these, the high cost of the former suggests that they had elaborately carved ornaments on them.

7. For an almost identical glass, see Antiques 92:3 (Sept. 1967): 317. For closely related examples, see Sack 1981, 1:156 (now St. Louis Museum of Art), 3:846.

8. Montgomery 1966, 256.

Cat. 42b

43
GIRANDOLE MIRROR
1810–1830
America or England

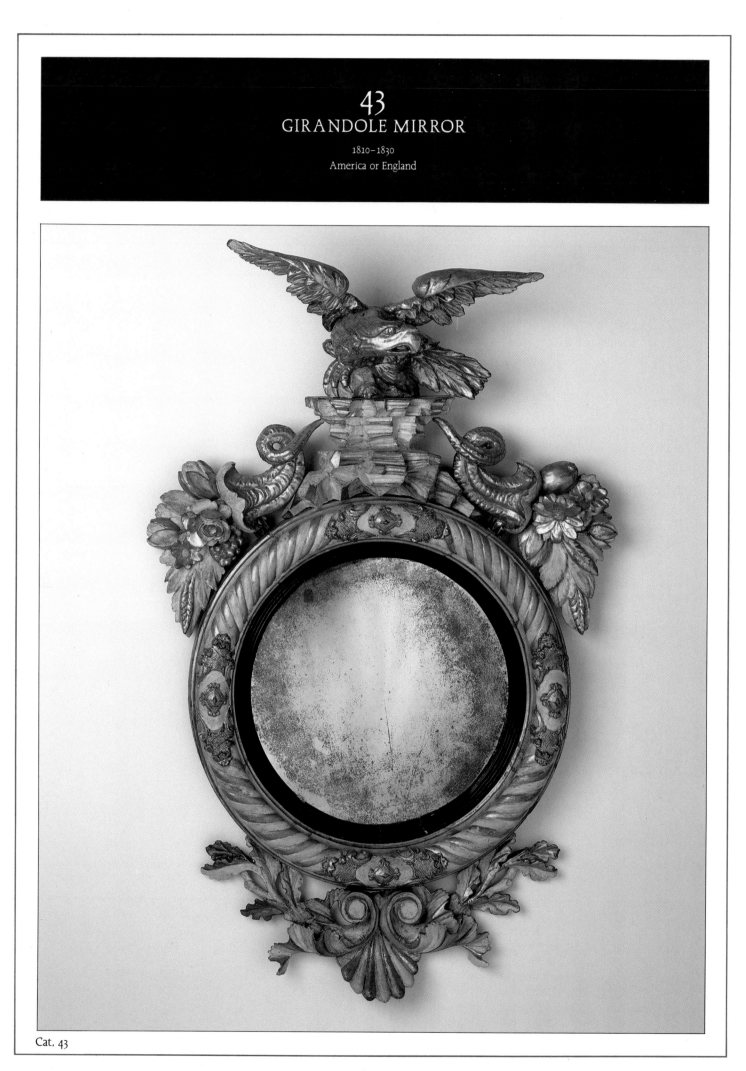

Cat. 43

IN 1803 the influential English designer Thomas Sheraton (1751–1806) commented: "As an article of furniture, a mirror is a circular convex glass in a gilt frame, silvered on the concave side, by which the reflection of the rays of light are produced.... They are now becoming universally in fashion."[1] Sheraton was not exaggerating their popularity. Americans appear to have acquired English girandole, or convex, mirrors soon after 1800. During the next two decades, hundreds of these mirrors were imported for wealthy Americans. A small portion of those used may have been made in this country. However, making round frames was difficult and only a few specialized woodworking shops would have been equipped to produce them.

If convex mirrors were made in America, most of them probably came from the shop of John Doggett of Roxbury, Massachusetts (see cat. 42). Doggett had a large manufactory which supplied looking glasses to customers from Maine to New Orleans during the early nineteenth century.[2] Significantly, his label depicts a girandole mirror similar to the one illustrated here (see cat. 42a). Both the label and this mirror are derived from ancient Roman imagery, a laurel wreath surmounted by an imperial eagle.

The Bybee mirror is made of native American pine, indicating that it could have been made here. However, American white pine was exported in huge quantities to Great Britain. Consequently, it is not possible to positively identify the origin of this mirror.

Whatever its place of manufacture, this mirror must have fascinated those who used it originally. In 1808 the English designer George Smith commented on the effect of such mirrors: "In apartments where an extensive view offers itself, these Glasses become an elegant and useful ornament, reflecting objects in beautiful perspective on their convex surfaces; the frames, at the same time they form an elegant decoration on the walls, are calculated to support lights."[3] In order to produce the desired distortion of light and space, such mirrors were hung high on a wall. The carver of the Bybee example compensated for the mirror's position far from the viewer's eye by using large, vigorous forms which could be read easily.

The Bybee mirror is unusual in two respects. First, the large rope motif seen on the frame is not common on girandole mirrors.[4] Similarly, the use of both white and gold, as opposed to several shades of gold, is atypical. It appears that this mirror was entirely gilded originally. Under the old white paint are traces of gold leaf. The paint may represent a contemporary attempt to integrate the mirror into a room furnished with white furniture. White and gold furniture was popular during the 1810s.[5]

STRUCTURE AND CONDITION: The circular rim is composed of two layers of arched sections. The carved rope molding is applied on top of this laminated base structure. The glass is surrounded by a ring of five laminated layers. The carved ornaments are attached to the circular frame with thin sticks and screws.

Given the fragility of such mirrors, this example is in relatively good condition. The carved ornament and glass are original. The backboard is missing and the lower ornament support is a replacement. The white paint is old, but not original. Losses to the white and gold decoration have been in-painted. Two small holes on either side of the frame suggest that this mirror once had wire sconces or side ornaments attached to it.

WOODS: All major components, eastern white pine.

DIMENSIONS: H. 47¾ (121.2); W. 31½ (80.0); D. 8¼ (20.9).

PROVENANCE: L. Evans, New York, N. Y.; Israel Sack, Inc., New York, N. Y.; Bybee Collection, 1964.

EXHIBITIONS AND PUBLICATIONS: MFA, H 1981.

1985.B42

1. Sheraton 1802, 271.
2. Montgomery 1966, 256–258.
3. G. Smith 1808, 25 (pls. 135–136).
4. For mirrors with rope borders, see DAPC 69.2711; Nutting 1928, 2:no. 3166. For illustrations of numerous girandole mirrors, see H. Schiffer 1983, nos. 602–616. For a mirror with similar carved elements, see Fairbanks and Bates 1981, 245.
5. For examples of white furniture, see Montgomery 1966, nos. 476, 483.

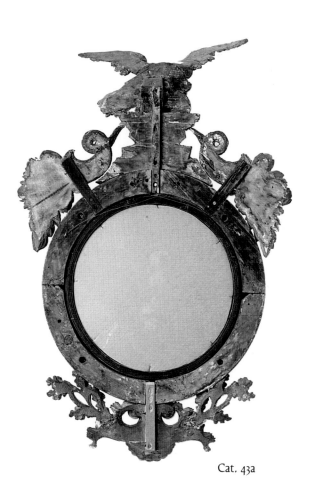

Cat. 43a

44
ARMCHAIR
1810–1830
New York, New York

THE CONTEMPORARY TERM "fancy chair" aptly describes this exceptional object. The entire surface is grained in red and black to resemble rosewood. The paw feet and ball-arm supports, as well as the stenciled "Grecian" decoration on the back stiles, front legs, and seat rail, were originally bright gold. The crest rail probably had similar classical decoration originally.[1] To add even more color to the design, a cushion was most likely placed on the seat. Such an elaborate use of paint, caning, and fabric made this chair an expensive object.[2]

Currently, this armchair is the only one of its type known. However, closely related side chairs do survive from New York.[3] In 1810 *The New-York Revised Prices for Manufacturing Cabinet and Chair Work* reflected the popularity of such chairs among the wealthy by including prices for fitting chairs with "scroll sweep elbows [arms]" and for "preparing the front legs for lion's paws."[4] These features, as well as the curving legs and back, were inspired by ancient Greek chairs called *klismos*.

Given the urbanity of this chair, it is interesting that it was originally owned in Lenox, Massachusetts.[5] Lenox is in the Berkshire Mountains in the far western part of the state. During the early nineteenth century, towns like Lenox were bound by trade routes to the Hudson River valley rather than to Boston and the Atlantic to the east. It is therefore not surprising that a successful doctor in Lenox looked down the Hudson to New York City for fashionable furnishings. By 1820 New York was the cultural capital for America's elite. Not unlike the imperial civilizations to which it looked for inspiration, New York's influence spread northward up the Hudson to Albany and the Great Lakes and southward to Richmond, Savannah, and New Orleans. As her "Grecian chairs" moved outward, so too did New York's cultural dominance.

STRUCTURE AND CONDITION: The chair is joined with mortise-and-tenon construction. The paw feet consist of two pieces of wood added to either side of the leg. The back caning is woven through holes in the crest and lower rails. The rear caning is secured to wooden strips attached to the inside of the vertical stiles. The bottom caning passes through holes in the front and rear rails. The sides of the seat frame are constructed with two sets of rails. It is the interior pair that provide holes for the caning. There is a ½" (1.3 cm.) space between these interior and exterior rails.

In the early 1970s, the chair was cleaned and the scrolled end of the right stile was reattached following a break. The right stile has been broken and repaired above the seat rail. Both stiles have been cracked and repaired at the crest rail. A split in the rear seat rail has been repaired with wooden pegs and screws. The back caning appears to be original. The seat is a replacement. The entire painted surface is worn; the decoration on the crest rail is probably not original.

WOODS: Front and rear legs, hard maple; front seat rail, soft maple; crest rail and arm, maple.

DIMENSIONS: H. 41⅝ (105.7); S.H. 17 (43.2); W. 23⅜ (59.4); D. 26¾ (68.0).

PROVENANCE: Dr. Joseph Thompson, Lenox, Mass.; Alice Hunt Bartlett, New York, N. Y.; William H. Robinson, New York, N. Y.; Israel Sack, Inc., New York, N. Y.; Bybee Collection, 1964.

EXHIBITIONS AND PUBLICATIONS: Fairbanks and Bates 1981, 258; MFA, H 1981.

1985.B56

1. The stenciled flowers and fruit on the crest rail are of a totally different character and are probably of a much later date. The crest rail likely received heavy wear from the sitter's head, thereby losing its decoration.

2. For an example where chairs with caned seats and cushions cost more than those with covered slip seats, see Montgomery 1966, 126–127.

3. See Bishop 1972, no. 455; Tracy and Gerdts 1963, no. 51; Montgomery 1966, nos. 77–78.

4. New York 1810, 56.

5. William H. Robinson, letter to Israel Sack, Inc., 13 July 1964, Sack archives, New York, N. Y. According to Robinson, he inherited the chair from Alice Bartlett in 1948. Bartlett had received it from her uncle, Dr. Joseph Thompson of Lenox. Bartlett remembered the chair as being part of Thompson's original furnishings which were described as by "Phyfe."

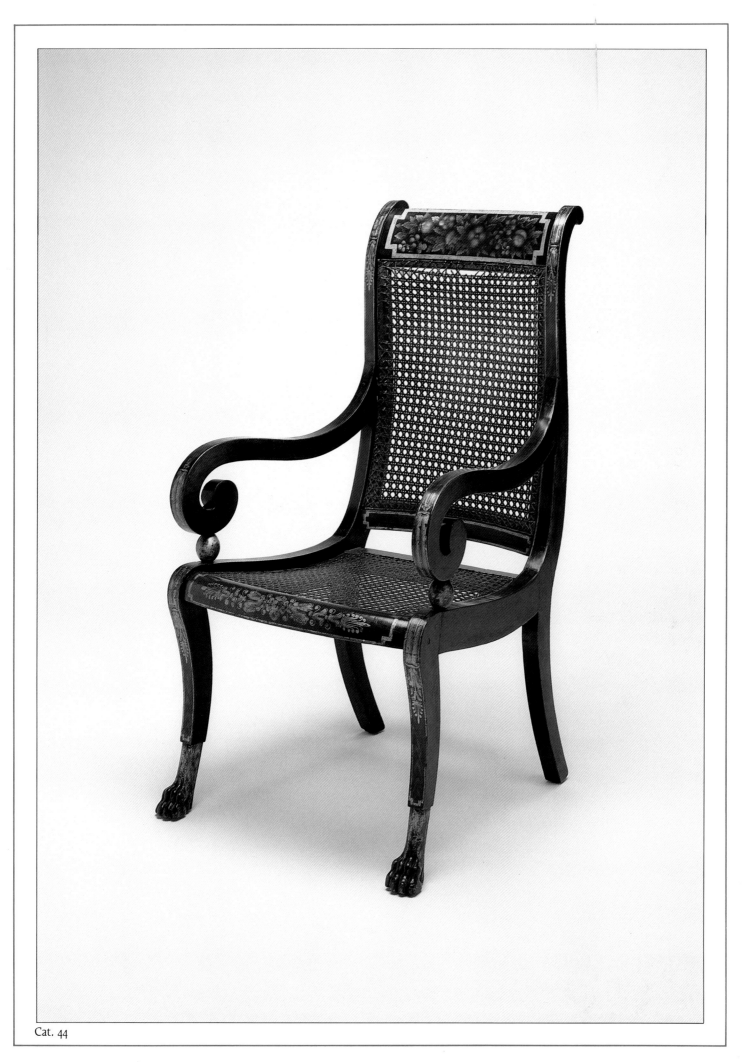

Cat. 44

45
PAIR OF KNIFE BOXES

1814
David Sackriter (1780–1849)
Philadelphia, Pennsylvania

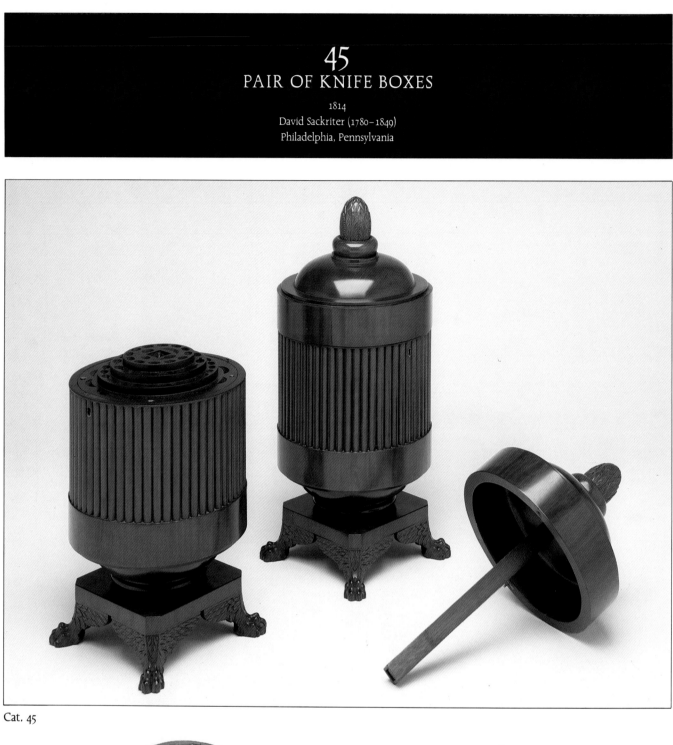

Cat. 45

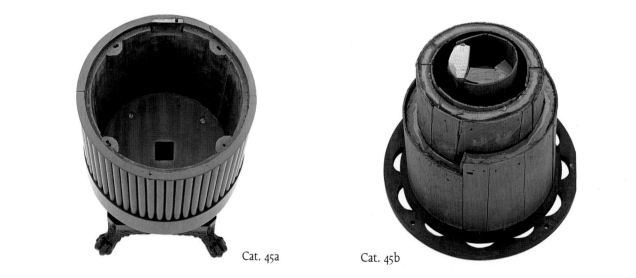

Cat. 45a Cat. 45b

SPECIALIZED BOXES for the holding of flat silver were seldom made in America during the eighteenth and early nineteenth centuries. The vast majority of those used in wealthy households in this country were imported from England. This pair of boxes, signed and dated by an American craftsman, is thus an especially important example.

Circular, urn-shape knife boxes first became popular in Great Britain in the 1760s as a result of the growing interest in classical antiquity. During the last quarter of the century, British specialty makers regularly produced urn-shape knife boxes with tops which were elevated on central, extendable shafts. Such boxes were placed on sideboards or on individual plinths.[1] In 1788 George Hepplewhite included four designs for such "knife cases" in *The Cabinet-Maker and Upholsterer's Guide*.[2]

In their use of a circular form, rectangular bases, and extendable, central shafts, these boxes are ultimately based on late eighteenth-century English examples. However, in terms of their massive scale and bold carving, they are quite different from their English predecessors. Rather than the delicate, stylized urns popular earlier, here the composition is blocky and bold, and the classical iconography more accurate. Symbols of Imperial Rome abound; winged paw feet support the bases and the reeded central section of each box suggests an ancient bundle of rods (*fasces*) symbolic of the state. Either placed on a massive sideboard or on the floor in a dining room, these boxes when filled with silver must have been an impressive sight.

Before the discovery of this pair of boxes, the life and work of their maker, David Sackriter, was totally obscure. Based on these signed and dated examples, three additional pairs can now be attributed to Sackriter. Although each set has slightly different finials and the Metropolitian examples rest on flat bases, all three pairs are otherwise identical.[3] No other examples of cabinetnetwork by Sackriter are known at present.

While Philadelphia city directories list him as a cabinetmaker between 1807 and 1845, it is possible that Sackriter actually worked as a specialty boxmaker.[4] English knife boxes were traditionally made in specialty shops, and by the early nineteenth century there was a strong movement toward specialization in this country as well.[5] Whether he concentrated on boxes or not, Sackriter appears to have been relatively active and successful as a craftsman. He was a member of the Society of Journeyman Cabinetmakers, for example.[6] Furthermore, in 1841 he was taxed on "3 Houses and lots [worth] $1700." Sackriter did not own all the land he used, however, because the same document records his paying $40 in ground rent to a Mrs. Levy and $26 to the Marine Insurance Company.[7] When he died in 1849, Sackriter left the use and income of his property in Moyamunsing to his son, Daniel P. Sackriter. Daniel is listed as working with his father as a cabinetmaker in the city directories between 1842 and 1849.[8]

STRUCTURE AND CONDITION: The base block is a solid piece of mahogany. Cleats with mitered ends are attached to opposite ends of this block. The feet are integral with their flanking wings and apparently tenon into the base blocks. Horizontal glue blocks brace the legs. The upper section is secured to the baseblock from below. The bottom of the upper section and the domed top are turned from solid pieces of wood. The cylindrical midsection is constructed like a barrel. Each mahogany section has had its exterior surface scored to enable it to bend easily. Reed-like strips are glued to the exterior of this section. The lower rim of the top is shaped from several curved sections of mahogany. The finial is screwed on from below. The square shaft extends so that the top stands open, exposing the silverware inside.

The interior cutlery holder is constructed of semicircular sections around which thin vertical boards are nailed and glued. The mahogany cap consists of four pierced layers. This interior unit is screwed to four projections on the interior wall of the housing.

INSCRIPTIONS: The bottom of one box signed in pencil "David Sackriter / Jan. 12, 1814." Both boxes signed in pencil on the interior "Fully restored by / Vincent Cerbone / MFA Boston, Mass. / 6-10-74."

WOODS: All exterior surfaces, solid mahogany; interior, eastern white pine.

DIMENSIONS: H. 27½ (69.8); W. across feet 15⅛ (38.4); D. 11¼ (28.5).

PROVENANCE: Gary Cole, New York, N. Y.; Ronald Bourgeault, Hampton, N. H.; Bybee Collection, ca. 1974.

EXHIBITIONS AND PUBLICATIONS: PMA 1976, 231; MFA, H 1981.

Promised gift of Faith P. Bybee, 2., 3.1986

1. For a discussion of English urn-shape boxes, see Norman-Wilcox 1934, 222–226.

2. Hepplewhite 1794, pl. 39.

3. One pair is in the Metropolitan Museum of Art, New York, N. Y. (1970.260.1,2); see Bordes 1972, no. 20. The second pair descended in the Cadwalader family and is now in the Hill-Physick-Keith house in Philadelphia (DAPC 69.1431). Family tradition states that this set was used upon an eight-foot-long sideboard now in the Hill-Physick-Keith house. For a third pair, see SPB 5142 (26–28 Jan. 1984): lot 715.

4. Sackriter worked at 149 Cedar (now South) St. (1807–1810); 7th and Bedford Sts. (1811–1817); and 259 South St. (1818–1845). For this and other general information, see PMA 1976, 231.

5. Sheraton 1802, 392, states that knife boxes were "not made in regular cabinet shops," but by "one who makes it his main business."

6. PMA 1976, 231.

7. 1841 State Tax List, (48), Philadelphia County, Philadelphia Municipal Archives, Philadelphia, Pa.

8. David Sackriter will and inventory, 1849:259, Philadelphia County Probate Records, City Hall Annex, Philadelphia, Pa. For Sackriter's obituary see *Public Ledger* (Philadelphia, 4 Sept. 1849). He was 69 years of age at his death.

46
FALL-FRONT SECRETARY
1815–1830
Philadelphia, Pennsylvania

IN THE EARLY nineteenth century this type of fall-front secretary was often called a *secrétaire à abattant* or French secretary. This sort of desk achieved its mature form in the work of Jean-François Oeben (ca. 1721–1763), a German immigrant cabinet-maker working in Paris.[1] Spreading outward from Paris, the fall-front desk soon became a major furniture form on the Continent, although it never was popular in England. During the first half of the nineteenth century, such desks were especially favored in those areas dominated by Biedermeier design, namely Germany, Austria, and Scandinavia. When it came time for journeymen in these areas to design and build a piece of furniture for their guild examinations, they almost invariably chose a fall-front secretary.[2]

This type of desk was of central importance among middle-class furnishings in nineteenth-century Germany. It not only served to bring order to the writing affairs of an individual, but acted as an intersection between the outside world and the characteristically introverted Germanic family of the period. It is this intimate relationship between the German middle class and this particular furniture form that Theodore Fontane describes in *My Youth* (1893). Remembering how as a child he watched his father at his fall-front secretary, Fontane says:

> He liked to sit at this his secretary, and to a greater or lesser degree was fond of every compartment and drawer thereof. He enjoyed an especially intimate relationship with a secret compartment hidden behind a small columned temple, into which he deposited his money when circumstances allowed him to do so. If conditions were adverse, however, and the box was empty, it did not cease being an object of his almost caressing contemplation. He would remove the temple, and, peeping inside with a certain humorous seriousness, would begin one of his speeches. I was often present at such a time. "You see, my son, I cannot gaze into this dark emptiness without emotion. Only a few days ago I calculated how much money used to be there. It came to a large amount, and there was something comforting about that." Everything he said, although he laughed about it, was meant to be taken quite seriously; he really comforted himself with the idea of what all had been there at some time or another. This Gascon trait in him always broke through.[3]

Since the fall-front desk was not popular in England, its appearance in Philadelphia must have been the result of continental influence. Some examples of continental secretaries, such as a German one owned by the wealthy merchant, Stephen Girard, were imported into Philadelphia in the 1810s.[4] Furthermore, the furniture designs which German craftsmen (and perhaps French ones as well) brought with them to America were generally dominated by this particular furniture form.[5]

Once in Philadelphia, the concept of the fall-front secretary found wide acceptance among the upper class, even though it never displaced the secretary-bookcase in popularity. Besides Girard, the Gratz, Kuhn, and Gilpin families are known to have owned examples before 1830.[6] The form was produced often enough to warrant inclusion in *The Philadelphia Cabinet and Chair Makers' Union Book of Prices for Manufacturing Cabinet Ware* (1828). According to this price book, a basic example cost $22 to build, exclusive of materials.[7]

The survival of more than a dozen early examples further attests to the form's acceptance in Philadelphia. Although other American cities, such as Boston, also produced this type of desk, the form does not seem to have been as popular there in comparison to Philadelphia, nor does its production in other cities exhibit the wide stylistic variations seen in Philadelphia. Most Boston desks, for example, are very French in orientation.[8]

Although the surviving Philadelphia examples are inherently similar in some respects, the degree of diversity within this group is striking. Several of the desks, for example, are extremely French in character.[9] In these the classical elements of columns, capitals, bases, and arches function in an architectural manner. The emphasis is on unity of design, classical proportions, and restraint. Extending from the feet to the cornice, the columns on these French-inspired desks frame the front facade and visually support their marble top. The placement of ormolu mounts further unifies their composition, those at top being echoed below.

Unlike such French-inspired examples, this fall-front secretary is based on Germanic prototypes. At present, six other desks from the same unidentified Philadelphia shop which produced this example are known (see fig. 11).[10] All of these pieces reflect a Germanic predilection for imaginative design in which the facade is an amalgamation of parts, not a unified whole.

Cat. 46a

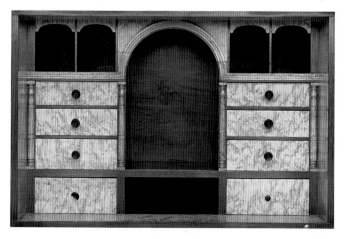

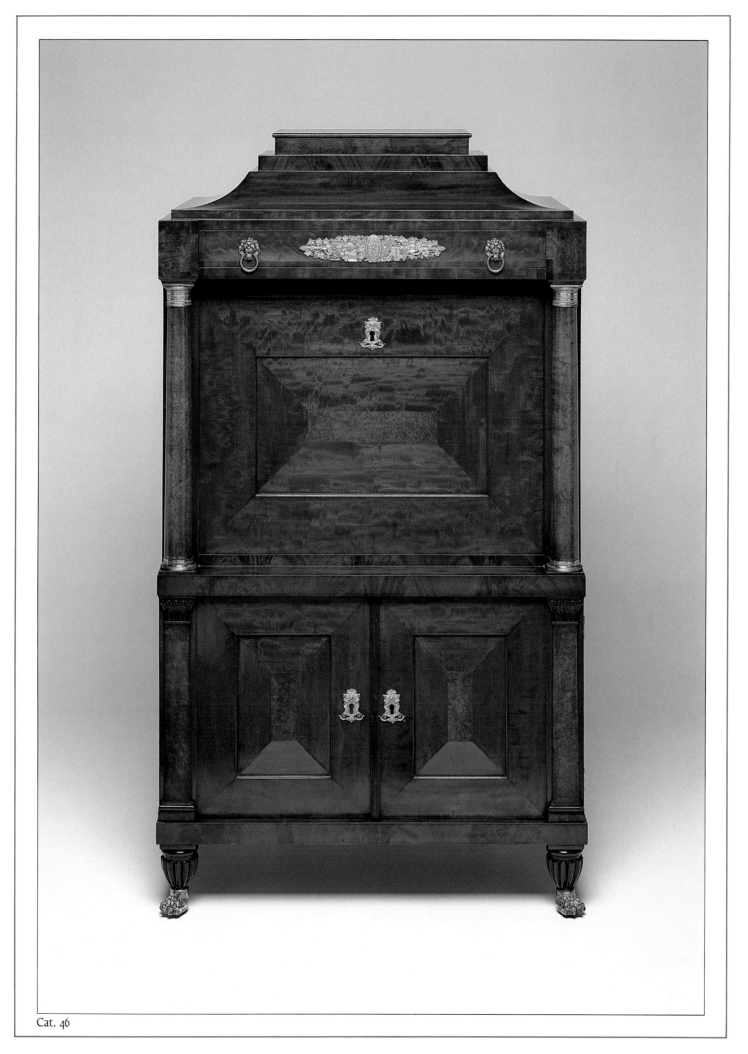

Cat. 46

Here, for example, the columns do not extend the length of the piece as in a typical French example, but rather stop halfway, changing into pilasters in the lower section. The upper and lower halves are further differentiated by the orientation of the doors—the central fall being horizontal, those below vertical. Both the use of contrasting burl-veneers inset at various places on the facade and the emphatic horizontal banding at top, middle, and bottom further fragment the facade.

Beyond this lack of unity, the desk's relationship to German aesthetics is further suggested by at least three other features. First, the Germanic predilection for imaginatively placing an architectural structure atop a secretary is present. As is evident from both surviving German examples and pattern books (see fig. 12), the placement of such structures on a sloping base was common in central Europe.[11] Another major German trait is the frequent use of light burl-veneers contrasted on both interior and exterior surfaces as here. A preference for lightwood furniture was especially prevalent in northern Germany and Scandinavia.[12]

Finally, the construction of this desk and the four others relates to German examples. Exactly alike in basic drawer, carcass, back, and interior construction, and in proportions, these desks must have come from the same unidentified shop. The way in which the backs are paneled, using a single spline down the middle without top or bottom framing members, is characteristic of central European work. This particular technique, while not the only one used in Germany, was the dominant mode there.[13]

STRUCTURE AND CONDITION: The case is basically a large dovetailed box. This box is screwed to a rectangular base frame which is mortise-and-tenoned together. The turned feet fit into this base frame with round tenons. The rear feet are uncarved, while the front ones are only carved on the front side. Two front-to-back supports run between the central rail (upon which the columns rest) and the backboards. The interior section rests on these two supports. The interior is not removable. The fall-front door is counterbalanced by metal arms which

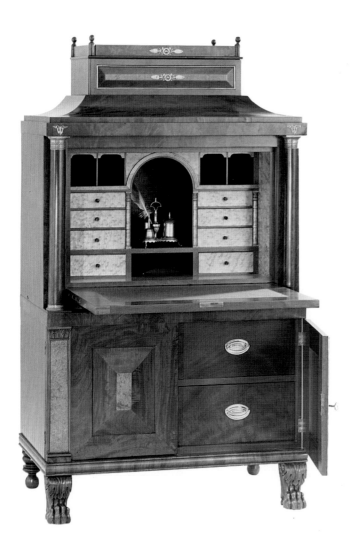

Fig. 11. Fall-front secretary, Philadelphia, Pennsylvania, 1815–1830. Mahogany, bird's-eye maple, pine; H. 63 (159.4), W. 36 (91.1), D. 21 (53.1). (Private collection.)

Fig. 12. Design for a fall-front secretary. From Marius Wölfer, Der Bau-und Meubel-Schreiner, eine bildliche Anweisung zur antiken und moderne Architektur (Ilmenau, Germany, 1828), plate 3, figure 19. (Watson Library, Metropolitan Museum of Art.)

have lead blocks at their ends. The pediment is mortise-and-tenoned together. The curved side elements of the pediment are constructed of four laminated boards. The interior of the pediment is braced by numerous glue blocks. The back consists of a central spline and two side boards.

Both the interior and top drawers are constructed with small dovetails. Their chamfered bottoms fit into grooves run in their sides and fronts and are nailed across the backs. The interior drawers run on the bottom of their compartments. Thin wooden strips have been added to the bottom edges of the top drawer's sides. Two 4" (10.2 cm.) blocks are glued to the bottom rear corners of the top drawer. Vertical drawer stops are attached to each drawer compartment. The lower right interior drawer is fitted with small compartments. The interior columns do not conceal document drawers and there was never a drawer in the lower central section of the interior.

The desk is in good condition; however, it has been adapted in several important ways. The maple veneer on the exterior columns, pilasters, and door panels has been stained to match the mahogany veneer. The lock on the bottom doors is missing. Originally the lower section contained four drawers as in figure 11. At some point, these drawers were removed along with their rails and runners. The space now contains a single shelf. The knobs on the lower two interior drawers are broken. The lion's-head drawer pulls are replacements. All of the brass mounts appear to be original (see cat. 46b).[14] The black paint in the central section of the interior is original.

Cat. 46c

INSCRIPTIONS: Written in pencil on the dustboard below the uppermost drawer is "John . . . 08." Written in varnish on the underside of the penholder in the interior, lower right drawer is "John Smith." The steel door catch is marked "PAT. SEPT 29. 74." The bottom board is marked in chalk " B l."

WOODS: Veneer, feet, interior drawer linings, top drawer sides, mahogany; front rail beneath top drawer, cherry; top drawer bottom, left and right backboards, bottom framing members, support braces under interior section, yellow poplar; top drawer runners, central backboard, bottom board, pediment framing members, eastern white pine; interior veneer, hard maple; knobs, probably ebony.

DIMENSIONS: H. 62⅞ (159.8); W. 35⅞ (91.1); D. 21⅛ (53.7).

PROVENANCE: Coleman Auction Gallery, New York, N. Y.; Lester Berry, New York, N. Y.; Israel Sack, Inc., New York, N. Y.; Bybee Collection, 1963.

EXHIBITIONS AND PUBLICATIONS: MFA, H 1981; Venable 1986, fig. 38.

1985.B51

1. For a discussion of Oeben, see Stratmann 1973, 110–113; Fleming and Honour 1977, *Oeben*. All of the information included here is taken from Venable 1986, 64–74.

2. See Bahns 1979, 91–108.

3. Fontane 1893, 49–50. Author's translation.

4. For an illustration of the Girard piece, see Schwarz 1980, 89. For a discussion of this piece and other examples of imported German furniture, see Venable 1986, 58–60.

5. For a discussion of German furniture designs and pattern books in Philadelphia, see Venable 1986, 54, 85–88.

6. See Ducoff-Barone 1983 for a discussion of the Gratz and Kuhn examples. An inventory for Thomas Gilpin lists "1 mahogany French Secretary" being sent to Wilmington, Del., for sale at auction in 1839. Thomas Gilpin inventory, Philadelphia, Pa. (1839), no. 2606, Joseph Downs Manuscript and Microfilm Collection, Winterthur Museum Library.

7. Philadelphia 1828, 38–39.

8. For a typical Boston example, see Talbott 1975, 880.

9. For French-inspired examples from Philadelphia, see R. Smith 4, 1973–1974, 180; Fitzgerald 1982, fig. VI-42.

10. One is in the Kaufman collection; see Flanigan 1986, no. 91. For two others, see Christie's 5890 (23 May 1985): lot 183 and SPB5810 (26–28 Jan. 1988): lot 1478. The other three are in private collections.

11. For related German examples, see Kreisel and Himmelheber 1983, pls. 341, 432. Besides the illustrated example, see Sammlung 1796, 4: pl. 9.

12. For a discussion of light-wood furniture in both Germany and America, see Venable 1986, 76–78.

13. Georg Himmelheber, letter to the author, 13 Aug. 1985, DMA files.

14. A truncated version of the central mount on this example which depicts symbols of the arts is used on a Boston pier table; see Talbott 1975, 886. For this mount on a New York pier table, see *Antiques* 135:1 (Jan. 1989): 194.

47
WORK TABLE

1820–1840
Philadelphia, Pennsylvania

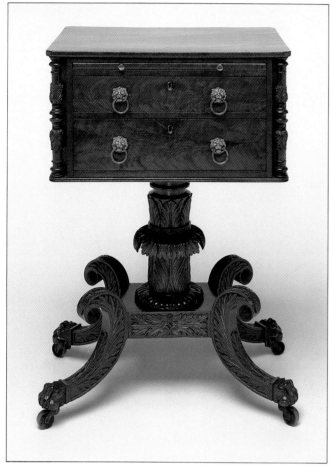

Cat. 47

DURING the late eighteenth and early nineteenth centuries, daughters of wealthy parents began attending schools in substantial numbers. As part of their education, these women practiced reading, writing, and arithmetic, as well as fancy sewing, drawing, and deportment. Once mastered, these activities often dominated the lives of such women.

To accommodate this host of educated elite women, small tables with storage compartments were developed (see cat. 49). Sometimes these work tables had cloth bags suspended beneath them to hold unfinished sewing. Others, like this example, were primarily designed to provide a surface upon which to write or draw and compartments in which to store paper, pen, and ink. Originally, the upper drawer of this table was fitted with an adjustable flap for writing letters. For larger work, this table contains a baize-covered board which pulls out from the case and rests against the top drawer at the desired angle. The casters allowed this table to be moved to take advantage of the best light while working.

At present two other tables from the shop which made this example are known.[1] One of these tables lacks the splendid carving on the legs seen here and has three-quarter corner columns, rather than free-standing ones. These differences demonstrate the wide range of decorative options which were available from a given cabinet shop. In 1828, *The Philadelphia Cabinet and Chair Maker's Union Book of Prices for Manufacturing Cabinet Ware* provided a list of such options.[2] For example, besides the "inverted square corner" seen here, one could order "hollow or round corners . . . to form place for column to stand in." Similarly, tables were available with "four turned legs" or the fancier (and more expensive) leg profiles seen in figure 13. As this plate also illustrates, cast-brass feet could be used or the ends of the legs could be carved into the shape of lion's paws as here.

This table and its mates from the same shop are part of a large group of related work tables from Philadelphia. Within this group, the greatest variations occur in the handling of the case corners, the pedestal, and the feet. Generally the corners are either completely cut out; cut out with columns (as here); or covered with ringed three-quarter columns. The pedestals on these tables usually consist of finely carved scrolled leaves as on this example; carved balustrades; or double lyres.[3] The various feet shapes include those seen in figure 13, as well as animal legs and a truncated C-scroll which does not rise up past the base block as on this example.[4]

The large number of surviving examples within this group suggest that several Philadelphia cabinet shops specialized in the production of work tables or perhaps tables in general. The

labeled tables of the Philadelphia cabinetmaker Anthony G. Quervelle (see cat. 56), for example, are more consistent in terms of design and execution than any other furniture form associated with his shop. It is possible that Quervelle specialized in producing tables and simply purchased many of the other forms he sold in his showroom from other craftsmen.[5]

Regardless of whether one or more Philadelphia cabinet shops specialized in making work tables during this period or not, it appears that Philadelphia craftsmen were well known for this particular type of table. Work tables made in places as diverse as Nova Scotia, Boston, New York, and Baltimore exist which seem to be patterned directly on Philadelphia examples.[6] Presumably, these compact and exceptionally well-crafted tables were exported from Philadelphia in quantity, ultimately influencing the design of work tables throughout America and Canada.

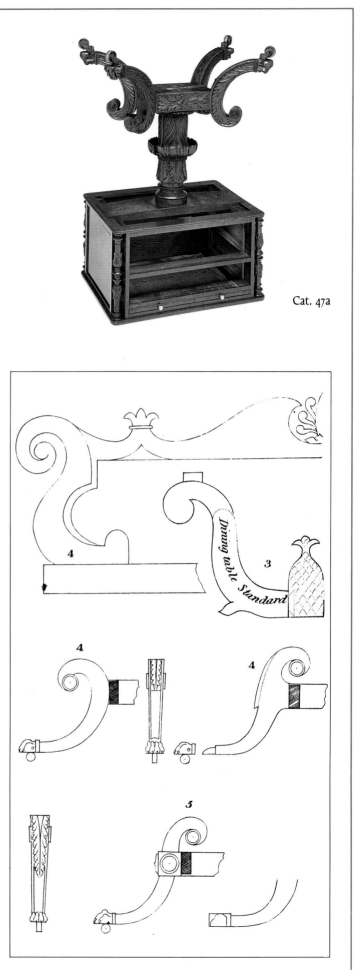

Cat. 47a

STRUCTURE AND CONDITION: The legs join the base block with sliding dovetails. These joints are strengthened by iron braces. The pedestal joins the base block in a double tenon. The carved base-ring fits loosely around this junction. The pedestal is attached to the central cross brace with a wedged double-tenon. The brace is screwed to the case. The corner columns dowel in place and were inserted before the top was attached. The molding surrounding the bottom edge of the case is screwed in place.

The drawer runners are nailed to the sides of the case. The drawers are constructed with small dovetails. Their chamfered bottoms fit into grooves run along the front and sides. They are nailed flush across the back. The upper drawer was originally fitted with a writing flap of some kind. The piece is in excellent condition. The brass drawer pulls are replacements.

WOODS: Exterior surfaces, mahogany; base block, ash; cross support under case, cherry; drawer fronts, drawer runners, case sides, eastern white pine; drawer sides, bottoms, and backs, writing pull, backboard, yellow poplar.

DIMENSIONS: H. 30⅝ (77.7); W. 22 (55.9); D. 15 (38.1).

PROVENANCE: Morgan Burns, N. H.; Israel Sack, Inc., New York, N. Y.; Bybee Collection, 1964.

EXHIBITIONS AND PUBLICATIONS: National Museum of American History, Washington, D. C., 1964; MFA, H 1981; *Antiques* 129:5 (May 1986): 956.

1985.B60

1. An identical table is in a private collection. For the one with three-quarter corner columns, see *Antiques* 28:3 (Sept. 1935): 128. For a closely related table with slightly different proportions, see J. Sweeney 1981, 904. For a card table with a closely related base, see *Antiques* 62:1 (July 1952): 16.

2. Philadelphia 1828, 33–35.

3. For illustrations of tables with this type of carving, see R. Smith 2, 1973–1974, 93–95.

4. For Philadelphia work tables from this group, see R. Smith 3, 1973–1974, 261–263; PMA 1976, no. 220; Sack 1981, 3:722; Christie's 6034 (5–6 Nov. 1985): lot 19.

5. For discussions of Quervelle and his shop, see R. Smith 1–5, 1973–1974; Venable 1986, 3–5.

6. For tables from these areas, see Webster 1979, 164; Davidson and Stillinger 1985, no. 213; Weidman 1984, no. 166; Elder and Stokes 1987, no. 132. For related tables with no history of origin, see *Antiques* 6:1 (July 1924): 4; 79:4 (Apr. 1961): 323; 85:3 (Mar. 1964): 284; SPB 745 (28 Feb.-1-2 Mar. 1946): lot 566.

Fig. 13. Designs for arm and leg profiles. From *Philadelphia Cabinet and Chair Maker's Union Book of Prices for Manufacturing Cabinet Ware* (Philadelphia, 1828), plate 5. (Winterthur Museum Library.)

48
PIER TABLE
1820–1840
Probably New York, New York

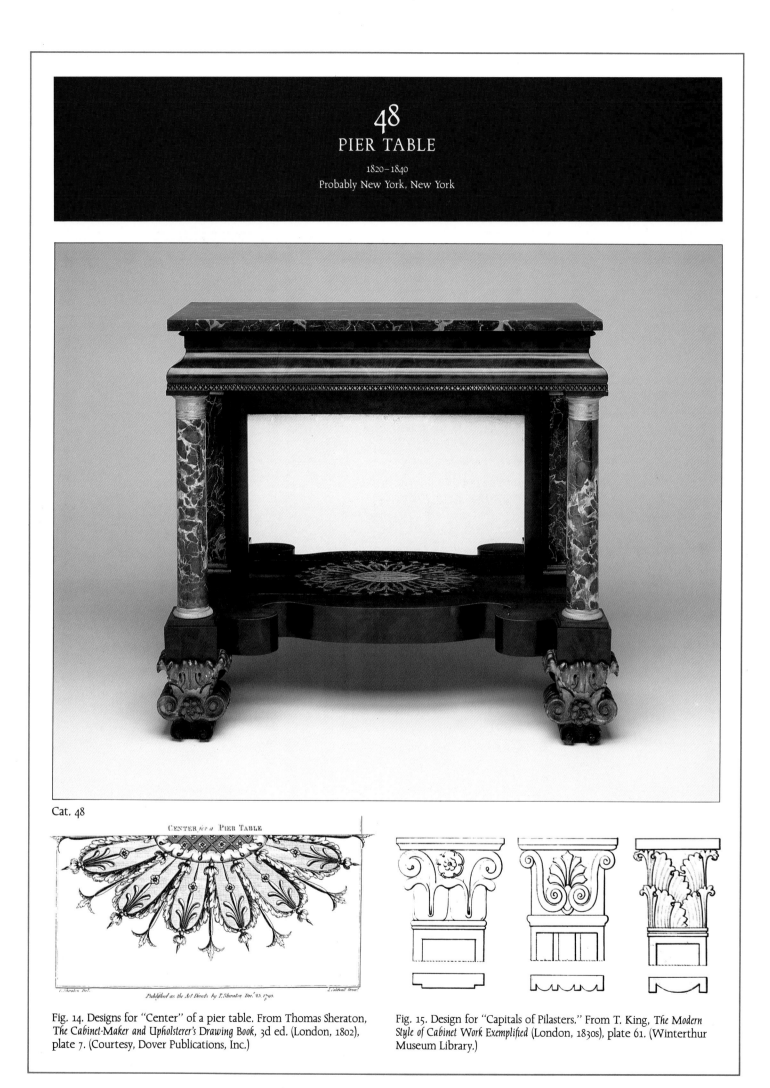

Cat. 48

CENTER for a PIER TABLE

Fig. 14. Designs for "Center" of a pier table. From Thomas Sheraton, *The Cabinet-Maker and Upholsterer's Drawing Book*, 3d ed. (London, 1802), plate 7. (Courtesy, Dover Publications, Inc.)

Fig. 15. Design for "Capitals of Pilasters." From T. King, *The Modern Style of Cabinet Work Exemplified* (London, 1830s), plate 61. (Winterthur Museum Library.)

THIS PIER TABLE is one of the most elaborate examples of its type to survive. Its richly carved and gilded feet, blue marble, ormolu bases and capitals, mirrored glass, exotic woods, and stenciled ornamentation made this object extremely expensive. Such opulence reflected the wealth and status of its original owner.

Although other pier tables of the period combine the same rich materials, few are as exuberant in overall design. At present, no identical table is known. However, two pier tables with identically carved feet and paired marble columns and pilasters are known.[1] The upper molding and lower shelf on these tables are also eccentrically shaped, though not identical to the Bybee table. Unfortunately, none of these three tables have firm family histories.

It is known that elaborate pier tables were made in both Philadelphia and New York City. Compared to numerous tables from these cabinetmaking centers, the Bybee example most closely resembles those from New York. Philadelphia pier tables seldom use marble columns and almost always have wooden pilasters in the rear. Also, when stenciled or veneered decoration appears on the lower shelf, it is invariably in the form of a half circle on Philadelphia tables (see cat. 56).[2] New York tables, on the other hand, often have marble pilasters paired with columns and oblong stenciled motifs.[3] Furthermore, the two tables that closely relate to the Bybee example feature stenciled decoration which is characteristic of New York work in its detail and exceptional execution.

Whoever made this table may have drawn inspiration for many of the decorative details from contemporary pattern books and architectural designs. The gilt "Center" on the lower shelf, for example, is similar to one published by Thomas Sheraton in 1794 (fig. 14).[4] Similarly, the front feet are closely related to printed designs for pilaster capitals (see fig. 15). The use of highly figured marble further accentuates the architectural character of this table. This allusion to antiquity is also evident in the *antique vert* color of the small Ionic volutes upon which the table rests. Greenish colors of this type were used in the period to simulate antique bronze.

STRUCTURE AND CONDITION: This table is in exceptional condition. The base is composed of massive front and rear rails which are tenoned into side members. A medial brace runs between the front and rear rails. The two vertical stiles join the base and top with huge dovetails and screws. The backboard is attached with screws. The glass appears to be original.

The upper frame is dovetailed together. The top molding is glued in place. The original top is held in place through the presence of several marble glue blocks on its underside.

WOODS: Most visible surfaces, mahogany veneer; top V–molding, cherry; column plinths, tropical wood veneer (probably rosewood); lower cross brace, upper framing members, and backboard and stenciled molding, yellow poplar; front and back feet, rear vertical stiles, eastern white pine; lower framing members, basswood.

DIMENSIONS: H. 36⅛ (91.8); W. 40⅜ (102.6); D. 18½ (47.0).

PROVENANCE: Israel Sack, New York, N. Y.; Bybee Collection, 1964.

EXHIBITIONS AND PUBLICATIONS: Fairbanks and Bates 1981, 269; MFA, H 1981.

1985.B58

1. For an illustration of one of these tables, see *Antiques* 115:5 (May 1979): 941. This table has an early history in Athens, Ga., and is now in a private collection in Savannah, Ga. The other table is in a private collection in Greenville, Del. For another table which relates to these three in its elaborateness and juxtaposition of geometric forms, see SPB 5599 (26 June 1987): lot 188.

2. See R. Smith 1, 1973–1974.

3. See Tracy and Gerdts 1970, no. 68; McLanathan 1961, 357; SPB 5429 (30 Jan. 1986): lot 602.

4. Sheraton 1802, 227.

Fig. 14. Designs for "Center" of a pier table. From Thomas Sheraton, *The Cabinet-Maker & Upholsterers' Drawing-Book* 3d ed. (London, 1802), plate 7. (Courtesy, Dover Publications, Inc.)

Cat. 48a

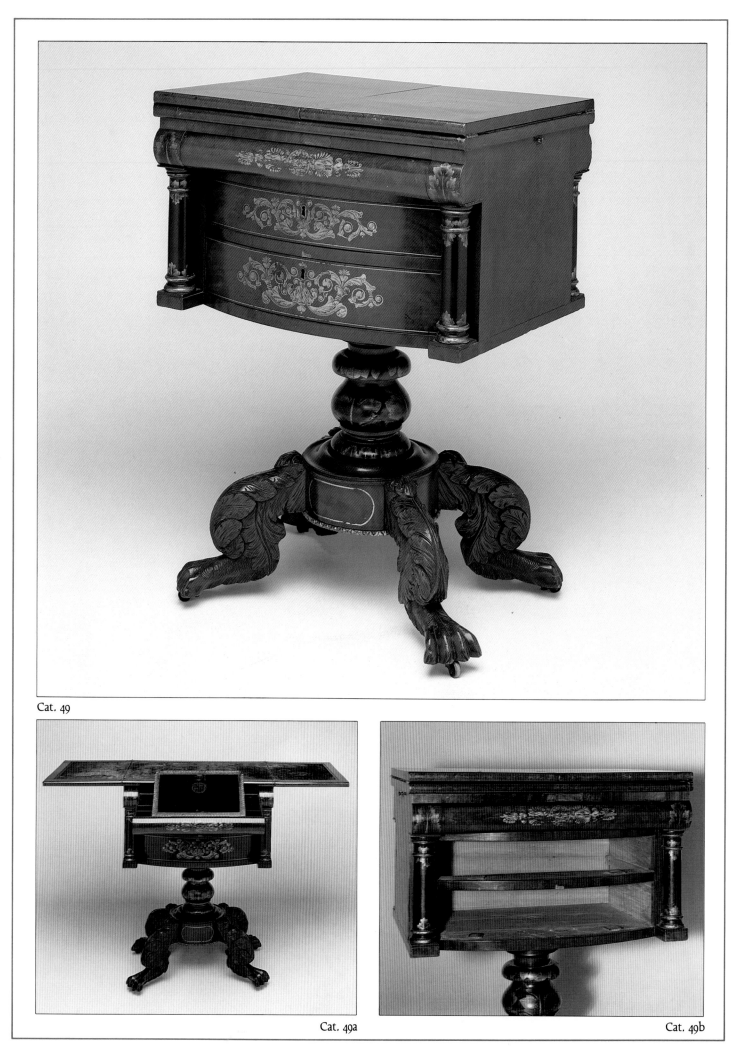

Cat. 49

Cat. 49a

Cat. 49b

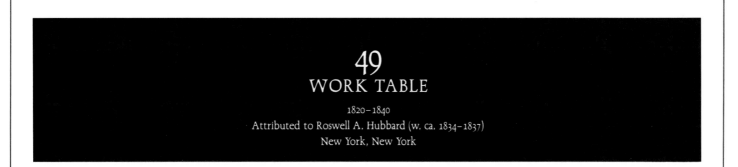

LIKE ITS PHILADELPHIA COUNTERPART (cat. 47), this work table was designed to provide a compact, movable surface upon which to write or draw and a storage space for writing paraphernalia. Not only is the top drawer divided into compartments for ink bottles, pens, and blotters, but it is fitted with an adjustable, velvet-covered writing flap (see cat. 49a) Furthermore, the top unfolds, doubling its size.

Unlike most desks, this work table was not meant to be placed against the wall. Rather, it was designed to be used in the center of a room. Since both the front and back sides are visible when used in this fashion, this table has two identical facades. On the front side there are columns flanking three drawers. The two rear columns flank what appear to be another bank of drawers, but in reality they are merely the curved rear of the case which is stencilled to match the front. False keyholes complete the *trompe l'oeil* effect. Besides presenting a pleasing appearance, this false rear facade must have proved a humorous folly for the unsuspecting user.

At present three such tables are known.[1] One table in the Winterthur collection is signed by the New York cabinetmaker Roswell A. Hubbard. Besides his being listed in New York City directories as a cabinetmaker at 52 Harrison Street between 1834 and 1837, nothing is known about Hubbard.[2] Given the complex structural nature of these tables and their elaborate gilt decoration, it is possible that his shop specialized in their production. However, other New York shops produced related, although less ornate, work tables. Contemporary examples survive by both Michael Allison and John Baird, as well as the Providence, Rhode Island, firm of S. and R. Rawson, Jr.[3]

STRUCTURE AND CONDITION: The legs join the base block with sliding dovetails. A wooden disk which has a stamped metal border around its perimeter covers these joints. The pedestal is turned from two pieces of wood glued together vertically. Besides being tenoned to the central cross-brace, the pedestal is secured to the upper case by an iron rod which runs from the base block through the bottom board of the upper case. The upper case is dovetailed together. The drawer runners are nailed to the sides of the case. The drawers are con-

structed with small dovetails. Their chamfered bottoms slide into grooves run along their fronts and sides and are nailed flush across the back. The top drawer is fitted with numerous compartments and a writing flap. It also has stops to prevent its accidental removal. Small wooden slides pull out of the case to support the two top leaves.

The work table is in good condition. The gilt decoration has suffered some wear, especially on the side out of which the drawers pull. Some overpainting has occurred on the columns and the veneer has minor losses. The top and writing flap retain their original green velvet and leather trim. Wooden strips have been added to the rear of each drawer to compensate for shrinkage.

INSCRIPTIONS: Written beneath the base block in pencil is "Bought / April 1894 / $25 / From Coit-Chappell Estate."

WOODS: Veneer, pedestal, leaves, legs, and central cross-brace, mahogany; drawer bottoms and backs, yellow poplar; base block, ash; columns on facade, hard maple; drawer fronts, drawer dividers, case bottom, top, and sides, eastern white pine.

DIMENSIONS: H. 32 (81.2); W. open 47 (109.4); W. closed 23⅜ (59.4); D. 18¼ (46.3).

PROVENANCE: Coit-Chappell estate, unidentified location, pre-1894; private collection, White Plains, N. Y., early 1970s; Peter Hill, Inc., Washington, D. C.; Bybee Collection, 1974.

EXHIBITIONS AND PUBLICATIONS: Warren and Howe 1978, no. 3; Howe 1979, 560; MFA, H 1981.

1985.B52

1. For the table (65.156) in the Metropolitan Museum of Art, see Libin 1985, fig. 225. For the Winterthur example (57.763) by Hubbard, see Smith and Hummel 1978, 1302.

2. A search of census records for New York City between 1820 and 1850 has not uncovered a Roswell A. Hubbard living in the city. However, in 1840 there was a person by that name living in Oneida, near Syracuse, N. Y.

3. For the table by Allison, see DAPC 74.5306. For one by Baird, see *Antiques* 81:5 (May 1962): 518. For another table of probable New York origin, see Davidson 1969, fig. 151. For one by S. and J. Rawson, Jr., see Monahan 1980, 142.

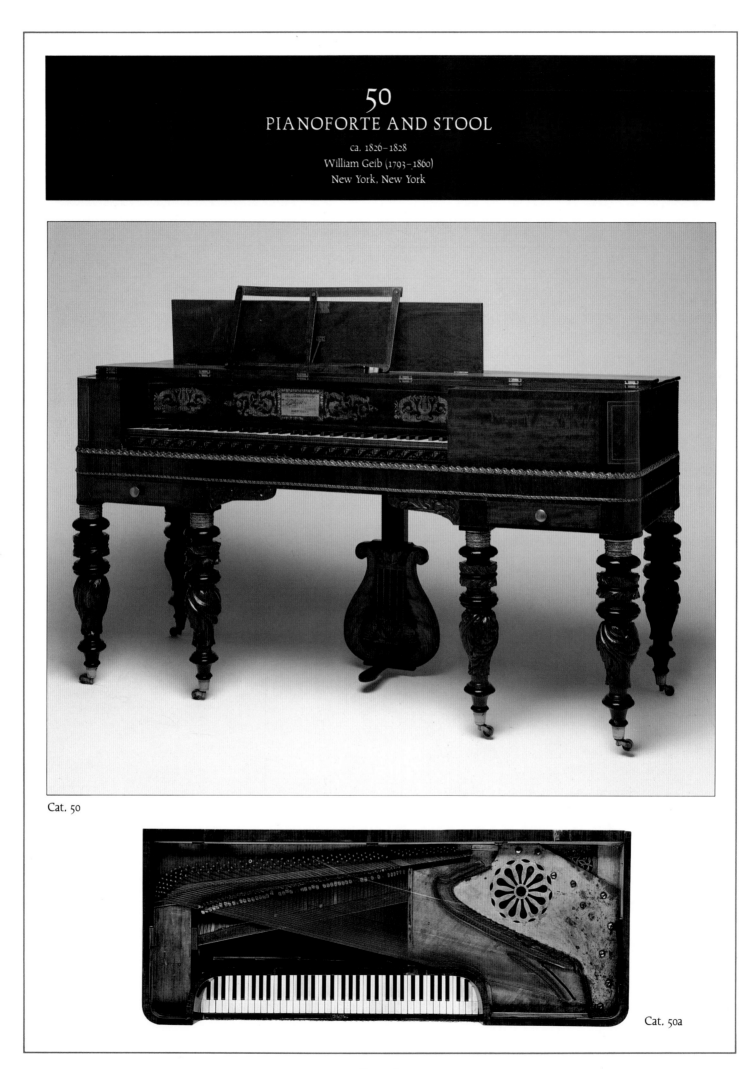

50
PIANOFORTE AND STOOL

ca. 1826–1828
William Geib (1793–1860)
New York, New York

Cat. 50

Cat. 50a

DURING THE FIRST HALF of the nineteenth century, the pianoforte became a prominent feature in wealthy American homes and a potent symbol of both female respectability and family unity. Families across the country gathered in parlors to hear their female members play the latest music.[1] As a result of the popularity of "musical evenings," the demand for pianos rose throughout the nineteenth century. Eastern cities like Boston, New York, Philadelphia, and Baltimore supported numerous pianomakers. These men supplied not only their local markets, but exported pianos throughout the country and to South America.[2]

The Geib family was one of New York's most prominent groups of pianoforte makers. The founder of the family, John Geib (1744–1819), left his native Germany for London in the 1770s. Although Geib produced hundreds of instruments in England, he left with his family for America in 1797. After passing through Philadelphia, Geib settled in New York City, where he opened a shop on Barclay Street. Following John Geib, Sr.'s death in 1819, his sons, John, Jr., Adam, and William, continued the business. John, Jr., died in 1821, but A. and W. Geib continued in business together until William left New York for Philadelphia in order to study medicine in 1828.[3] Based on its serial number (6730) and the departure of William, this example must have been made between 1826 and 1828.[4]

According to recent research, William worked primarily with his brother Adam at 23 Maiden Lane during this period. However, the existence of several pianos bearing only William's name and the Third Avenue address suggests that William worked apart from his brother at some point during the late 1820s.[5]

Even though only William's name is stenciled above the keyboard, this piano is closely related to those that bear the names of his other family members.[6] In terms of case design, most Geib pianos from this period are virtually indistinguishable from English examples which also employ carved legs, rosewood crossbanding, and die-rolled brass trim. While the Geib shop may have had its own case maker, as well as numerous specialty craftsmen, it is possible that their piano cases came from an outside supplier.[7] With its finely carved legs, rosewood and mahogany veneer, brass trim, and elaborate painted decoration, this pianoforte is one of the most lavish examples known bearing the Geib name. It is also one of the few pianofortes known which still retains its original stool (cat. 50b).

STRUCTURE AND CONDITION: Much of the case structure is obscured by the works. The rear and sides of the case appear to be solid. The curved front is of laminated construction. The legs screw up into threaded sockets in the bottom of the case. The drawer bottoms fit into grooves run along the front and sides. They are nailed across the rear. The drawers slide on runners nailed to the sides of the case. The legs of the stool join the pedestal in sliding dovetails. Each leg terminates in a wooden knob. The seat is supported by a circular wooden platform fastened to the top of the pedestal.

The case is in good condition. It is cracked above the front left leg. There are losses to the painted decoration on both the keyboard and the pedal. The works are not in playable condition. The stool is in good condition. The seat and one leg are cracked. The velvet covering may be the original upholstery.

INSCRIPTIONS: Stenciled above the keyboard is "Improved Patent / W. Geib / 3rd Avenue & 170 . . . / New York." On the sounding board is stamped "6730."

WOODS: Veneer, legs, damper pedal, and hammer arms, mahogany; music holder and central band of veneer, rosewood; damper pedal screw shaft, birch; hammer heads, damper tips, lyre, hard maple; drawer bottoms, Spanish cedar; top of stool, case bottom cross-braces, beech; case sides and bottom board, eastern white pine; sounding board, spruce; keys, basswood; block for pushing damper, ash.

DIMENSIONS: H. 35⅝ (98.1); W. 67½ (171.4); D. 26½ (67.3). Stool: H. 20¾ (52.7); W. 16⅞ (42.9); D. 13⅝ (34.1)

PROVENANCE: Israel Sack, Inc., New York, N. Y.; Bybee Collection, 1963.

EXHIBITIONS AND PUBLICATIONS: MFA, H 1981.

1985.B54.1,.2

1. Although little research has been done on the importance of pianos in nineteenth-century culture, see Gellerman 1973 for information on the importance of music and musical instruments (primarily the reed organ) in America.

2. For a discussion of American pianomakers, see Spillane 1890.

3. For this and other information on the Geib family, see Libin 1985, 172–175.

4. According to Libin 1985, 173, John Geib, Sr., probably continued his English serial number series upon arrival in this country, beginning with 4911. The Metropolitan Museum of Art owns a piano by Adam and William Geib (45.126) bearing the serial number 6152. Libin dates this instrument around 1825. If this dating is correct, the Bybee example must date between 1826 and 1828.

5. For other pianos by William Geib, see DAPC 64.117; 65.5633; and 70:270.

6. For closely related examples by A. and W. Geib, see Antiques 19:6 (June 1931): 488; Reed 1973, 173; Stayton 1984, 885; Christie's 6034 (5–6 Nov. 1985): lot 524; Libin 1985, no. 208; Ward 1988, no. 232; and DAPC 73.134.

7. For a discussion of the various specialty craftsmen employed in the large pianomaking shop of Conrad Meyer of Philadelphia, see Venable 1986, 317–319.

Cat. 50b

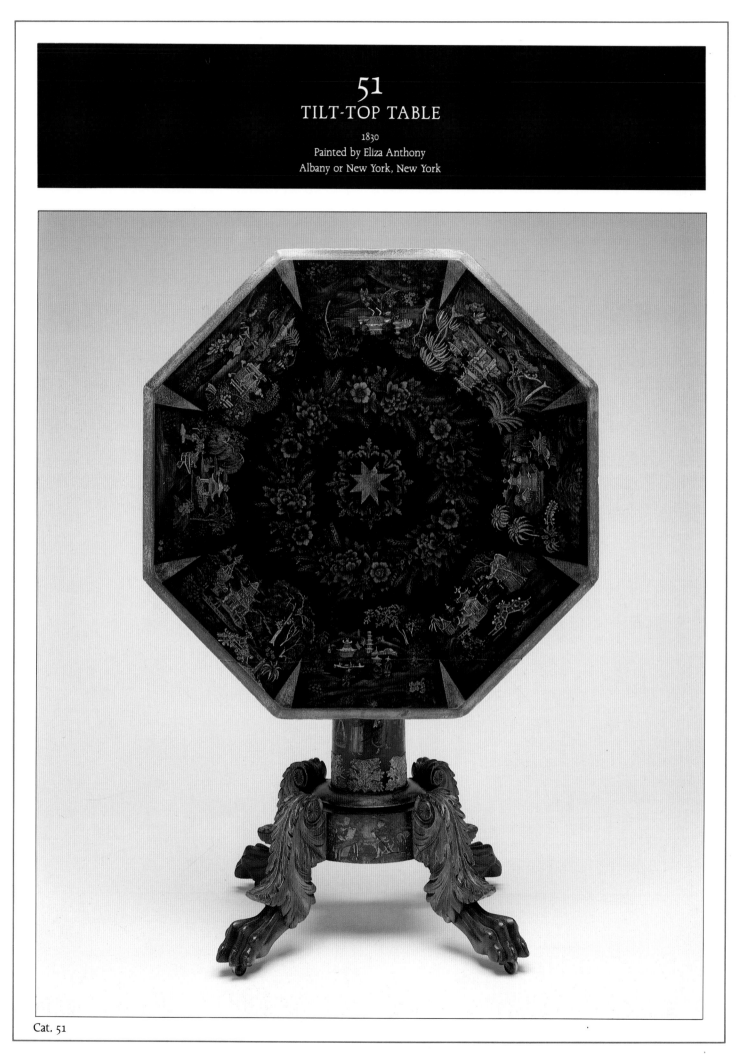

Cat. 51

FOLLOWING THE REVOLUTION, American ships were able to trade directly with the Far East for the first time. Through this trade Chinese products such as tea, porcelain, silk, and furniture flowed into the country. Most of the furniture which the Chinese produced for the American market was based on Western prototypes which had been sent to the East for copying. Such furniture was often "Chinese" only in its use of elaborate gilt and lacquered surface decoration. Americans were impressed by such hybrid pieces and imitated them.[1] This table is a consummate example of Chinese influence on American design during the second quarter of the nineteenth century. Its surface is covered with western visions of Chinese gardens, architecture, and costumes.

According to an inscription on the table, it was painted by Eliza Anthony in the summer of 1830 and subsequently exhibited in New York City.[2] In October of that year, New York's American Institute, dedicated to the advancement of this country's manufactures, held its annual fair at Masonic Hall. After describing the merits of tables exhibited by the cabinetmakers John Egertes of New Brunswick, New Jersey, and Samuel Barret of New York City, a writer for the *Commercial Advisor* commented:

> Among the tables, also, were several specimens of imitations of Chinese workmanship, the art or mystery of which is taught by an ingenious lady residing in this city; and very neat specimens they are.[3]

The very "neatest" of these specimens was the table seen here. For her "Gilt Centre Table with Chinese figures" Miss Anthony received a "first premium."[4] The same list of premium winners also notes that Anthony was a pupil of Mrs. James Russell, evidently the "ingenious lady" mentioned above. In 1830 Mrs. Russell was teaching decorative painting at her female seminary at 469 Broadway. By 1832 her girls' school had moved uptown to 526 Broadway.[5]

The practice of teaching decorative painting to daughters of wealthy families began in the late eighteenth century as female education became more acceptable. Young ladies also regularly learned to do fancy sewing and embroidering. Such skills were designed to improve their marriage prospects.

Whether or not Miss Anthony's table attracted a genteel and wealthy husband, her decorative painting was of the highest quality. As inspiration for her designs, Anthony probably drew upon contemporary prints which illustrated Westernized and distorted views of the East.[6] Once she had selected the scenes to be depicted, Anthony first painted the unfinished table black. The table probably came from a local Albany or New York City cabinetmaker. The figures were next sketched onto the surface and built up with gesso. These raised details were then hand painted, while the central wreaths of Western-style flowers, leaves, and wheat sheaves were applied with stencils. Next, the edges of the top and the upper part of the feet were gilded. Finally, the entire piece was varnished to protect the ornament.

The manner in which the top's ornament is divided into eight "panels" by gilt triangles relates it to the "scrap tables" which were similarly popular among young women. In fact the official list of winners at the 1830 fair describes Anthony's table as a "superior Scrap Table, Chinese figures and gilt, the best work of the kind exhibited."[7] However, the term "scrap table" is more correctly applied to the tables entered by Misses Earle, Tappen, and Isaacs (fig. 16). After describing Anthony's table, the *Commercial Advisor* noted:

> There is also a handsome specimen of female industry exhibited, in one of those fancy tables, the surface of which is covered with prints and pictures, fantastically, yet tastefully, arranged, the whole being varnished over so as to present a smooth polished surface.[8]

While painted tables and pieces covered with prints presented the viewer with a "fantastic" visual experience, they were both inherently fragile. Only rare survivals like Eliza Anthony's tour de force remain to remind us of the role of handiwork in social rituals of wealthy young ladies and the importance of China as a design source in early nineteenth-century America.

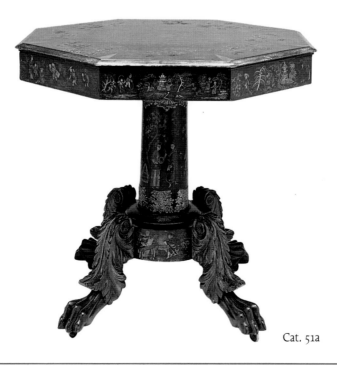

Cat. 51a

STRUCTURE AND CONDITION: The pedestal is apparently secured to the top block with blind tenons. The upper block has cracked and been reinforced through the addition of two screws from the side. Two short, wooden braces have been screwed to the underside of the top to repair a crack. The metal casters and catch under the top are original. The catch plate on the upper block has broken loose and been repaired. The joints between the skirting boards are reinforced with wooden blocks. The cleats are attached with screws. The feet are dovetailed into the base block. Metal bracing strips have been added to the underside of three of the feet. The pedestal joins the base block with three round tenons.

Although there are minor losses, the state of preservation of this table's painted surface is exceptional. It is marred only by the ring left by a wet glass.

INSCRIPTIONS: A pencil inscription on the underside of the top reads: "Painted by / Eliza Anthony / in the city of / Albany in the / summer of the year / 1830. / This table was / Exhibited at the Fair held at Masonic Hall in City of New York / and received the highest . . . / for ornamented work."

WOODS: Top and skirt, eastern white pine; column, ash; cleats, feet, base and top blocks, cherry; painted base ring, not tested.

DIMENSIONS: H. 28½ (72.3); Diam. top 34½ (87.6).

PROVENANCE: Robert Trump, Flourtown, Pa.; Israel Sack, Inc., New York, N. Y.; Bybee Collection, 1963.

EXHIBITIONS AND PUBLICATIONS: Fairbanks and Bates 1981, 371; MFA, H 1981.

1985.B53

Cat. 51b

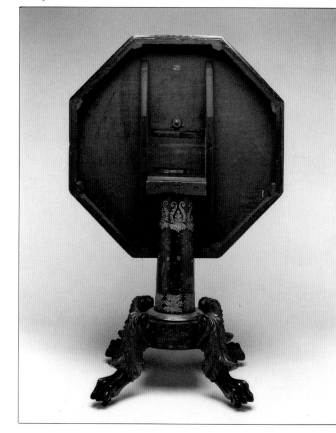

Fig. 16. "Scrap" table, possibly Baltimore, Maryland, 1830–1850. Pine, hemlock, paint and paper; H. 30 (75.9), Diam. of top 31¾ (80.3). (Winterthur Museum [79.163].)

1. For examples of imported Chinese furniture, see Denker 1985.
2. Although the inscription says that Miss Anthony painted the table in Albany, extensive research in Albany records, including newspapers, directories, baptismal, marriage, court, burial, and genealogical records, has uncovered no further information on her.
3. Commercial Advisor (New York City, 14 Oct. 1830). Other comments on the 1830 American Institute Fair appear in the Commercial Advisor (13 and 15 Oct. 1830), and The New-York Mirror (23 Oct. 1830): 127.
4. Report 1830, 23.
5. New York City directories for the years 1831–1833 show the school at these addresses.
6. H. A. Crosby Forbes, letter to the author, 23 Jan. 1987, DMA files.
7. Burges 1830, 30.
8. Commercial Advisor (14 Oct. 1830).

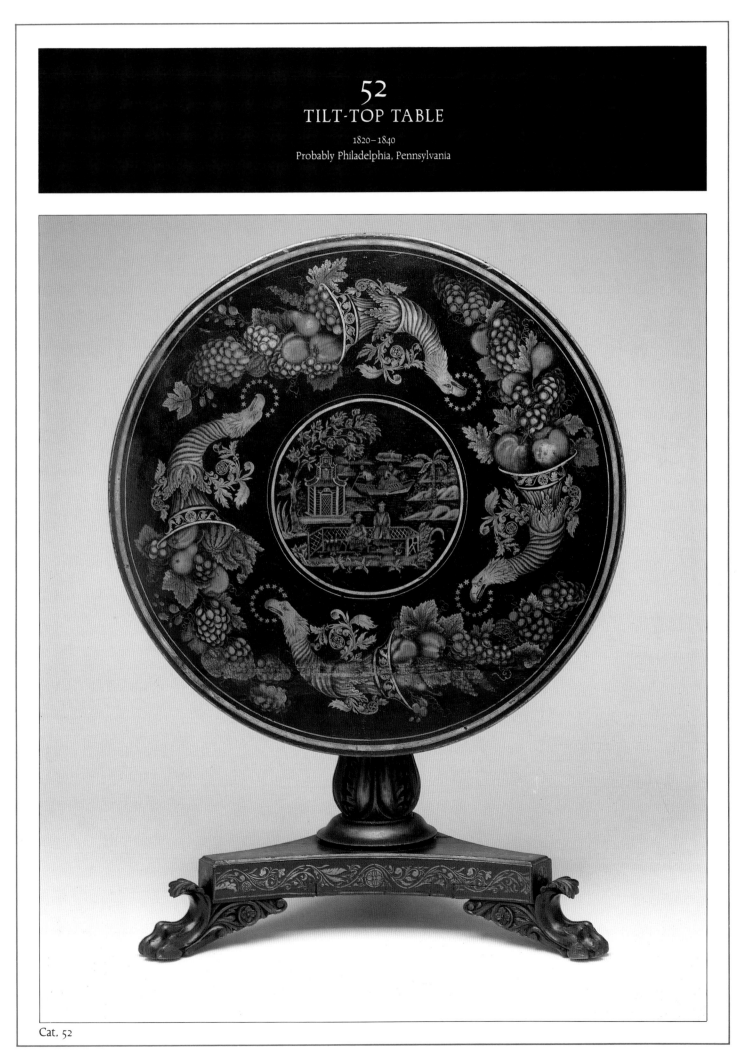

52
TILT-TOP TABLE
1820–1840
Probably Philadelphia, Pennsylvania

Cat. 52

THE USE OF PAINT and gilding as the primary ornamentation on furniture reached a peak of popularity in this country during the second quarter of the nineteenth century. Inspired by images of Imperial Rome, the grand iconographical scheme of this table represents the best of this painted tradition.

Virtually the entire table's surface carries painted decoration. The sides of the tripartite base are ornamented with a running floral border. On its upper surface are three vases of flowers. The carved foliage of the pedestal and its bottom ring are painted gold. The skirt beneath the top repeats the same border design seen on the base. The top's surface is decorated with a series of four eagle-headed cornucopia overflowing with fruit. This motif encircles a central roundel containing an imaginary Chinese landscape with figures. Although some of the decoration was hand painted, the vast majority of it was achieved by using a series of complex stencils and metallic powders.

The symbolism of the top is most interesting. Undoubtedly, the outer ring represents America and her prosperity. The cornucopia not only terminate in eagle heads, but each head is ringed by thirteen stars symbolic of the thirteen original colonies. The fruit which cascades from the elaborate cornucopia reflects the agricultural bounty of America's fertile soil. Was this table made to commemorate the fiftieth anniversary of American independence in 1826? Why does such overtly na-tionalistic symbolism encircle a Chinese scene? Did Americans during this period see the new nation's prosperity as stemming from both her own fertility and foreign commerce? Or does this table represent a hopeful vision of America's future in which her power reaches to the four corners of the earth? Whatever the nationalistic idea embodied in this table, it must have been widely held, since several pieces of furniture from this period juxtapose neoclassical and Chinese imagery (see cat. 51).

The use and origin of this superb table are unclear. Its top tilts up, suggesting that when it was made furniture was still regularly removed from the center of a room when not in use. An explanation for this mobility can be found in contemporary pattern books. In *Designs of Furniture* (London, ca. 1830–1840) by the English firm of William Smee and Son, such tables are called "Loo Tables" (fig. 17). As in the eighteenth century, this table and others like it were evidently placed against a wall when not being used in a card game. Furthermore, the practice of tilting up the top allowed elaborately painted pieces such as this example to function in a room like a painting on an easel.

This table has a twentieth-century history of ownership in Philadelphia and relates in its overall form and carved details to documented Philadelphia work.[1] Furthermore, Philadelphia decorative painters are known to have produced elaborately painted furniture.[2] However, an attribution to Philadelphia is

Fig. 17. Design for a loo or card table. From William Smee and Sons, *Designs for Furniture* (London, 1830s), plate 52. (Winterthur Museum Library.)

complicated by the survival of a table in Baltimore that has an identical Chinese scene surrounded by similar, though not identical, cornucopia.[3] The basic form of this second table is also similar. Given the fact that Baltimore produced some of the most elaborate, late neoclassical furniture in America (see cat. 53), it is tempting to attribute the Bybee table to Baltimore. However, the handling of the painted decoration and the use of a tripartite base supported by winged-paw feet are not typical of Baltimore work.[4] Finally, it is possible that this second table may simply have been imported from Philadelphia. Baltimore has a long tradition of looking to Philadelphia as a design center. But whatever its origin, the Bybee table stands as a monument to both the skill of America's decorative painters and to her optimism for a glorious future.

STRUCTURE AND CONDITION: The triangular base consists of two boards glued one atop the other. The lower member is cracked in several places. The carved feet are screwed onto the base. The feet have been reinforced with new screws and once had casters.

The pedestal joins the base in a double tenon. Both tenons are wedged along their breadth. The juncture of the pedestal and the upper block is concealed. The upper block consists of three wooden layers. The top's skirt consists of three laminated layers and is screwed to the top. The top is made of three boards. One of the outside boards has separated from the top and the resulting crack has been filled with a strip of wood. The cleats are screwed to the top and pinned to the upper block of the central support. The table's painted surface is on the whole in excellent condition. There has been some inpainting where the top has cracked.

WOODS: Most exterior surfaces, eastern white pine; feet and pedestal, yellow poplar; cleats, cherry.

DIMENSIONS: H. 27⅞ (70.8); Diam. top 36½ (92.7).

PROVENANCE: Freeman's Auction Company, Philadelphia, Pa.; Charles E. Paterson, Philadelphia, Pa.; Bybee Collection, early 1960s.

EXHIBITIONS AND PUBLICATIONS: MFA, H 1981.

1985.B61

1. See Tracy and Gerdts 1970, no. 58, for a related table with composite marble top by Anthony G. Quervelle of Philadelphia.

2. For a discussion of painted Philadelphia furniture, see Garvan 1987, 90–93.

3. The table is in the collection of the Carroll Mansion, City Life Museums, Baltimore, Md. (ME 20,257). Unlike the Bybee table, this example has a pentagonal support. In general, the design and execution of the decoration on the Bybee table are of higher quality. For a third table painted with cornucopia, see *Antiques* 135:1 (Jan. 1989): 168.

4. Gregory Weidman, letter to the author, 22 July 1987, DMA files. For numerous examples of Baltimore painted furniture, see Elder 1972.

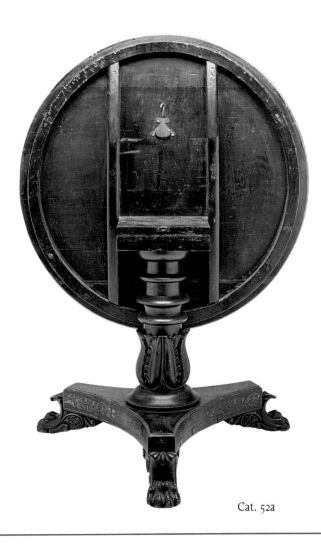

Cat. 52a

DURING THE SECOND QUARTER of the nineteenth century, the cabinetmakers and decorative painters of Baltimore produced some of the most sophisticated painted furniture in America.[1] Both in terms of execution and design, pieces such as this card table were on a level with the best London work of the period. The scrolled brackets on the base gracefully move the eye upward from the horizontal X-stretcher to the vertical pedestal which supports the top. The composition is further unified through the use of graining. This technique, which simulates rosewood, visually masks the use of various woods and provides a consistent background upon which classical motifs could be executed.[2]

Although the decorator of this table simulated expensive rosewood over cheaper woods like yellow poplar, his work was not necessarily a cost-cutting effort. Rather, the exceptional graining and painting seen here must have added greatly to the expense of this table. Indicative of the pleasure which nineteenth-century customers took in having *trompe l'oeil* surfaces in their home is the covering of this table's mahogany top with graining. The artist's ability to imitate nature was as important as that which was being imitated.

This form of X-base card table with a swiveling top was popular among Baltimore's elite. Several examples of identical form but employing a variety of decorative motifs have survived.[3] The decorator who painted this example also appears to have executed similar motifs and graining on a wide variety of furniture forms including pier tables, mixing tables, window benches, and fire screens.[4]

STRUCTURE AND CONDITION: The X-shaped base is constructed of two members which lap across one another. The base stretchers tenon into mortises in the turned feet. The pedestal is pieced-up from two boards. A cross brace is dovetailed to the sides of the upper section. The pedestal appears to be joined to this cross brace with a double tenon. The top swings on a pivot so that it can be opened.

This table is in excellent condition. The grained surface and classical decoration are almost completely intact. The original red, calendered wool fabric is extant on the interior of the table (see cat. 53a). The brass rosettes on the base are replacements. Originally, small nipples sat atop the metal caps at each end of the base. The top of the pedestal has suffered a minor loss. The casters are original.

WOODS: Feet, pedestal, and skirt rails, yellow poplar; base cross stretchers, cherry; bottom board, eastern white pine; top, mahogany.

DIMENSIONS: H. 29½ (74.9); W. 36 (91.3); D. closed 17⅞ (45.4); D. open 35⅛ (90.3).

PROVENANCE: Private collection, Baltimore, Md.; unidentified antiques dealer, Baltimore, Md.; Peter Hill, Inc., Washington, D. C.; Bybee Collection, early 1970s.

EXHIBITIONS AND PUBLICATIONS: Warren and Howe 1978, no. 1; Howe 1979, 556; Fairbanks and Bates 1981, 270; MFA, H 1981.

1985.B44

Cat. 53a

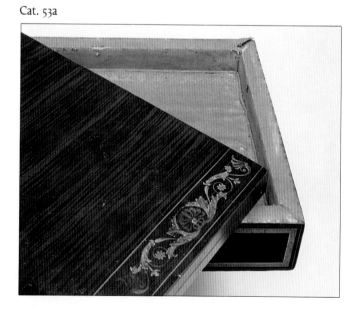

1. For a discussion of Baltimore painted furniture, see Elder 1972.
2. The classical motifs seen on this table and related examples could have been derived from numerous European pattern books. Sources with similar decoration in them include Hope 1807, Percier and Fontaine 1812, and Mésangère 1796.
3. For tables with identical structure, see Elder 1972, no. 44; Weidman 1984, no. 172; SPB 6000 (29–30 Apr. 1987): lot 3215 and Christie's 6666 (1 Oct. 1988): lot 376. Another is in the collection of the Valentine Museum, Richmond, Va. (OM.18.2). For a card table with different feet and scrolled brackets, see Fitzgerald 1982, 168.
4. For related other forms, see Montgomery 1966, nos. 279–280; Elder 1972, nos. 27–28; Fitzgerald 1982, 168.

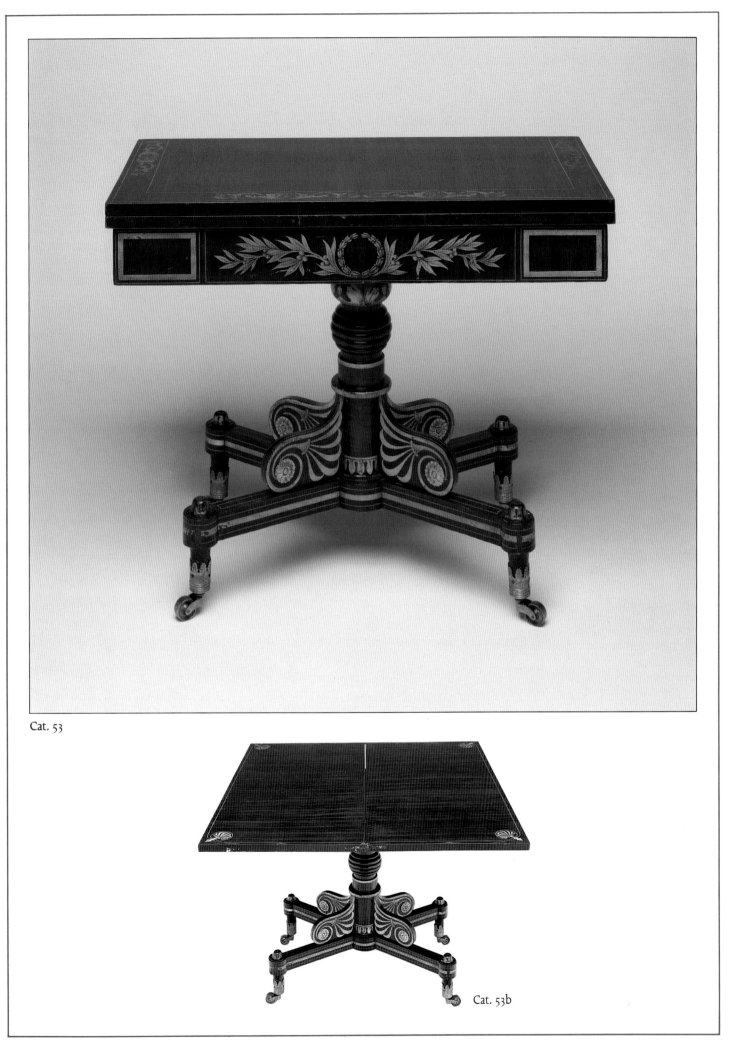

Cat. 53

Cat. 53b

ISAAC VOSE (1767–1823) was one of Boston's most important cabinetmakers during the early nineteenth century. Born in Milton, Massachusetts, Vose came to Boston in 1788 and established a cabinet shop on Orange Street. Between 1805 and 1816 Vose was in partnership with Joshua Coates. Known as Vose and Coates, their shop was located on Washington Street. In 1816 Vose's son, Isaac, Jr. (1794–1872), joined the business and the name was changed to Vose, Coates, and Co. However, when Coates died in 1819, the firm became Isaac Vose and Son.[1]

In their shop at 705 Washington Street Vose and Son made "a large assortment of CABINET FURNITURE, manufactured in the most faithful manner, which they offer[ed] for sale on as favorable terms as [could] be purchased in [Boston]."[2] In this effort the firm was extremely successful. They received the patronage of Boston's wealthy elite and their products became renowned for their good taste and high quality. Indicative of the respect which their furniture garnered was its listing by name in estate inventories and used-furniture advertisements of the period. By the time Isaac Vose, Sr., died in 1823, his furniture manufactory consisted of over 14,000 square feet, with a three-story main building and numerous auxiliary structures. His estate was valued at $43,504.96. A year after his father's death, Isaac, Jr., sold the business and left cabinetmaking altogether.

At present three tables virtually identical to this example are known. One of these is stenciled with the label of Vose and Sons. The mark reads: "ISAAC VOSE & SON / Cabinet, Chair & / Furniture Warehouse / Washington St. / BOSTON."[3] In designing such tables, Vose and Son relied heavily on contemporary English card tables (see fig. 18). The foot design, pylon-shaped pedestal, and skirt layout were probably copied directly from an imported table or made by an English journeyman. In 1818 Vose advertised that he employed "2 experienced workmen" familiar with "the present European style."[4]

STRUCTURE AND CONDITION: The base block is a solid piece of chestnut. The feet are attached with screws. The pedestal and the cross brace under the top are secured to the base block with an iron rod and bolt. The skirting members are dovetailed together. The cross brace is screwed to the skirt sides. The table top pivots to the side and opens into a square. When pivoted to the side a storage compartment is exposed beneath the top.

This table survives in excellent condition. The original finish has been slightly marred through use. There are minor stress cracks in the base block and veneer. The casters are original.

INSCRIPTIONS: Written in chalk on the interior compartment is what appears to be "To No. . . ."

WOODS: All exterior surfaces, mahogany; cross brace under top section, birch; base block, chestnut.

DIMENSIONS: H. 29¾ (75.6); W. 36⅝ (93.1); D. closed 18 (45.8); D. open 36⅛ (91.6).

PROVENANCE: Unidentified dealer, Boston, Mass.; Ronald Bourgeault, Hampton, N. H.; Bybee Collection, early 1980s.

Gift of Faith P. Bybee, 1988.B71

1. All information on Vose and Son cited here is taken from Talbott 1977.

2. *Columbian Centinel* (Boston, 3 Mar. 1824), quoted in Talbott 1977, 43.

3. For a satinwood veneered example, see Talbott 1975, 880. For the labeled example in the St. Louis Art Museum (127 : 1965), see Talbott 1975, 883; Talbott 1977, 44; Springer 1980, 25. For another undocumented example, see *Maine Antique Digest* 16 : 12 (Dec. 1988): 2-B.

4. *Columbian Centinel* (Boston, 13 May 1818), quoted in Talbott 1977, 42. For a discussion of the influence of English design on American furniture during this period, see Fennimore 1981.

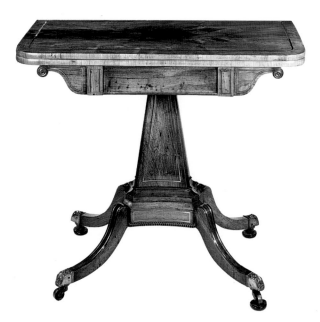

Fig. 18. Card table, England, probably London, 1815–1830. Rosewood with brass inlay; W. 35½ (90.0). (Courtesy, Christie, Manson, and Woods, Ltd.)

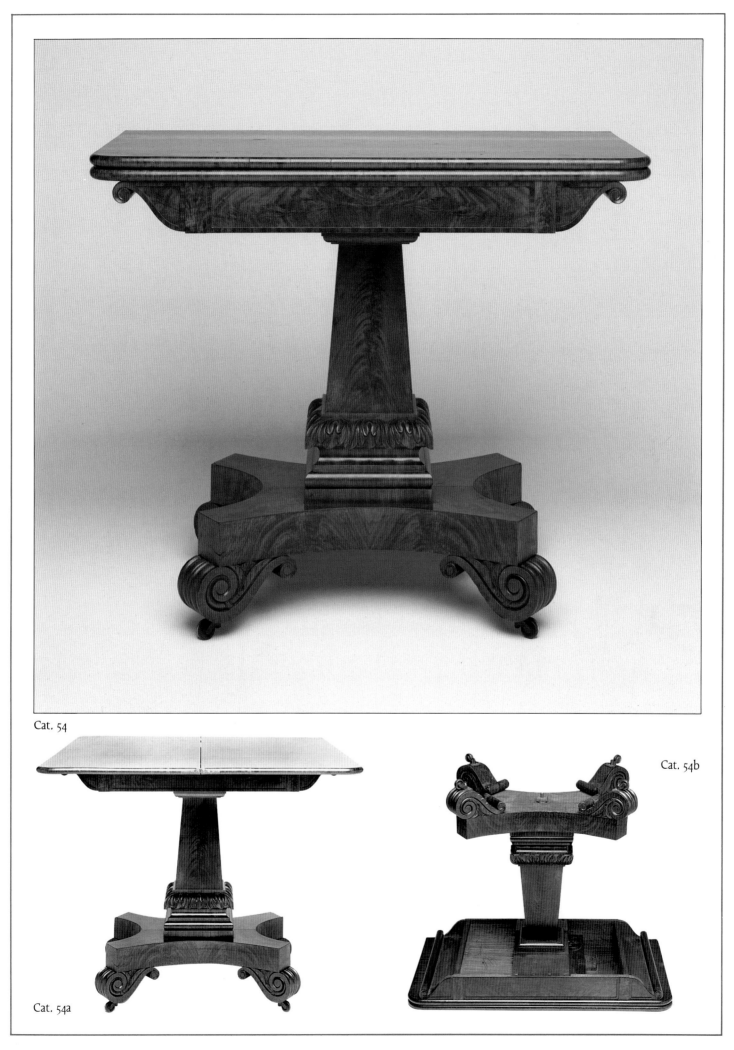

Cat. 54

Cat. 54a

Cat. 54b

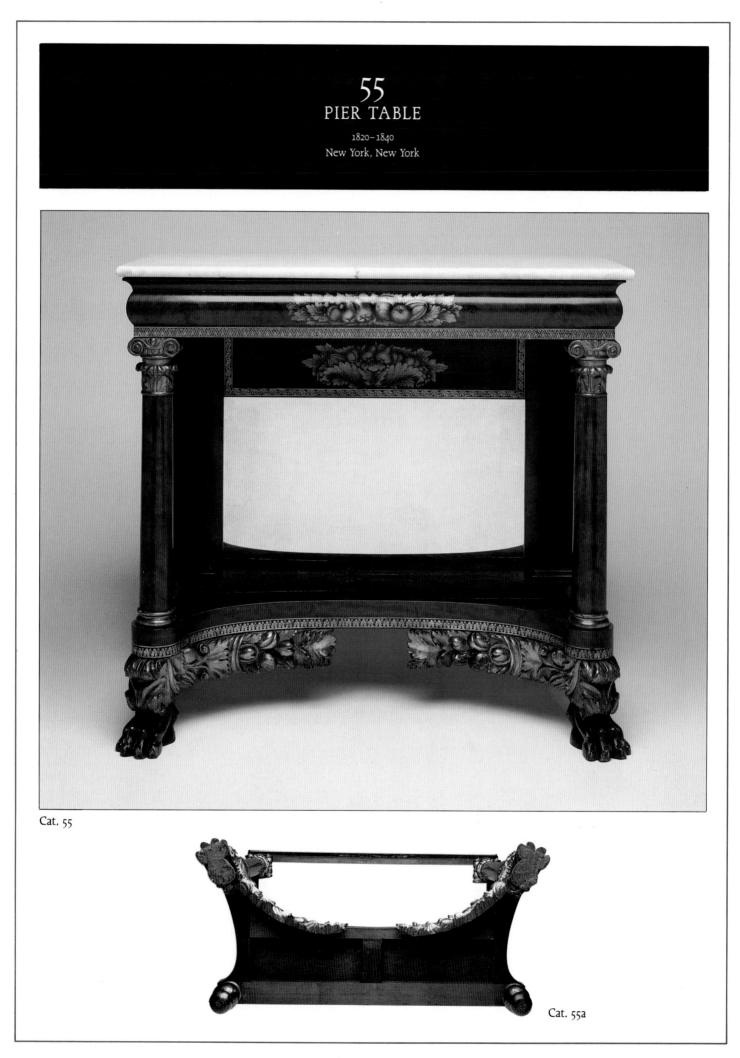

55
PIER TABLE
1820–1840
New York, New York

Cat. 55

Cat. 55a

IN ITS USE of carved lion feet with foliate wings, Ionic capitals, a curved lower shelf, and stenciled decoration on its cornice and upper rear rail, this pier table is closely related to a large group of New York examples.[1] However, due to the number of craftsmen involved in the production of such tables, they are difficult to attribute to a specific cabinet shop.

The construction of this table's frame probably required the skills of two or more craftsmen. A cabinetmaker who knew a variety of joinery techniques would have cut and framed the basic components, while a turner produced the columns on a lathe. The application of thin sheets of wood veneer may well have been done by someone who specialized in veneering. Although probably cheaper than using marble, veneering round, tapered columns required great skill and added to a table's cost.

Another group of craftsmen were responsible for decorating the table. A carver was required to produce the feet, foliate brackets, and column capitals. Once these elements were completed, the table could be assembled. Next, a finisher smoothed the wood's surface and applied several coats of varnish or oil. A gilder then built up the surface of the carved areas with gesso, applied a base coat of binder, and finally applied sheets of gold leaf. The same artisan or another specialized decorator created the border designs and reserves of flowers and fruit using stencils to complete the table.

The process of applying designs with stencils was one in which New York decorators excelled. Stencils were introduced into ornamental painting about 1815. Their use made it possible to produce border designs, as well as reserves of decoration, much more cheaply than with gold leaf or cast ormolu mounts. The stencils used on furniture were made of paper. Once a piece was varnished, a thin coat of binder such as turpentine or varnish was applied. When the binder was nearly dry, the paper stencil was placed on the surface and metallic powders brushed over it. The powder adhered to the exposed areas, thus forming the desired pattern. In a complicated design, such as the fruit and foliage seen on this pier table, many stencils were required. Once completed, the entire surface of an object was given a final coat of varnish to protect the decoration.[2]

Since decorative painters, as well as gilders and carvers, usually worked for several cabinetmaking shops, it is virtually impossible to attribute work such as this table to a specific maker. In reality, no specific maker exists; rather, such tables represent the combined effort of a group of specialists.

STRUCTURE AND CONDITION: The base framing is mortise-and-tenoned together. The vertical stiles tenon into the base and upper framework. This upper framing is dovetailed together. There are triangular corner blocks behind the front corners and rectangular ones attached to the inside rear of the upper section.

The table, and especially its painted decoration, is in good condition. The backboard is missing and the glass has been replaced. The tacking strips holding the glass are also replacements. The marble has been cracked and repaired, but appears to be original. There are minor losses to the veneer and leaf carving. The green, primary layer for the gilding survives on the lower edges of the foliate brackets.

INSCRIPTIONS: "William Winn" is written in pencil on the back of the table. A search of New York City directories and census returns has found no one by this name living in the city between 1820 and 1850. This may well be the name of an owner living outside of New York.

WOODS: All visible surfaces, mahogany and mahogany veneer; triangular blocks, front feet and brackets, and base framing, yellow poplar; baseboard, rear vertical supports, upper frame, and rear square blocks, eastern white pine; rear feet, soft maple.

DIMENSIONS: H. 37¼ (94.5); W. 41 ⅜ (105.2); D. 19⅝ (49.8).

PROVENANCE: Abraham Shapiro, New York, N. Y.; Israel Sack, Inc., New York, N. Y.; Bybee Collection, 1963.

EXHIBITIONS AND PUBLICATIONS: MFA, H 1981.

1985.B49

1. See Fairbanks and Bates 1981, 273; Elder and Stokes 1987, no. 124; and Otto 1965, nos. 191–193. The canted feet of no. 192 are especially close to those on the Bybee example.

2. The information presented here on stenciling is taken from Fales 1972, 159, 186. For a list of decorative painting manuals, see Fales 1972, 293.

Cat. 55b

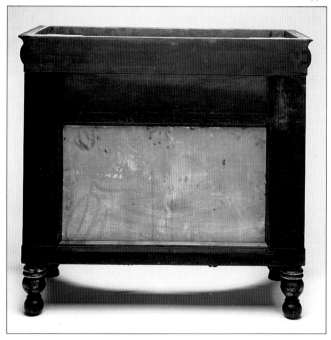

56
PIER TABLE

1825–1845
Attributed to the shop of Anthony G. Quervelle (1789–1856)
Philadelphia, Pennsylvania

ANTHONY G. QUERVELLE was one of Philadelphia's most important cabinetmakers during the second quarter of the nineteenth century.[1] Born and presumably trained in Paris, Quervelle was in Philadelphia by 1817. Between 1825 and 1849 Quervelle's shop was located at 126 South Street. Initially advertised as a "Cabinet and Sofa Manufactory," Quervelle soon changed the name of his firm to the "United States Fashionable Cabinet Ware House." By 1833 he could advertise that he had on hand

> a very large assortment of furniture, consisting of sofas, chairs, mahogany bedsteads, pier tables, marble tops; wardrobes, secretaries, pedestals, marble tops, and every other article in the cabinet line.[2]

In an early nineteenth-century context, advertisements such as this and terms like "manufactory" and "cabinet ware house" are difficult to interpret. On the surface such statements suggest that Quervelle maintained a large shop with many workmen. If so, the shop probably produced much of what it sold. However, the second quarter of the nineteenth century was one of dynamic change in the cabinetmaking trade.

During this period, certain firms, such as Quervelle's and Meeks and Son of New York, came to dominate the American market for higher priced furniture through the use of advertising and widespread distribution systems. Although research is scant in this area of American furniture history, it seems probable that many of these large concerns did not produce all they sold and labeled. Rather, many of the biggest shops probably bought furniture wholesale in large quantities from the hundreds of smaller, more specialized shops which existed in cities like Philadelphia and New York. Once acquired by the retailer, the furniture could be marked with his own label for advertisement purposes and put into his "Cabinet Ware House" at a considerable markup in price. Given the variety in both quality and design of objects bearing Quervelle's label, it is likely that he was acting more as a furniture dealer than as a producer by the 1830s.[3]

The Bybee pier table is connected to Quervelle's firm by the survival of several similar examples bearing his label.[4] Of all the furniture associated with Quervelle, his pier tables are the most consistent in design and may well represent his shop's specialty, or at least the work of a single specialized supplier. In either case, it is probable that Quervelle had control over the basic design of such tables due to his role as shop master and retailer.

Since Quervelle was French, it is interesting that this table, as well as most of the pieces bearing his label, is based upon English design sources, rather than continental ones.[5] The table's carved and ebonized supports, for example, closely relate to those shown on a "consol table" in William Smee and Sons's pattern book, *Designs of Furniture* (fig. 19).[6] Similar supports are also illustrated in books by the English designers George Smith and T. King.[7] The reliance on English ideas by a French craftsman suggests that most wealthy Philadelphians still looked to London as a style center, rather than Paris in the 1820s and 1830s.[8] If he was to make a profit, Quervelle could not work against this tendency, no matter how strong his feelings were concerning his native country and its design aesthetic.

STRUCTURE AND CONDITION: The base is a solid board. The turned feet, scrolled supports, and rear vertical stiles are tenoned into this baseboard. The rear stiles are also tenoned into the upper frame which is dovetailed together. The outermost edge of the cornice is an applied 1" (2.6 cm.) strip. The circular decoration on the lower shelf consists of four wedge-shape pieces of veneer surrounded by a stenciled border. The scrolled supports are ebonized.

The table is in good condition. The marble top appears to be original. There is a central brace under the marble which may be an addition. The backboard has been off and may be an old replacement like the mirrored glass.

WOODS: All front surfaces, mahogany and mahogany veneer; blocks above carved supports, yellow poplar; upper and lower framing members, eastern white pine; central brace under top (probably an addition), southern yellow pine.

DIMENSIONS: H. 35⅞ (91.2); W. 41¾ (106.1); D. 18⅞ (47.9).

PROVENANCE: Bybee Collection, 1960s.

EXHIBITIONS AND PUBLICATIONS: MFA, H 1981.

1985.B55

1. All biographical information on Quervelle is taken from R. Smith 1964. For more information on Quervelle, see R. Smith 1–5, 1973–1974; and PMA 1976, 277–278.
2. Quoted in R. Smith 4, 1973–1974, 192.
3. For a discussion of Philadelphia cabinetmaking during this period, see Catalano 1979. For a discussion of problems with the Smith series on Quervelle and problems of historical interpretation of this period, see Venable 1986, 1–9.
4. For related, documented tables, see R. Smith 1964, 304–306; PMA 1976, 278. Similar undocumented tables are illustrated in R. Smith 1, 1973–1974; H. Schiffer 1983, 235; AAA (Hudnut Collection sale, 19 Nov. 1927), lots 56–57. A related table is also in the collection of the Virginia Museum of Fine Arts, Richmond (76:40.2). For information on the original cost of such tables, see Philadelphia 1828, 10–11.
5. For related French and German tables, see Ledoux-Lebard 1965, 64; Kreisel and Himmelheber 1983, no. 548. The German example may well have been inspired by English designs.
6. Smee 1830, pl. 86.
7. G. Smith 1826, pl. 17 ; King 1830, pl. 21.
8. For a discussion of French influence on Philadelphia furnishings, see Garvan 1987, 54–65.

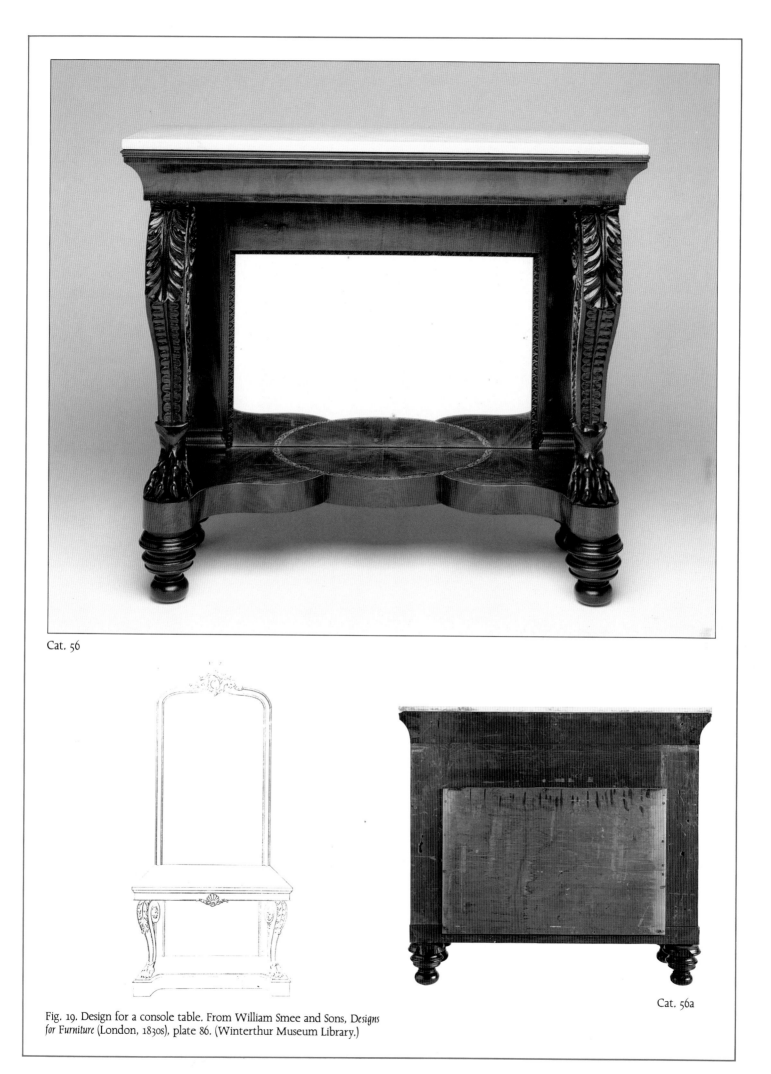

Cat. 56

Fig. 19. Design for a console table. From William Smee and Sons, *Designs for Furniture* (London, 1830s), plate 86. (Winterthur Museum Library.)

Cat. 56a

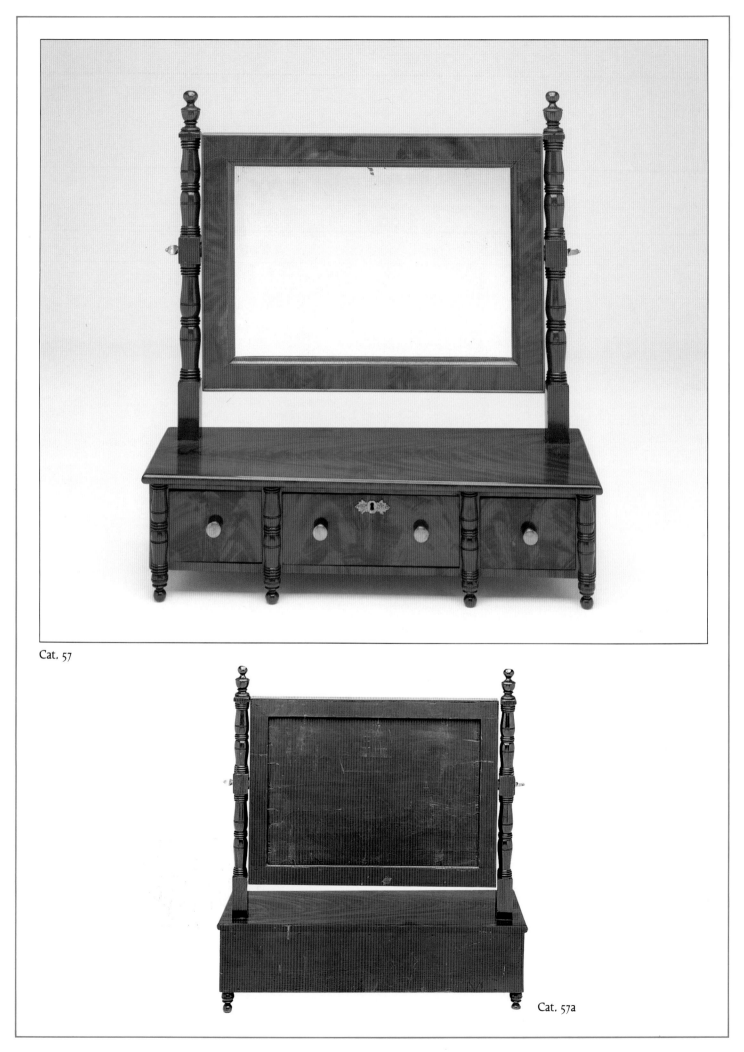

Cat. 57

Cat. 57a

VARIOUS COMBINATIONS of small boxes and looking glasses have existed for centuries. Used for the storage of items such as combs, ribbons, makeup, and jewelry, these case pieces with glasses were ideal for personal grooming. This particular form of dressing box with its tripartite facade and turned uprights is directly based on early nineteenth-century English examples.[1] One period term for such pieces was "looking glass with drawers."[2]

Boston appears to have been the center of production for this type of box from 1820 to 1850. It is known that both the shops of Edward Lothrop (d. 1837/8) and Stephen Badlam, Jr. (1779–1847) produced dressing glasses. Other looking-glass makers probably made them also. The similarity of the turnings on Boston dressing boxes suggests that various makers relied on a single shop for the specialized turnings they needed.[3]

The Bybee example relates most closely to the work of Edward Lothrop. The details of the turned uprights and the feet are almost identical to documented Lothrop pieces.[4] Lothrop's shop first appeared in Boston directories in 1813. It produced mirrors and dressing boxes in quantity for both local and export markets. His label for the early 1820s advertising his shop at 28 Court Street states:

> KEEPS constantly on hand, a good assortment of well made *Guilt* and *Mahogany* framed LOOKING GLASSES, of the first quality. Miniature and Profile Frames, by wholesale or retail. Looking Glasses, Portraits, Pictures, and Embroidery framed in the best manor.
>
> N.B. Country Traders who buy and sell again have found, and will still find it for their interest to call as above, where they can have Glasses packed with perfect safety for transport, free of expense. *Gold Leaf for sale, as usual, by the single book, or dozen, at Factory prices.* Old plates new silvered.[5]

With such an extensive trade, Lothrop's shop must have employed several journeymen and apprentices. The "CB" written in the central compartment of the Bybee dressing glass may be the initials of one of these workers.

Besides the exportation of Boston dressing glasses, emigrating craftsmen also transplanted Boston shop traditions to other parts of the country. Spencer Nolen, for example, left Boston in 1816 for Philadelphia where he labeled Boston-type glasses. He continued in business in Philadelphia as an ornamental painter and looking-glass maker until 1849.[6] Others who are known to have made and/or retailed Boston-type dressing glasses include Thomas J. Natt of Philadelphia and New York, James Evans of New York and Richmond, Virginia, and John Needles of Baltimore.[7] Although it is difficult to document, many merchants and craftsmen probably put their own labels on imported Boston examples.

STRUCTURE AND CONDITION: The case is fitted with vertical drawer dividers which stop 1″ (2.6 cm.) short of the backboard. The drawers run on the bottom of the case. The mirror supports are double tenoned into the top of the case. A mahogany, half-round molding surrounds the veneered top. The feet are continuous extensions of the decorative turnings on the facade.

The drawers have fine dovetails. Their chamfered bottoms slide into grooves along the front and sides and are nailed into place along their rear edge. Two vertical stops are glued to the back of each drawer.

The box is in good condition. The knobs and glass are replacements.

INSCRIPTIONS: The drawers and their respective compartments are numbered 16, 17, and 18. "CB" is inscribed on the bottom of the central compartment. A paper label in the central drawer reads: "Mrs. R. Summer / Bathroom."

WOODS: Most exterior surfaces, mahogany and mahogany veneer; veneer trim around glass, cherry; all drawer parts, case top, sides, bottom, and backboards, eastern white pine.

DIMENSIONS: H. 28¾ (73.0); W. 27 (68.6); D. 9⅝ (24.4).

PROVENANCE: This dressing box was purchased in Philadelphia, Pa.; Bybee Collection, probably 1960s.

EXHIBITIONS AND PUBLICATIONS: MFA, H 1981.

1985.B48

1. For a similar English example, see Christie's 3589–90 (London, 7 May 1987): lot 80.

2. An 1817 bill from Barelli, Torre and Company of Charleston, S. C., lists "One Looking Glass with Drawers, $22." Reproduced in H. Schiffer 1983, nos. 541–542.

3. See DAPC 69.2709 for a labeled example by Badlam.

4. DAPC 64.998. A virtually identical dressing box is illustrated in SPB 634 (13–17 Feb. 1945): lot 1654.

5. DAPC 64.998. See H. Schiffer 1983, nos. 428–429, for a different label.

6. H. Schiffer 1983, 620–621.

7. See *Antiques* 130:1 (July 1986): 34; SPB 5551 (28–31 Jan. 1987): lot 1193; *Antiques* 65:4 (Apr. 1954): 295; H. Schiffer 1983, no. 539. Other related, but undocumented, examples are illustrated in *Antiques* 49:6 (June 1946): 340; SPB 613 (6–8 Dec. 1944): lot 663; SPB 5551 (28–31 Jan. 1987): lot 1202.

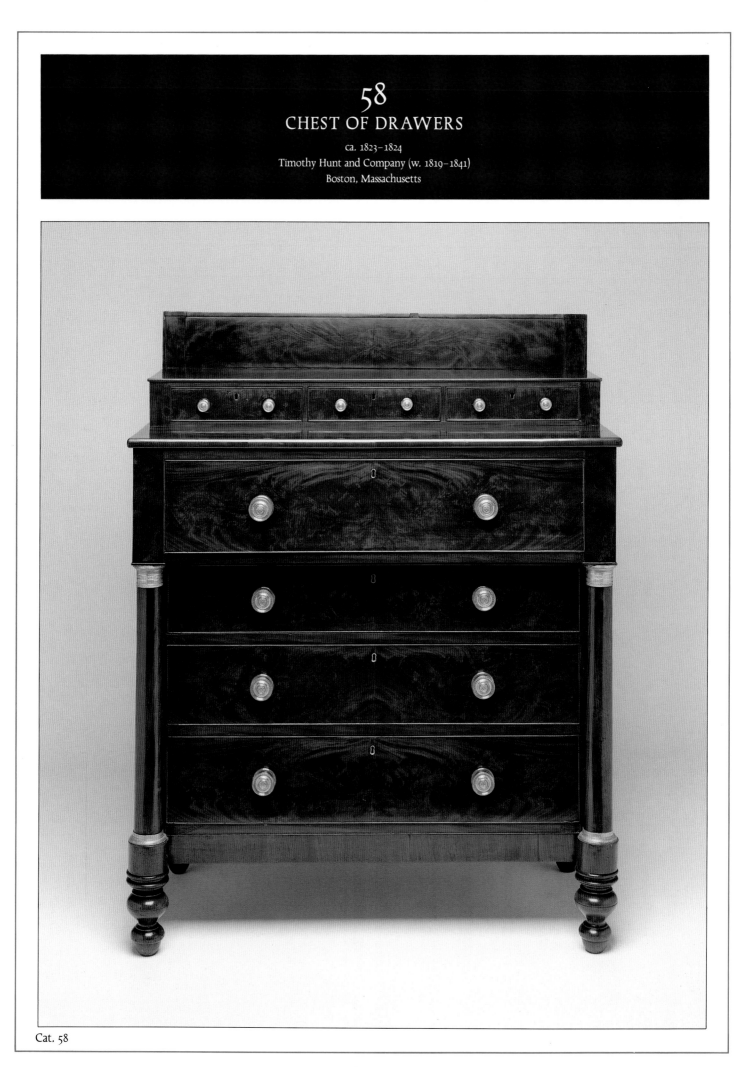

58
CHEST OF DRAWERS

ca. 1823–1824
Timothy Hunt and Company (w. 1819–1841)
Boston, Massachusetts

Cat. 58

UNLIKE THEIR COUNTERPARTS in New York, Philadelphia, and Baltimore, Boston cabinetmakers primarily produced restrained, late-classical furniture during the 1820s and 1830s.[1] Seldom does one see elaborate uses of gilding, marble, or bronze mounts on Boston products of this period. As demonstrated by this chest of drawers, Boston craftsmen and their customers chose to make wood grain and clear design their visual focus. In this example the mahogany veneer has been carefully chosen and matched. Beading along the perimeters of the drawer fronts serves to frame the patterned areas. The design of the chest continues this sense of containment through the use of framing columns and layered horizontals. The various elements—feet, drawers, and upper section—are all well defined.

Chests of drawers of this kind were made by several Boston cabinetmakers.[2] This example bears the stamp of one of Boston's most important furniture making firms, Timothy Hunt and Company. Hunt (d. 1874) began business in 1819. At his workshop at 10 Newbury Street he offered "a complete assortment of cabinet furniture of the newest and most approved patterns made of the best materials."[3] Between 1823 and 1824, Hunt and his employees worked in a shop located at 8 Newbury Street. This chest is believed to have been produced while the firm was at this location.[4]

STRUCTURE AND CONDITION: This chest of drawers is massively constructed. The side framing members are 2" (5.1 cm.) thick. Panels ½" (1.3 cm.) thick are set into these framing members. Horizontal rails are tenoned into the side stiles. There is a 1" (2.6 cm.) space between the horizontal rails and the side panels. The drawer runners are nailed into the side rails. The upper section is screwed to the top of the case. The case sides are screwed to the bottom. The feet tenon into the bottom framework. The back consists of a central spline into which two side panels fit.

The drawers are constructed with small dovetails. The front dovetails are hidden by beading strips. The chamfered drawer bottoms slide into grooves run along the drawer sides and are nailed in place across their back edge.

The chest of drawers is in good condition. It has had several sets of drawer pulls; one former set was oval in shape. All of the locks on the upper drawers are missing. Several drawer runners are replacements, and there are minor veneer losses.

INSCRIPTIONS: On the bottom of the upper large drawer is stamped twice in ink: "T. Hunt & Co. / Cabinet & Chair / Manufactury / N° 85 Newbury St. / Boston." A pencil inscription in the top overhanging drawer reads: "Refinished by Joe S. Dentz for A. E. Kennedy / 1016 Conn. Ave. Wash. D. C." On the bottom of the bottom board is written in pencil "B."

WOODS: Veneer, feet, small drawer sides and backs, large drawer sides, mahogany; little drawer fronts, big drawer linings, most of case, eastern white pine; case bottom side rails, birch; replaced drawer runners, yellow poplar.

DIMENSIONS: H. 53½ (136.0); W. 43⅜ (110.2); D. 23⅛ (58.7).

PROVENANCE: A. E. Kennedy, Washington, D. C.; unidentified dealer, Marblehead, Mass.; Peter Hill, Inc., Washington, D. C.; Bybee Collection, 1968.

EXHIBITIONS AND PUBLICATIONS: MFA, B 1976; Talbott 1976, 1007; MFA, H 1981.

1985.B47

1. For a discussion of late-classical Boston furniture, see Talbott 1975 and Talbott 1976.
2. For a related example made by Boston cabinetmaker Rufus Pierce, see *Antiques* 111 : 2 (Feb. 1977): 282. For another example with a probable Boston provenance, see *Antiques* 13 : 3 (Mar. 1928): 178. Related examples are also known from New Hampshire; see Page and Garvin 1979, no. 57.
3. Quoted from the *Columbian Centinel* in Talbott 1976, 1007.
4. The discrepancy between the ink stamp on this piece, which lists 85 Newbury Street as Hunt's address, and the Boston directory, which lists 8 Newbury, is probably a simple printing error. Inconsistency in street numbering was common in American cities in the early nineteenth century. In 1824 Hunt moved his shop to Washington Street.

Cat. 58b

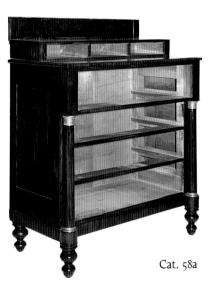

Cat. 58a

Cat. 58c

59
CHEST OF DRAWERS

1825–1845
America or Canada

WHEN COMPARED with its mahogany (cat. 58) and painted (cat. 60) counterparts, it is clear that the basic form of this chest was extremely popular in America during the second quarter of the nineteenth century. Chests with side columns or pilasters and overhanging top drawers were made throughout this country and Canada by urban and rural craftsmen alike.[1] Without a history of ownership or similar documented examples, the popularity of this chest form over a wide geographic area makes it difficult to determine the origin of this particular example.

Unlike the previous Boston example, the facade of this chest of drawers is veneered in highly figured bird's-eye maple. Like the paint on the following example, the maple veneer gives this chest a power and animation which the Boston piece lacks. The intent of this chest's maker was not subtlety and restraint, but boldness and vibrancy. When illuminated, this chest's facade has a glistening, jewel-like quality.

Although they never became as popular as dark mahogany, light-color woods were favored by many cabinetmakers and customers during the 1830s and 1840s. Among some, their use was seen as a patriotic statement, since woods such as maple were native to North America, as opposed to mahogany which was imported from Central and South America. During this period, for example, the Philadelphia firm of J. and A. Crout repeatedly received accolades for its "American-wood furniture" at the Franklin Institute's annual craft exhibitions. In 1841 J. and A. Crout advertised in Philadelphia's *Public Ledger* that they had on hand a

> splendid assortment of furniture, manufactured from a selection of American wood, such as has never before been introduced to the American public, and which, for beauty and design, cannot be surpassed by any cabinet ware manufactured from Imported Wood.[2]

Apparently the Crouts were not exaggerating the high quality of native-American light woods. Furniture makers in Europe were also impressed and ordered figured American woods for their own products.[3]

STRUCTURE AND CONDITION: The chest is primarily mortise-and-tenoned together. It never had a bottom board or lower rear rail. The sides are framed with floating panels in their cen-

ters. The drawer runners are nailed to the side rails. These rails tenon into the corner stiles, but are not flush with the case sides. The rails are inset 1" (2.6 cm.). The pilasters are attached to the stiles with dowels. The top is screwed on from below. The back consists of three horizontal members which tenon into the stiles. Two panels fit into grooves run along the edges of these tenoned members.

The drawers are constructed with precise, medium-size dovetails. Running strips are attached to the bottom of the drawer sides. The bottoms of the two middle drawers consist of three boards oriented parallel to the facade. Those of the top and bottom drawers are single widths. Their chamfered edges fit into grooves run along the front and sides. They are nailed flush across the back. The curved section of the top drawer is applied.

The chest has been apart. Several veneer losses have been repaired. The top and sides were evidently never veneered, but simply stained to match the maple facade. The top has several deep dents in it. The brass oval pulls are replacements. The chest originally had wooden knobs. Two braces have been glued under the top to try to stop cracking.

INSCRIPTIONS: The top of the pilasters are incised "I" and "II," respectively.

WOODS: Veneer, maple; top, top medial brace, drawer dividers, drawer sides and fronts, backboards, eastern white pine; pilasters, thin blocks on drawer dividers, drawer running strips, drawer bottoms, yellow poplar; pilaster dowels, cherry; turned rear feet, probably beech.

DIMENSIONS: H. 46¼ (117.4); W. 43⅜ (110.1); D. 23⅛ (58.8).

PROVENANCE: Purchased in Houston, Tex.; Bybee Collection, early 1970s.

Gift of Faith P. Bybee, 1988.B81

1. For Canadian examples which use figured maple in a related way, see Paine 1978, 439.
2. *Public Ledger* (Philadelphia, 10 May 1841). For a discussion of the Crout shop, see Talbott 1980, 209–211.
3. For a discussion of light-wood furniture in Philadelphia and its importation by Central Europeans, see Venable 1986, 74–77.

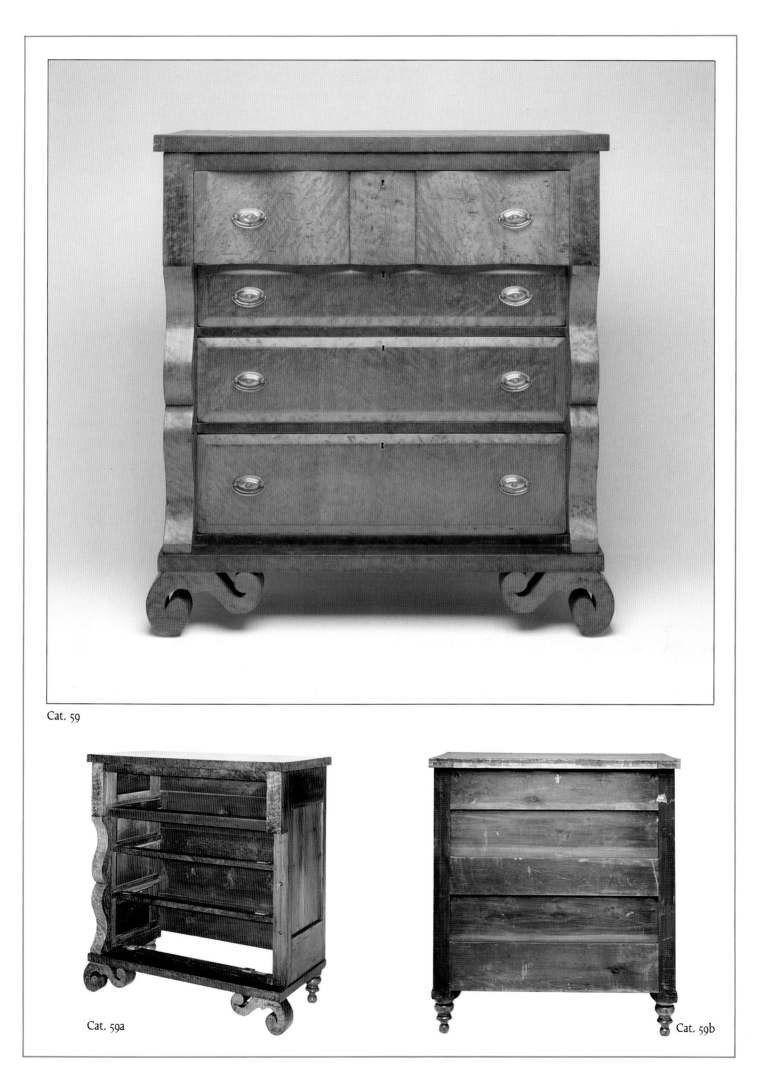

Cat. 59

Cat. 59a

Cat. 59b

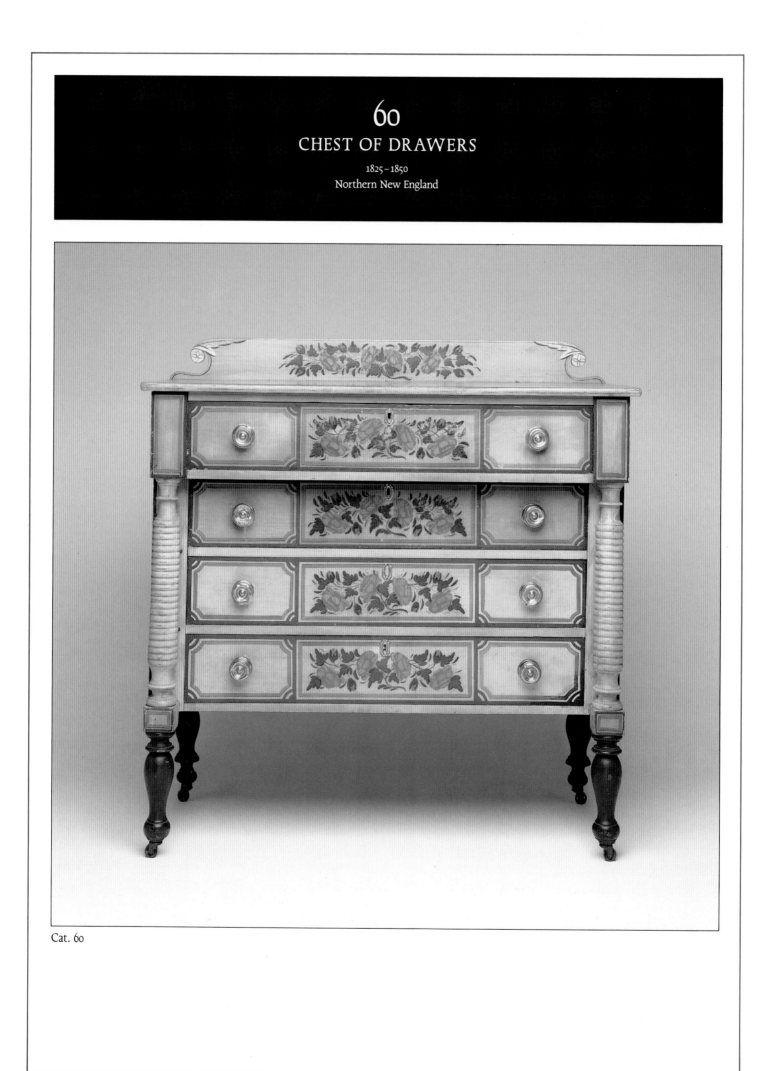

60
CHEST OF DRAWERS

1825–1850
Northern New England

Cat. 60

IN ITS BASIC FORM, this chest of drawers relates closely to one made by Timothy Hunt and Company of Boston (cat. 58). Both chests employ turned feet, side columns, overhanging upper drawers, and elements which rise above their tops. Also, the decoration on each is contained in rectangular reserves on the drawer fronts. In the case of the Hunt chest, a raised beading frames the crotch mahogany on each drawer. Here, the flowers and brass knobs are framed by painted rectangles. But in spite of the similarity in the placement of decoration on these two chests, the character of that decoration could not be more dissimilar. Where the Boston example is monochromatic and reserved, this chest is colorful and bold. The emphasis is not on natural wood grain, but on large areas of pure color and flat patterns.

Where this chest of drawers was made is not known. However, its similarity to examples from southern Maine and New Hampshire and the use of birch in its construction suggest a northern New England origin.[1] Furthermore, its nailed construction and floral decoration indicate that this piece was produced for a cost-conscious middle-class market. Furniture joined primarily with nails rather than dovetails and mortise-and-tenons required less labor and skill and was therefore cheaper. Using stencils to paint the pink flowers also reduced the cost of ornamenting this chest of drawers. The leaves were expertly and quickly filled in freehand after the roses were in place.

STRUCTURE AND CONDITION: The case is almost completely joined with cut nails. The bottom boards are dovetailed to the sides of the case. The backboards are nailed to the rabbeted edges of the sides. The drawer runners are nailed to the sides of the case and strengthened with glue blocks. The drawers are joined with large dovetails. Their flat drawer bottoms fit into grooves run along the front and sides. They are nailed flush across the back edges. More ornate turnings were used on the rear feet than on the front ones.

This chest is in excellent condition. The painted surface has suffered minor wear. The original hardware has several dents in it. The rear bottom board is a replacement. The case lists slightly to the left. The casters are original.

WOODS: Legs, blocks above legs, drawer dividers, drawer fronts, top, case sides, birch; drawer bottoms, drawer runners, pads on drawer dividers, eastern white pine; backboards, side glue blocks, drawer sides, basswood.

DIMENSIONS: H. 44⅝ (113.5); W. 44⅝ (113.5); D. 21¾ (55.3).

PROVENANCE: Bybee Collection, 1970s or early 1980s.

Gift of Faith P. Bybee, 1988.B82

1. The relationship of this chest to examples from northern New England is discussed in Edwin A. Churchill, letter to the author, 10 Sept. 1987, DMA files. For related examples, see Churchill 1983, nos. 4, 12–13. For related painting on mid-nineteenth-century "cottage" furniture, see Fales 1972, no. 499. For general discussions of painted furniture in New England, see Fales 1972; Harlow 1979.

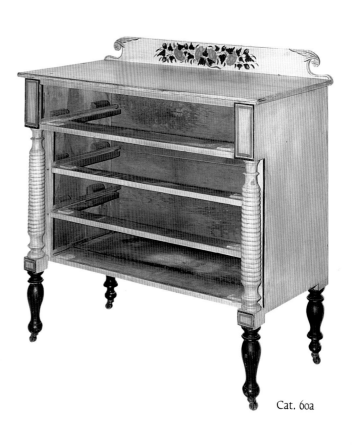

Cat. 60a

Cat. 60b

61
DRESSING TABLE
[1820–1840]
New England

LIKE ITS eighteenth-century counterpart (cat. 9), this dressing table was designed to hold personal items such as jewelry, ribbons, combs, and hairpins. However, unlike the earlier mahogany and cherry example, this piece was not made for an exceptionally wealthy owner. Inexpensive pine is used throughout and wooden knobs take the place of brass hardware. Furthermore, the exaggerated proportions of the thin legs, broad top, and scrolled back suggest that this piece was made by a rural craftsman for a client who was not accustomed to urban products.[1]

Regardless of its rural origins, however, this dressing table is not without its merits. Its painted surface, for example, is well executed. To achieve this grained effect, the decorative painter first applied a coat of yellow paint. Next, a layer of white was applied as a ground for the graining. The wood grain patterns were created with a translucent brown paint through which the underlying white is visible.[2]

During the second quarter of the nineteenth century, colorful painted furniture, such as this example, was popular among America's middle class, especially in rural areas. Similarly, decorative or "fancy" painting was applied to trunks, floorcloths, and interior woodwork. When combined with the colorful textiles and wallpapers used during this period, homes done in the "fancy" taste became a complicated maze of patterns and colors (see fig. 20).

STRUCTURE AND CONDITION: The sides and back of the table tenon into the legs. The top is nailed on. The structure housing the upper three drawers is constructed with and attached to the top of the table with nails. The backboard is supported by two vertical braces and is nailed to the sides of this upper drawer section. The drawers are constructed with medium-size dovetails. Their chamfered bottoms slide into grooves run along their fronts and sides and are nailed flush across the backs. The drawer runners for the lower drawer are glued to the side rails. Drawer stops are glued to the rear of each of the three upper drawer compartments.

This table is in good condition. The front left leg has suffered a minor loss at its base. The curved backboard has been cracked and repaired. The two vertical back supports are replacements. The wooden knobs are probably original. The original paint has suffered minor wear.

INSCRIPTIONS: The top drawers are numbered in pencil 1–3.

WOODS: All elements, eastern white pine.

DIMENSIONS: H. 42⅝ (108.2); W. 34¼ (87.0); D. 18 (48.8).

PROVENANCE: Bybee Collection, late 1970s or early 1980s.

Gift of Faith P. Bybee, 1988.B78

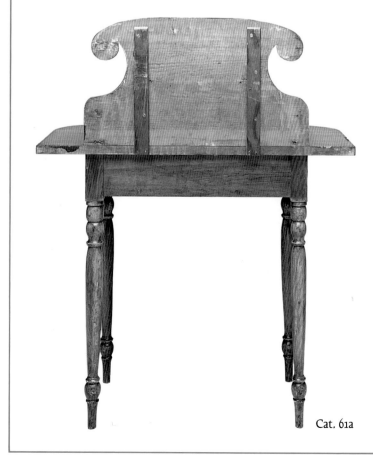

Cat. 61a

1. This form of dressing table is known from northern New England, as well as Connecticut. For a discussion of this piece, see Edwin A. Churchill, letter to the author, 10 Sept. 1987, DMA files. For related examples, see Fales 1972, nos. 311–312; Churchill 1983, nos. 5–6.
2. For a discussion of period painting techniques, see Fales 1972, 196–205.

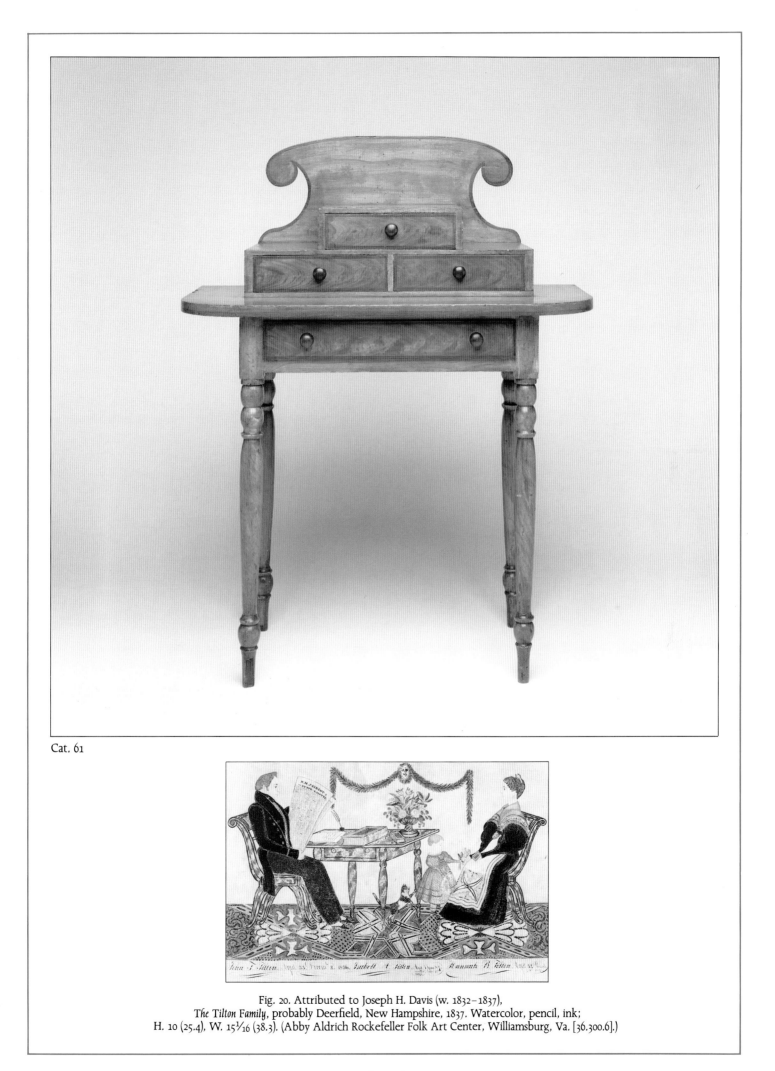

Cat. 61

Fig. 20. Attributed to Joseph H. Davis (w. 1832–1837),
The Tilton Family, probably Deerfield, New Hampshire, 1837. Watercolor, pencil, ink;
H. 10 (25.4), W. 15¹⁄₁₆ (38.3). (Abby Aldrich Rockefeller Folk Art Center, Williamsburg, Va. [36.300.6].)

62
HIGH POST BEDSTEAD

1820–1850
Probably Philadelphia, Pennsylvania

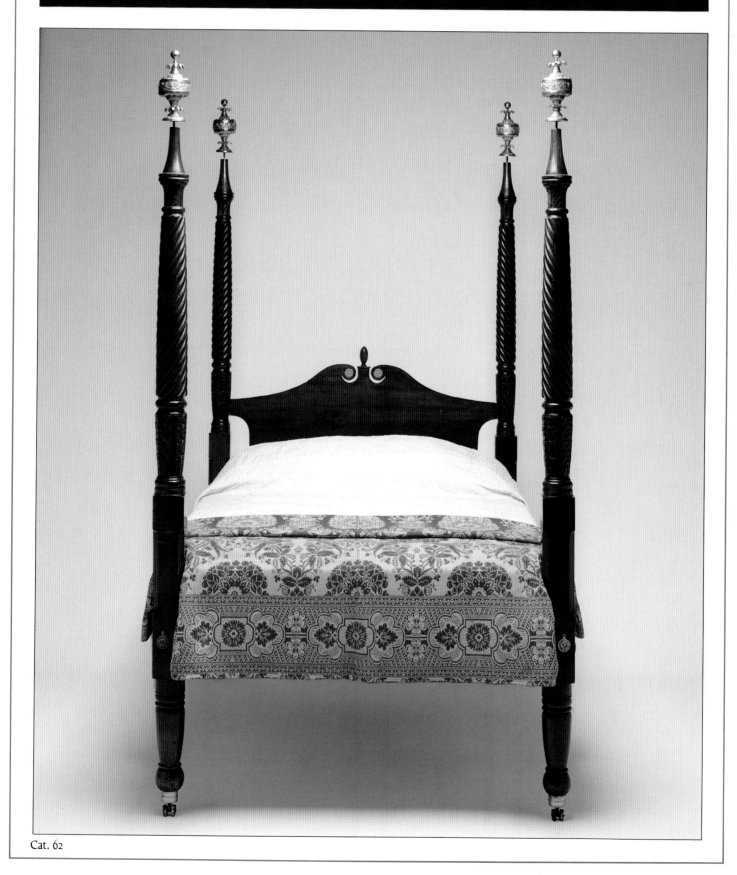

Cat. 62

DURING THE FIRST HALF of the nineteenth century, high post beds with elaborate hangings continued to be a potent symbol of one's wealth and social status (see cat. 25). However, by this period beds were typically placed in specialized bedrooms. No longer were they located in parlors as they often had been in the eighteenth century.

The twisted-rope motif and oak leaves seen on this bed's posts are typical of expensive beds made during this period. The use of wooden or brass spheres on the bottoms of the posts is also seen on numerous early nineteenth-century beds. However, this bed has several unusual features. For example, the elaborate stamped-brass finials on its posts are remarkable survivals (cat. 62a). To date no other examples are known.

The size and character of this bed's posts are also unusual. Although the front and back posts appear to be identical, they are not. The rear pair are smaller in diameter and were carved by a different hand than the front set. The reason for these differences is unclear. Perhaps the difference in size was an attempt to create a false perspective by which the bed would seem longer. The difference in the carving may indicate that this bed came from a large shop which employed more than one carver. It is also possible that the original owners had two similar beds which they ordered at different times from the same shop. At some point they could have inadvertently mixed the posts of the two beds.

Based only on design and carved decoration, this bed could have been made in almost any major urban area of America during the early nineteenth century. However, since it was collected in Philadelphia and has a tradition of ownership in the Reed family, it is likely that it was made there. During the 1820s and 1830s, there were several Reeds in Philadelphia who could have afforded a bed such as this.[1]

STRUCTURE AND CONDITION: The four posts are turned from single pieces of wood. The rails and headboard tenon into the posts. Iron bolts secure the rails through the posts. The bed originally had hickory pegs along the rails to which a sack cloth attached. These pegs have been cut off flush with the rails and metal L-supports were once added to the rails to accommodate box springs. The headboard is a replacement, as are the bolt covers on the posts. The casters are original and the period finials may be as well.

WOODS: Posts and rails, cherry; pegs, hickory; headboard (replacement), yellow pine.

DIMENSIONS: H. 89¾ (228.0); W. 56 (142.2); D. 79½ (201.9).

PROVENANCE: Lester Berry, Philadelphia, Pa.; Israel Sack, Inc., New York, N. Y.; Bybee Collection, 1963.

EXHIBITIONS AND PUBLICATIONS: MFA, H 1981.

1985.B46

1. The most likely candidates are John Reed (merchant); Joseph Reed (city recorder and lawyer); and James Reed (merchant). Philadelphia city directories for this period list numerous Reeds.

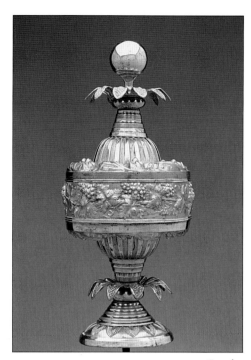

Cat. 62a

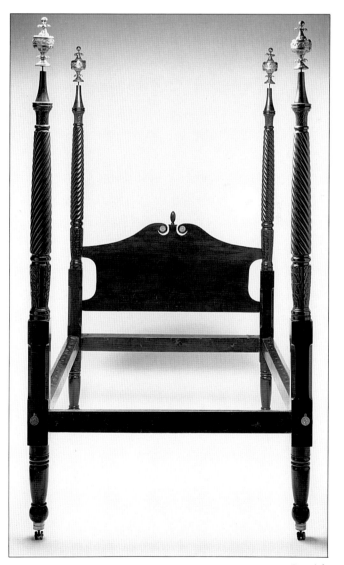

Cat. 62b

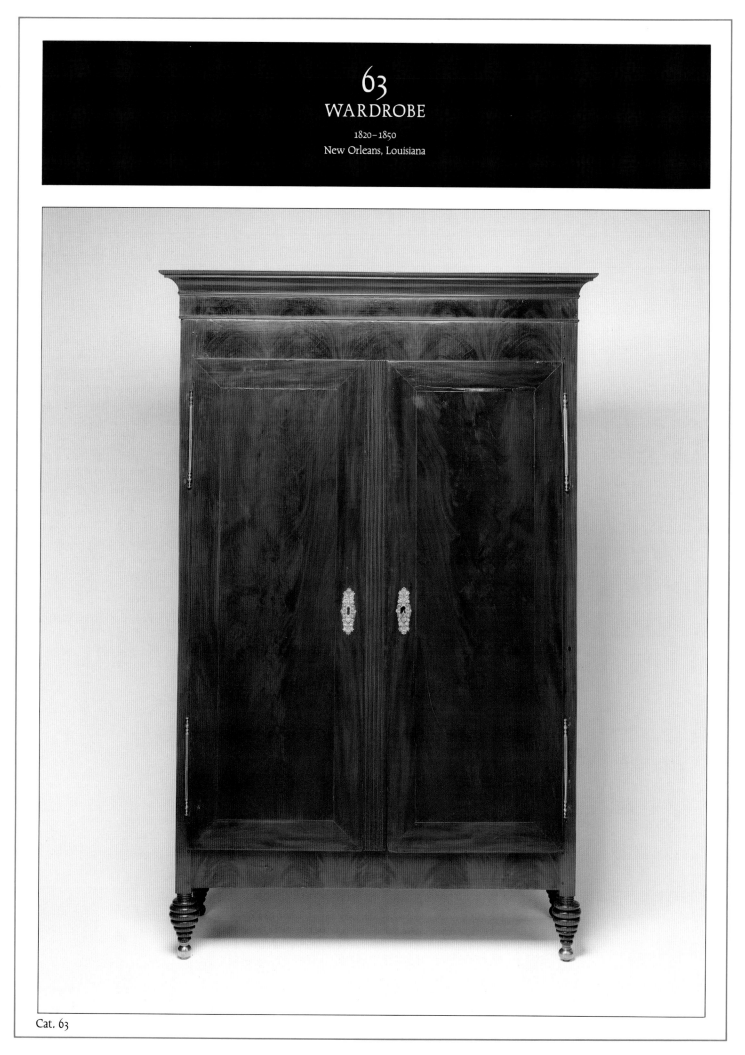

63
WARDROBE

1820–1850
New Orleans, Louisiana

Cat. 63

AS AN EIGHTEENTH-CENTURY colonial center for both the Spanish and French, New Orleans design and craft traditions were heavily influenced by continental ideas. By the early nineteenth century, however, New Orleans cabinetmakers were being influenced by the influx of both furniture and craftsmen coming in from the East Coast. This wardrobe represents the blending of these various traditions.[1] The presence of a central bank of interior drawers and a massively constructed back probably relate to continental craft traditions, while the design's overall restraint and use of brass caps on the feet are suggestive of contemporary pieces from cities like New York. The boldly turned feet are seen on several New Orleans examples.

The survival of several closely related wardrobes suggests that this form was popular among the wealthier residents of the lower Mississippi Valley.[2] However, the presence of the inscription "Maurice Hebenstiedt / • Matamoros •" on this example indicates that such wardrobes were exported from New Orleans to Mexican cities, like Matamoros. While no research has been done on the quantities of furniture shipped from and through New Orleans to Central and South America, the quantities must have been substantial.[3] Not only did New Orleans support a large population of cabinetmakers, but it was one of the busiest ports in America throughout the nineteenth century. As the cultural and economic hub of the Gulf Coast, many wealthy citizens of Gulf cities, such as Galveston, Mobile, and Biloxi, came to New Orleans to purchase their finest furnishings. This wardrobe indicates that customers from Central and South America also came to New Orleans for many of their furnishings.

STRUCTURE AND CONDITION: The square corner stiles are continuous from floor to cornice. The ring turnings of the feet are pieced out on all four sides of these stiles. The case's rails tenon into the corner stiles and are pinned in place. The bottom board fits into grooves cut into the side rails and corner

stiles. The removable shelves rest on side rails. The only exception is the central shelf which rests on top of the medial bank of drawers. The drawers are constructed with small, but widely spaced, dovetails. Their chamfered bottoms fit into grooves along the front and sides. They are nailed flush across the rear edge. Each door contains a single framed panel. The doors are easily removed by lifting up on their hinges. The rear of the case is massively constructed with six panels. The removable cornice is reinforced with numerous glue blocks.

The wardrobe is in excellent condition. The door locks and interior drawer pulls have been replaced. One of the brass caps on the front feet is replaced. The original hinges, which tenon into mortises cut into the door frames, have been secured with new screws. The door escutcheons are appropriate, but might be replacements.

INSCRIPTIONS: Written on the rear of the cornice in ink is "Maurice Hebenstiedt /• Matamoros •."

WOODS: All visible surfaces and interior drawer fronts, mahogany veneer and solid mahogany; back panels, back framing members, drawer bottoms, shelves, eastern white pine; shelf supports, yellow poplar.

DIMENSIONS: H. 89⅜ (227.0); W. 59⅛ (150.3); D. 23 (58.4).

PROVENANCE: Maurice Hebenstiedt, Matamoros, Mexico; Mifflin Kennedy family, Sarita, Tex., early twentieth century; Sarita Kennedy East, Sarita, Tex., before 1965; Oblates of Mary Immaculate, Sarita, Tex., ca. 1965–1984; unidentified south Texas dealer; Peter W. Patout, New Orleans, La.; Bybee Collection, 1986.

Gift of Faith P. Bybee, 1988.B72

1. For a discussion of Louisiana furniture, see Poesch 1972.
2. For related wardrobes, see Poesch 1968, 204–205, and Poesch 1972, nos. 9, 57.
3. To date the only significant research done on American furniture exports to Central and South America has been on Philadelphia and Newark, N. J.; see Catalano 1979 and Skemer 1987.

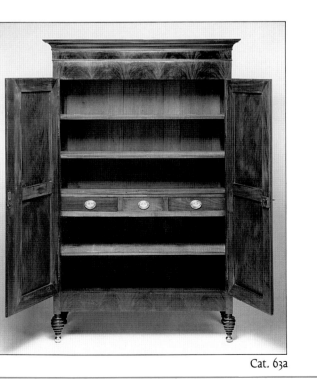

Cat. 63a

Cat. 63b

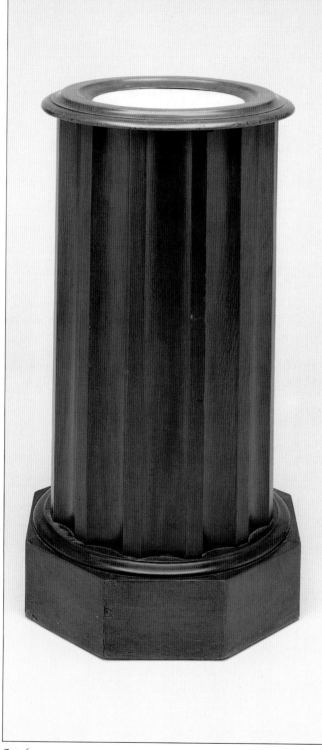

NEOCLASSICISM EMERGED at the royal court level in European art and architecture during the mid eighteenth century. However, in the more rural areas of Europe and in America, which totally lacked a wealthy aristocracy with avant-garde tastes, neoclassicism did not have a major impact in furnishings and architecture until the 1780s. In America the earliest phase of neoclassical design was characterized by an extreme lightness in scale and attenuation of form. Light-color wood veneers were popular, as were classically inspired inlays featuring eagles, ovals, and flowers. During the first half of the nineteenth century the style changed.

In the early decades of the century designers became more accurate in their use of ancient sources. The bronze furniture excavated at the Roman resorts of Herculaneum and Pompeii, for example, was widely copied in wood. Similarly, Greek and Roman architectural details inspired much of the carving found on American furniture between 1810 and 1830 (see cat. 55).

During the second quarter of the nineteenth century, neoclassicism once again moved away from a literal revival of ancient designs to a more imaginative use of the past. For the most part, cabinetmakers no longer ornamented surfaces with

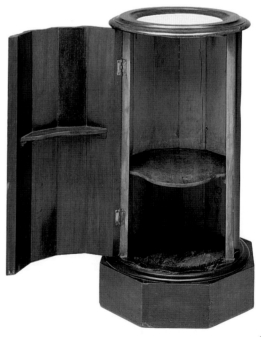

Cat. 64

Cat. 64a

elaborately carved and gilt decoration, but rather concentrated on bold forms covered with dark mahogany veneer.

This small cupboard for the storage of a chamber pot in a bedroom reflects this later stage of neoclassical design. Here the only ornamentation is that of subtle moldings and dark brown mahogany. Rather than expressing boldness through gilt and carved surfaces, the designer achieved a sense of power through the use of basic geometric shapes. The thick octagonal base both visually and physically carries the weight of the composition. The concave elements which compose the cupboard's midsection draw the eye both up and around the cylindrical form. The top's circular molding, which encloses a piece of white marble, abruptly stops the visual thrust upwards. Through the combination of a base and truncated, fluted cylinder, the designer has transformed the mundane holder of a chamber pot into the quintessential icon of the ancient world—a ruined classical column.

In creating this cupboard, the cabinetmaker may well have been inspired by an imported English example or pattern book (fig. 21). English, as well as French and German, furniture and designs were widely available to the American craftsman by the second quarter of the nineteenth century. A major result of this increased traffic in furniture and pattern books was that American furniture as a whole became increasingly similar. At present, for example, it is impossible to positively determine where this cupboard was made.[1] It was collected in New Orleans, and may well be a product of one of that city's many skilled (and unstudied) cabinetmakers.

However, by the 1830s New Orleans was one of the busiest ports in the country. Tons of furnishings and raw materials flowed into it from the East Coast and Europe for local consumption or for transshipment up the Mississippi River to points such as Natchez, Vicksburg, and St. Louis. The New Orleans trade in home furnishings was so lucrative, in fact, that some Eastern producers maintained showrooms in the city.[2]

STRUCTURE AND CONDITION: The sides of the cupboard are built up from vertical wooden sections which are butt-joined and glued. The shelf and door brace have glue blocks beneath them to stabilize the walls. The central section is nailed to the base. Four 6" (15.3 cm.) glue blocks strengthen this juncture from beneath the bottom board. The base is nailed and glued together. Its corners are reinforced with eight glue blocks.

This piece is in excellent condition. The marble top and hardware are original, as is the light orange paint which covers the interior. The interior has suffered minor insect damage.

INSCRIPTIONS: The base board is marked "# 6" in pencil; the interior shelf "# 4."

WOODS: All exterior surfaces, mahogany and mahogany veneer; all structural elements, eastern white pine.

DIMENSIONS: H. 28 (71.1); Diam. across base 16⅝ (42.8).

PROVENANCE: Frank Kane Antiques, New Orleans, La.; Bybee Collection, 1960s.

1985.B66

1. For a similar, though unfluted example with a New Jersey history, see DAPC 78.1164.
2. Good examples of eastern firms maintaining close ties to the New Orleans market are Joseph Meeks and Sons and Hyde and Goodrich of New York. For information on their extensive distribution system, see Pearce 1964; *Crescent City* 1980, 2–5.

Fig. 21. Design for a pot cupboard. From William Smee and Sons,
Designs for Furniture (London, 1830s), plate 231. (Winterthur Museum Library.)

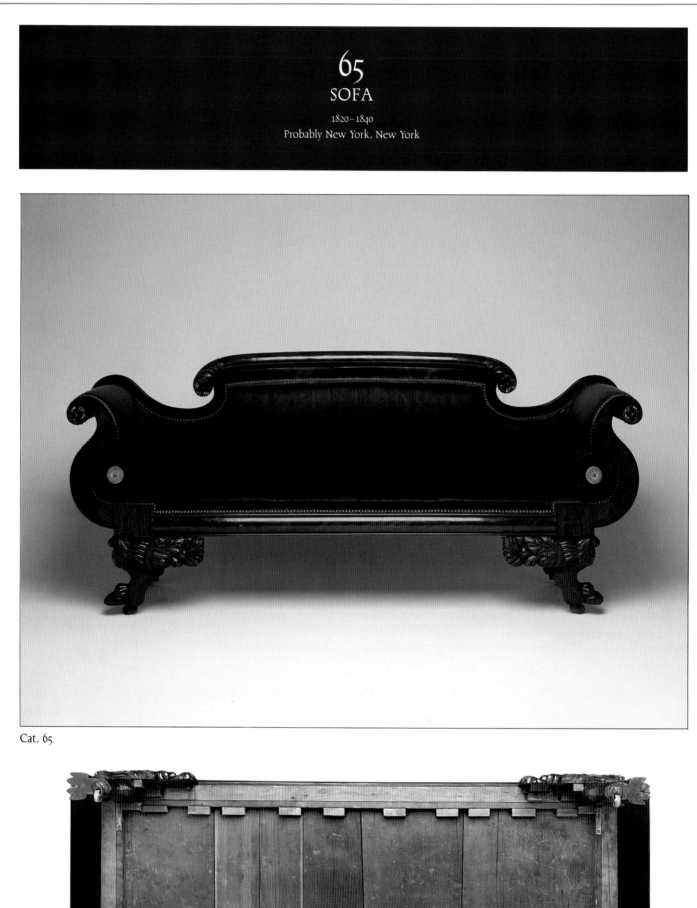

65
SOFA

[1820–1840]
Probably New York, New York

Cat. 65

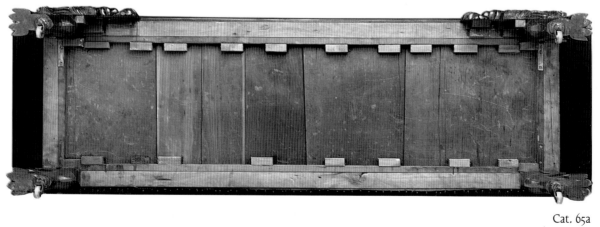

Cat. 65a

FURNITURE closely patterned on ancient Greek and Roman examples became popular among the elite in England and on the Continent at the close of the eighteenth century. By 1802 scroll-armed "Grecian" sofas were included in *London Chair-Makers' and Carvers' Book of Prices for Workmanship*. American craftsmen were familiar with this style of furniture by the 1810s.[1]

"Grecian" sofas proved to be very popular among American consumers. Elaborate examples featuring brass inlay and gilded decoration were made for the wealthy, while attractive, but less opulent pieces like this sofa, were purchased by the middle class. Even less affluent customers could buy cheaply made examples of this style of furniture. Grecian chairs with scrolled backs and flaring legs, for example, were produced in all price ranges from the 1830s until the early twentieth century.

The "Grecian" style also proved to be popular in Central and South America. Consequently, furniture made in the United States was exported in large quantities to these markets (see cat. 63).[2] American sofas closely related to this one, for example, are known to have been used in Argentina.[3] In Peru, local cabinetmakers used American imports as prototypes for their own versions of "Grecian" sofas, complete with boldly curved arms, winged paw feet, and decorated crest rails.[4] Unfortunately, the impact of American design of this period on Central and South American furniture remains totally unexplored.

The use of carved scrolls as termini on the crest rail and cornucopia as knee brackets seen on this example is typical of American "Grecian" sofas. However, the vigorous reverse curve of the arm supports is unusual.[5] More common are arms that scroll outward in a gentle S-shape. The Bybee example is also notable for the survival of its under-upholstery. The slightly domed appearance of the seat is characteristic of early spring seating.[6]

Family tradition holds that a bill from the New York firm of Joseph Meeks and Sons once accompanied this sofa. Meeks and Sons may well have produced this piece of furniture. The firm advertised similar sofas in the 1830s and is known to have shipped furniture to destinations throughout the United States.[7] However, without firm documentation an attribution to Joseph Meeks and Sons is not possible. By the 1830s cities such as New York and Philadelphia had dozens, if not hundreds, of native- and foreign-born cabinetmakers capable of producing this sofa.

STRUCTURE AND CONDITION: The underframe of the sofa was not examined. The inner seat rails are nailed and glued to the outer framing members. This inner frame supports the bottom boards which are further secured with glue blocks. Most, if not all, of these glue blocks are replacements. The seat springs rest upon the bottom boards, rather than on linen webbing which would have been the case in a more expensive sofa.

This sofa is in good condition. It was found with the original black horsehair upholstery in tatters. The horsehair was removed and new horsehair placed over the original under-upholstery and springs. The gilt bosses on each bolster are original, as are the casters. Steel L-braces have been added behind the feet for added strength. The right rear foot has suffered a loss to its carving.

WOODS: Feet, carved brackets, veneer, mahogany; outer seat frame, aspen; inner seat frame and bottom boards, eastern white pine; glue blocks (replaced), Sylvester's pine.

DIMENSIONS: H. 35⅞ (91.1); S.H. 16 (40.7); W. 86⅝ (220.1); D. 23⅞ (60.7).

PROVENANCE: This sofa was purchased in Houston from a descendant of the original North Carolina owner during the early 1970s. The seller stated that the bill of sale from Joseph Meeks and Company of New York City once accompanied the piece. To date no such bill has been located.

EXHIBITIONS AND PUBLICATIONS: Howe 1979, 556; Fairbanks and Bates 1981, 373; MFA, H 1981.

1985.B45

1. See Montgomery 1966, 117–118, for a discussion of the introduction of the "Grecian" style into America.

2. For a discussion of furniture exports from Philadelphia during this period, see Catalano 1979, 81–91.

3. Carreno 1963, 283.

4. Gilbert 1978, 2:479.

5. For related examples, see Singleton 1901, 4:510a; *Antiques* 8:5 (Nov. 1925): end page; 10:5 (Nov. 1926): 330; 31:6 (June 1937): 298; Nutting 1928, 1:nos. 1710–1714; Kane 1976, 250; Scherer 1984, no. 51; DAPC 74.6074. No sofa with the same arm design as the Bybee sofa has been located to date.

6. Although the author has not examined the under-upholstery personally, an archival photograph confirms that this sofa was purchased with its original upholstery intact. Evidently, only the severely damaged horsehair covering was replaced. For information on this type of sofa and its proper upholstery, see Trent 1988, 13-B. As Trent explains, the use of bottom boards and a wooden front rail, as on this sofa, is characteristic of middle-level sofas. By securing springs to wooden supports, the upholsterer did not have to invest time in creating a foundation of webbing to which he could sew the springs. The wooden front rail also reduced the price of this sofa because it took the place of an expensive stitched front edge on the seat cushion.

7. For information on Meeks and Sons, see Pearce 1964; Otto 1962.

66
PAIR OF OTTOMANS
1830–1850
America

Cat. 66a

AS ITS NAME IMPLIES, the ottoman appears to have been introduced into western Europe during the late eighteenth century from the Ottoman Empire.[1] Shortly thereafter, ottomans began appearing in English pattern books. In 1807, for example, Thomas Hope (1769–1831) included several upholstered footrests in his influential *Household Furniture and Interior Decoration*.[2] By the 1840s ottomans were widely used in America.

Since ottomans were designed to rest one's feet upon, their textile coverings suffered great wear. Consequently, examples which retain their original upholstery are rare. The covers on this pair of ottomans have survived because of their needlework scenes. Ottomans, like firescreens, were frequently ornamented with fancy needlework by women during the second quarter of the nineteenth century.[3] The forest scenes with deer and rabbits on these examples are worked in multicolored wool and have a high, shaped pile. Once finished, these ottomans were probably placed in a parlor as symbols of a woman's industriousness and good taste, rather than as actual footrests. This symbolic usage is reflected in the mid-nineteenth-century portrait of *The Carryl Children of Salisbury Center, New York*, which depicts two boys sitting upon similar ottomans (fig. 22). The boys are seated so that their mother's needlework is clearly evident.

STRUCTURE AND CONDITION: The frames are in good condition. The casters are original. The original coverings have suffered moth and stress damage. They have recently been attached to new horsehair and reupholstered. The lower frames are dovetailed together. The corners are braced with glue blocks.

WOODS: Veneer, mahogany; bottom frames, cushion frame, and bottom board, eastern white pine; corner blocks and upper beading strip, American black walnut.

DIMENSIONS: H. to top of cushion 18 (45.7); W. 22 (55.9); D. 17⅝ (44.8).

PROVENANCE: Private collection, Boston, Mass.; Ronald Bourgeault, Hampton, N. H.; Bybee Collection, 1980s.

Gift of Faith P. Bybee, 1988.B75.1,.2

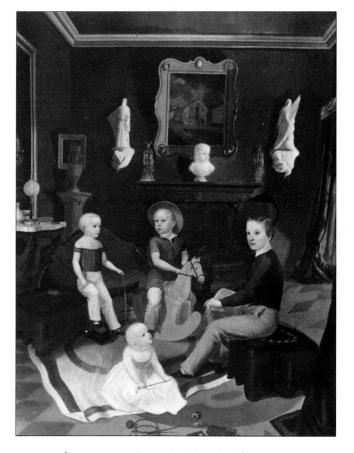

Fig. 22. Unknown artist, *The Carryl Children of Salisbury Center, New York*, ca. 1850. Oil on canvas; H. 47¼ (120.0), W. 38 (96.5). (Fruitlands Museum, Harvard, Massachusetts [286].)

1. Osborne 1975, 598.
2. Hope 1807, pl. 11.
3. Other pairs of ottomans with fancy needlework covers are at Strawbery Banke Museum, Portsmouth, N. H., and at Cherry Hill, Albany, N. Y. For those at Cherry Hill, see Blackburn 1976, 37. Except for their covers, all of these ottomans are relatively plain and could have been made in numerous cabinetmaking shops. However, large firms such as Joseph Meeks and Sons of New York City must have produced many of them. For an 1833 advertisement in which Meeks illustrates ottomans, see Davidson and Stillinger 1985, 164.

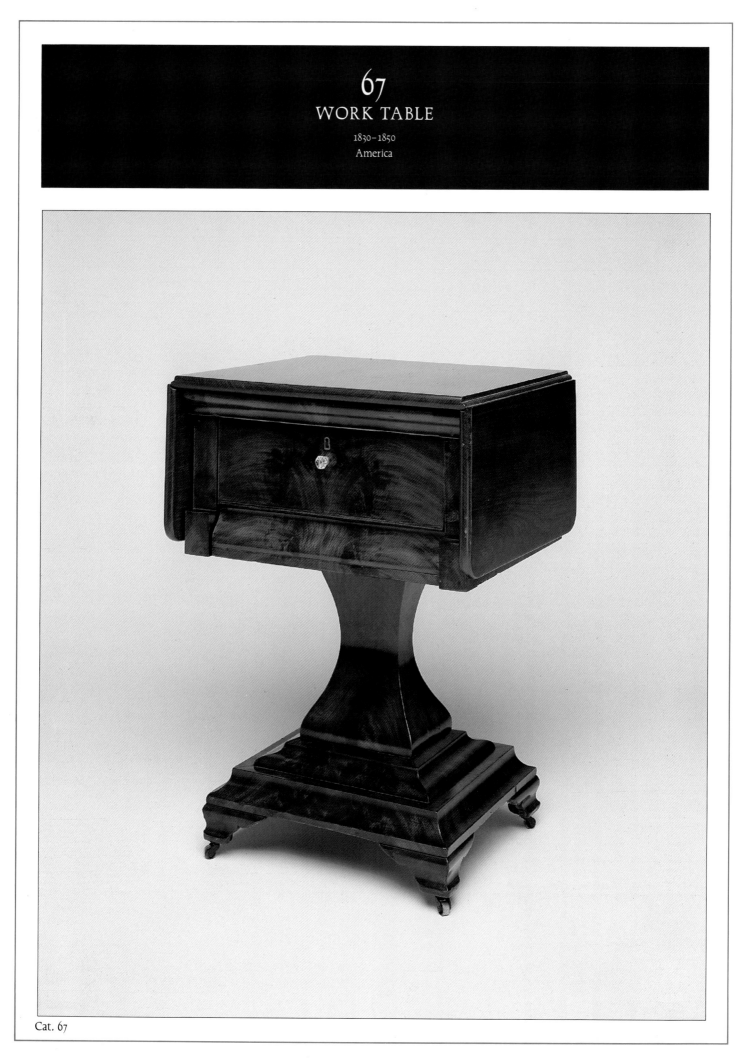

67
WORK TABLE
1830–1850
America

Cat. 67

THE EXTENSIVE USE of nails in this table, rather than more laborious and costly joinery techniques, indicates that it was a relatively inexpensive piece of furniture when new. Nevertheless, the design of this table is quite interesting. Basically it is conceived of as two rectangular boxes separated by a pedestal. However, within this design framework the veneered surface constantly undulates forward and backward. Moving from the floor upward, the bracket feet move in, then out along their ogee surface. The concave molding above the feet moves the eye inward only to be confronted by another ogee form on the next molding.

As if channeling the base's power, the pedestal sweeps the eye upward into the top section. Here again the surface moves forward, only to retreat. The front of the lower drawer projects along its bottom edge, but then recedes to meet the plane of the central drawer. Above this drawer an ogee molding brings the eye out to meet the projecting edge of the top.

The manipulation of surfaces in this fashion and the intentional creation of tension between natural wood grains and artificial geometric forms is typical of contemporary German furniture. Since highly skilled German cabinetmakers flooded into urban America during the second quarter of the century, it is probable that they introduced this form of surface manipulation to American cabinet shops, including the one which produced this table. By midcentury much of Philadelphia and New York's furniture industry was controlled by Germans. In 1850 Philadelphia had 494 cabinetmakers and 76 turners of German birth (38.8 and 29.2 percent of the total, respectively). New York supported 2,153 German woodworkers (61 percent) in 1855.[1]

Where this work table was made is unknown. Like other pieces in the Bybee Collection (see cats. 64 and 69), it was purchased in New Orleans. However, the importation of huge quantities of furniture from cities like Philadelphia and New York during this period makes it impossible to determine this table's place of origin.

STRUCTURE AND CONDITION: The base is constructed of two mitered frames set one atop the other. Twelve glue blocks brace the base. The pedestal is shaped from a "sandwich" of two thick boards separated by two narrow ones. The cross brace is nailed to the pedestal and to the sides of the case. The upper section is dovetailed together. The drawer runners are nailed to the sides of the case. The top is screwed to the case from below. Short wooden supports pivot out from the sides of the case under the leaves. The drawers are constructed with fine dovetails at their front corners. They are butt-joined and nailed in the rear. Their chamfered bottoms fit into grooves along the fronts and sides and are nailed flush across the rear edges.

The table is in good condition. The veneer has suffered minor losses. The glass knob and casters are original. Shadows on the front facade indicate that decorative pilasters or some other type of ornament once rested on the plinths flanking the lower drawer. The hinges of the drop-leaves are attached with new screws.

Cat. 67a

INSCRIPTIONS: On the cross support and bottom drawer is written "# 6" in pencil.

WOODS: Veneer and top, mahogany; drawer bottoms, backs, and sides, yellow poplar; drawer fronts, drawer runners, cross brace, pedestal, base, glue blocks, eastern white pine.

DIMENSIONS: H. 30¼ (69.9); W. closed 21⅝ (45.9); W. open 40½ (102.9); D. 18 (45.7).

PROVENANCE: Frank Kane Antiques, New Orleans, La.; Bybee Collection, late 1960s or early 1970s.

1986.B65

1. For a discussion of German cabinetmakers in Philadelphia and New York, see Venable 1986, 27; see pp. 55–56 for a discussion of Germanic design and its manipulation of space.

Cat. 67b

68
SIDE CHAIR (one of a pair)
1830–1850
America

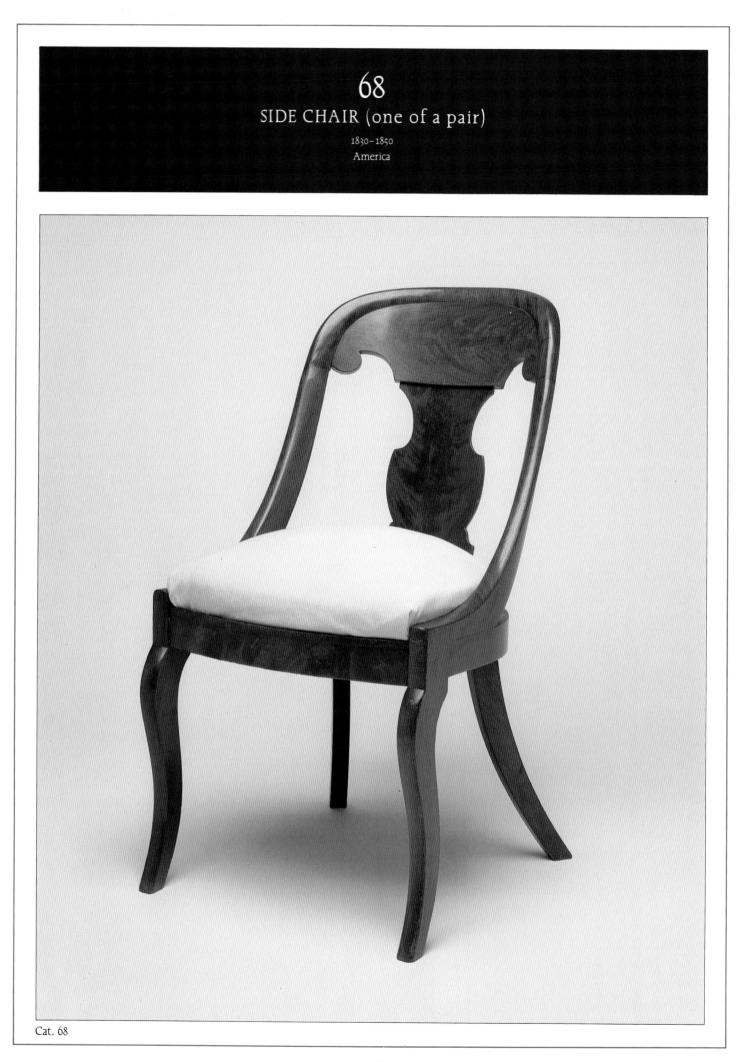

Cat. 68

THE DESIGN of this chair and the following example (cat. 69) is based on contemporary French examples. The sweeping lines of the rear stiles and crest rail, the semicircular rear seat rail, the canted rear legs, and the S-curved front legs are all seen on late-classical continental examples.[1] During the second quarter of the nineteenth century, such chairs proved exceptionally popular with Americans who often purchased them in large sets of twelve or more. This particular chair is numbered XII.[2]

This example was owned in New Orleans, Louisiana, and may have been produced there.[3] However, other cabinetmaking centers are also known to have produced such chairs. New York, for example, was a center of production for this type of mahogany-veneered furniture. In 1834 *The New York Book of Prices for Manufacturing Cabinet and Chair Work* included an illustration for such chairs (see fig. 23). Furthermore, the firm of Joseph Meeks and Sons advertised similar chairs in 1833.[4] Since firms like Meeks and Sons are known to have shipped huge quantities of furniture to New Orleans during this period, it is impossible to determine if this particular chair was actually made in New Orleans or imported from the East Coast.

STRUCTURE AND CONDITION: The rear seat rail consists of three curved sections which appear to tenon into the rear legs.

It and the front rail tenon into the front legs. The back stiles apparently tenon into the seat frame. The rear legs slot into notches cut in the rear seat rail. These joints are braced with wooden brackets which are screwed in place. Triangular glue blocks brace the front seat rail and legs.

As with most of these chairs, this example has suffered from weak construction. The crest rail has cracked where it joins the side stiles. The damage has been repaired and the area scraped. The rear legs have broken away from the rear seat rail and have been reattached. The blocks which brace the rear legs inside the seat rail are probably replacements. The right portion of the veneer strip which covers the top of the rear seat rail is a grained replacement. There are several other losses to the veneer.

INSCRIPTIONS: The slip seat frame is marked "VIII" with a chisel. The front seat rail is marked "XII."

WOODS: Veneer, legs, splat, crest rail, mahogany; seat rail, cherry; front glue blocks, ash; rear glue blocks (probably replaced), American black walnut.

DIMENSIONS: H. 32¾ (83.2); S.H. 15⅜ (39.0); W. 18⅛ (46.7); D. 21⅝ (54.9).

PROVENANCE: Private collection, New Orleans, La.; Mrs. Kirtley Lynch, Opelousas, La.; Bybee Collection, 1964.

Promised gift of Faith P. Bybee, 51.1987

1. The widely circulated French designs in Mésangère 1796 are full of related chairs.
2. Besides this chair and its mate, six additional chairs from the original set are at Bayou Bend. See Warren 1975, no. 180.
3. New Orleans had numerous craftsmen capable of making such a chair. Although poorly documented, examples have traditionally been associated with the New Orleans chairmaker François Signouret (active 1815–1853).
4. For a detail of the Meeks and Sons broadside showing such chairs, see Davidson 1969, fig. 302.

Fig. 23. Designs for chairs. From *The New-York Book of Prices for Manufacturing Cabinet and Chair Work* (New York, 1834). (Winterthur Museum Library.)

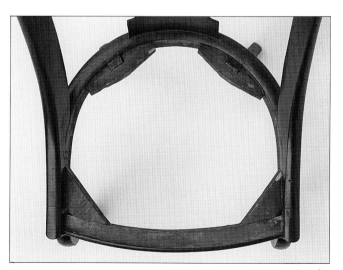

Cat. 68a

69
SIDE CHAIR (one of a pair)
1830–1850
America

IF ONE COMPARES this side chair to the preceding example (cat. 68), the similarities in design and construction are striking; the only substantial differences between the two are in splat and crest rail design. This example incorporates Gothic revival pointed-arches and a "pinched" splat, while the other uses a classical balustrade shape and volutes on the crest rail. Examples from the huge New York shop of Duncan Phyfe are known which employ a straight splat and crest rail.[1]

By limiting design differences to the shape of the splat and crest rail, a shop was able to increase production while lowering unit costs. For example, the legs, seat rails, and rear stiles of this chair and the preceding example could have been shaped from pre-cut, standardized stock using the same patterns. The different back elements could then have been added according to the customer's wishes. An otherwise standardized and relatively mass-produced product was thus given a degree of variety to help it attract attention in a highly competitive market.

STRUCTURE AND CONDITION: This chair is constructed in the same manner as cat. 68. The chair has suffered from poor struc-

tural design. The rear legs have broken away from the seat rail and have been reattached with screws from behind. Both the front and rear glue blocks are replacements. The slip seat is probably original to the set, but not to this chair. The springs it contains may be original.

INSCRIPTIONS: The slip seat frame is marked "II" with a chisel. The front seat rail is marked "XI."

WOODS: Veneer, legs, splat, crest rail, mahogany; slip seat frame, cherry; glue blocks (replacements), spruce; seat frame, ash.

DIMENSIONS: H. 32⅜ (82.2); S. H. 15½ (39.3); W. 18⅜ (46.7); D. 20 (50.8).

PROVENANCE: Unidentified dealer, New Orleans, La.; Bybee Collection, 1960s.

Promised gift of Faith P. Bybee, 52.1987

1. For the related chair by Phyfe, see Davidson 1969, fig. 307. This chair was made in 1837.

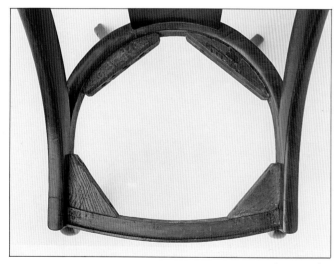

Cat. 69a

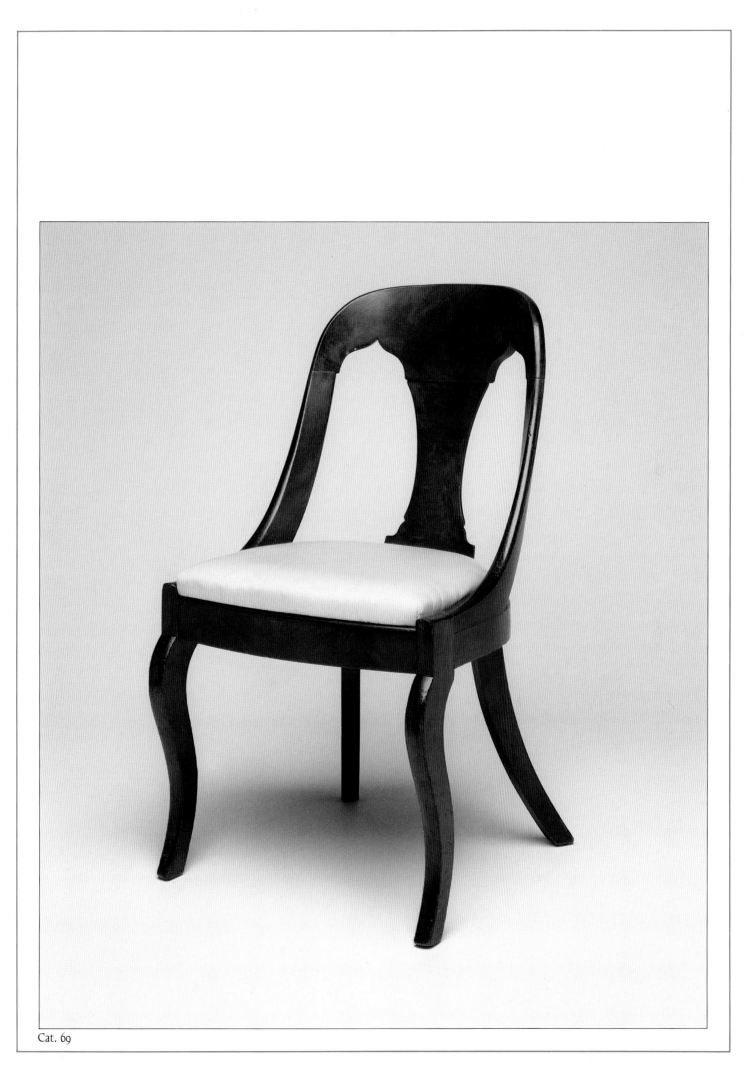

Cat. 69

70
HALL CHAIR
1845–1855
New Orleans, Louisiana

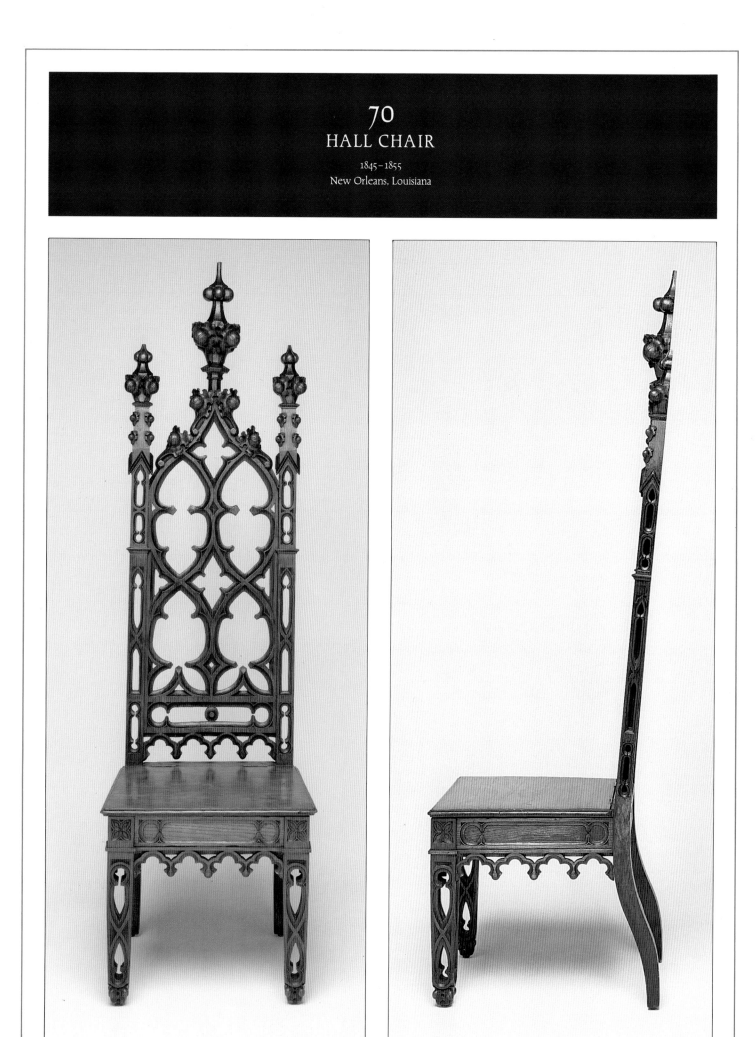

Cat. 70

Cat. 70a

AS PART OF the romantic and picturesque movements in art and literature during the late eighteenth and early nineteenth centuries, Europeans and Americans became fascinated with the image of the overgrown Gothic ruin. In this country, the use of Gothic revival details in architecture and furnishings reached its apex during the second quarter of the nineteenth century. Gothic decorative devices such as quatrefoils and pointed arches appeared on objects as diverse as glass bottles and silver forks, cast-iron stoves and carved interior woodwork.[1]

This hall chair is part of an exceptional group of Gothic revival furniture which contains at least two hall stands, two sofas, a chaise longue, and several other hall chairs.[2] Since no member of this group has been found outside the lower Mississippi Valley, it is highly probable that they were produced in New Orleans, the social and economic center of the region. Besides the local clientele, wealthy planters from towns like Natchez and Vicksburg regularly purchased furnishings for their homes in New Orleans. This chair, along with three others, two sofas, and a hall stand, originally belonged to Jared Reese Cook of Hard Times Plantation, Mississippi, near Vicksburg. Although Cook built Hard Times in the mid-1830s, this set was probably purchased for the house when it was expanded and redecorated following his marriage to Minerva Hynes in 1845.[3] An identical set of hall furnishings was ordered in the mid-1850s by Hulda and Frederick Stanton for their new Greek revival mansion, Stanton Hall in Natchez, Mississippi.[4]

During the nineteenth century, entry halls and their furnishings served several important functions in the operation of a large home. First, they provided a storage area for various types of garments and paraphernalia. The seat of this chair, for example, opens to reveal a compartment for the storage of gloves. The hall stand which stood next to this chair provided hooks for hats and coats, a place for a calling card receiver, and a stand for umbrellas. More importantly, however, the hall and its furnishings acted as a screen against the outside world. Expected and desired guests would be ushered past these overpowering objects and into the plush, comfortable atmosphere of the parlor. Unwelcome callers and tradesmen, on the other hand, were required to perch upon these stern and uncomfortable chairs, waiting to be received. The over-upholstered parlor was beyond their social reach.[5]

STRUCTURE AND CONDITION: The front legs and rear stiles are carved from single blocks of oak. The three finials are carved from the solid and dowel into holes on the rear stiles and crest rail. The back is carved from a single board and joined to the back stiles with dowels. The seat frame is joined with mortise-and-tenon construction. The seat is hinged. The bottom boards and scalloped skirting boards beneath the seat rail are nailed in place.

The chair is in good condition. The scalloped skirt beneath the front seat rail is a replacement. The bottom boards beneath the seat have been removed and spread out to compensate for a lost board, resulting in several gaps. The central finial is attached with a new dowel.

WOODS: Legs, back, white oak; seat top and frame, red oak; bottom boards, eastern white pine.

DIMENSIONS: H. 69½ (176.5); S.H. 18¼ (46.4); W. 20½ (52.0); D. 23⅛ (58.7).

PROVENANCE: Jared Reese (d. 1878) and Minerva Hynes Cook (d. 1865), Hard Times Plantation, near Vicksburg, Miss., ca. 1845–1878; William V. D. Cook, Hard Times Plantation; Robert Cooke, Vicksburg, Miss.; Sisters of Mercy Convent, Vicksburg, Miss., early 1900s; Neal Alfred Company Sale (30 Aug. 1986), Vicksburg, Miss.; Peter Hill, Inc., East Lempster, N. H.; Bybee Collection, 1987.

EXHIBITIONS AND PUBLICATIONS: Neal Alfred Company auction brochure, 30 Aug. 1986.

Gift of Faith P. Bybee, 1988.B68

1. For an excellent discussion of the Gothic revival in America, see Howe and Warren 1976.
2. Of this group, two hall chairs and a hall stand are at Stanton Hall in Natchez. Other chairs from this set are in private hands. Two additional hall chairs were sold by the Neal Alfred Company on 28 May 1988 in New Orleans. A chaise longue is at the Metropolitan Museum of Art, New York. All of the Cook pieces went to dealers. Peter Hill, East Lempster, N. H., acquired the four hall chairs. Didier, Inc., New Orleans, La., acquired a sofa and Deanna Vondrak of New York City purchased a sofa and hall stand. For illustrations of members from this group, see Otto 1965, fig. 269; Howe and Warren 1976, 29; Maine Antique Digest 15 :6 (Jan. 1987): 16B; Davidson and Stillinger 1985, fig. 271; Neal Alfred Company auction brochure, 30 Aug. 1986.
3. The gift of this set to the Sisters of Mercy Convent is recorded on a paper label on the back of the hall stand. For information concerning the Cook family and Hard Times Plantation, see William C. Maute, letter to the author, 30 May 1987, DMA files.
4. For information on Stanton Hall, see C. Smith 1988. There has been recent speculation that this entire group of furniture was made by Henry N. Siebrecht (1805–1890) of New Orleans. It is true that Siebrecht billed Frederick Stanton for furnishings for Stanton Hall in 1859. However, the bill does not list any hall furnishings. It is primarily for curtains, trimmings, and carpets. Besides these, Siebrecht billed the Stantons for bedroom furnishings, "1 Mahogany glass door armoir," "2 Fine card tables," 12 mahogany armchairs, and a cedar box. See Siebrecht bill, 17 Oct. 1859, Frederick Stanton Estate Papers (1859), docket 173, folder 2, Adams County Courthouse, Natchez, Miss. Siebrecht came to New Orleans from Hesse-Kassel, Germany, around 1826 and opened an upholstery shop. While he did advertise that he "has on hand and makes to order, the NEWEST PATTERNS of Rosewood, Mahogany and Oak Parlor, Dining-Room and Bed-Room FURNITURE," it is likely that he did not make these pieces himself, but rather had in-house journeymen or outside suppliers furnish his showroom. According to city directory listings and the U. S. Census, Siebrecht was an upholsterer and merchant by trade. For information on Siebrecht, see Dubrow 1983, 51.
5. For an excellent discussion of halls and hall furnishings, see Ames 1978.

71
BENCH (one of a pair)
1850–1880
America or England

DURING THE EIGHTEENTH CENTURY, English metal founders made great advances in the smelting and casting of iron. Although they were slow to adopt English techniques and technology, such as coke-fired blast furnaces, American foundries had achieved a relatively high level of proficiency in iron-casting by the second quarter of the nineteenth century. From the 1830s onward, American firms produced huge quantities of cast-iron fences, architectural elements, garden ornaments, and furniture.[1]

Cast-iron furniture which incorporated Gothic revival motifs such as this bench, as well as those which used naturalistic details, were popular throughout the last half of the nineteenth century thanks to the dramatic growth of man-made outdoor landscape environments. During this period, middle- and upper-class homes were typically surrounded by landscaped lawns and gardens. Similarly, urban parks, such as New York's Central Park (1857), were laid out in numerous cities from mid-century onward. And finally, "rural" landscape cemeteries, like Mount Auburn (1831) near Boston and Laurel Hill (1836) in Philadelphia, were established in many cities as both an eternal resting place for the dead and a park-like space for the public.

As Ellen Marie Snyder has pointed out, all of these environments proved conducive to the use of cast-iron furniture because they were arenas in which nineteenth-century Americans played out their ideas of man's dominance over nature and the moral and domestic importance of the home. Consequently, the use of interior, artificial symbols like this Gothic revival bench in the exterior, natural environments of lawn, park, and cemetery made it clear that man was in control of his universe. Thanks to man's technological genius and ideological inclination, unrefined ore had been turned into a domestic garden bench, and the wilderness had become an extension of the protected Victorian parlor.

Since iron furniture was cast in molds, the same designs were used at numerous iron works. If one foundry's design became popular, rival firms could produce identical copies by making casting molds from their successful competitor's pieces. The ease with which designs flowed between iron foundries makes it difficult to pinpoint the origins of particular examples. This Gothic revival bench, for example, appears most frequently in mid-nineteenth-century English trade catalogues.[2] However, the design is occasionally seen in American catalogues, and other examples survive in this country.[3] Consequently, it is difficult to determine whether this particular bench was imported from England or cast in America by a founder who looked to his English counterparts for inspiration. An apparently identical bench appears in the 1870 trade catalogue of the New York firm of Janes, Kirtland & Company.[4]

STRUCTURE AND CONDITION: The back, seat, sides, and front skirt are individual units which have been bolted together with iron rods and nuts. One or more legs on both benches have cracked and been repaired. The present green paint is not original.

MATERIALS: Cast iron.

DIMENSIONS: H. 35¼ (89.5); W. 38⅝ (98.0); D. 20¼ (51.5).

PROVENANCE: Purchased in Houston, Tex.; Bybee Collection, 1970s or early 1980s.

Gift of Faith P. Bybee, 1988.B74.1,.2

1. For an excellent discussion of cast-iron furniture in nineteenth-century America, see Snyder 1985. All general information noted here is taken from this source.

2. According of Ellen Marie Snyder's research, this particular design appears much more frequently in English catalogues, and only rarely in American ones. See Snyder, letter to the author, 22 Sept. 1987, DMA files.

3. There are other pairs in the collection of the Metropolitan Museum of Art and at Hagley Museum, Wilmington, Del. These examples are not marked.

4. See Pyne 1971, no. 138.

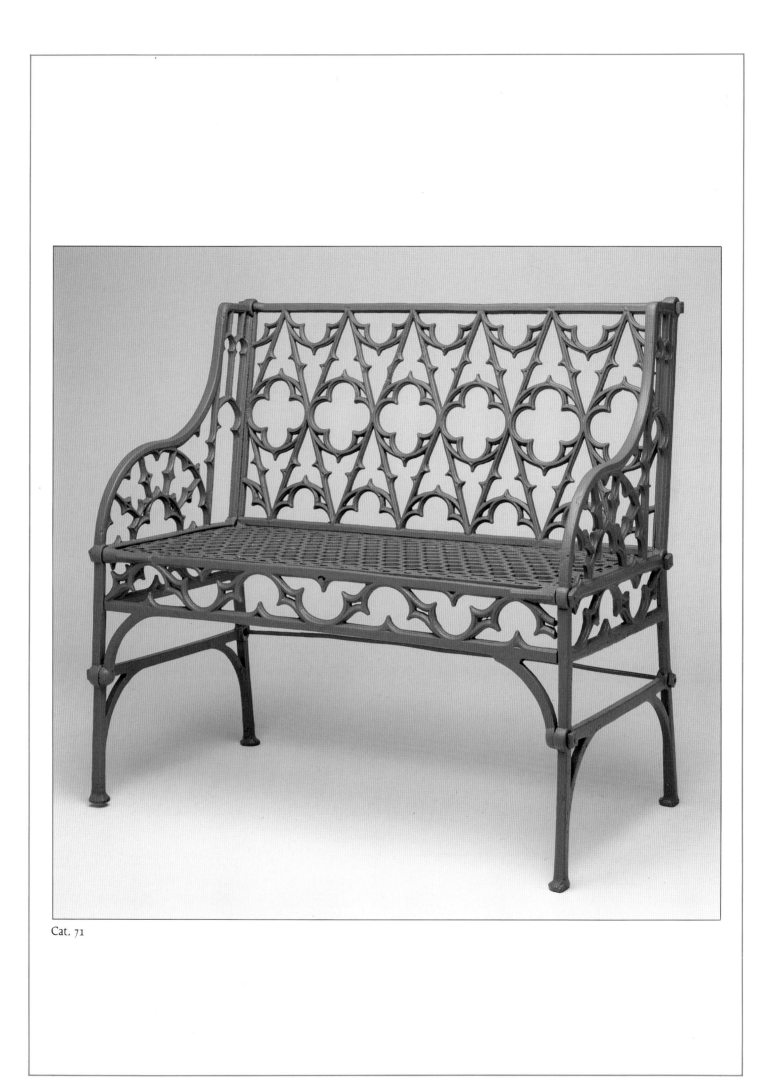

Cat. 71

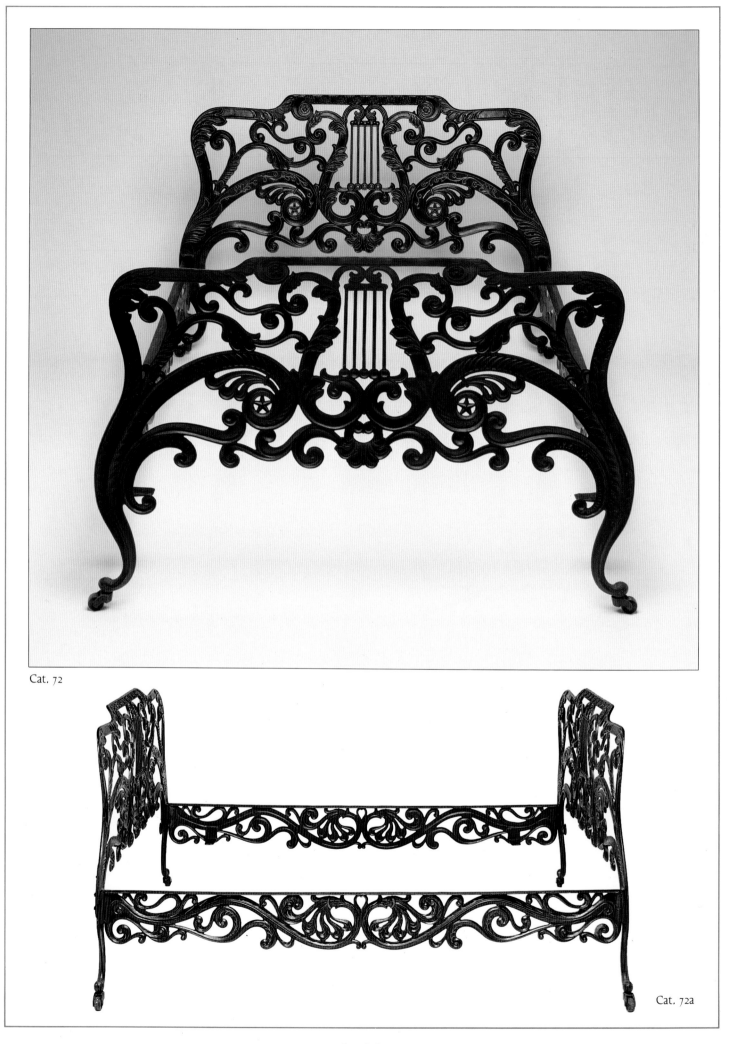

Cat. 72

Cat. 72a

FURNITURE MADE OF metal was known in antiquity. The late eighteenth-century excavations of the Roman towns of Herculaneum and Pompeii, for example, uncovered bronze furniture dating from the first century A. D. Improvements in iron smelting and casting developed in England during the early Industrial Revolution led to a revival of metal furniture in the early nineteenth century.

Following their English counterparts, American foundries were producing cast-iron furniture by the 1830s. By 1850 a wide variety of furniture forms, as well as fountains, railings, and mantels, were being cast. One of the largest makers of decorative iron products was the New York Wire Railing Company. Founded in 1850 by John B. Wickersham (1823–1892), the firm maintained a large showroom in New York City (fig. 24).

To promote their goods, Wickersham and his subsequent partner, Ira Hutchinson, printed trade catalogues which illustrated their products. These catalogues were sent to merchants across the country. The bed seen here appears in the company's 1857 catalogue (fig. 25).[1] Advertised as the "'Harp' Bedstead . . . A very beautiful and elaborate design," the bed was available in two sizes at a cost of $20 and $25, respectively.

The combination of motifs used on this bed is most interesting. The vines which rise up from the floor and burst into scrolls of leaves are characteristic of rococo revival design which was at the height of its popularity in the 1850s. However, entwined amongst the foliage are classical images which had been introduced decades earlier. Harps, for example, were used as chair backs and table supports in the 1810s and 1820s. The use of anthemia among the vines is also more typical of late-classical design than of the rococo revival style.

STRUCTURE AND CONDITION: The head and foot sections are cast in one piece. The end of the side rails slide into slots on the head and foot boards. Each rail has two circular "eyes" screwed into them. Supports of some kind were originally suspended between these "eyes" to provide a framework for wooden slats upon which a mattress rested (fig. 25).

The gold highlights on the cast details may not be original and the footboard has broken off above the side rail brackets. Iron plates have been welded across these fractures. The casters are original.

MATERIALS: All parts including casters, cast iron.

DIMENSIONS: H. 39¾ (101.0); W. 58¼ (147.9); D. 82⅜ (209.3).

PROVENANCE: Purchased in Houston, Tex.; Bybee Collection, 1970s.

Gift of Faith P. Bybee, 1988.B80

1. Wickersham 1977, 64. An identical bed is illustrated in Arthur and Ritchie 1982, 140.

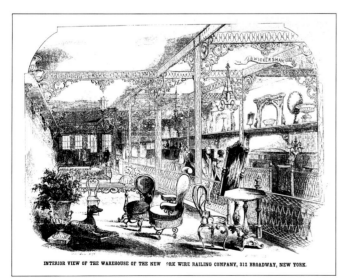

Fig. 24. Showroom of the New York Wire Railing Company, New York City. From the company's 1857 trade catalogue. (Philadelphia Athenaeum.)

Figure 13 is the "Harp" Bedstead, also of cast iron. A very beautiful and elaborate design.

Fig. 13.

Prices.——High foot and head, 4-4 size, $25. Style shown in engraving, 4-4 size, $20

Fig. 25. "Harp" bedstead. From the New York Wire Railing Company's 1857 trade catalogue, figure 13. (Philadelphia Athenaeum.)

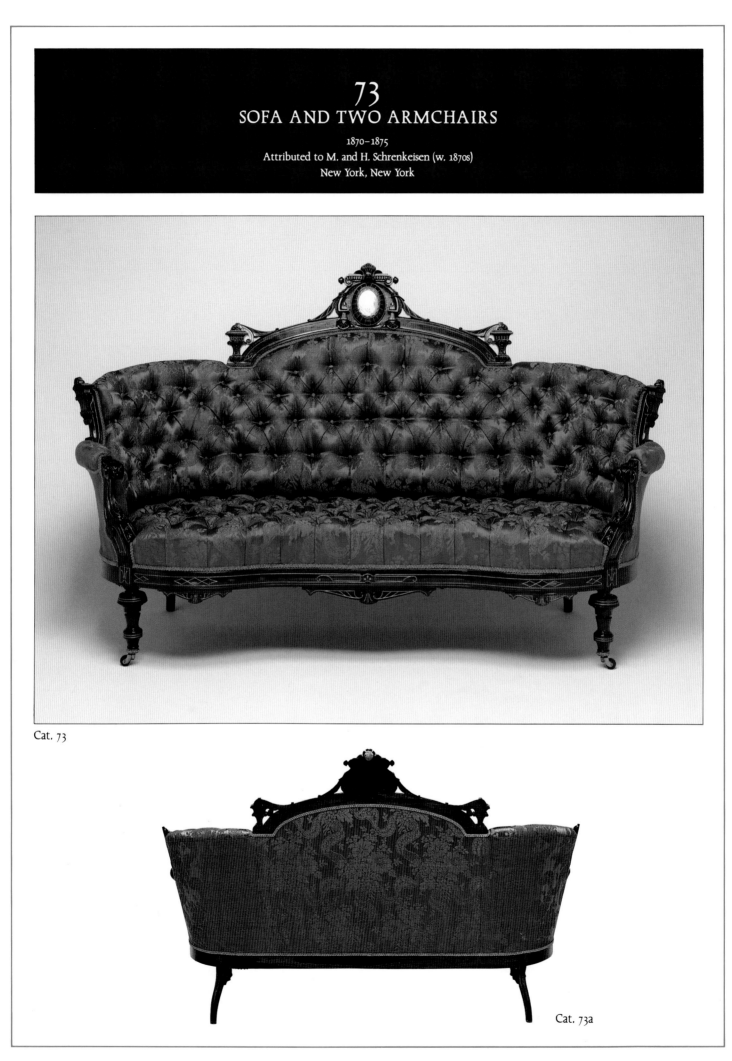

73
SOFA AND TWO ARMCHAIRS

1870–1875
Attributed to M. and H. Schrenkeisen (w. 1870s)
New York, New York

Cat. 73

Cat. 73a

ALTHOUGH THE USE OF coiled springs in seating furniture first became widespread in the 1830s (see cats. 65, 66), it was during the third quarter of the nineteenth century that their use achieved its greatest success. By the time these pieces were made, the practice of using machine-made springs to achieve a textured, yet comfortable, surface had become routine.[1] Placed in an environment of wall-to-wall carpet, floor-length drapes, and patterned wall coverings, tufted furniture such as this helped create an atmosphere of plush security.[2] Originally these pieces were part of a larger parlor set which probably included smaller armchairs for women and several side chairs.

Besides being exceptional in terms of its carved and gilt ornament and rich materials, this set is important because each piece bears the stamped inscription "C.W. PAT." However, to date no corresponding design or mechanical patent filed between 1850 and 1880 has been identified. Patentees with initials other than C. W., however, did file designs for closely related furniture. In 1872, for example, David Denyven of Cambridgeport, Massachusetts, received a design patent in which he stated:

> This design consists of a head or medallion sunk into the back of a chair, sofa, or other article of furniture, thus giving it an exceedingly ornamental and unique appearance, while the head or the medallion is also prevented from hurting the back of a person leaning against it. My invention also consists in an ornamental design for the upper portion of the back of a chair or sofa.[3]

Even though patents were granted for various aspects of such pieces, the basic furniture forms and ornamental details seen here were used by numerous furniture makers. For example, several New York-area firms, including John Jelliff and Company of Newark, New Jersey, and Barmitz and Diehl of New York are known to have produced similar pieces. However, examples illustrated in an 1873 trade catalogue by the firm M. and H. Schrenkeisen of New York are so similar that it is highly probable that both the Bybee sofa and chairs were produced by this firm (see fig. 26).[4] The cameo medallions like the ones used here could have been imported or produced by

American cameo-cutting firms, such as Bernard, Bonet, and Company of New York.[5]

When these pieces were new and fashionable, one observer stated that they were in the "Marie Antoinette" style.[6] This description was no doubt based on the similarity between the eighteenth-century French use of inset porcelain plaques on furniture and the use of inset cameo busts on the crest rails of these pieces. However, in reality this type of furniture has little to do with eighteenth-century French design. Rather, the C. W. who designed these pieces drew upon Italian mannerist design and contemporary ideas being popularized by the English designer Charles Locke Eastlake. The mannerist details are most easily seen in the way in which forms in the crest rails seem to be precariously perched upon one another. Eastlake's influence is seen in the use of incised and gilded lines throughout the compositions.[7]

STRUCTURE AND CONDITION: Although the frames of these pieces were not examined in person, photographs of the frames indicate that they are primarily joined with mortise-and-tenon construction. The upholstered backs are supported by central braces and low cross braces. Holes in the vertical braces allow tufting cords to pass through.

The set is in exceptionally fine condition. The varnish and gilt details appear to be original, as are the casters. The rosewood frames have minor cracks in several places. The upholstery is a reconstruction. Originally, the seat may not have been tufted like the backs.[8]

INSCRIPTIONS: All three pieces are marked "C.W. PAT." on their left rear legs.

WOODS: All exterior surfaces, rosewood; the interior framing members were not examined; however, based on photographs they appear to be pine and possibly ash.

DIMENSIONS: Chairs: H. 43⅝ (110.8); S.H. 17 (43.2); W. 29⅝ (75.3); D. 33 (84.7). Sofa: H. 46⅛ (117.1); S.H. 16 (40.6); W. 77¾ (197.4); D. 36½ (92.7).

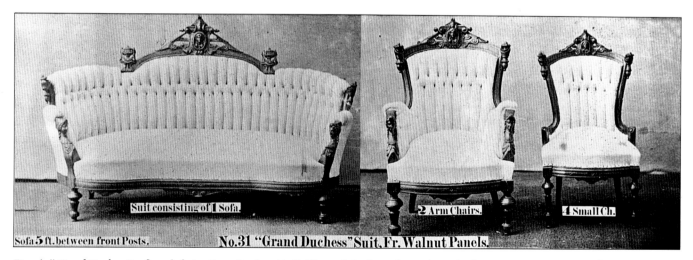

Fig. 26. "Grand Duchess" sofa and chairs. From *Supplement to the Illustrated Catalogue of M. and H. Schrenkeisen, Warerooms: No. 17 Elizabeth Street, near Canal, Factory, Nos. 328, 330, 332 & 334 Cherry Street, New York*, (New York, [1873]), page 7, no. 31. (Bourne Collection, Joseph Downs Manuscript and Microfilm Collection, Winterthur Museum Library [79x233.1-].)

PROVENANCE: Private collection, Ohio; Stevens Antiques, Frazer, Pa.; Peter Hill, Inc., East Lempster, N. H.; Bybee Collection, 1987.

Gift of Faith P. Bybee, 1988.23–25

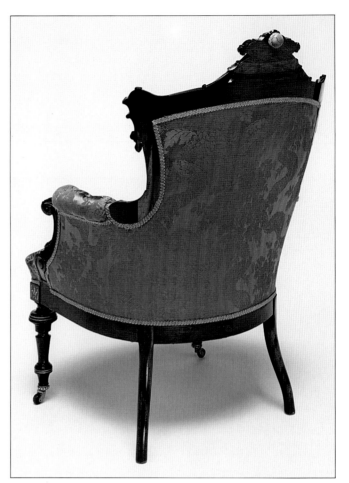

Cat. 73c

1. For information on the development of the coiled spring, see Giedion 1948, 379–383.

2. For a discussion of the connection between upholstery, women, and security in the nineteenth-century home, see Green 1983, 130–132.

3. David Denyven, design patent no. 6236 (5 Nov. 1872), United States Patent Office, Washington, D. C. For another closely related design patent, see a "Design for Parlor Furniture," Daniel Shales and Newman McCully, Boston, Mass., no. 6891 (23 Sept. 1873).

4. For information on Jelliff, see Johnson 1972; Dietz 1983, 45–48. For a related design by Barmits and Diehl from 1876, see Otto 1965, no. 404. For another related sofa, see Hanks and Peirce 1983, 86. For more information on M. and H. Schrenkeisen, see Schrenkeisen 1873, 7. Besides the information in this catalogue, nothing is known about this firm.

5. In the 1871 New York City directory Bernard, Bonet and Company stated that they could supply "likenesses cut on shell and precious stones." They were located at 599 Broadway.

6. In 1870 Jede Wilcox purchased an almost identical parlor set for his new forty-room mansion in Meriden, Conn. A contemporary newspaper article noted that the "sitting room was fitted up in the Marie Antoinette style of art, the crimson curtains, sofas, lounges, chairs and furniture generally being covered in scarlet satin." For this and other information on this set, see Davidson and Stillinger 1985, 90–91. This set is exceptionally close to those illustrated in Schrenkeisen 1873, 7. Schrenkeisen marketed this model as "Grand Duchess."

7. Charles Locke Eastlake's famous book on decorating, *Hints on Household Taste, in Furniture, Upholstery and Other Details* (London, 1868), was widely followed in America. For a discussion of his influence in this country, see Madigan 1974; Madigan 1975; McClaugherty 1983. For a discussion of various related furniture forms, see Grand Rapids 1976.

8. For a period photograph of a similar sofa with an untufted seat, see Dietz 1983, 4.

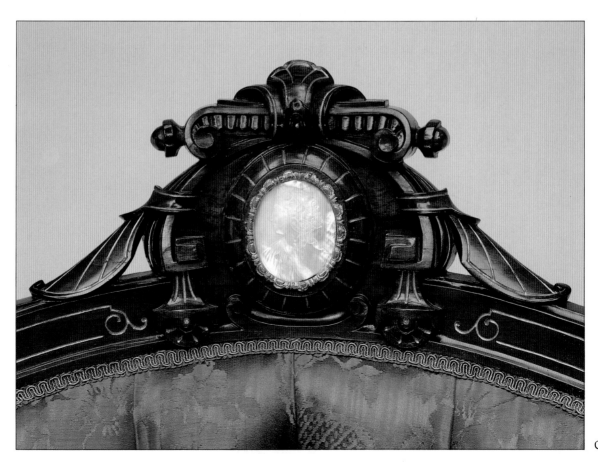

Cat. 73b

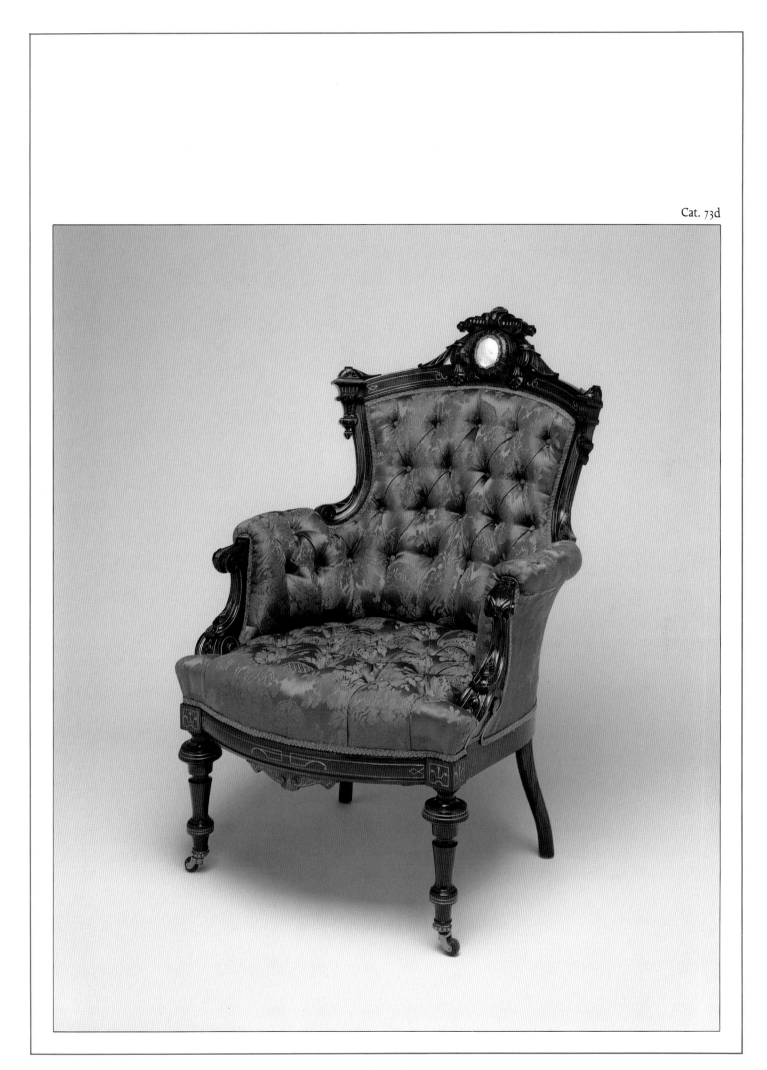

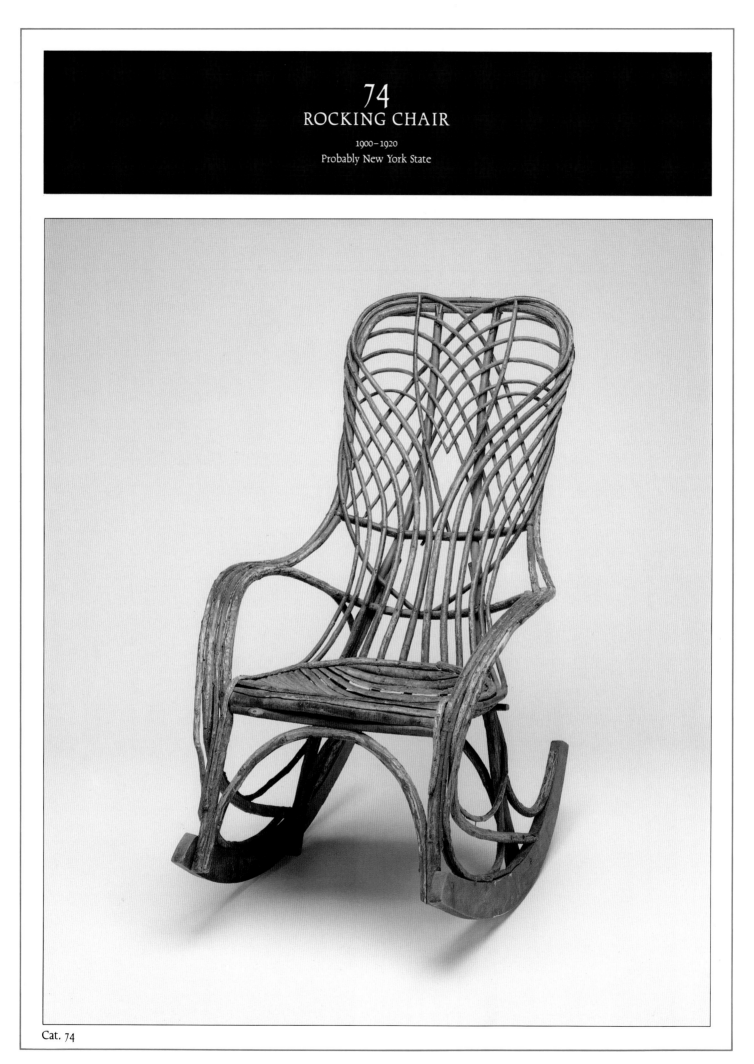

Cat. 74

ALTHOUGH THIS ROCKING CHAIR was made during the first decades of this century in response to the swirling lines of the art nouveau movement, it is part of a tradition which stretches back to tenth-century China and Renaissance Europe.[1] The Chinese appear to have been the first makers of "rustic" furniture—furniture constructed from tree twigs, branches, and bark. When objects in the Chinese taste became popular in eighteenth-century Europe, rustic furniture was introduced from the East. In 1754 designs for such furniture were included in the English pattern book, *A New Book of Chinese Designs*. The first English design book devoted entirely to furniture made from twigs and branches was *Ideas for Rustic Furniture*, which appeared in 1780. By the early nineteenth century, rustic furniture was in use in gardens and conservatories across Europe.

Even though rustic furniture was introduced into Europe from the Orient, it fit squarely into a Western tradition of "rustic" furnishings and architecture which had begun in the Renaissance. During the sixteenth and early seventeenth centuries, Italian builders modeled new rural villas on ancient examples. Included in the gardens of the finest of these estates were underground grottoes complete with water displays and shell-encrusted walls. As part of the furnishings for these spaces, fantastic furniture covered with shells was used. In northern Europe, where cold weather made such water grottoes impractical, hunting lodges in the forest were constructed and furnished with furniture of horn, wood, and leather. In both instances, the goal was to create a refuge from the present, to construct a mythic world.

These ideas survived throughout the eighteenth century and were enhanced by the emergence of the concept of the picturesque in art and architecture during the late eighteenth and early nineteenth centuries. As American cities grew increasingly crowded during the nineteenth century, it was only natural that many of their wealthier inhabitants drew upon this escapist tradition and retreated to the wilderness, far removed from the congestion of the city. One of the areas which was "discovered" by these urban escapists was the Adirondack Mountains of New York State. Aided by an ever-increasing network of rail lines and roads, people began vacationing in this region shortly after the Civil War. During the last quarter of the century, homes ranging from one-room hunting shacks to enormous lodges were constructed in the Adirondacks. While the better homes lacked none of the comforts of their urban counterparts, they nevertheless provided an antidote for urban living through their rustic decor. The houses themselves were usually constructed of rough logs and bark. Inside they were decorated with stuffed animals, fur rugs, and rustic furniture (see fig. 27).

Whether this rocking chair was actually made in the Adirondacks is not known. A virtually identical chair has a history of ownership in the mountain community of Long Lake, New York.[2] However, the demand for rustic furniture was so great around the turn of the century that numerous small shops and factories in New York and the Midwest produced a wide variety of rustic furniture which they shipped into isolated areas like the Adirondacks. The high quality of this chair's design and construction and its similarity to others suggest that its maker produced such chairs in relatively large numbers.

STRUCTURE AND CONDITION: All components are held together with wire nails. The bent elements were probably intertwined while green and then nailed in place. The chair is in excellent condition. There are a few minor losses to the ends of whips (saplings or small branches stripped of their leaves) and several nails have fallen out. Much of the original bark material is still in place.

WOODS: Rockers, hard maple; larger support whips, hickory; smaller back whips, willow; seat, chestnut bark.

DIMENSIONS: H. 38 (96.5); S.H. 15¾ (40.0); W. 24 (61.0); D. 40⅛ (101.9).

PROVENANCE: Purchased in Houston, Tex.; Bybee Collection, early 1980s.

Gift of Faith P. Bybee, 1988.B76

1. For an extensive discussion of rustic furniture and its historical development, see Gilborn 1987. For other information, see Stephenson 1979.
2. For an illustration of this chair, see Gilborn 1987, pl. 42.

Fig. 27. "Living Room Cabin" of Kamp Kill Kare, Lake Kora, New York. Photograph, ca. 1916–1920. (The Adirondack Museum, Blue Mountain Lake, N.Y.)

75
STAND

1900–1920
America

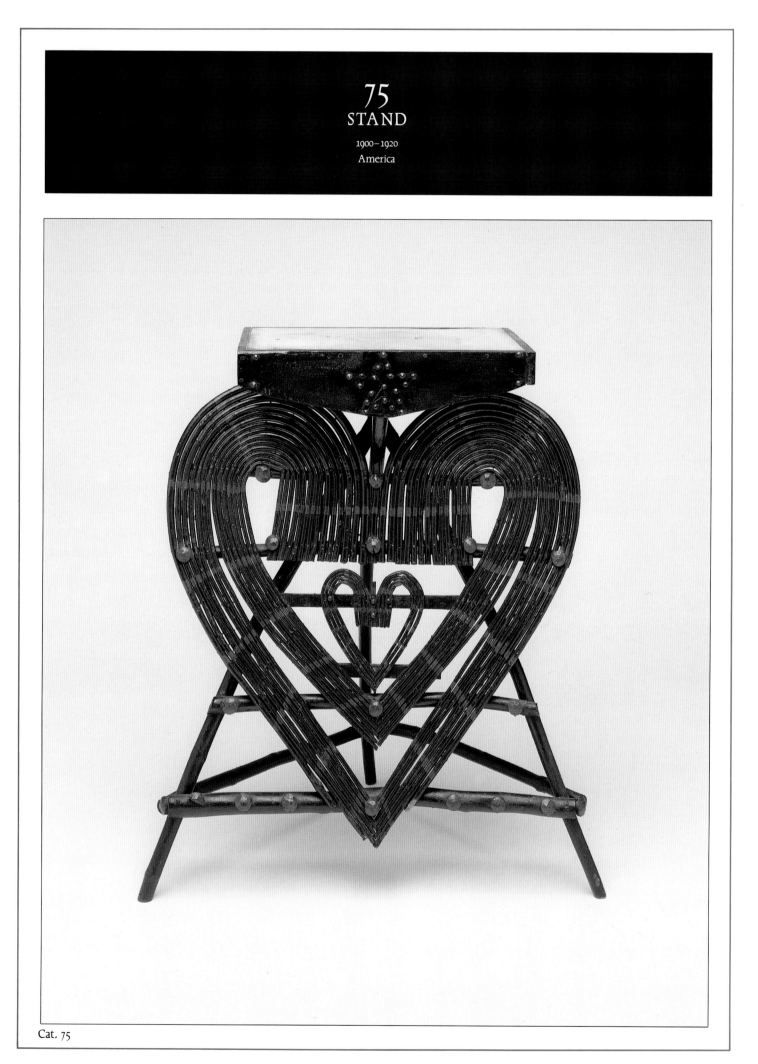

Cat. 75

LIKE THE PRECEDING rocking chair, this small stand reflects America's romantic fascination with nature during the late nineteenth and early twentieth centuries. Used for holding such things as lamps, fish bowls, and plants (see fig. 28), this stand helped to create a "rustic" environment in which nature was brought inside the home for the enjoyment and purification of man. Although the makers and users of such "rustic" pieces wanted their rural retreats to have a rugged, healthy decor, they were not willing to allow untamed nature into their homes. In this stand, for example, natural materials and colors have been manipulated into a highly artificial creation. The design of the base is strongly geometric—a pyramid divided by horizontals. The thin maple saplings have been forced into geometric heart-shapes and decorated with round bosses. Finally, the natural color of the bark has been "domesticated" with paint applied in geometric bands. Examples are known which stress man's control over nature even more through the incorporation of artificial birds in the center of their hearts.[1]

By whom or where this stand was made is unknown. Traditionally, pieces such as this have been called "gypsy" furniture.[2] This terminology suggests that they were made by itinerant craftsmen who traveled about selling their products. While this is possible, the survival of substantial numbers of stands which appear to be by the same hand as this example may indicate that they were made in a more traditional workshop setting and marketed through normal channels over a wide area.

STRUCTURE AND CONDITION: The stand is crudely constructed and entirely held together with wire nails. The thin heart-shape elements and interwoven saplings have been bent into place. The top is nailed to the tripod base from above with wire nails. Butt-joined skirting boards are nailed to the sides of the top. The front skirt is decorated with wooden pegs arranged in a star-pattern.

The stand is in good condition. There are minor losses to the bottom of the outer heart and bosses. The top retains its original cotton covering, and the paint is original.

WOODS: Legs, stretchers, bosses, bent saplings, soft maple; two horizontal supports behind hearts, yellow poplar; top, eastern white pine.

DIMENSIONS: H. 30½ (77.5); W. 27 (68.7); D. 18 (45.8).

PROVENANCE: Unknown.

Gift of Faith P. Bybee, 1988.B77

1. The author has seen numerous examples with heart-shape bases. For one, see *Maine Antique Digest* 16:7 (July 1988): 18-B. For one with an artificial bird on it, see DMA files.
2. See Craig A. Gilborn, letter to the author, 18 June 1987, DMA files.

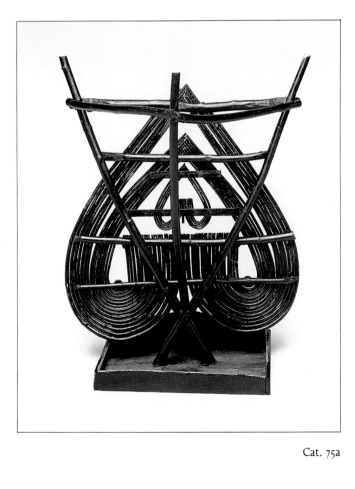

Cat. 75a

Fig. 28. Robert Gwathmey (b. 1903), *Portrait of a Farmer's Wife*, ca. 1954. Oil on canvas; H. 23 (58.2); W. 19⅜ (49.0). (Dallas Museum of Art, gift of Mr. and Mrs. Stanley Marcus [1959.10].)

76
ROCKING CHAIR

1984
Sam Maloof (b. 1916)
Alta Loma, California

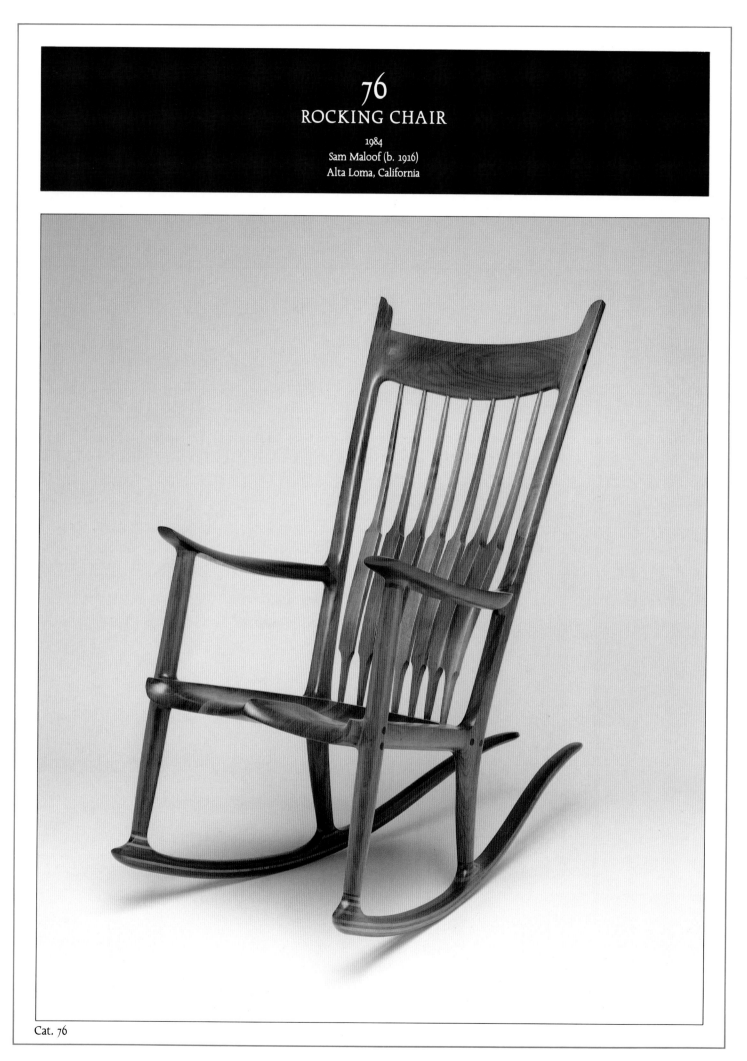

Cat. 76

IN 1976 JONATHAN FAIRBANKS founded a program entitled "Please Be Seated" for the Museum of Fine Arts, Boston, where he is curator of American decorative arts and sculpture. This project is designed to give the public an opportunity to experience sitting on furniture made by some of America's most important contemporary craftsmen. The museum's first purchase consisted of twelve pieces of furniture by Sam Maloof, which it placed throughout the galleries as visitor seating. It was in this context that Faith Bybee first saw Maloof's work.

Upon one of her numerous visits to the museum, Mrs. Bybee was invited to dinner by Jonathan Fairbanks. Sam Maloof and his wife, Alfreda, were also invited. At the museum Mrs. Bybee had seen an armchair which had an extended horn-shape crest rail. Over dinner she asked Maloof what he called this particular chair. Thinking quickly and taking his fellow diner into account, Maloof answered, "my Texas chair." That chair continues to be called the "Texas" chair to this day.[1] Ironically, in the end Mrs. Bybee decided not to order the "Texas" chair, but rather the rocking chair, armchair (cat. 77), and settee (cat. 78) seen here.

In discussing his rockers and other chairs, Maloof says:

> It is difficult for me to explain how I reach the conclusion on how a chair is to be made—the height, the depth, the width, the cant of the seat to the back—I have no formula or answer. I do it all by eye. I do it by feel. I use the measure of my hand rather than the rule. In essence, there is no logic to this. Design is a matter of instinct and inner impulse. It cannot be systematized and rationalized.[2]

Maloof's combination of "eye" and "feel" results in furniture which is extremely comfortable. As intended, the seat cradles the buttocks and the rear spindles give lower back support. It is perhaps due to these qualities that this particular type of rocker is Maloof's most popular chair.

STRUCTURE AND CONDITION: The seat is shaped from several pieces of wood glued together. On the interior of the seat's cut-out corners is a central rabbet which fits into grooves on the legs. These joints are secured with screws which are covered with plugs. The crest rail is also attached with hidden screws. The arm supports are attached to the arms with dowels and are secured to the rear stiles with hidden screws. The rockers are of laminated construction.[3] The chair is in excellent condition.

INSCRIPTIONS: Written with a wood burner under the seat is "No. 56 / 1984 / Sam Maloof f.A.C.C. [Fellow, American Craft Council]."

WOODS: All major elements, American black walnut; plugs covering screws, probably rosewood (not tested).

DIMENSIONS: H. 45⅝ (115.9); S.H. 17 (43.2); W. 26⅜ (67.0); D. 45¾ (116.2).

PROVENANCE: Sam Maloof, Alta Loma, Cal.; Bybee Collection, 1984.

Gift of Faith P. Bybee, 1988.B85

1. See Sam Maloof, letter to the author, 27 Aug. 1987, DMA files.
2. Maloof 1983, 186. This work is an exceptional insight into the creative process of furniture making.
3. For an extensive photographic essay on how such rocking chairs are constructed, see Maloof 1983, 106–120.

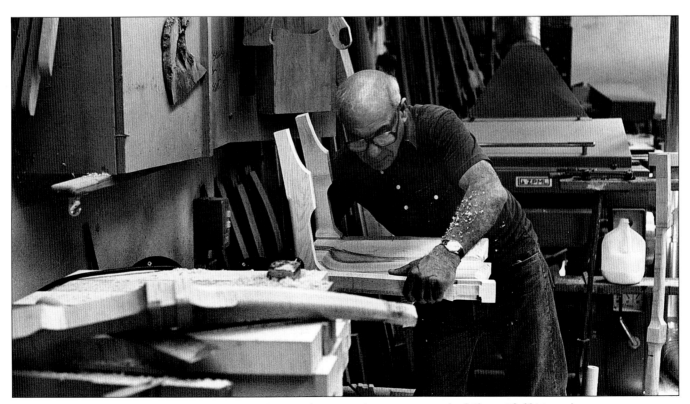

Fig. 29. Sam Maloof at work. Photograph, ca. 1982. (Courtesy, Sam Maloof: Photo, Khalil Marcos.)

FOR THE FURNITURE HISTORIAN it is usually difficult, if not impossible, to know exactly why a long-dead craftsman designed a piece the way he did. Therefore when a craftsman commits his thoughts and actions to paper as Maloof has done in *Sam Maloof: Woodworker*, it not only illuminates the process behind his own creations, but helps us to understand the types of basic decisions which his predecessors made in producing their furniture.

For example, a future observer might think that the low arms on this chair were designed for purely aesthetic reasons. However, Maloof tells us that:

> The very low arm on some of my chairs acts as a handle, and, structurally, takes the place of a stretcher below the chair seat. This arm is used to lower yourself into and to raise yourself out of the chair. It also serves as a convenient means of moving the chair forward or backward from a seated position without having to grab the bottom of the chair seat. A stretcher below the seat would clutter the clean flow of my designs. The only time I make a high arm is for rocking chairs, some side chairs, and occasional chairs. Dining chairs for host and hostess may have high arms if requested. The low arm has the added advantage of being both comfortable and not interfering with the motion of your body, particularly your elbows. Furthermore, you can throw your knee over the low arm and slouch with abandon, and the chair will endure.[1]

Aesthetics are only one factor in design; durability, structure, and usage are often just as important.

STRUCTURE AND CONDITION: This chair is constructed with the same joinery as the preceding example (cat. 76). Plastic pads are attached to the bottom of the legs. The chair is in excellent condition.

INSCRIPTIONS: Written with a wood burner under the seat is "No. 55 / 1984 / Sam Maloof f.A.C.C."

WOODS: All major elements, American black walnut; plugs covering screws, probably rosewood (not tested).

DIMENSIONS: H. 30½ (77.5); S.H. 18¼ (36.3); W. 21⅝ (54.9); D. 23 (58.5).

PROVENANCE: Sam Maloof, Alta Loma, Cal.; Bybee Collection, 1984.

Gift of Faith P. Bybee, 1988.B83

1. Maloof 1983, 57. Maloof states that this particular chair form is perhaps his favorite.

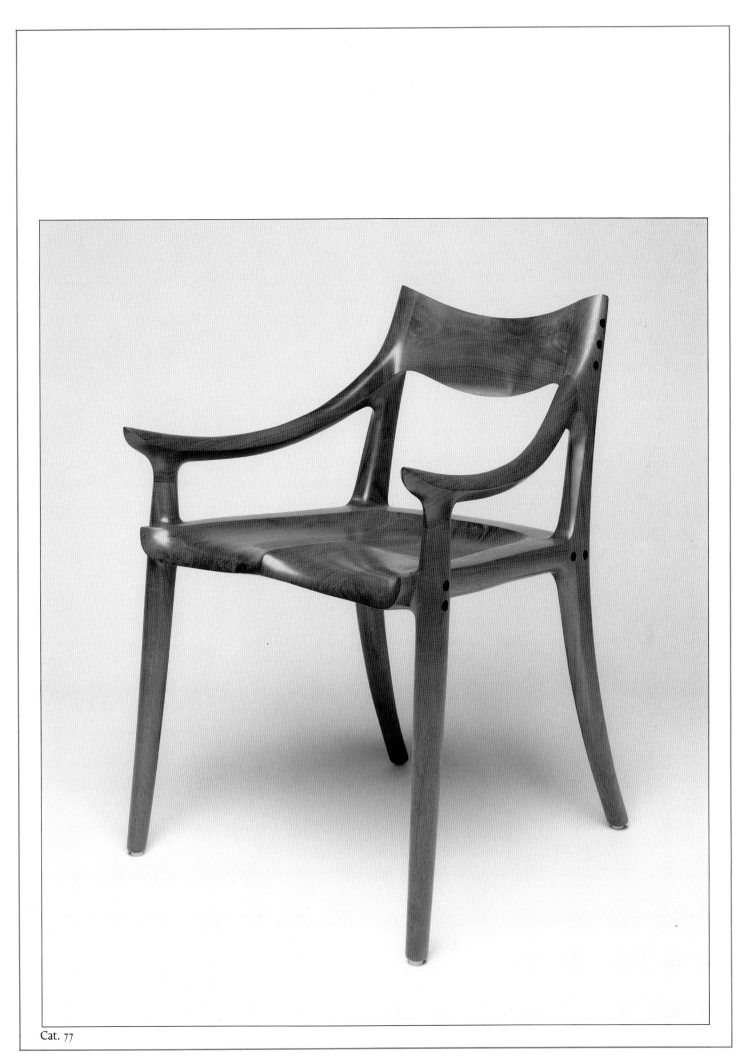

Cat. 77

ALTHOUGH MOST OF Maloof's chairs and this settee contain curved arms, flaring legs, and scooped-out seats and crest rails, none of the wood is bent to shape using steam and pressure. Rather, every curved element is cut from solid wood. To achieve these various forms, Maloof uses both hand and power tools. For example, to make the type of scooped wooden seat seen on this settee, Maloof says:

> I originally used a large gouge and mallet, then finished with a scraper and sandpaper. I found this quite time-consuming; so I purchased a large body grinder (disk sander) and used 16 grit paper. This chews the wood right out to rough-shape a seat. The rough form can then be finished with smaller disk sanders and finer papers.[1]

After it is attached to the legs, chisels are used to sculpt the seat so that it flows smoothly into the legs.

Double-back settees, like this example, are some of the most structurally problematic pieces which Maloof makes due to the large span of unsupported wood between the legs. Maloof says, "When I attach the leg, the tops and bottoms tend to splay out. The entire piece is made stable and functional by the attachment of the crest rail. This is not something that I engineered by study of abstract principles; I just did it."[2]

STRUCTURE AND CONDITION: This piece employs the same joinery as the preceding examples (cats. 76, 77).

INSCRIPTIONS: Written with a wood burner under the seat is "No. 54 / 1984 / Sam Maloof f.A.C.C."

WOODS: All major elements, American black walnut; plugs covering screws, probably rosewood (not tested).

DIMENSIONS: H. 30½ (77.5); S.H. 17⅞ (45.4); W. 38½ (95.2); D. 22¼ (56.5).

PROVENANCE: Sam Maloof, Alta Loma, Cal.; Bybee Collection, 1984.

Gift of Faith P. Bybee, 1988.B84

1. Maloof 1983, 70. 2. Maloof 1983, 57.

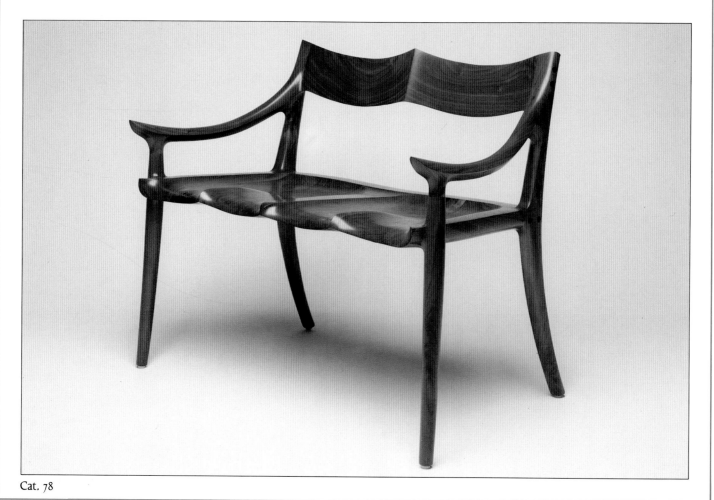

Cat. 78

STUDY OBJECTS

As with all large collections, the Bybee Collection
contains several objects which have been compromised in terms of
condition or provenance. In order to aid other collectors and curators
in understanding similar pieces in their care,
the four study objects which follow have been catalogued
in the same manner as the rest of the collection.

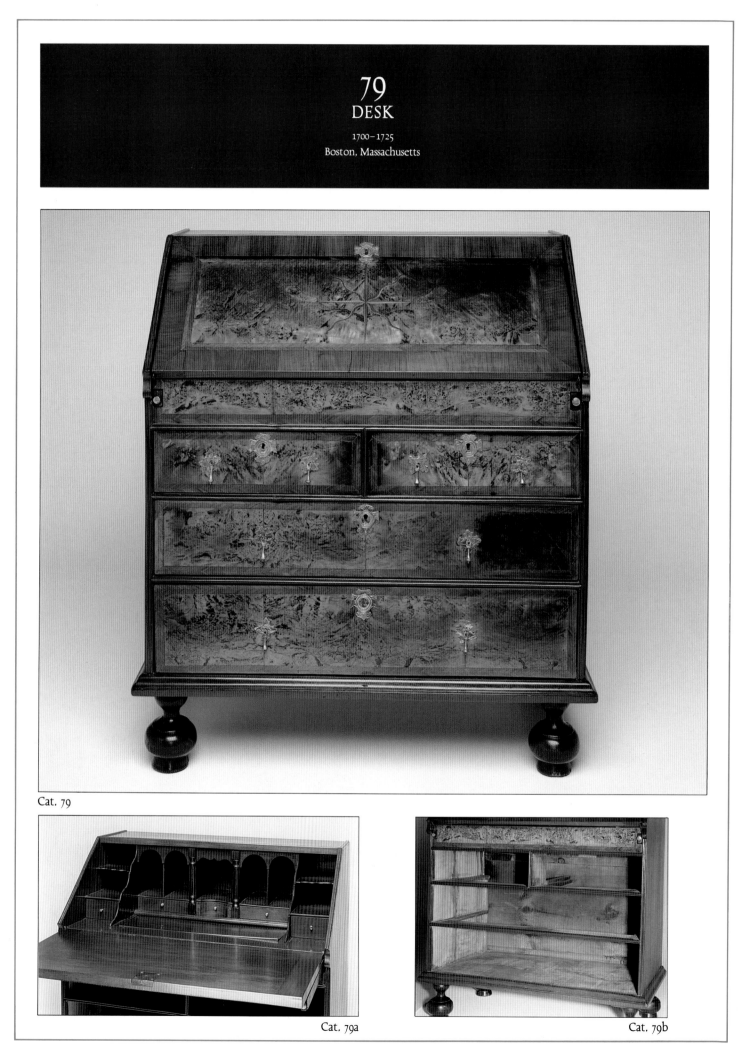

79
DESK

1700–1725
Boston, Massachusetts

Cat. 79

Cat. 79a

Cat. 79b

DURING THE LATE seventeenth century, as woodworkers became increasingly skilled at using dovetails and veneers, the basic character of English furniture was transformed. By using these new techniques, furniture was produced with broad flat surfaces and concealed joints. Rich patterns were obtained through the application of exotic wood veneers, rather than carving.[1]

This desk reflects the presence of cabinetmakers and customers in Boston who were familiar with the changes which were occurring in English, and especially London, furniture in the late seventeenth and early eighteenth centuries. Here the drawer facades, fall-front, and top are veneered with highly figured and costly burl walnut. Not only are the veneers matched to create symmetrical mirror images, but each is surrounded by a herringbone border of walnut. On the lid is an inlaid eight-point star of light and dark woods. Imported brass hardware is used to enrich the patterned surface still further. The overall effect is one of exotic tortoiseshell studded with gold.

Desks of this quality were extremely expensive and uncommon in early eighteenth-century America. Most people simply used a table or slant-top box for their writing. Labor-intensive products of costly materials such as this desk were available only to the wealthy mercantile elite of towns like Boston. Among this small group, these desks were popular as symbols of the owners' wealth and sophistication. Today over a dozen survive. However, few examples are as elaborately veneered and inlaid as the one seen here. Only two others are known with a star inlaid on their fall-fronts, and another is veneered in imported olive wood.[2] Most have no inlay at all and many are unveneered.[3]

Cat. 79c

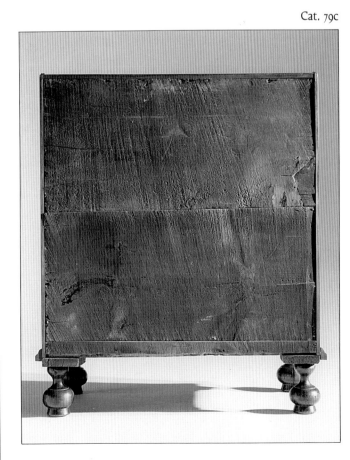

STRUCTURE AND CONDITION: The top and bottom boards are dovetailed to the case sides. The drawer dividers and runners and the full dustboard beneath the desk compartment are set into grooves in the case sides. The bottom drawer runs on the bottom board. Double-bead tacking strips cover the front edges of the sides and drawer dividers. The base molding is nailed to the case. The top of the turned feet tenon up through base blocks into the baseboard. The horizontal backboards are nailed into the rabbeted edges of the case sides and top.

The desk is veneered on top, as well as on the front facade. Each reserve of burl walnut is surrounded by a band of walnut herringbone inlay. The central panel on the desk's fall-front contains an inlaid eight-point star. On either side of this star are two irregularly shaped areas formed by a veneer stamp which was used to remove flaws in the veneer such as knots. The lower and interior drawers are joined with large dovetails. Their bottoms fit into rabbets along the drawer fronts and are nailed onto the bottoms of the sides and backs. Running strips are glued along the side edges of each drawer.

This desk was severely damaged by fire in 1972. Subsequently it was conserved for study purposes at the Museum of Fine Arts, Boston. All original components which could be saved were retained, including the feet and hardware. However, various elements had to be replaced or consolidated and refinished. The sides and top of the case and the fall-front are new. The sides and the new sections of base molding attached to them are grained to approximate the color of walnut, as is the interior of the fall-front. The double-bead tacking strips on the front facade are replacements. The interior of the desk was scraped down and recolored. All of the walnut veneer and inlays on the front and top are original. However, since they were charred in the fire, all the veneers were lifted, turned over, and reattached to the surface of the desk. What was originally the glue-side is now on the exterior.

INSCRIPTIONS: On the inside of the backboard is scratched "IIII IX."

WOODS: Veneer, moldings, and interior desk compartment, American black walnut; feet, ash; bottom of document drawers, oak; drawer linings, back and bottom boards, eastern white pine.

DIMENSIONS: H. 39⅝ (100.6); W. 35⅜ (89.8); 19¾ (50.2).

PROVENANCE: Israel Sack, Inc., New York, N. Y.; Bybee Collection, 1953.

EXHIBITIONS AND PUBLICATIONS: A. Sack 1950, 139; Fairbanks 1967, 834; Fairbanks and Bates 1981, 61; MFA, H 1981; Kirk 1982, fig. 601.

1985.B2

1. For a discussion of the transformation of case furniture production in England and America, see Forman 1985; Trent 2, 1985.
2. See Fitzgerald 1982, fig. II-21; Comstock 1962, fig. 95; Davidson and Stillinger 1985, fig. 136.
3. See Antiques 27:2 (Feb. 1935): 44; 58:6 (Dec. 1980): 440; Randall 1965, no. 55; Warren 1975, no. 35. For unveneered examples, see Lyon 1924, fig. 48; Fales 1976, fig. 460.

80
EASY CHAIR

1750–1780
Eastern Massachusetts, probably Boston

OF THE TWO easy chairs in this catalogue from the Boston area (see cat. 14), this example with its pad front feet, plain rear legs, and stretchers is the more typical. Due to their sturdy construction and comfort, dozens of related easy chairs survive today.[1] What is unusual about this particular easy chair is that it was originally one of a pair.[2] In the eighteenth century, upholstered easy chairs were the most expensive form of chair made and appear to have seldom been purchased in pairs. Oral tradition states that this pair of easy chairs descended in the Patterson-Long family of Boston. Unfortunately, the second was destroyed by fire in 1972. The right front leg and right side stretcher of this chair were severely damaged and had to be replaced (see cat. 80b).

STRUCTURE AND CONDITION: Judging from photographs, the frame of this chair is primarily joined with mortise-and-tenon construction. The inside edges of the seat rails appear to be rabbeted in order to support a toilet frame. The front legs slot into the front corners of the seat frame. The ends of the stretchers have rectangular tenons to prevent them from rotating.

The mate to this chair was destroyed by fire in 1972 and this chair was severely damaged. The right front leg and right side stretcher are replacements. The remaining exterior surfaces were scraped down and refinished. The underframe has been consolidated and covered with canvas in several places. Casters were once attached to the legs. Vertical bracing members have been added at the rear of each wing to create "pull-throughs" for the upholstery.

WOODS: Front legs and stretchers, walnut; rear legs and seat frame, maple; rest of frame, not tested.

DIMENSIONS: H. 46⅝ (118.4); S.H. 14¼ (36.2); W. 35½ (90.2); D. 30⅞ (78.4).

PROVENANCE: Descendents of the Patterson-Long families of Boston, Mass.; Israel Sack, Inc., New York, N. Y.; Bybee Collection, 1958.

EXHIBITIONS AND PUBLICATIONS: Fairbanks 1967, 836; Ward 1977, fig. 35; Sack 1981, 1:13.

1985.B12

1. For representative examples, see Downs 1952, no. 74; Jobe and Kaye 1984, no. 104; Heckscher 1985, nos. 70–71.
2. For illustrations of both chairs, see Sack 1981, 1:13; Fairbanks 1967, 836.
3. Albert Sack believes that the descendant of the Patterson-Long family from whom this chair was purchased was probably Susan Higginson Nash of Boston.

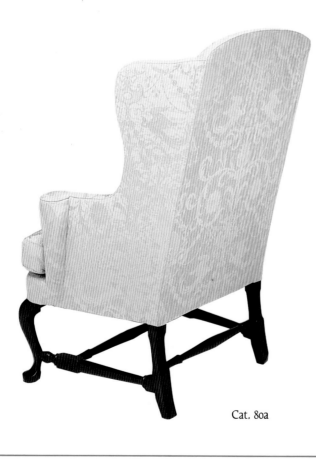

Cat. 80a

Cat. 80b Photo: Robert Walter

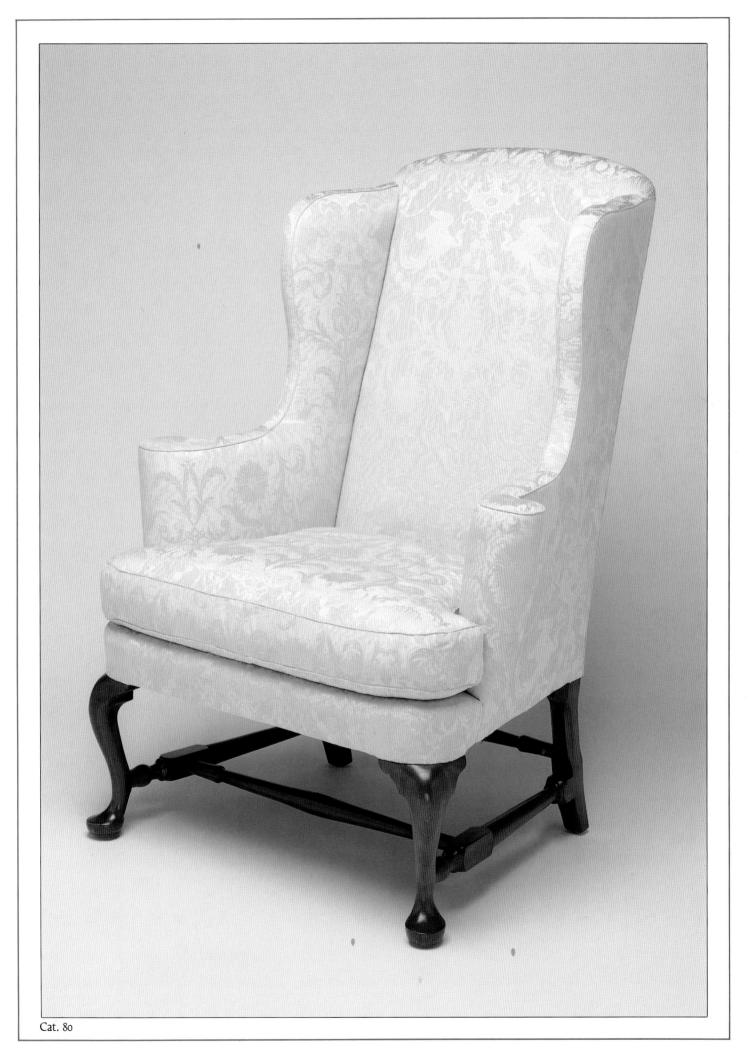

Cat. 80

81
WORK TABLE

1830–1850
Essex County, Massachusetts

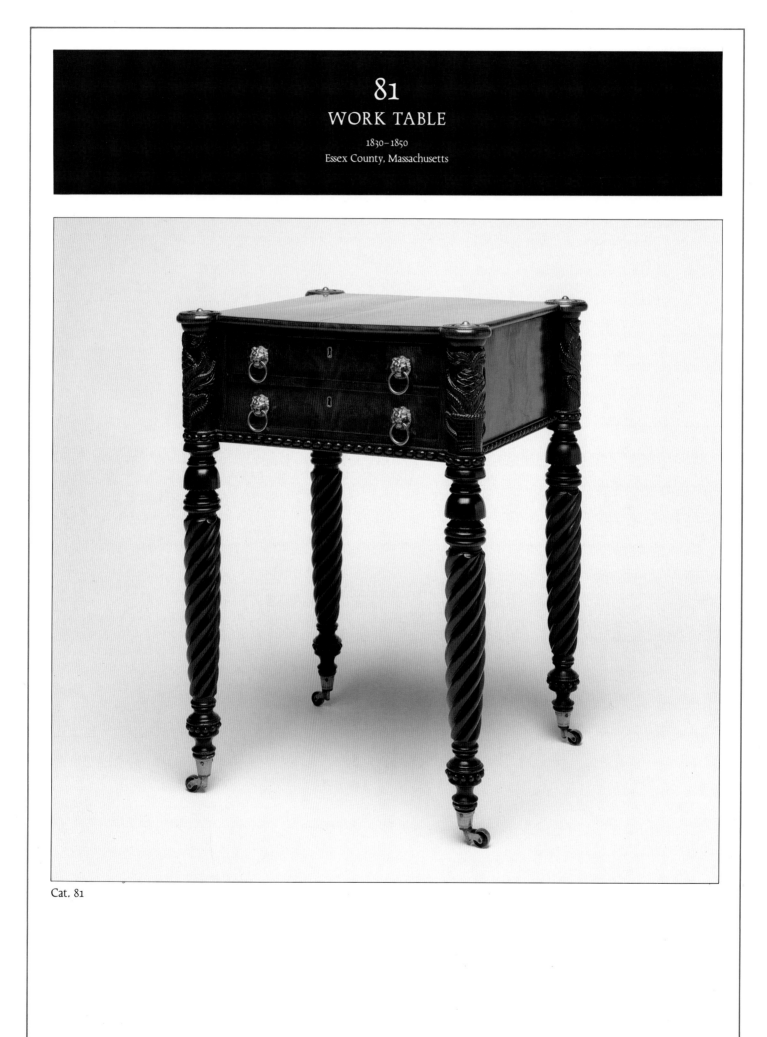

Cat. 81

EVER SINCE AMERICAN FURNITURE became popular to collect in the late nineteenth century, signed and labeled examples have been highly prized. Consequently, documented pieces have consistently brought higher prices than their undocumented counterparts. This added value has therefore made it profitable for unscrupulous persons to add fake signatures or attach labels to otherwise undocumented pieces of furniture.

During the 1960s, several pieces of Essex County furniture appeared on the market bearing labels with the names of famous American cabinetmakers, including John Seymour and Samuel Chapin.[1] The table seen here is part of this group. Like the others, this table's label (cat. 81a) is hand-lettered on extremely porous woven paper. Eighteenth- and early nineteenth-century labels are typically printed on laid paper. By associating this table with the famous New York cabinetmaker, Duncan Phyfe, the owner undoubtedly was able to make an enormous profit on an otherwise undistinguished object.[2]

Although the forger selected a New York provenance for his piece, it is typical of work tables made north of Boston in Essex County during the second quarter of the nineteenth century. Square tables with turned legs and carved turret-corners were made in large quantities in this area after 1800. Those made during the 1810s and 1820s usually have light proportions and realistic carving.[3] However, by the second quarter of the century, such tables became heavier and their ornamentation exaggerated and idiosyncratic.[4]

Rather than the small circular beading and delicate fluting seen on earlier examples, this table has large beads around its case and feet and boldly twist-carved legs.[5] Where acanthus leaves would have been carved on earlier tables, here the upper part of the legs consists of ring turnings and deeply undercut and undecorated trumpet-turnings. The carving on the turret-corners is poorly designed and crudely executed. Who made this table is unknown. However, related examples of similar quality were produced by the Dodge Furniture Company of Manchester, Massachusetts, in the 1840s.[6]

STRUCTURE AND CONDITION: The case is dovetailed together. The drawer runners are nailed to the sides of the case. The carved beading is applied, as is the half-round molding which surrounds the top. The drawers are constructed with

small dovetails. Their chamfered bottoms fit into grooves along their fronts and sides and are nailed flush across the backs. The top drawer is fitted with compartments.

The table is in good condition. The drawer pulls are reproductions. The right rear brass-boss atop the corner post is a crude casting made from one of the three surviving examples. The casters are original. The top has been off to fill a crack and reset. The carving on the turret corners has been badly scraped down. The punched star work on the background has been virtually obliterated.

INSCRIPTIONS: The drawer of this table carries a spurious Duncan Phyfe label (see cat. 81a).

WOODS: Veneer and legs, mahogany; all remaining elements, eastern white pine.

DIMENSIONS: H. 28¼ (71.2); W. 20⅞ (53.1); D. 19⅞ (50.3).

PROVENANCE: Weiner's Antiques, Boston, Mass.; Israel Sack, Inc., New York, N. Y.; Bybee Collection, 1964.

EXHIBITIONS AND PUBLICATIONS: MFA, H 1981.

1985.B41

1. For examples, see *Maine Antique Digest* 16:8 (Aug. 1988): 39-A; DAPC 67.1523, 67.1796. Samuel Chapin is probably a fictitious member of the well-known Chapin family of Connecticut cabinetmakers.

2. The identity of the person who placed these fake labels on this group of furniture is unknown. This particular label was in place when it was purchased by Israel Sack, Inc., in Boston in the early 1960s.

3. For early examples, see Kimball 1933, 90; Fales 1965, nos. 4, 45; Montgomery 1966, no. 413; Elder and Stokes 1987, no. 131.

4. See *Antiques* 51:3 (Feb. 1947): back cover; SPB 5599 (26 June 1987): lot 84; DAPC 71.836, 71.992.

5. For illustrations of carved beading on Essex County pieces, see Swan 1937, 180.

6. For discussions of the Dodge Furniture Company, see Fales 1965, no. 12; and especially Roessel 1987. For a more refined table with similar decorative turning on the upper leg and carved pineapples on the turret-corners, see AAA 3915 (15–17 Oct. 1931): lot 412.

Cat. 81a

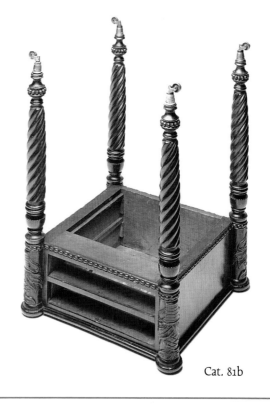

Cat. 81b

TURNED CHAIRS were one of the earliest furniture forms made in America by European settlers (see cat. 4). Consequently, when Americans rediscovered their colonial past as a result of the Centennial World's Fair held in Philadelphia in 1876, "antique" turned "Pilgrim" chairs became icons of this romanticized heritage.[1] Collecting seventeenth- and early eighteenth-century furniture soon emerged as a fashionable and patriotic pursuit.

To satisfy this demand for early American furniture, a network of antique dealers, restorers, and reproducers developed along the East Coast. While most of these individuals were honest, some supplied collectors with fakes and rebuilt objects. This chair is such a piece. It appears that the only old elements of this chair are its front posts. These elements were probably originally part of a Massachusetts or Connecticut turned chair.[2] The turnings on the rear posts, back spindles, and front upper stretcher are of a completely different character. Where the front posts are rather crude, the rest of the turnings are extremely animated and crisply executed. Although the back should have received heavy wear from countless sitters, its turnings and crest rail are unmarred.

The use of fully rounded spindles in the back is also atypical. Usually, chairmakers used "split-spindles" in the back of their chairs. These spindles were produced from two pieces of wood which had been glued together with a piece of paper in between. The wood was then turned to the desired shape and subsequently "split" along the glue line. The smooth side of the split-spindle was most often placed toward the sitter's back for comfort, although the rounded side occasionally faced inward.[3] In the eighteenth century, fully rounded turnings were almost never used in the backs of chairs. Finally, on a period chair, the finials of the rear posts would have been formed while the posts were being turned. Here, these "turnings" are hand-carved and tenoned into the top of the rear posts.

Unlike many pieces of furniture which were made and sold as honest reproductions, this chair was created to deceive the buyer.

STRUCTURE AND CONDITION: This chair is entirely mortise-and-tenoned together. The front posts were probably salvaged from a late eighteenth- or early nineteenth-century chair. All other parts are new. The finials atop the rear posts are not turned, but hand-carved and tenoned down into the posts. The entire surface is painted black.

WOODS: All parts, ash.

DIMENSIONS: H. 47⅜ (120.3); S.H. 18¼ (46.3); W. 19⅝ (49.8); D. 14⅝ (37.2).

PROVENANCE: Bybee Collection, probably 1970s.

EXHIBITIONS AND PUBLICATIONS: MFA, H 1981.

1985.B5

1. For a discussion of the colonial revival, see Axelrod 1985.
2. For chairs with similar front posts and/or overall design, see Fales 1976, fig. 37; Jobe and Kaye 1984, III-21-22; Trent 1977, fig. 29.
3. For chairs with the rounded side of their spindles facing the sitter, see Ward and Hosley 1985, nos. 87–89.

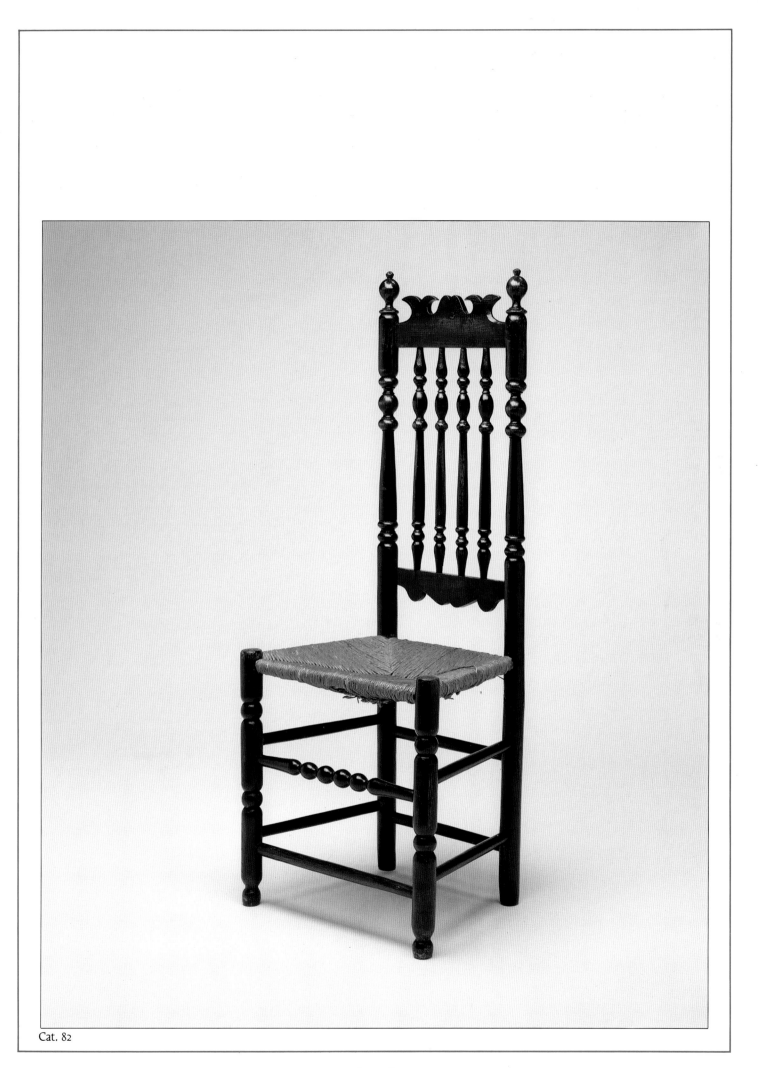

Cat. 82

REFERENCES

AAA
American Art Association auction gallery. Succeeded by Parke-Bernet, New York, N. Y.

Ames 1978
Kenneth L. Ames. "Meaning in Artifacts: Hall Furnishings in Victorian America." *Journal of Interdisciplinary History* 9:1 (Summer 1978): 19–46.

Andrews 1981
Carol Damon Andrews. "John Ritto Penniman (1782–1841), An Ingenious New England Artist." *Antiques* 120:1 (July 1981): 147–171.

Arthur and Ritchie 1982
Eric Arthur and Thomas Ritchie. *Iron: Cast and Wrought Iron in Canada from the Seventeenth Century to the Present.* Toronto: University of Toronto Press, 1982.

Atkins 1931
C. E. Atkins. *Register of Apprentices.* London: Privately printed, 1931.

Axelrod 1985
Alan Axelrod, ed. *The Colonial Revival in America.* New York: W. W. Norton and Co., 1985.

Bahns 1979
Jörn Bahns. *Biedermeier Möbel: Entstehung, Zentren, Typen.* Munich: Keyser, 1979.

Baillie 1969
G. H. Baille. *Watchmakers and Clockmakers of the World.* London: N.A.G. Press, Ltd., 1969.

Bentley 1962
William Bentley. *The Diary of [the Reverend] William Bentley, D.D.* 4 vols. Salem, Mass.: Essex Institute, 1905–1912. Reprint. Gloucester, Mass.: Peter Smith, 1962.

Bishop 1972
Robert Bishop. *Centuries and Styles of the American Chair, 1640–1970.* New York: E. P. Dutton & Co., 1972.

Blackburn 1976
Roderic H. Blackburn. *Cherry Hill: The History and Collections of a Van Rensselaer Family.* Albany: Historic Cherry Hill, 1976.

Blades 1987
Margaret B. Blades. *Two Hundred Years of Chairs and Chairmaking: An Exhibition of Chairs from the Chester County Historical Society.* West Chester, Pa.: Chester County Historical Society, 1987.

Bordes 1972
Marilynn Johnson Bordes. *Baltimore Federal Furniture.* New York: Metropolitan Museum of Art, 1972.

Bowdoin 1974
The Art of American Furniture: A Portfolio of Furniture in the Collections of the Bowdoin College Museum of Art. Brunswick, Me.: Bowdoin College Museum of Art, 1974.

Brown 1980
Michael K. Brown. "Scalloped-top Furniture of the Connecticut River Valley." *Antiques* 117:5 (May 1980): 1092–1099.

Burgess 1830
Tristan Burgess. *Address Delivered Before the American Institute of the City of New York.* New York, 1830.

Burton 1955
E. Milby Burton. *Charleston Furniture, 1700–1825.* Charleston, S. C.: Charleston Museum, 1952.

Cabinet-Makers 1803
London Society of Cabinet-Makers. *The Cabinet-Makers' London Book of Prices, and Designs of Cabinet Work, Calculated for the Convenience of Cabinet-Makers in General: Whereby the Price of Executing any Piece of Work May be Easily Found.* 3d ed. London, 1803.

Caldwell 1985
"Germanic Influences on Philadelphia Early Georgian Seating Furniture." Master's thesis, University of Delaware, 1985.

Carpenter 1954
Ralph E. Carpenter, Jr. *The Arts and Crafts of Newport, Rhode Island, 1640–1820.* Newport: Preservation Society of Newport County, 1954.

Carreno 1963
Virginia Carreno. "American Federal Furniture in Argentina." *Antiques* 84:3 (Sept. 1963): 283–287.

Catalano 1979
Kathleen M. Catalano. "Cabinetmaking in Philadelphia, 1820–1840: Transition from Craft to Industry." In *American Furniture and Its Makers: Winterthur Portfolio 13*, ed. Ian M. G. Quimby. Chicago: University of Chicago Press, 1979, 81–138.

Cescinsky and Hunter 1929
Herbert Cescinsky and George Leland Hunter. *English and American Furniture.* Garden City, N. Y.: Garden City Publishing Co., 1929.

Christie's
Christie, Manson, and Woods, Ltd. All sale catalogues from this auction company are from their New York gallery unless otherwise noted.

CHS 1963
Frederick K. and Margaret R. Barbour's Furniture Collection. Connecticut: Connecticut Historical Society, 1963.

Churchill 1983
Edwin A. Churchill. *Simple Forms and Vivid Colors.* Augusta: Maine State Museum, 1983.

Clunie 1980
Margaret Burke Clunie, Anne Farnam, and Robert Trent. *Furniture at the Essex Institute.* Salem, Mass.: Essex Institute, 1980.

Comstock 1953
Helen Comstock. "Frothingham and the Question of Attributions." *Antiques* 63:6 (June 1953): 502–505.

Comstock 1962
Helen Comstock. *American Furniture: Seventeenth, Eighteenth, and Nineteenth Century Styles.* New York: Viking Press, 1962.

Cooke 1987
Edward S. Cooke, Jr., ed. *Upholstery in America and Europe from the Seventeenth Century to World War I.* New York: W. W. Norton and Co., 1987.

Cooke 1988
Edward S. Cooke, Jr. "A Closer Look at Camelback Sofas." *Maine Antique Digest* 16:7 (July 1988): 1D-4D.

Cooper 1980
Wendy A. Cooper. *In Praise of America: American Decorative Arts,
1650–1830 / Fifty Years of Discovery Since the 1929 Girl Scouts Loan Exhibition.*
New York: Alfred A. Knopf, 1980.

Crescent City 1980
Crescent City Silver. New Orleans: Historic New Orleans Collection, 1980.

Cummings 1961
Abbott Lowell Cummings, comp. *Bedhangings: A Treatise on Fabrics and
Styles in the Curtaining of Beds, 1650–1850.* Boston, Mass.: Society for the
Preservation of New England Antiquities, 1961.

Currier Gallery 1964
Decorative Arts of New Hampshire, 1723–1825. Manchester, N. H.: Currier
Gallery of Art, 1964.

DAPC
Decorative Arts Photographic Collection, The Henry Francis du Pont
Winterthur Museum, Winterthur, Del.

Davidson 1969
Marshall B. Davidson, ed. *Three Centuries of American Antiques.* Vol. 1, *The
American Heritage History of Colonial Antiques.* Vol. 2, *The American Heritage
History of American Antiques from the Revolution to the Civil War.* Vol. 3, *The
American Heritage History of Antiques from the Civil War to World War I.* 3
vols. in 1. New York: Bonanza Books, 1969.

Davidson and Stillinger 1985
Marshall B. Davidson and Elizabeth Stillinger. *The American Wing at the
Metropolitan Museum of Art.* New York: Alfred A. Knopf, 1985.

Denker 1985
Ellen P. Denker. *After the Chinese Taste: China's Influence in America,
1730–1930.* Salem, Mass.: Peabody Museum, 1985.

Dietz 1983
Ulysses G. Dietz. "Century of Revivals: Nineteenth-Century American
Furniture in the Newark Museum." *Newark Museum Quarterly* 31:2/3
(Spring/Summer 1980): 1–63.

Discover Dallas 1988
Discover Dallas / Fort Worth. New York: Alfred A. Knopf, 1988.

DMA
Dallas Museum of Art, Dallas, Tex.

Dow 1927
George Francis Dow, comp. *The Arts and Crafts in New England,
1704–1775.* Topsfield, Mass.: Wayside Press, 1927.

Downs 1949
Joseph Downs. *American Chippendale Furniture, 1750–1780: A Picture Book.*
Rev. ed. New York: Metropolitan Museum of Art, 1949.

Downs 1952
Joseph Downs. *American Furniture, Queen Anne and Chippendale Periods in
the Henry Francis du Pont Winterthur Museum.* New York: Macmillan Co.,
1952.

Drake 1900
Samuel A. Drake. *Old Landmarks and Historic Personages of Boston.* Boston:
Little, Brown, and Co., 1900.

Dubrow 1983
Elaine Dubrow and Richard Dubrow. *American Furniture of the 19th
Century, 1840–1880.* West Chester, Pa.: Schiffer Publishing Co., 1983.

Ducoff-Barone 1983
Deborah Ducoff-Barone. "Design and Decoration on Early Nine-
teenth-Century American Furniture: A Case Study of a Philadelphia
Secretary Bookcase." *Decorative Arts Society Newsletter* 9:1 (Mar. 1983): 1–8.

Elder 1972
William Voss Elder III. *Baltimore Painted Furniture, 1800–1840.* Baltimore:
Baltimore Museum of Art, 1972.

Elder and Stokes 1987
William Voss Elder III and Jayne E. Stokes et al. *American Furniture
1680–1880 from the Collection of the Baltimore Museum of Art.* Baltimore: Bal-
timore Museum of Art, 1987.

Fairbanks 1967
Jonathan L. Fairbanks. "American Antiques in the Collection of Mr.
and Mrs. Charles L. Bybee, Part I." *Antiques* 92:6 (Dec. 1967): 832–839.

Fairbanks 1968
Jonathan L. Fairbanks. "American Antiques in the Collection of Mr.
and Mrs. Charles L. Bybee, Part II." *Antiques* 93:1 (Jan. 1968): 76–81.

Fairbanks and Bates 1981
Jonathan L. Fairbanks and Elizabeth Bidwell Bates. *American Furniture:
1620 to the Present.* New York: Richard Marek Publishers, 1981.

Fairbanks and Cooper 1975
Jonathan L. Fairbanks and Wendy A. Cooper et al. *Paul Revere's Boston,
1735–1818.* Boston: Museum of Fine Arts, 1975.

Fales 1965
Dean A. Fales, Jr. *Essex County Furniture: Documented Treasures from Local
Collections, 1660–1860.* Salem, Mass.: Essex Institute, 1965.

Fales 1972
Dean A. Fales, Jr. *American Painted Furniture, 1660–1880.* New York: E. P.
Dutton, 1972.

Fales 1976
Dean A. Fales, Jr. *The Furniture of Historic Deerfield.* New York: E. P. Dut-
ton, 1976.

Fennimore 1981
Donald L. Fennimore. "American Neoclassical Furniture and Its
European Antecedents." *American Art Journal* 13:4 (Autumn 1981):
49–65.

Fitz-Gerald 1969
Desmond Fitz-Gerald. *Georgian Furniture.* London: Her Majesty's Station-
ery Office, 1969.

Fitzgerald 1982
Oscar P. Fitzgerald. *Three Centuries of American Furniture.* New York: Gra-
mercy Publishing Co., 1982.

Flanigan 1986
J. Michael Flanigan. *American Furniture from the Kaufman Collection.* Wash-
ington, D.C.: National Gallery of Art, 1986.

Fleming and Honour 1977
John Fleming and Hugh Honour. *The Penguin Dictionary of Decorative
Arts.* London: Penguin, 1977.

Fontane 1893
Theodor Fontane. *Meine Kinderjahre.* 1893. Reprint. Munich: Nymphen-
burger, 1961.

Footman's Directory 1823
The Footman's Directory and Butler's Remembrancer. London, 1823.

Forman 1971
Benno M. Forman. "Salem Tradesmen and Craftsmen Circa 1762:
A Contemporary Document." *Essex Institute Historical Collections* 107:1
(January 1971): 63–81.

Forman 1980
Benno M. Forman. "Delaware Valley 'Crookt Foot' and Slat-Back
Chairs: The Fussell-Savery Connection." *Winterthur Portfolio* 15:1 (Spring
1980): 41–64.

Forman 1985
Benno M. Forman. "The Chest of Drawers in America, 1635–1730:
The Origins of the Joined Chest of Drawers." *Winterthur Portfolio* 20:1
(Spring 1985): 1–30.

Garvan 1987
Beatrice B. Garvan. *Federal Philadelphia, 1785–1825, The Athens of the West-
ern World.* Philadelphia: Philadelphia Museum of Art, 1987.

Gavit 1923
Joseph Gavit. "Philip Gavet of Salem, Mass., and Some of His Descendants." *New England Historical and Genealogical Register* 72 (1923): 34–58.

Gellerman 1973
Robert F. Gellerman. *The American Reed Organ: Its History; How it Works; How to Rebuild it.* Vestal, N. Y.: Vestal Press, 1973.

Giedion 1948
Sigfried Giedion. *Mechanization Takes Command: A Contribution to Anonymous History.* New York: Oxford University Press, 1948.

Gilborn 1987
Craig Gilborn. *Adirondack Furniture and the Rustic Tradition.* New York: Harry N. Abrams, Inc., 1987.

Gilbert 1978
Christopher Gilbert. *Furniture at Temple Newsam House and Lotherton Hall.* 2 vols. London: Lund Humphries, 1978.

Gillingham 1930
Harold E. Gillingham. "Benjamin Lehman, A Germantown Cabinet-Maker." *Pennsylvania Magazine of History and Biography* 54:4 (1930): 289–306.

Girl Scouts 1929
Loan Exhibition of Eighteenth and Nineteenth Century Furniture and Glass . . . for the Benefit of the National Council of Girl Scouts, Inc. New York: American Art Galleries, 1929.

Girouard 1978
Mark Girouard. *Life in the English Country House: A Social and Architectural History.* New Haven, Conn.: Yale University Press, 1978.

Gloag 1956
John Gloag. *Georgian Grace: A Social History of Design from 1660–1830.* London: Adams and Charles Black, 1956.

Grand Rapids 1976
Renaissance Revival Victorian Furniture. Grand Rapids: Grand Rapids Museum, 1976.

Green 1983
Harvey Green. *The Light of the Home: An Intimate View of the Lives of Women in Victorian America.* New York: Pantheon Books, 1983.

Greenlaw 1974
Barry A. Greenlaw. *New England Furniture at Williamsburg.* Williamsburg, Va.: Colonial Williamsburg Foundation, 1974.

Griffith 1986
Lee Ellen Griffith. *The Pennsylvania Spice Box—Paneled Doors and Secret Drawers.* West Chester, Pa.: Chester County Historical Society, 1986.

Hagler 1976
Katharine Bryant Hagler. *American Queen Anne Furniture, 1720–1755.* Dearborn: Edison Institute, 1976.

Hanks and Peirce 1983
David A. Hanks and Donald C. Peirce. *The Virginia Carroll Crawford Collection: American Decorative Arts, 1825–1917.* Atlanta: High Museum of Art, 1983.

Harlow 1979
Henry J. Harlow. "Decorated New England Furniture." *Antiques* 116:4 (Oct. 1979): 860–871.

Heckscher 1, 1971
Morrison H. Heckscher. *In Quest of Comfort: The Easy Chair in America.* New York: Metropolitan Museum of Art, 1971.

Heckscher 2, 1971
Morrison H. Heckscher. "In Quest of Comfort: The Easy Chair in America." *Metropolitan Museum of Art Bulletin* n. s. 30:2 (Oct./Nov. 1971): 64–65.

Heckscher 3, 1971
Morrison H. Heckscher. "Form and Frame: New Thoughts on the American Easy Chair." *Antiques* 100:6 (Dec. 1971): 886–893.

Heckscher 1985
Morrison H. Heckscher. *American Furniture in the Metropolitan Museum of Art.* Vol. 2, *Late Colonial Period: The Queen Anne and Chippendale Styles.* New York: Metropolitan Museum of Art and Random House, 1985.

Hepplewhite 1794
George Hepplewhite. *The Cabinet-Maker & Upholsterer's Guide.* 3d ed. London, 1794. Reprint. New York: Dover Publications, Inc., 1969.

Hewitt 1982
Benjamin A. Hewitt, Patricia E. Kane, and Gerald W. R. Ward. *The Work of Many Hands: Card Tables in Federal America, 1790–1820.* New Haven, Conn.: Yale University Art Gallery, 1982.

Hinckley 1971
F. Lewis Hinckley. *A Directory of Queen Anne, Early Georgian, and Chippendale Furniture Establishing the Pre-eminence of the Dublin Craftsmen.* New York: Crown Publishers, Inc., 1971.

Hipkiss 1929
Edwin J. Hipkiss. *Handbook of the Department of Decorative Arts of Europe and America.* Boston: Museum of Fine Arts, Boston, 1929.

Hipkiss 1950
Edwin J. Hipkiss. *Eighteenth-Century American Arts: The M. and M. Karolik Collection.* 1941. 2d ed. Cambridge: Harvard University Press for the Museum of Fine Arts, Boston, 1950.

Hodson 1967
Peter Hodson. "The Design and Building of Bremo, 1815–1820." Master's thesis, University of Virginia, 1967.

Hope 1807
Thomas Hope. *Household Furniture and Decoration.* London, 1807. Reprint. New York: Dover Publications, Inc., 1971.

Hopkins and Cox 1936
Thomas S. Hopkins and Walter S. Cox, comps. *Colonial Furniture of West New Jersey.* Haddonfield, N. J.: Historical Society of Haddonfield, 1936.

Hornor 1935
William M. Hornor, Jr. *Blue Book: Philadelphia Furniture.* Philadelphia: Privately printed, 1935.

Howe 1979
Katherine S. Howe. "Nineteenth-century American Decorative Arts in Houston." *Antiques* 115:3 (Mar. 1979): 556–563.

Howe and Warren 1976
Katherine S. Howe and David B. Warren. *The Gothic Revival Style in America, 1830–1870.* Houston: Museum of Fine Arts, 1976.

Hummel 1955
Charles F. Hummel. "The Influence of English Design Books Upon the Philadelphia Cabinetmakers, 1760–1820." Master's thesis, University of Delaware, 1955.

Hummel 1970
Charles F. Hummel. "Queen Anne and Chippendale Furniture in the Henry Francis du Pont Winterthur Museum." *Antiques* 97:6 (June 1970): 902–903.

Hummel 1976
Charles F. Hummel. *A Winterthur Guide to American Chippendale Furniture.* New York: Crown Publishers, 1976.

Hurst forthcoming
Ronald L. Hurst. "Cabinetmakers and Related Tradesmen in Norfolk, Virginia, 1770–1820." Master's thesis, College of William and Mary, forthcoming.

Jobe 1976
Brock Jobe. "A Desk by Benjamin Frothingham of Charlestown." *Currier Gallery of Art Bulletin* (1976): 3–23.

Jobe and Kaye 1984
Brock Jobe and Myrna Kaye. *New England Furniture, The Colonial Era: Selections from the Society for the Preservation of New England Antiquities.* Boston: Houghton Mifflin Company, 1984.

Johnson 1972
J. Stewart Johnson. "John Jelliff, Cabinetmaker." *Antiques* 102:2 (Aug. 1972): 256–261.

Kane 1976
Patricia E. Kane. *300 Years of American Seating Furniture: Chairs and Beds from the Mabel Brady Garvan and Other Collections at Yale University*. Boston: New York Graphic Society, 1976.

Kimball 1933
Fiske Kimball. "Salem Furniture Makers, I: Nathaniel Appleton, Jr." *Antiques* 24:3 (Sept. 1933): 90–91.

Kimball 1949
Fiske Kimball. "The Building of Bremo." *Virginia Magazine of History and Biography* 57:1 (Jan. 1949): 3–13.

Kindig 1978
Joseph K. Kindig III. *The Philadelphia Chair: 1685–1785*. Harrisburg, Pa.: Historical Society of York County, 1978.

King 1830
T. King. *The Modern Style of Cabinet Work Exemplified*. London, 1830s.

Kirk 1967
John T. Kirk. *Connecticut Furniture, Seventeenth and Eighteenth Centuries*. Hartford, Conn.: Wadsworth Atheneum, 1967.

Kirk 1972
John T. Kirk. *American Chairs: Queen Anne and Chippendale*. New York: Alfred A. Knopf, 1972.

Kirk 1982
John T. Kirk. *American Furniture and the British Tradition to 1830*. New York: Alfred A. Knopf, 1982.

Kreisel and Himmelheber 1983
Heinrich Kreisel and Georg Himmelheber. *Die Kunst des deutschen Möbels*. Munich: Verlag C. H. Beck, 1983.

Ledoux-Lebard 1965
Denise Ledoux-Lebard. *Les ébénistes du XIX siècle, 1795–1889*. Paris: Les éditions de l'amateur, 1965.

Levy
Bernard and S. Dean Levy, Inc., New York, N. Y. This firm periodically publishes brochures of its inventory.

Libin 1985
Laurence Libin. *American Musical Instruments in the Metropolitan Museum of Art*. New York: W. W. Norton and Co., 1985.

Little 1984
Nina Fletcher Little. *Little By Little: Six Decades of Collecting American Decorative Arts*. New York: E. P. Dutton, 1984.

Lockwood 1907
Luke Vincent Lockwood. *A Collection of English Furniture of the XVII & XVIII Centuries*. New York: Tiffany Studios, 1907.

Lockwood 1926
Luke Vincent Lockwood. *Colonial Furniture in America*. 2 vols. New York: Charles Scribner's Sons, 1901. Rev. ed. New York: Charles Scribner's Sons, 1926.

Loomes 1976
Brian Loomes. *Watchmakers and Clockmakers of the World, Volume II*. London: N.A.G. Press Ltd., 1976.

Louis and Sack 1987
Peter A. Louis and Donald R. Sack. "John Chipman, Cabinetmaker of Salem, Massachusetts." *Antiques* 132:6 (Dec. 1987): 1318–1325.

Lyon 1924
Irving Whitall Lyon. *The Colonial Furniture of New England*. New York, 1891. 2d ed. New York: Houghton Mifflin and Co., 1924.

McClaugherty 1983
Martha Crabill McClaugherty. "Household Art: Creating the Artistic Home, 1868–1893." *Winterthur Portfolio* 18:1 (Spring 1983): 1–26.

McClelland 1980
Nancy McClelland. *Duncan Phyfe and the English Regency, 1795–1830*. New York, 1939. Reprint. New York: Dover Publications, Inc., 1980.

McLanathan 1961
Richard B. K. McLanathan. "History in Houses." *Antiques* 79:4 (Apr. 1961): 357.

Madigan 1974
Mary Jean Smith Madigan. *Eastlake-Influenced American Furniture, 1870–1890*. Yonkers, N. Y.: Hudson River Museum, 1974.

Madigan 1975
Mary Jean Smith Madigan. "The Influence of Charles Locke Eastlake on American Furniture Manufacture, 1870–90." In *Winterthur Portfolio* 10, ed. Ian M. G. Quimby. Charlottesville: University Press of Virginia for Henry Francis du Pont Winterthur Museum, 1975, 1–22.

Maloof 1983
Sam Maloof. *Sam Maloof: Woodworker*. New York: Kodansha International Ltd., 1983.

Manwaring 1765
Robert Manwaring. *The Cabinet and Chair-maker's Real Friend and Companion*. London, 1765.

Mason 1969
Bernard Mason. *Clock and Watchmaking in Colchester*. London: Hamlyn Publishers Co., 1969.

Mésangère 1796
Pierre de la Mésangère. *Collection de meubles et objets de goût*. Paris, 1796-ca. 1835.

MESDA
Museum of Early Southern Decorative Arts, Winston-Salem, N. C.

MFA, B
Museum of Fine Arts, Boston, Mass.

MFA, H 1981
"An American Sampler, 1700–1875: The Charles Lewis Bybee Memorial Collections." An exhibition held at the Museum of Fine Arts, Houston, 23 Oct. 1981—7 Feb. 1982.

E. Miller 1937
Edgar G. Miller, Jr. *American Antique Furniture: A Book for Amateurs*. 2 vols. Baltimore: Lord Baltimore Press, 1937.

Monahon 1980
Eleanor Bradford Monahon. "The Rawson Family of Cabinetmakers in Providence, Rhode Island." *Antiques* 98:1 (July 1980): 134–147.

Monkhouse and Michie 1986
Christopher P. Monkhouse and Thomas S. Michie. *American Furniture in Pendleton House*. Providence, R.I.: Rhode Island School of Design, 1986.

Montgomery 1966
Charles F. Montgomery. *American Furniture: The Federal Period, in the Henry Francis du Pont Winterthur Museum*. New York: Viking Press, 1966.

Moses 1984
Michael Moses. *Master Craftsmen of Newport, The Townsends and Goddards*. Tenafly, N.J.: MMI Americana Press, 1984.

Myers and Mayhew 1974
Minor Myers, Jr., and Edgar deN. Mayhew. *New London County Furniture, 1640–1840*. New London, Conn.: Lyman Allyn Museum, 1974.

Neal Alfred Company
Neal Alfred Company, New Orleans, La. This auction company published catalogues of its sales.

New Jersey State Museum 1970
An Exhibition of Furniture and Furnishings from the Collection of the New Jersey State Museum. Trenton: New Jersey State Museum, 1970.

New York 1810
The New-York Revised Prices for Manufacturing Cabinet and Chair Work. New York, 1810.

Norman-Wilcox 1934
Gregor Norman-Wilcox. "Knife Cases: Part II. Urns and Allied Forms." *Antiques* 26:6 (Dec. 1934): 222–226.

Norwalk 1979
Connecticut Furniture 1700–1800. Norwalk, Conn.: Norwalk Historical Society, 1979.

Nutting 1928
Wallace Nutting. *Furniture Treasury (Mostly of American Origin), All Periods of American Furniture with Some Foreign Examples in America, also American Hardware and Household Utensils*. 3 vols. Framingham, Mass.: Old America Co., 1928–1933.

Ormsbee 1933
Thomas H. Ormsbee. "The Furniture of Lannuier and his Successor." *Antiques* 23:6 (June 1933): 224–226.

Ormsbee 1934
Thomas H. Ormsbee. *The Story of American Furniture*. New York: Macmillan Co., 1934.

Osborne 1975
Harold Osborne, ed. *The Oxford Companion to the Decorative Arts*. Oxford: Clarendon Press, 1975.

Ott 1965
Joseph K. Ott et al. *The John Brown House Loan Exhibition of Rhode Island Furniture, Including Some Notable Portraits, Chinese Export Porcelain, and Other Items*. Providence: Rhode Island Historical Society, 1965.

Otto 1962
Celia J. Otto. "Pillar and Scroll: Greek Revival Furniture of the 1830's." *Antiques* 81:5 (May 1962): 504–507.

Otto 1965
Celia J. Otto. *American Furniture of the Nineteenth Century*. New York: Viking Press, 1965.

Page 1969
John F. Page. *Litchfield County Furniture, 1730–1850*. Litchfield, Conn.: Litchfield Historical Society, 1969.

Page and Garvin 1979
John F. Page and James L. Garvin. *Plain & Elegant, Rich & Common: Documented New Hampshire Furniture, 1750–1850*. Concord, N. H.: New Hampshire Historical Society, 1979.

Pain 1978
Howard Pain. *The Heritage of Country Furniture: A Study in the Survival of Formal and Vernacular Styles from the United States, Britain and Europe found in Upper Canada, 1780–1900*. New York: Van Nostrand Reinhold Co., 1978.

Partridge 1935
Albert E. Partridge. "Benjamin Bagnall of Boston, Clockmaker." *Old-Time New England* 26:1 (July 1935): 26–31.

Pearce 1964
John N. Pearce, Lorraine W. Pearce, and Robert C. Smith. "The Meeks Family of Cabinetmakers." *Antiques* 85:4 (Apr. 1964): 414–420.

Percier and Fontaine 1812
Charles Percier and Pierre F. L. Fontaine. *Recueil de décorations intérieures*. Paris, 1812.

Philadelphia 1828
The Philadelphia Cabinet and Chair Makers' Union Book of Prices for Manufacturing Cabinet Ware. Philadelphia, 1828.

Pickman 1864
Col. Benjamin Pickman. "Some Account of Houses and Other Buildings in Salem." *Essex Institute Historical Collections* 6:3 (June 1864): 93–109.

Pierson 1986
William H. Pierson, Jr. *American Buildings and Their Architects: The Colonial and Neoclassical Styles*. New York, 1970. Reprint. Oxford: Oxford University Press, 1986.

PMA 1976
Philadelphia: Three Centuries of American Art. Philadelphia: Philadelphia Museum of Art, 1976.

Poesch 1968
Jessie J. Poesch. "Early Louisiana Armoires." *Antiques* 94:2 (August 1968): 196–205.

Poesch 1972
Jessie J. Poesch. *Early Furniture of Louisiana, 1750–1830*. New Orleans: Louisiana State Museum, 1972.

Price 1977
Lois Olcott Price. "Furniture Craftsmen and the Queen Anne Style in Eighteenth-Century New York." Master's thesis, University of Delaware, 1977.

Pyne 1971
Ornamental Ironwork. [Reprint of Janes, Kirkland, and Co.'s *Illustrated Catalog of Ornamental Iron Work* (1870).] Princeton: Pyne Press, 1971.

Quimby 1984
Ian M. G. Quimby, ed. *The Craftsman in Early America*. New York: W. W. Norton and Co., 1984.

Randall 1965
Richard H. Randall, Jr. *American Furniture in the Museum of Fine Arts, Boston*. Boston: Museum of Fine Arts, 1965.

Record Commissioners 1881
A Report of the Record Commissioners of the City of Boston. Vols. 1–15. Boston, 1881–1886.

Reed 1973
Helen S. T. Reed. "Decorative Arts in the Valentine Museum." *Antiques* 103:1 (Jan. 1973): 167–174.

Report 1830
Report of the Third Annual Fair of the American Institute of the City of New York, Held at Masonic Hall, October 1830. New York, 1830.

Rice 1962
Norman S. Rice. *New York Furniture Before 1840 in the Collection of the Albany Institute of History and Art*. Albany: Albany Institute of History and Art, 1962.

Ring 1981
Betty Ring. "Check List of Looking-glass and Frame Makers and Merchants Known by Their Labels." *Antiques* 115:5 (May 1981): 1183–1195.

Rodriquez Roque 1984
Oswaldo Rodriquez Roque. *American Furniture at Chipstone*. Madison: University of Wisconsin Press, 1984.

Roessel 1987
Elizabeth Roessel. "'The Way We've Always Made It': The Dodge Furniture Company and the Cabinetmaking Industry of Manchester, Massachusetts." Master's thesis, University of Delaware, 1987.

Rogers 1923
John C. Rogers. *English Furniture: Its Essentials and Characteristics*. New York: Charles Scribner's Sons, 1923.

Rogers 1947
Meyric R. Rogers. *American Interior Design: The Traditions and Development of Domestic Design from Colonial Times to the Present*. New York: W. W. Norton and Co., 1947.

Roth 1961
Rodris Roth. "Tea Drinking in Eighteenth-Century America: Its Etiquette and Equipage." *United States National Museum Bulletin*, 225, Contributions from the Museum of History and Technology. Washington, D.C.: Smithsonian Institution, 1961.

Rust 1891
Albert D. Rust. *Record of the Rust Family Embracing the Descendants of Henry Rust, Who Came from England and Settled in Hingham, Massachusetts, 1634–1635*. Waco, Tex., 1891.

Sack 1981
American Antiques from Israel Sack Collection. 8 vols. Washington, D.C.: Highland House Publishers, 1981–1986.

Sack Collection 1931
The Israel Sack Collection of Antique American Furniture, Etc. Sale 4528 (23–25 Apr. 1931). New York: James P. Silo Auction Gallery, 1931.

A. Sack 1950
Albert Sack. *Fine Points of Furniture, Early American.* New York: Crown Publishers, 1950.

H. Sack 1988
Harold Sack. "The Development of the American High Chest of Drawers." *Antiques* 133:5 (May 1988): 1112–1127.

Sammlung 1796
Sammlung von Zeichnungen der neusten Londoner und Pariser Meubles als Muster für Tischler. Leipzig, 1796-?

Santore 1981
Charles Santore. *The Windsor Style in America, 1730–1830.* Philadelphia: Running Press, 1981.

Scherer 1984
John L. Scherer. *New York Furniture at the New York State Museum.* Old Town Alexandria, Va.: Highland House Publishers, 1984.

H. Schiffer 1983
Herbert F. Schiffer. *The Mirror Book: English, American, and European.* Exton, Pa.: Schiffer Publishing, 1983.

M. Schiffer 1966
Margaret Berwind Schiffer. *Furniture and Its Makers of Chester County, Pennsylvania.* Philadelphia: University of Pennsylvania Press, 1966.

M. Schiffer 1980
Margaret Schiffer. *Arts and Crafts of Chester County, Pennsylvania.* Exton, Pa.: Schiffer Publishing, 1980.

Schrenkeisen 1873
M. and H. Schrenkeisen. Supplement to the Illustrated Catalogue of M. and H. Schrenkeisen, Warerooms: No. 17 Elizabeth Street, near Canal, Factory, Nos. 328, 330, 332 & 334 Cherry Street, New York, N. Y., [1873].

Schwarz 1980
Robert D. Schwarz. *The Stephen Girard Collection: A Selective Catalogue.* Philadelphia: Girard College, 1980.

Selleck 1976
George A. Selleck. *Quakers in Boston, 1656–1964: Three Centuries of Friends in Boston and Cambridge.* Cambridge: Friends at Meeting at Cambridge, 1976.

Shephard 1978
Lewis A. Shephard. *American Art at Amherst.* Middletown, Conn.: Wesleyan University Press, 1978.

Sheraton 1802
Thomas Sheraton. *The Cabinet-Maker and Upholsterer's Drawing Book.* 3d ed. London, 1802. Reprint. New York: Dover Publications, Inc., 1972.

Shove 1941
Benjamin Jay Shove. *The Family Shove.* Privately printed, 1941.

Singleton 1901
Esther Singleton. *The Furniture of Our Forefathers.* 4 vols. New York: Doubleday, Page and Co., 1900–1901.

Skemer 1987
Don C. Skemer. "David Alling's Chair Manufactory: Craft Industrialization in Newark, New Jersey, 1801–1854." *Winterthur Portfolio* 22:1 (Spring 1987): 1–21.

Smee 1830
William Smee and Sons. *Designs for Furniture.* London, 1830s.

Smith and Hummel 1978
James Morton Smith and Charles F. Hummel. "The Henry Francis du Pont Winterthur Museum." *Antiques* 113:6 (June 1978): 1268–1306.

C. Smith 1988
Carolyn V. Smith. "Stanton Hall in Natchez, Mississippi." *Antiques* 133:3 (Mar. 1988): 704–713.

G. Smith 1808
George Smith. *A Collection of Designs for Household Furniture and Interior Decoration.* London, 1808. Reprint. New York: Praeger Publishers, 1970.

G. Smith 1826
George Smith. *The Cabinet-Maker and Upholsterer's Guide: Being a Complete Drawing Book.* London, 1826.

R. Smith 1964
Robert C. Smith. "Philadelphia Empire Furniture by Antoine Gabriel Quervelle." *Antiques* 86:3 (Sept. 1964): 303–309.

R. Smith 1–5, 1973–1974
Robert C. Smith. "The Furniture of Anthony G. Quervelle." *Antiques.* "Part I: The Pier Tables," 103:5 (May 1973): 984–994; "Part II: The Pedestal Tables," 104:1 (July 1973): 290–299; "Part III: The Worktables," 104:2 (Aug. 1973): 260–268; "Part IV: Some Case Pieces," 105:1 (Jan. 1974): 180–193; "Part V: Sofas, Chairs, and Beds," 105:3 (Mar. 1974): 512–521.

Snyder 1985
Ellen Marie Snyder. "Victory Over Nature: Cast-Iron Seating Furniture." *Winterthur Portfolio* 20:4 (Winter 1985): 221–242.

Spalding 1928
Dexter E. Spalding. "Benjamin Frothingham of Charlestown, Cabinetmaker and Soldier." *Antiques* 14:6 (Dec. 1928): 535–537.

SPB
Sotheby Parke Bernet, Inc., New York, N. Y. Formerly Parke-Bernet, Inc. All sale catalogues are for the New York gallery.

Spillane 1890
Daniel Spillane. *History of the American Pianoforte: Its Technical Development and the Trade.* New York, 1890.

SPNEA
Society for the Preservation of New England Antiquities, Boston, Mass.

Springer 1980
Lynn E. Springer. "American Furniture." *St. Louis Museum of Art Bulletin* 15:3 (Summer 1980): 1–48.

Stearns 1928
"Dr. William Stearns, Merchant and Apothecary, With Some Account of the Sprague Family." *Essex Institute Historical Collections* 64:1 (Jan. 1928): 1–19.

Stayton 1984
Kevin L. Stayton, Shirley Mills, and Larry Weinberg. "The Harrison House Rooms at the Brooklyn Museum." *Antiques* 126:4 (Oct. 1984): 884–890.

Stephenson 1979
Sue Honaker Stephenson. *Rustic Furniture.* New York: Van Nostrand Reinhold, 1979.

Stockwell 1961
David Stockwell. "Irish Influence in Pennsylvania Queen Anne Furniture." *Antiques* 79:3 (Mar. 1961): 269–271.

Stockwell 1981
David Stockwell. "Living with Antiques." *Antiques* 118:5 (May 1981): 1100–1105.

Stone 1977
Lawrence Stone. *The Family, Sex and Marriage in England, 1500–1800.* New York: Harper and Row, 1977.

Stoneman 1959
Vernon C. Stoneman. *John and Thomas Seymour, Cabinetmakers in Boston, 1794–1816.* Boston: Special Publications, 1959.

Stratmann 1973
Rosemarie Stratmann. "Design and Mechanism in the Furniture of Jean-François Oeben." *Furniture History* 4 (1973): 110–113.

Stroup 1981
Roger E. Stroup. "The Robert Mills Historic House, Columbia, South Carolina." *Antiques* 120:6 (Dec. 1981): 1432–1440.

Sturges 1973
W. K. Sturges. "Arthur Little and the Colonial Revival." *Journal of the Society of Architectural Historians* 32:2 (May 1973): 147–163.

Swan 1937
Mabel M. Swan. "John Seymour and Son, Cabinetmakers." *Antiques* 32:4 (Oct. 1937): 176–180.

Swan 1944
Mabel M. Swan. "Furnituremakers of Charlestown." *Antiques* 46:4 (Oct. 1944): 202–206.

Swan 1952
Mabel M. Swan. "Major Benjamin Frothingham, Cabinetmaker." *Antiques* 62:5 (Nov. 1952): 392–395.

Swank 1983
Scott T. Swank et al. *Arts of the Pennsylvania Germans*. Ed. Catherine E. Hutchins. New York: W. W. Norton and Co., 1983.

J. Sweeney 1981
John A. H. Sweeney. "Furniture in the Sewell C. Biggs Collection." *Antiques* 119:4 (Apr. 1981): 902–905.

K. Sweeney 1984
Kevin M. Sweeney. "Furniture and Furniture Making in Mid-Eighteenth-Century Wethersfield, Connecticut." *Antiques* 125:5 (May 1984): 1156–1163.

Talbott 1975
Page Talbott. "Boston Empire Furniture, Part I." *Antiques* 107:5 (May 1975): 878–887.

Talbott 1976
Page Talbott. "Boston Empire Furniture, Part II." *Antiques* 109:5 (May 1976): 1004–1013.

Talbott 1977
Page Talbott. "The Furniture of Isaac Vose." *St. Louis Art Museum Bulletin* 13:2 (Mar./Apr. 1977): 40–49.

Talbott 1980
Page Talbott. "The Philadelphia Furniture Industry 1850 to 1880." Diss., University of Pennsylvania, 1980.

Theus 1967
Mrs. Charlton M. Theus. *Savannah Furniture, 1735–1825*. Savannah: Privately printed, 1967.

Thornton 1978
Peter Thornton. *Seventeenth-Century Interior Decoration in England, France, and Holland*. New Haven: Yale University Press, 1978.

Thornton 1984
Peter Thornton. *Authentic Decor: The Domestic Interior, 1620–1920*. New York: Viking Press, 1984.

Tolles 1983
Bryant F. Tolles, Jr. *Architecture in Salem*. Salem, Mass.: Essex Institute, 1983.

Tracy 1970
Berry B. Tracy et al. *19th-Century America: Furniture and Other Decorative Arts, An Exhibition in Celebration of the Hundredth Anniversary of the Metropolitan Museum of Art*. New York: Metropolitan Museum of Art, 1970.

Tracy and Gerdts 1963
Berry B. Tracy and William H. Gerdts. *Classical America, 1815–1845*. Newark, N. J.: Newark Museum Association, 1963.

Trent 1977
Robert F. Trent. *Hearts and Crowns: Folk Chairs of the Connecticut Coast, 1720–1840, as Viewed in the Light of Henri Focillon's Introduction to Art Populaire*. New Haven: New Haven Colony Historical Society, 1977.

Trent 1, 1985
Robert F. Trent. "New London Joined Chairs, 1720–1790." *Connecticut Historical Society Bulletin* 50:4 (Fall 1985): 1–195.

Trent 2, 1985
Robert F. Trent. "The Chest of Drawers in America, 1635–1730: A Postscript." *Winterthur Portfolio* 20:1 (Spring 1985): 31–49.

Trent 1988
Robert F. Trent. "More on Sofas." *Maine Antique Digest* 16:9 (Sept. 1988): 10-B–14-B.

Valentine 1926
Catalogue of Articles to be Sold at Public Auction at the Mansion House, on Bremo Plantation, at Strathmore, Fluvanna Co., Virginia, on Thursday, Nov. 18, 1926, 10 a. m. Richmond: Valentine Auction Co., 1926.

Van Deusen 1912
Albert Harrison Van Deusen. *Van Deursen Family*. Vol. 1. New York: Frank Allaben Genealogical Co., 1912.

Van Wagenen 1901
Avis Stearns Van Wagenen. *Genealogy and Memories of Isaac Stearns and his Descendants*. Syracuse, N. Y.: Currier Printing Co., 1901.

Venable 1986
Charles L. Venable. "Philadelphia Biedermeier: Germanic Craftsmen and Design In Philadelphia, 1820–1850." Master's thesis, University of Delaware, 1986.

Vibert 1981
Jeanne A. Vibert. "The Market Economy and the Furniture Trade of Newport, Rhode Island: The Career of John Cahoone, Cabinetmaker, 1745–1765." Master's thesis, University of Delaware, 1981.

Ward 1977
Gerald W. R. Ward, ed. *The Eye of the Beholder: Fakes, Replicas, and Alterations in American Art*. New Haven: Yale University Art Gallery, 1977.

Ward 1988
Gerald W. R. Ward. *American Case Furniture in the Mabel Brady Garvan and Other Collections at Yale University*. New Haven: Yale University Art Gallery, 1988.

Ward and Hosley 1985
Gerald W. R. Ward and William N. Hosley, Jr., eds. *The Great River: Art and Society of the Connecticut Valley, 1635–1820*. Hartford, Conn.: Wadsworth Atheneum, 1985.

Warren 1975
David B. Warren. *Bayou Bend: American Furniture, Paintings, and Silver from the Bayou Bend Collection*. Houston: Museum of Fine Arts, 1975.

Warren and Howe 1978
David B. Warren and Katherine S. Howe. *Houston Collects Nineteenth-Century American Decorative Arts*. Houston: Museum of Fine Arts, 1978.

Waters 1979
Deborah Dependahl Waters. "Wares & Chairs: A Reappraisal of the Documents." In *American Furniture and Its Makers: Winterthur Portfolio 13*, ed. Ian M. G. Quimby. Chicago: University of Chicago Press, 1979, 161–174.

Webster 1979
Donald B. Webster. "The Identification of English-Canadian Furniture, 1780–1840." *Antiques* 115:1 (Jan. 1979): 164–179.

Weidman 1984
Gregory R. Weidman. *Furniture in Maryland, 1740–1940*. Baltimore: Maryland Historical Society, 1984.

Weil 1979
Martin E. Weil. "A Cabinetmaker's Price Book." In *American Furniture and Its Makers: Winterthur Portfolio 13*, ed. Ian M. G. Quimby. Chicago: University of Chicago Press, 1979, 175–192.

White 1958
Margaret E. White. *Early Furniture Made in New Jersey, 1690–1870*. Newark, N. J.: Newark Museum Association, 1958.

Whitehill 1974

Walter Muir Whitehill, ed. *Boston Furniture of the Eighteenth Century*. Boston: Colonial Society of Massachusetts, 1974.

Wickersham 1977

J. B. Wickersham. *Victorian Ironwork*. [Reprint of 1857 trade catalogue of the New York Wire Railing Company.] Philadelphia: Philadelphia Athenaeum, 1977.

Williamsburg 1966

The Glen-Sanders Collection from Scotia, New York. Williamsburg, Va.: Colonial Williamsburg, 1966.

Winchester 1961

Alice Winchester, ed. *Collectors and Collections*. New York: Antiques, 1961.

INDEX